MARISA BERENSON

A Life in Pictures

RIZZOLI
NEW YORK

New York · Paris · London · Milan

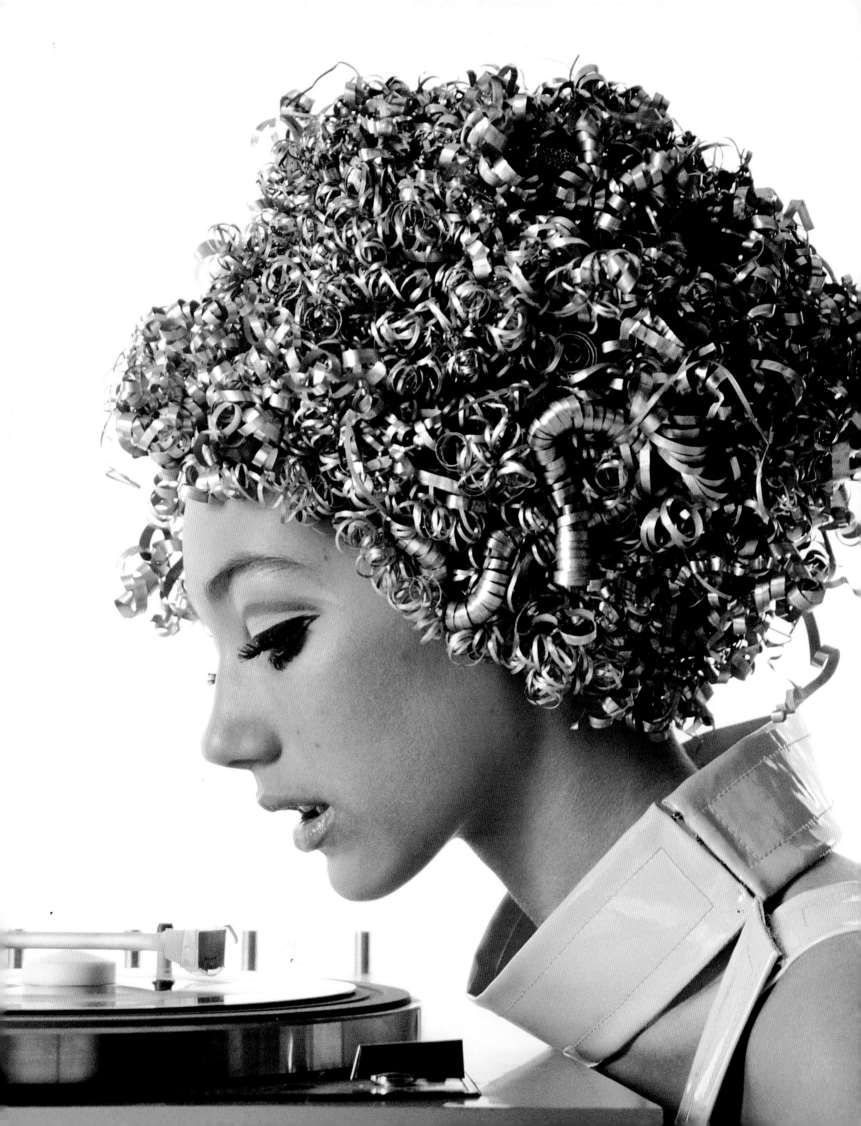

MARISA BERENSON

A Life in Pictures

Guest Editor
STEVEN MEISEL

Art Director
JASON DUZANSKY

Executive Producer
LINA BEY

rom her earliest breath, Vittoria Marisa Schiaparelli Berenson has lived her life in the sight of a camera's lens. Even her christening portrait was published in *Vogue*. Marisa was born to style; her formidable grandmother was Elsa Schiaparelli, the Italian-born designer with Medici blood who transformed the fashion landscape with her antic and surrealist designs. Schiap's pretty and creative daughter, the Countess Maria Luisa Yvonne Radha de Wendt de Kerlor (known as Gogo) married Robert L. Berenson, a dashing diplomat from a dynasty of intellectuals. The happy union produced Marisa and her younger sister, Berinthia, who as "Berry" Berenson Perkins was to become a photographer who mastered the art of the captured moment.

Marisa's childhood was spent following her peripatetic parents, although her education in a succession of European boarding schools was firmly entrenched in old-fashioned values and the culture of finishing school.

At sixteen, she was "discovered" by *Vogue*'s dynamic editor Diana Vreeland, a family friend, who was to prove to be Marisa's Svengali, transforming the painfully shy and self-conscious teenager into the epitome of worldly self-possession, of-the-moment pizzazz, and ultimately the ideal of chameleon Youthquake beauty. As one of the most successful models of the age, she has worked with many of the great photographers of the late twentieth and early twenty-first centuries, from Penn and Avedon and Hiro and Sokolsky and Sieff and Stern and Rizzo and Bailey and Beaton and Newton and Bourdin to Meisel and Scavullo and Ritts and Moon and Issermann and Afanador and Roversi and Lacombe, to name just a few. Off the printed page she has animated the work of designers from Ossie Clark and Yves Saint Laurent and Emanuel Ungaro and Valentino and Halston and Giorgio Sant'Angelo and Loris Azzaro to Azzedine Alaïa and Donna Karan and John Galliano and Tom Ford. Each has found a different facet of Marisa's diamond-like beauty to illuminate with their lenses or accent with the cut of their cloth or feature on the cover of *Vogue* or *Bazaar* or *Elle* or *Playboy* or *Newsweek* or *Time*.

The legendary filmmaker Luchino Visconti, responding to her poetic, green-eyed beauty, cast her as Von Aschenbach's tormented wife in his magnificently evocative 1971 adaptation of Thomas Mann's *Death in Venice*, and successfully mined the histrionic talents that her modeling roles had hinted she might possess. Her performance in Bob Fosse's 1972 *Cabaret* as the chic but naïve Fräulein Landauer brought her Golden Globe nominations and confirmed a talent that Stanley Kubrick amplified further still when he cast her in his 1975 eighteenth-century epic, *Barry Lyndon*. Berenson inhabited the role of Lady Lyndon, an ambulant Gainsborough beauty who glided, preened, and primal-screamed through some of the stateliest rooms and most ravishing landscapes in Britain. Her movie career has subsequently taken her from comedic Hollywood romps (Blake Edwards's 1981 *S.O.B.*—and the comedy continued when she gave Miss Piggy some dating advice on *The Muppet Show*) to a channeling of Katherine Hepburn in Clint Eastwood's *White Hunter Black Heart* to European art house productions, latterly Luca Guadagnino's acclaimed 2009 Viscontian dynastic drama *I Am Love*. She has shined of Broadway's boards in giddy Coward plays, and written manuals to style and dressing.

Meanwhile Marisa's private life has been the stuff of legend. She has stepped out with some of the most dashing and eligible and dangerous bachelors of the age, from the beauteous actors Terence Stamp and Helmut Berger and Sam Shepard and Kevin Kline to the crooning Bryan Ferry and the tousle-haired sugar scion and surfer Arnaud de Rosnay (whose photo essays for *Vogue*, starring Marisa, defined sixties fantasy fashion), Rikky von Opel, of the car-making family and Formula One racing driver, and best-dressed David de Rothschild, scion of the French banking dynasty and whose stepmother, Marie-Hélène, gave the most dazzling costume balls of the sixties and seventies (several of them illuminated by Marisa herself).

Celebrating birthdays and openings and fashion shows and weddings and parties and the sheer joy of being young and beautiful and glamorous and at the pulsing heart of the fashionable world, Marisa's early life was lived in the full glare of paparazzi flashbulbs, of Berry Berenson's and Gerard Malanga's lenses, and of Andy's Polaroid flash. They recorded her at Xenon and Studio 54 and Regine's and Le Sept and Le Palace with Andy and Halston and Liza and Truman (who named her Shih Tzu King Kong, which she abbreviated to K.K.) and bronzing on the beaches of Saint Tropez and striking poses in the salons of Ferrières and gossiping with Bianca and Paloma and Loulou in the couture houses of Paris and dazzling at the White House (in Halston's hammered satin toga) and dancing with Travolta in the Hall of Mirrors at Versailles. Marisa transformed from golden girl to golden woman before our eyes and (wearing Valentino ruffles) she gave her hand to the riveting James Randall before eight hundred guests, including Angelica and Jack and Alana and George and le tout Hollywood, as Rona Barrett declared, "Romance is back!" The union produced a beloved daughter, Starlite Melody, but proved short-lived (her second marriage to the lawyer Richard Golub lasted only a little longer).

Through it all, through the scintillations of being an "It" Girl and the desolations of private tragedies that became public ones, Marisa has remained beautiful and serene, her life guided by the mysticism and spirituality that she first discovered during a vigil at an Indian ashram with the Beatles in the sixties.

Over tea in her Manhattan aerie embowered in paisley and leopard, Marisa considers a life as Model, Muse, Actress, Granddaughter, Sister, Mother. As the girl and the woman everyone wanted to be.
H.B.

MARISA BERENSON

I was five when I was photographed for my first *Elle* cover. My grandmother made the dresses for my sister Berry and me: ruby-colored velvet with shocking pink organdie sashes. Even then, Berry and I were completely different but very complementary. In the years when I became a model, Berry became a great photographer in her own right.

When we were very young, my grandmother would have huge children's tea parties for us, with hats and balloons and Berry and I being waited on by waiters in white gloves! All of my friends that I still know today, I knew from those parties when I was tiny.

Schiap had a big *hôtel particulier* on the rue de Berri in Paris. These huge statues of Mr. and Mrs. Satan would greet you; they were daunting. It was a house full of treasures—so eclectic and arranged any old way. The television would be sitting on top of a huge pile of ancient eighteenth-century encyclopedias; the Picasso could be on the floor; nothing was really decorated per se. In our family, nobody has ever had decorators; we've always had taste and style. My mother's the same way—she has great style.

Later, as a teenager, I lived in an apartment upstairs, with my own entrance. I did have to come down and see my grandmother occasionally. I would just tremble at the thought, because although she was revolutionary in her time she couldn't believe my clothes in the sixties—she thought that mine was the most vulgar generation, and that there was no more chic or style.

My grandmother's family was very aristocratic on her mother's side and very intellectual and political on her father's side. She was very strictly brought up. But she just didn't want to be in this environment, in this family, so the minute she could leave home, she left home. For a woman who was born in Rome at the Palazzo Corsini, she was a complete rebel. She did it all on her own, and that was so difficult for a woman in those days that I think maybe she wanted to protect me. Because my grandmother really wanted me to marry a boy from a very good family and settle down to a secure life.

She never wanted my mother involved in her business either. She had done it on her own; she had succeeded. But she had suffered. She had a marriage to a French aristocrat called Count William de Wendt de Kerlor, who was my mother's

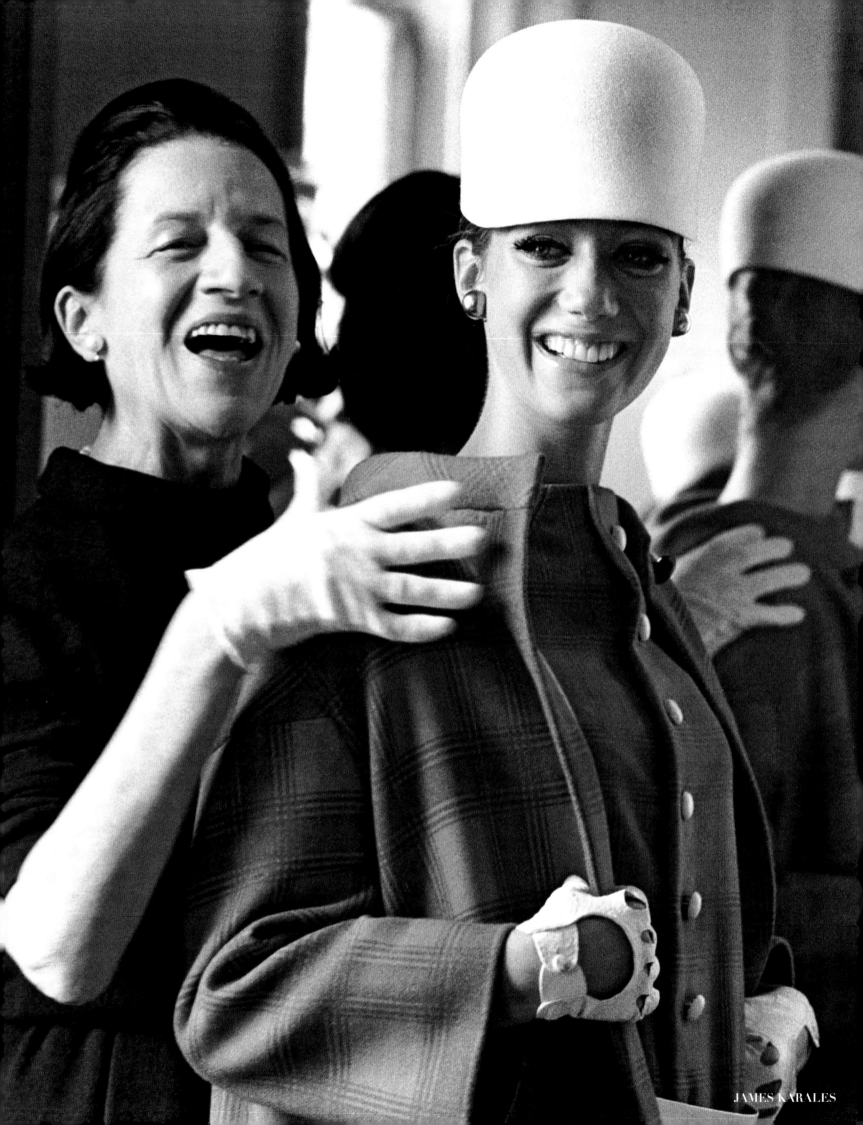

JAMES KARALES

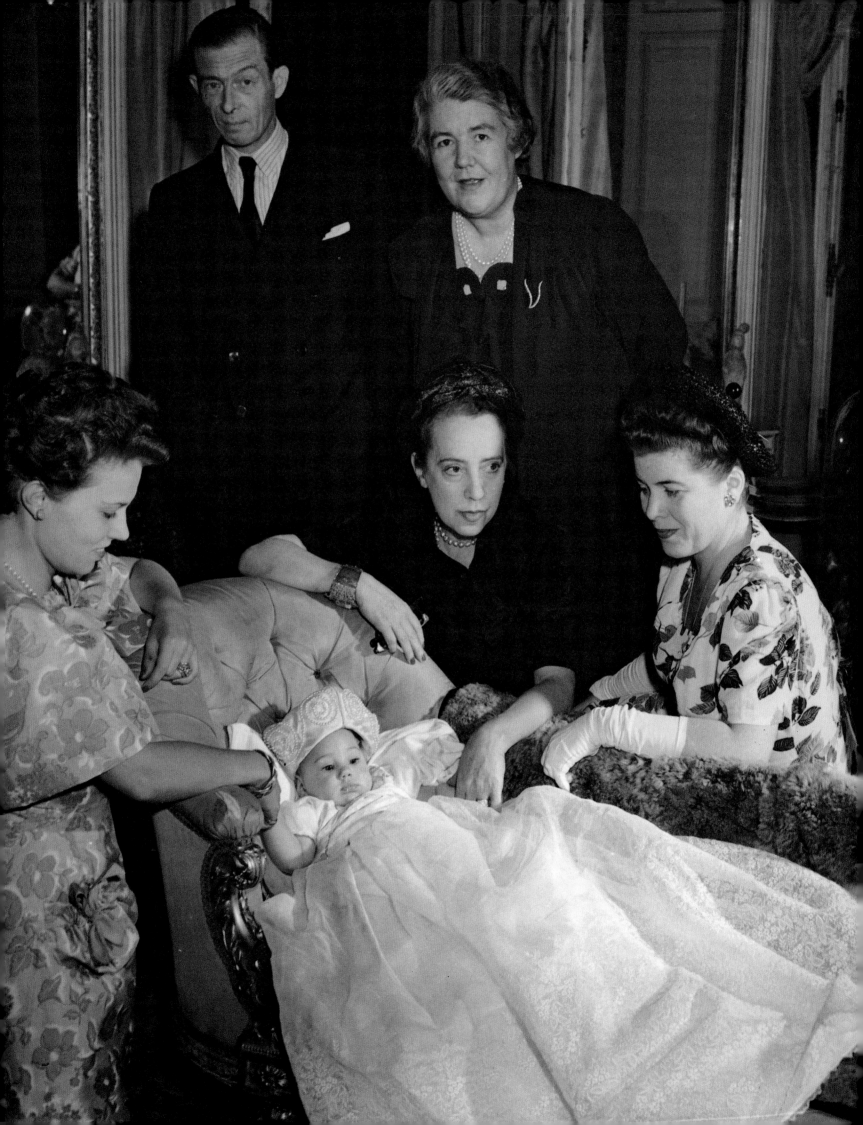

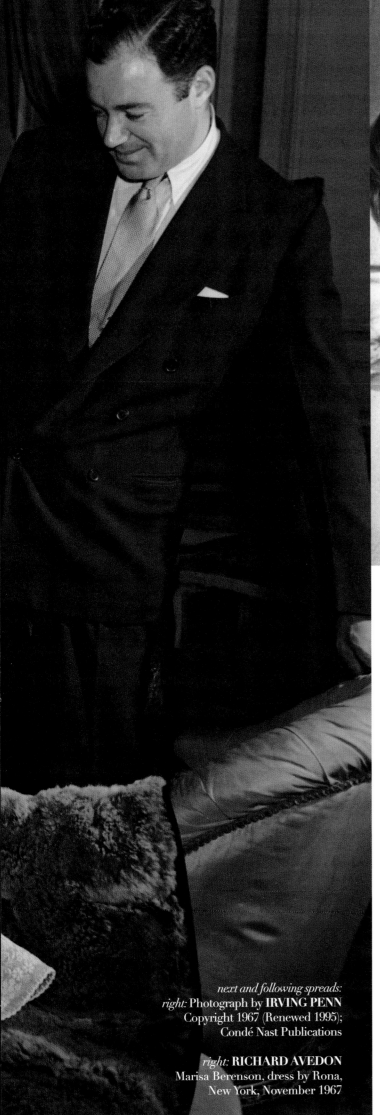

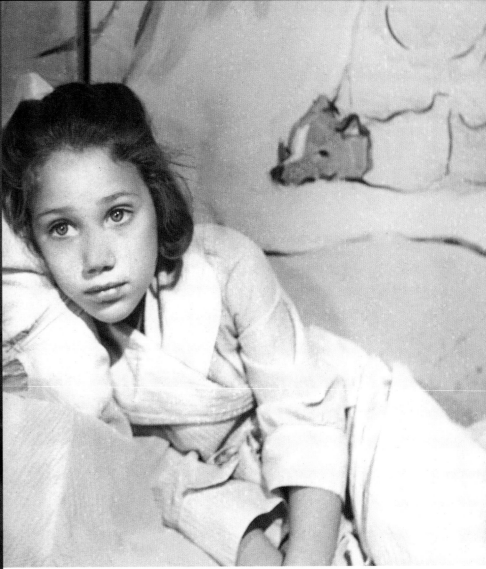

father, a very good-looking theologist. She fell in love with him in London listening to him speak about Hindu religions and all kinds of spiritual things. I think he had a mad affair with Isadora Duncan. Anyway, she left him and brought up my mother by herself. And he was persona non grata; he disappeared from the face of the planet. My mother never knew him. I think Schiap carried that pain around. What I learned from my grandmother was independence, and a certain originality and eclectic taste, because she had all that in her.

My grandmother put my mother in boarding school, as one did in those days with children, and so she didn't see her very much. My mother stayed away from the fashion world. To have a mother like that—it's overwhelming, you can't possibly compete with that. So she married my father and she was a diplomat's wife. She was very social and very sociable and very amusing and pretty and smart and cultured. She actually had great talent for sculpture and painting—she was an artist, too. But she never exploited that.

I think it was hard being my grandmother's daughter and then, later on, being my mother. She always said, "I'm sort of sandwiched in between you two." She felt like it jumped a generation. The independent quality that I had, she didn't have. But she traveled a lot with my father and they had a tremendous, very rich life.

My father was the head of Onassis's shipping company and he later became an American diplomat; Kennedy appointed him as a *ministre plénipotentiaire*, for countries in development. So my parents were always in the Far East or in Libya or in Yugoslavia, whilst my sister Berry and I were in boarding schools. We would go and join our parents in these places during the holidays, which was interesting.

I was in boarding school from the age of five—in Switzerland, Florence, and at Heathfields in England. Strict, strict boarding schools. I used to learn manners—girls from

good families needed to know how to do everything! Fencing and lacrosse and riding. I even learned how to make a "Chanel" suit—and I used to wear it!

We had a chalet at Klosters in Switzerland, where we would get together in the winter. Klosters was like a little Hollywood. It was a teeny village but filled with incredible people—Greta Garbo and Dirk Bogarde and Deborah Kerr and Gene Kelly and Peter Viertel and Irwin Shaw and Prince Charles—everybody! They were all at my parents' house at Christmas. Gene taught me how to dance, and he would take us sleigh riding through the snow to cut Christmas trees, singing Christmas carols.

When I was fifteen or sixteen, I went to London, which was bubbling! I had friends at Oxford, and it was the period of the Beatles and the Rolling Stones, of Ossie Clark and Zandra Rhodes and all those wonderful fashion people. It was very inspiring; all the fashion came out of London at that time...and I was madly in love with Terence Stamp—he was wonderful!

I studied at Michael Inchbald's architecture school because I thought I wanted to be an architect, or be a designer; I love decorating.

I came to New York when I was sixteen going on seventeen because my father was very sick, and as a last resort he was in a New York hospital. The last party I went to with him was my first New York party—and that's where I was "discovered." Diana Vreeland was there, and she said, "Oh, we have to photograph her!" And that was it!

I had known Diana all my life; she was a friend of my grandmother's and my parents. She used to call my sister and me "The Cunard Liners"—the Mauretania and the Berengaria!

So I started working for *Vogue*. Arnaud de Rosnay became my boyfriend and I introduced him to Diana, who "discovered" him, too, and he became a great photographer. Diana loved to send us out on these exotic trips for *Vogue*.

I would go to Diana's office to try things on. I had a great relationship with her—she was like my godmother. I would have lunch with her at least once a week, and then when my parents were in town. Her apartment was wonderful, the whole place like a beautiful red box. It was not a big chichi apartment, but it was an intimate place and it was divine. You walked in and it smelled of Rigaud candles.

She had a French cook who was with her till the day she died. It was simple cooking; she didn't like to eat a lot. Her husband, Reed, was a very good-looking man; he was beautiful. Like my father, he was very tall and long and lanky, and very handsome in that Gregory Peck way. And he adored her.

We would go to lunch at La Grenouille on Saturdays. She would still be at the office and Reed would order tiny little lamb chops for her, and a little bowl of spinach, a little glass of vodka, and then he would put a red rose next to her plate. It was so divine. I always thought that was the most romantic thing ever.

Diana was wonderful; she taught me a lot about life—and the importance of discipline. She really was a big supporter of creative people; she loved to encourage talent and celebrate beauty and personality—big personalities. In those days, all the models had huge personalities. We were all very different. I found myself working with Twiggy, who was just so whimsical and sweet, and Jean Shrimpton, who was the great beauty of the time, and the fabulous Veruschka, who was fabulous with her amazing movements—and the creativity in her!

I never really thought of myself as a beauty. I never thought I would make it in this business. I used to go into Irving Penn's studios and there would be models like Mirella Pettini and Brigitte, these beautiful and very sophisticated women who all had very high cheekbones and thin noses. And Lauren Hutton, who was a very American beauty. And I would think, "What am I doing here with this baby face and this nose?" I couldn't understand how I could possibly

be a part of all that. But Diana obviously saw something in me.

You walked into Penn's studio and it was like walking into a sanctuary. He was very, very, very quiet. Very disciplined. There was no music, no talking, no carrying on. Penn was a quiet man with a great, dry sense of humor. One would pose for hours, being lit like a still life. There were hairdressers like Ara Gallant or Christophe, but basically we did our own makeup. I invented huge lashes that I would apply one by one—those spider eyes—at one of Penn's sittings. Working with Penn taught me a lot. When I worked with Stanley [Kubrick], I found that same level of time and patience spent on lighting, and the same control and patience one had to have.

Other people I worked with were very different. Avedon was much more about movement. And [*Vogue's* fashion editor] Polly Mellen was always working with him. It was so much fun. Guy Bourdin was a difficult one; it was not fun. He nearly set me on fire once, but of course he didn't care. Arnaud also put me in dangerous situations; he always had me do things where I was just traumatized out of my mind.

I loved Henry Clarke. When I think of some of the amazing trips we did—standing half-naked on a blue mosque in Iran!—there was no stopping the creativity and the adventure. The trips were quite long, and the amount of stuff that came was awesome: suitcases full of clothes and jewels and accessories—Dynel hair (the wonderful hairdresser Christophe from Carita would do those trips)—and the whole équipe. Susan Train was his great editor. It was total fantasy and creativity—the way we were dressed and the hairdos and the body makeup. It was a dream. In those days it was really discovering the world in the best way possible. I saw all of India, and I saw the whole of Australia.

Every photographer, of course, brought a different kind of experience—like making a movie where every director brings a different experience. In modeling I discovered that I liked being a chameleon, transforming myself. For me it was the beginning of acting. And I wasn't afraid, which was really astonishing because I was actually a very insecure child and didn't think that I was at all attractive. When I got in front of a camera, though, that whole insecurity disappeared.

When I was in New York modeling, I was studying acting, because in the back of my mind I always had the dream of becoming an actress. Although I never thought I would—I was so incredibly shy. So I forced myself to go to Herbert Berghof and Sandy Meisner and Bob Motiger, who were my teachers at the time, and go to night classes and work, work, work. I'd do the most pathetic Off-Off-Off-Broadway plays to get myself on stage and over my terror. And the acting classes forced you to get up and make a total fool of yourself, so it did all help. But what really taught me was just working, and that is instinctive. I'm much more of an instinctive actress.

I met Luchino Visconti through Helmut Berger, whom I met in New York at the opening of The Damned. I came out of the movie and I was completely in awe.

Helmut was the most beautiful man you've ever seen. I went to the screening with Diane and Egon [von Furstenberg], and I came out and I said, "Oh, I'm madly in love!" and Egon said, "You can't be with him, he's—!" and I said, "I don't care." And they placed me next to him at dinner that night and we fell madly in love with each other. That was it. I've never known anybody to attract like that—men, women! He was so funny—and troubled.

At the time my mother had a wonderful house in Ischia, and Luchino also had this wonderful house in Ischia. So I would go to visit my mother and because of our mutual friend Helmut, I ended up in Luchino's house all the time. One day I was sitting next to him at lunch and he said, "I think you have the perfect look for my next film, but I need a very emotional actress who's very sensitive, but I don't know if you can act." I didn't really believe that it was possible that he was actually thinking of me for a film, but I remember sitting in his living room one eve-

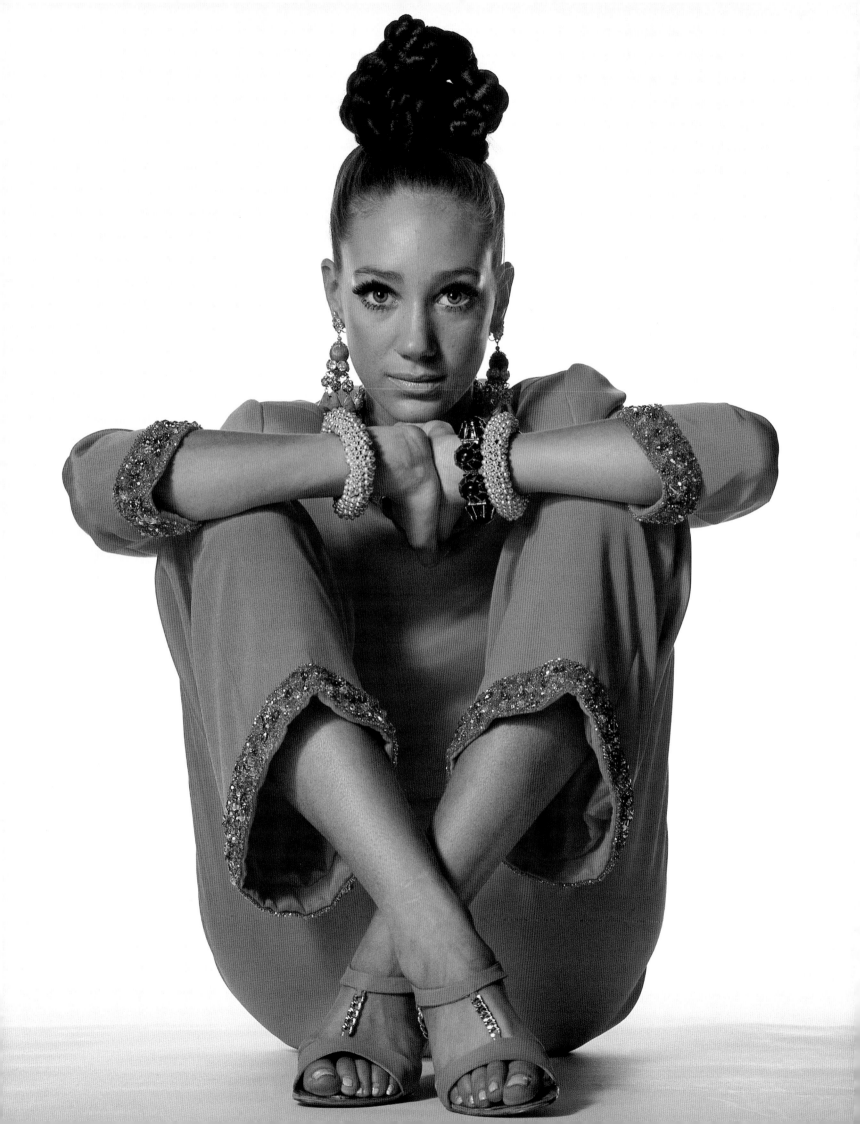

ning and listening to Mahler's Fifth Symphony, writing poetry and crying, the music moved me so much—and not even realizing that I was going to play Mrs. Mahler.

I went back to New York, where I was living, and months went by and one day I got a telegram: "You've got to be on the set in ten days. You've got to be in Rome in two days for costume fittings with the extraordinary Piero Tosi." And that was it! I flew to Rome—no screen test, nothing! I was living in Luchino's house on via Salaria, which looked exactly like his film sets—wonderful taste.

Piero Tosi was an angel, and such a perfectionist that it was inspiring just to be dressed by him; already you feel part of the film (he later dressed me for Marie Hélène de Rothschild's Bal Proust as the Marchesa Casati and came to Paris, where he spent a whole day doing my hair and makeup). The first day on the set I was so nervous.

We were filming in a big concert hall, the scene where Dirk Bogarde's character, Von Aschenbach (based on Mahler), is booed because the audience hates his music. Luchino says to me, "You have to come in, and be half-fainting, half-crying, and you have to run to him. I want a lot of emotions!" And that was it! And there were five hundred extras, and this was my first-ever time on a set. And Visconti was standing in the corner, and the minute I heard "Action!" I walked onto that set, and I'll never forget the feeling—it's like I was home. I said to myself, "This is exactly where I want to be in life." It was just so natural.

Visconti came into my room that night and he said, "Marisa, you've made an entrance like Sarah Bernhardt. You're not afraid of the camera, and if you want to continue in this business, you have my blessings."

When somebody believes in you so much when you're so young and insecure, and gives you that kind of opportunity, that's one of the most important things that can happen. Diana Vreeland and Visconti—they really were a huge gift in my life very early on because they gave me the mental and spiritual support that I needed to continue.

Right after that, I got a call to come and read for Bob Fosse's *Cabaret*. They had seen Penn's *Vogue* spread of me—"Esprit de corps" it was called, and featured me as the magazine's first nude.

Unlike Luchino, Bob Fosse had me sit in this huge, barren, cold room with nothing but a chair, and of course I was very intimidated. They had me study a German accent. I did the screen test and I got the part!

Liza [Minnelli] and Michael [York] and Joel [Grey] were such wonderful, generous people to work with. I was very nervous and Bob Fosse didn't make it easy for me, but as the film went along we became really close friends. He was a very good actor's director; he did everything to get a great performance out of one.

Sometime later I was lying in bed with 110-degree fever, practically unconscious, and Stanley Kubrick called. I'd gone to the opera with my beau David de Rothschild in a totally transparent "Dietrich" dress made by Loris Azzaro (who did make very glamorous clothes for me—I always wanted to look like a movie star from another era), and by the time I arrived home I had pneumonia.

Stanley didn't let me get a word in edgewise, which was lucky because I couldn't have spoken anyway, and at the end of it he said, "I want you to be in my next movie, to play an English countess, with Ryan O'Neal. It's taken from a William Thackeray book and I'll send you the book and you tell me what you think."

So I went to London to do the costumes with Milena Canonero and wonderful Leonard to do the wigs. And I lived in London for about three or four months and I learned how to behave like an eighteenth-century English countess, learning perfect English and dancing the minuet and the language of fans and riding sidesaddle—everything you can possibly learn about how a lady of that period would act and look. And then we would try on makeup and hair and that went on

for weeks and weeks and months and months until we got to Ireland where we started the film. And I sat in Ireland for three months and never did a day's work!

I was living in this huge Versailles-type castle, delighting Stanley that I was going to get into the whole mood. But the house was the most dingy and depressing place with hardly any electricity and hardly any heat. It ended up raining and raining every day. I was alone in this dreadful place, accompanied only by the ghost of a young, forlorn, and desperate duchess who had been murdered by her husband and would walk down into the living room every night. I was *désespérée*.

I never shot a day in Ireland and then moved to England and lived for a year at the Connaught in London, and we worked at these very cold castles all over England. It was really an amazing experience, because it was being in a sort of eighteenth-century bubble for a year, hardly seeing anything of the outside world. I must say I was very inhabited by Lady Lyndon by the end of that movie. And it's followed me around my entire life. So it was a very powerful spell.

But there was more to my life than all this.

On one of those modeling trips with Arnaud in the sixties we ended up in India. We traveled all over the country and did these amazing pictures. And then at some point I ended up alone on the ashram of Maharishi Mahesh Yogi in Rishikesh, up above the Ganges. I was searching for a spiritual path and spiritual understanding. And at this moment of my life, it opened up some doors in my consciousness, so I stayed up there. George Harrison and Ringo Starr were there, and Mia Farrow and the Beach Boys. I didn't think of it as being extraordinary at the time; we were just meditating all day long. We became vegetarians, and we all had meals together and then we'd end up in George's room and he would play the guitar and we would sit on the floor. It was very wonderful and natural.

I got into transcendental meditation, which was the new horizon at the time. So I started a spiritual path, thanks to that experience. I had many others and went many different directions, with different masters over the years. But Maharishi Mahesh Yogi was the first and it was very enlightening. I've been on the path ever since—you are always searching and evolving. And I found my own truth in all of it, which has given me my strength in life. My core and everything that I am is rooted in that.

It was not easy because when I came back from India, it was the time of sex, drugs, and rock 'n' roll, and everybody said I ate lotus leaves! But I went out every night and got up early and worked every day and was absolutely in the center of everything at the time. To find a balance between the path of enlightenment and the challenges of that world was very interesting and strengthening. Sometimes I wondered, "Should I go live in a monastery to really be who I want to be?" But that's not my destiny. So I came to terms with the fact that you can do as much good and be as spiritual and as good of a person, even in the world of fashion and film and social everything—that world that I had been projected into. Just staying sane and staying in balance is important when you're very young and in that kind of world and I think I understand how a lot of people get totally lost and destroyed. Without that core, a lot of people don't survive. And I was very lucky because I got to see the best of that world—and to work with the most interesting people, so it was a gift from heaven, all of it.

As told to Hamish Bowles
New York City, March 11, 2011

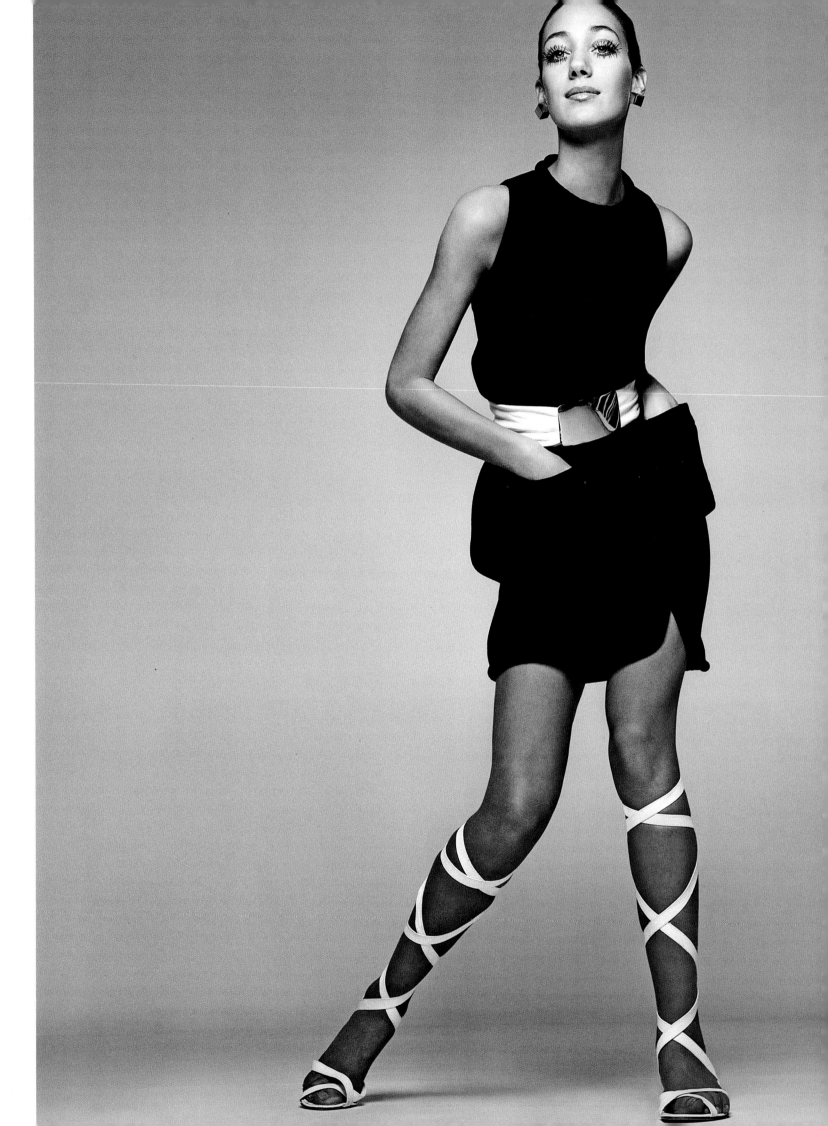

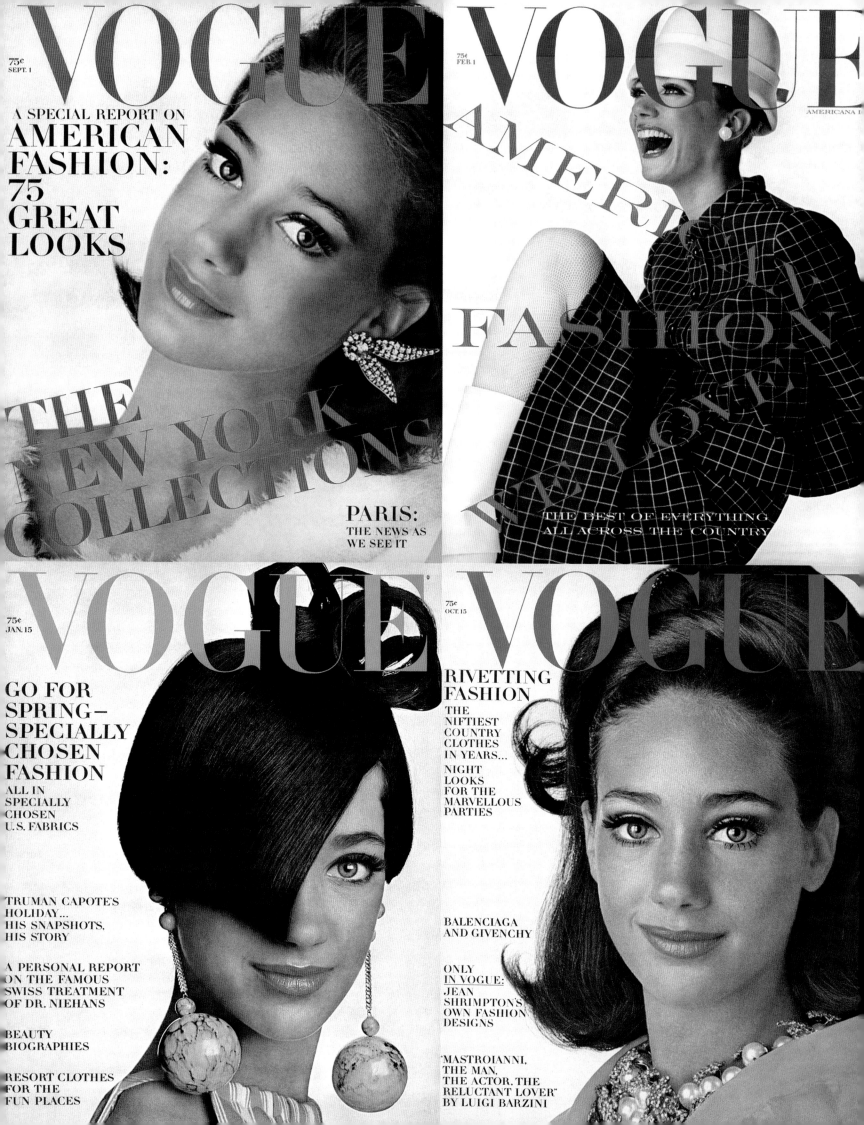

VOGUE

75¢
SEPT. 1

A SPECIAL REPORT ON
AMERICAN
FASHION:
75
GREAT
LOOKS

THE
NEW YORK
COLLECTIONS

PARIS:
THE NEWS AS
WE SEE IT

VOGUE

75¢
FEB. 1

AMERICANA

AMERICA

FASHION
WE LOVE

THE BEST OF EVERYTHING
ALL ACROSS THE COUNTRY

VOGUE

75¢
JAN. 15

GO FOR
SPRING—
SPECIALLY
CHOSEN
FASHION
ALL IN
SPECIALLY
CHOSEN
U.S. FABRICS

TRUMAN CAPOTE'S
HOLIDAY...
HIS SNAPSHOTS,
HIS STORY

A PERSONAL REPORT
ON THE FAMOUS
SWISS TREATMENT
OF DR. NIEHANS

BEAUTY
BIOGRAPHIES

RESORT CLOTHES
FOR THE
FUN PLACES

VOGUE

75¢
OCT. 15

RIVETTING
FASHION
THE
NIFTIEST
COUNTRY
CLOTHES
IN YEARS...
NIGHT
LOOKS
FOR THE
MARVELLOUS
PARTIES

BALENCIAGA
AND GIVENCHY

ONLY
IN VOGUE:
JEAN
SHRIMPTON'S
OWN FASHION
DESIGNS

"MASTROIANNI,
THE MAN,
THE ACTOR, THE
RELUCTANT LOVER"
BY LUIGI BARZINI

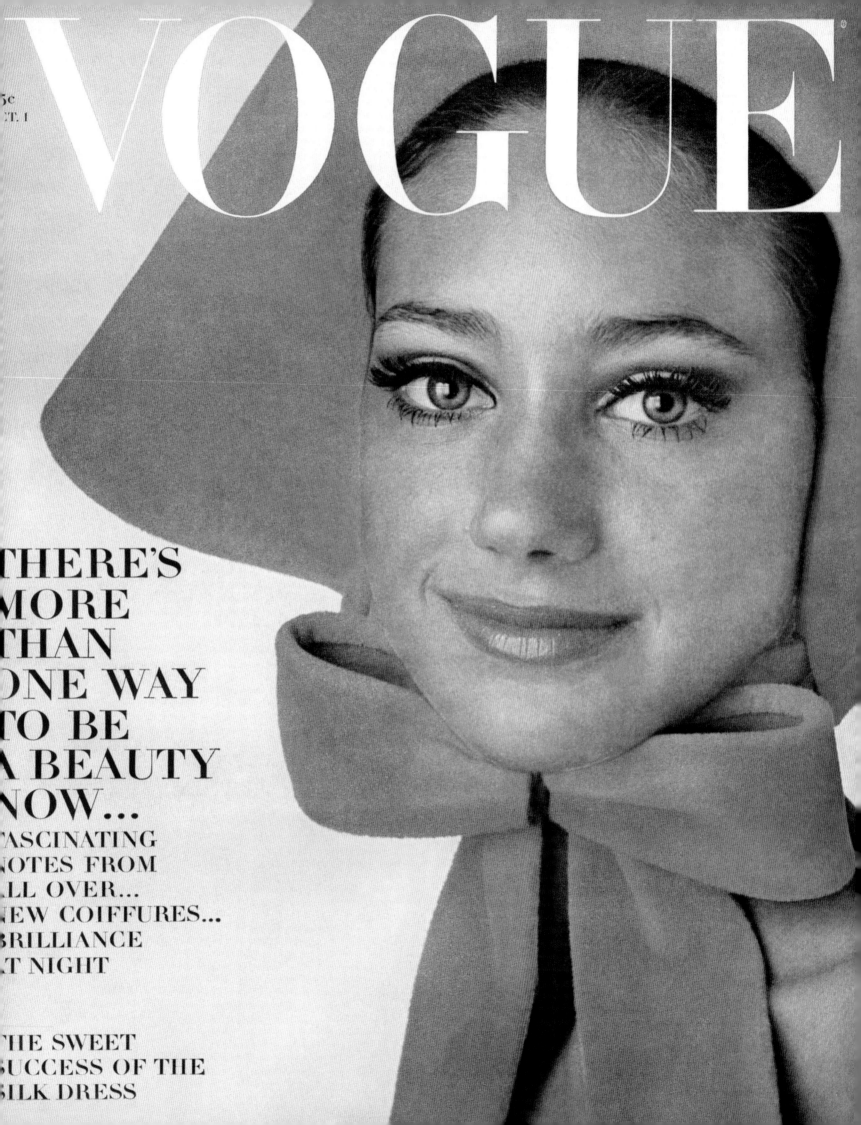

VOGUE

5c

CT. 1

THERE'S
MORE
THAN
ONE WAY
TO BE
A BEAUTY
NOW...

ASCINATING
OTES FROM
LL OVER...
EW COIFFURES...
RILLIANCE
T NIGHT

HE SWEET
UCCESS OF THE
ILK DRESS

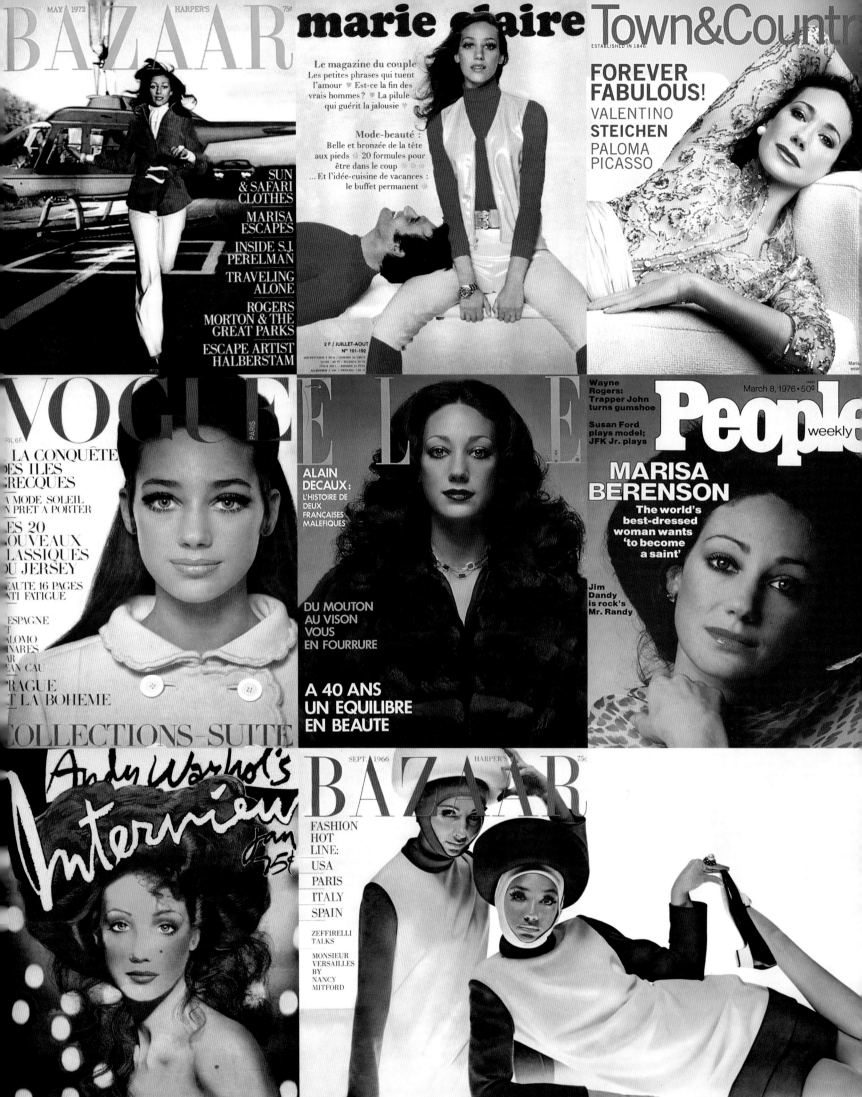

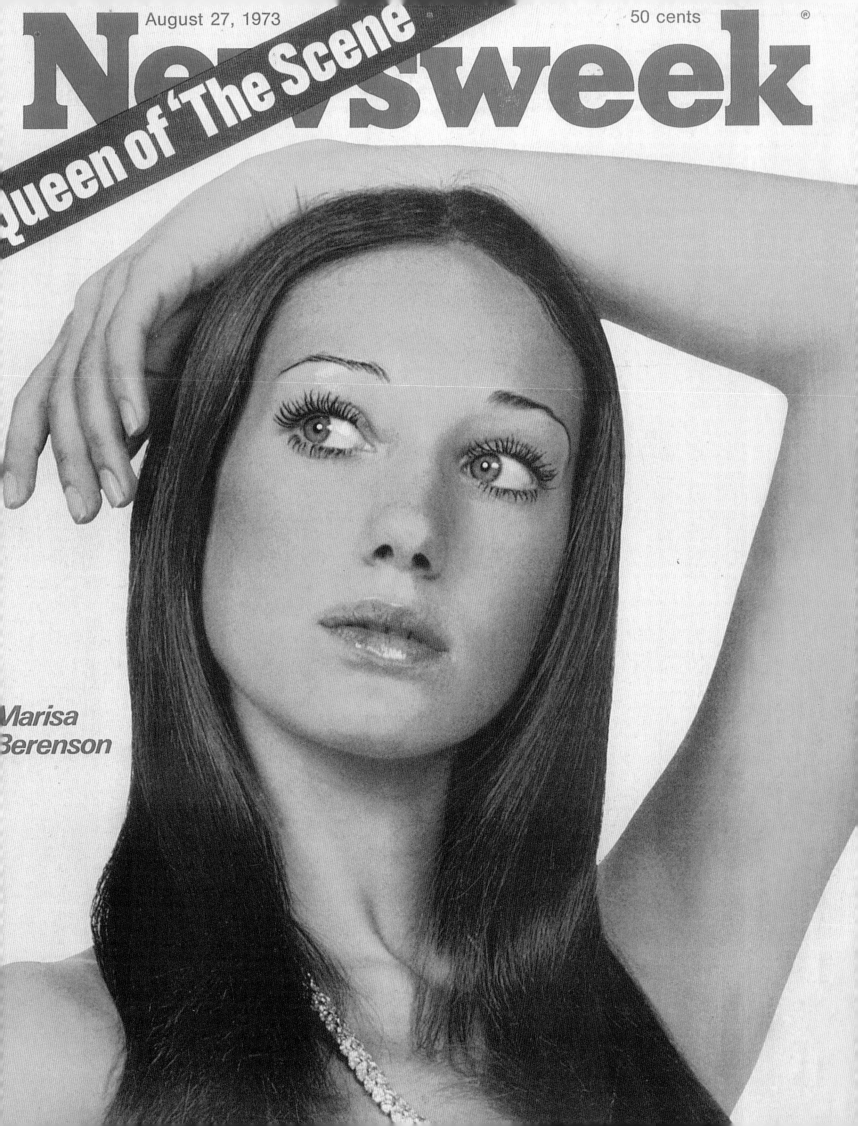

August 27, 1973

50 cents

®

NewSweek

Queen of 'The Scene'

Marisa Berenson

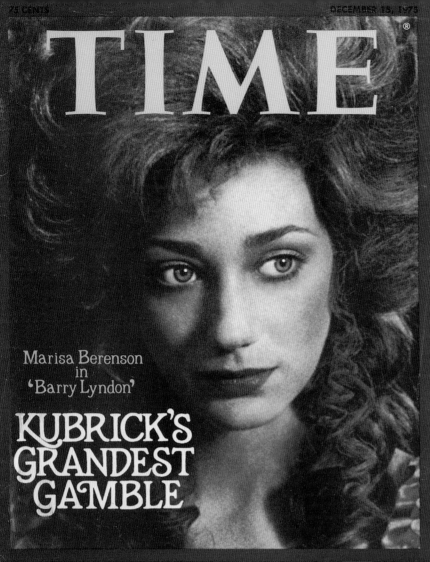

75 CENTS

DECEMBER 15, 1975

TIME

Marisa Berenson
in
'Barry Lyndon'

KUBRICK'S GRANDEST GAMBLE

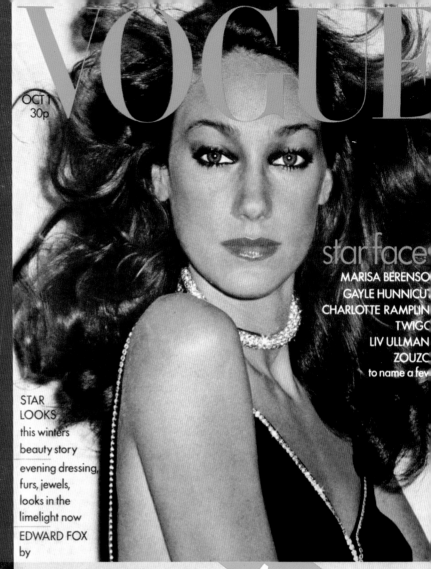

VOGUE

OCT 1
30p

starface

MARISA BERENSON
GAYLE HUNNICUTT
CHARLOTTE RAMPLING
TWIGGY
LIV ULLMAN
ZOUZOU
to name a few

STAR
LOOKS
this winters
beauty story
evening dressing,
furs, jewels,
looks in the
limelight now
EDWARD FOX
by

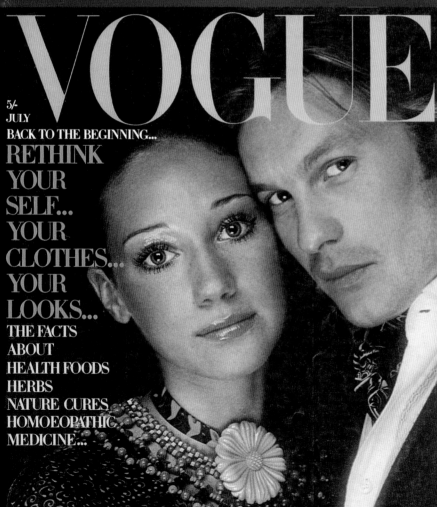

VOGUE

5/-
JULY
BACK TO THE BEGINNING...
RETHINK
YOUR
SELF...
YOUR
CLOTHES...
YOUR
LOOKS...
THE FACTS
ABOUT
HEALTH FOODS
HERBS
NATURE CURES
HOMOEOPATHIC
MEDICINE...

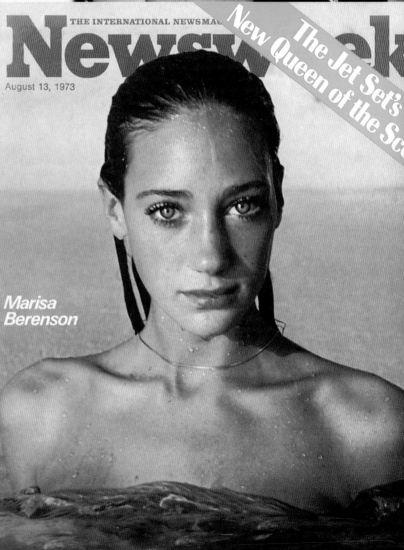

THE INTERNATIONAL NEWSMAGAZINE

Newsweek

August 13, 1973

The Jet Set's
New Queen of the Screen

Marisa
Berenson

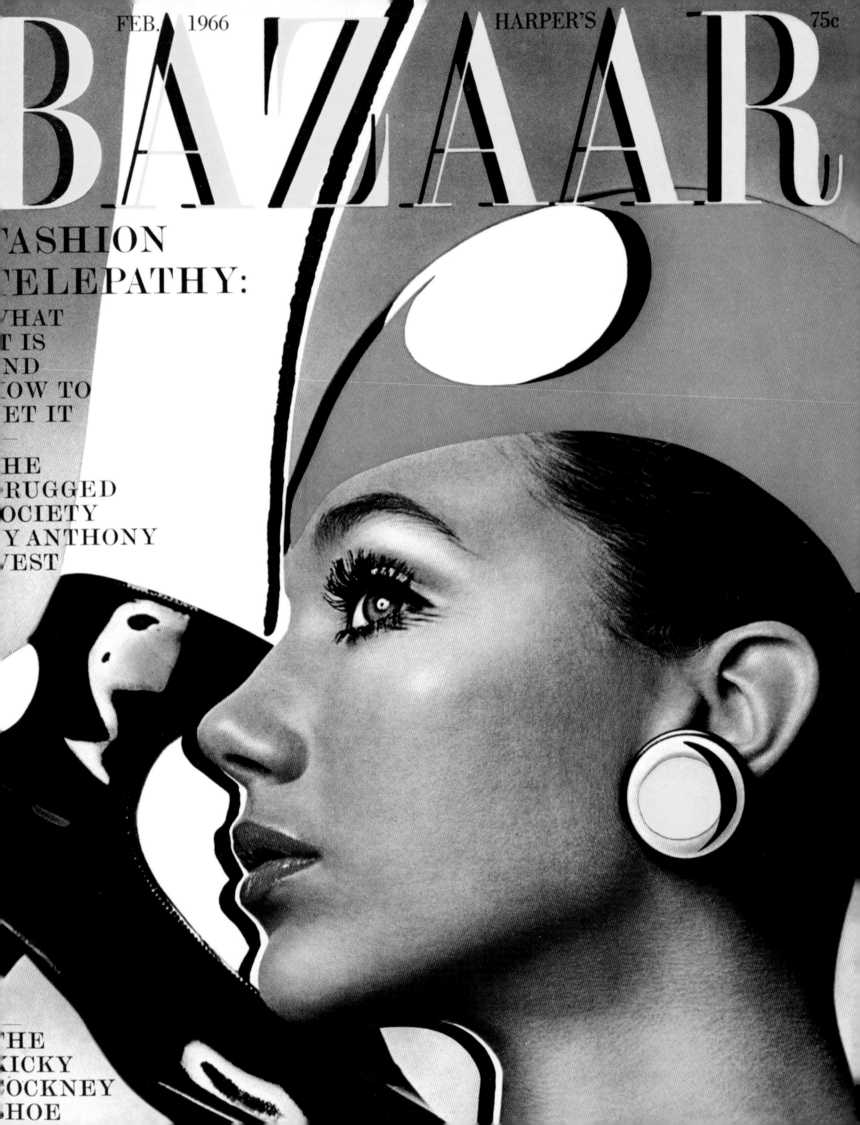

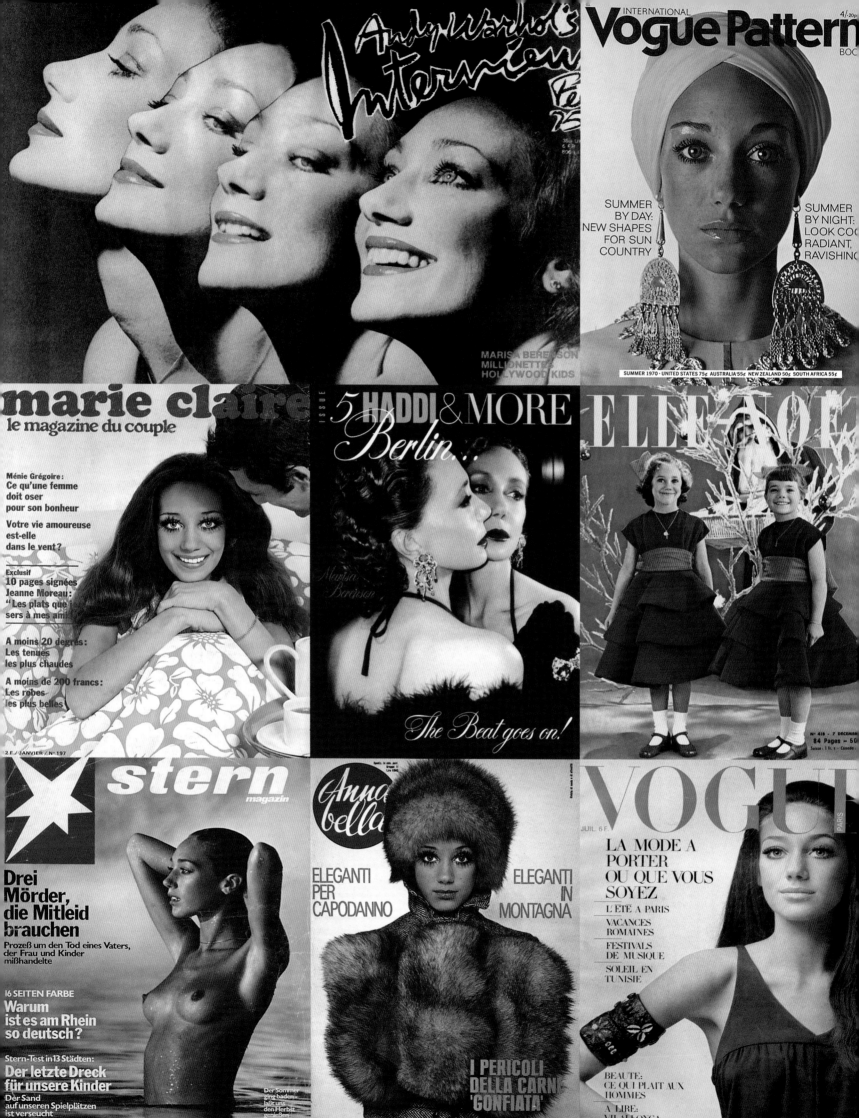

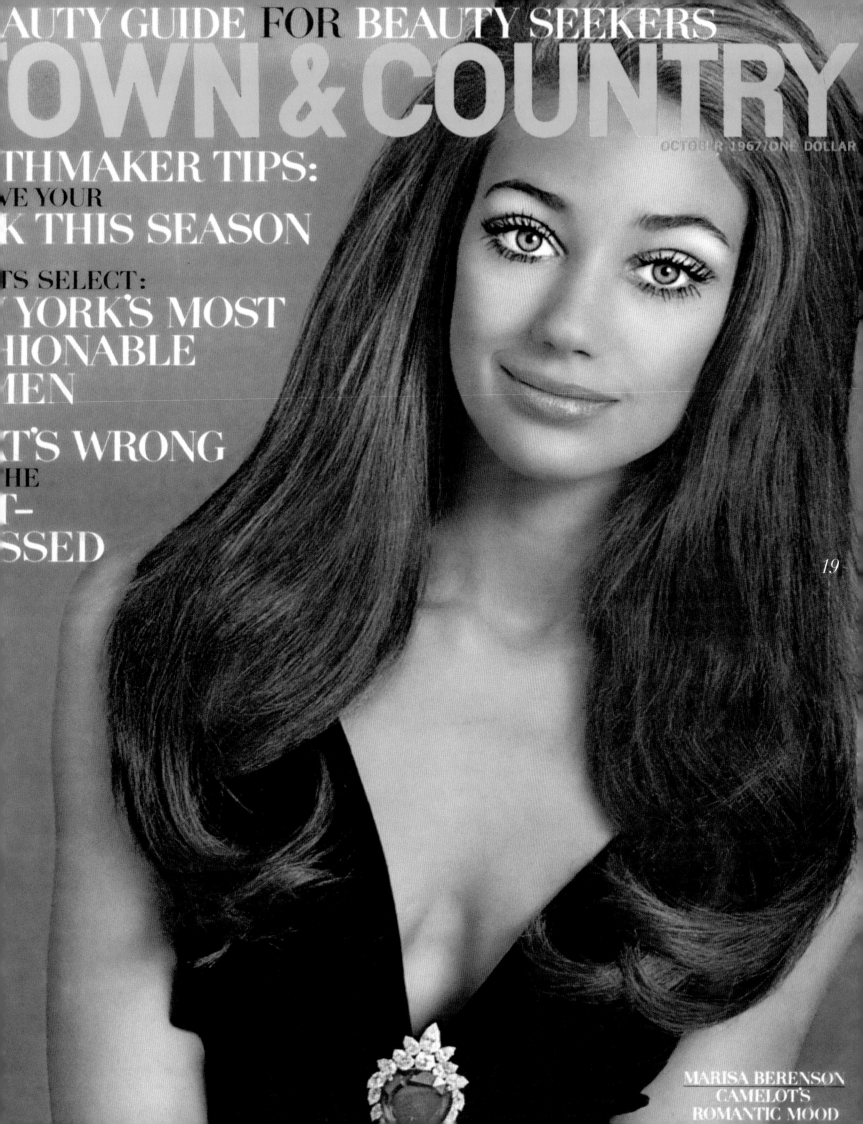

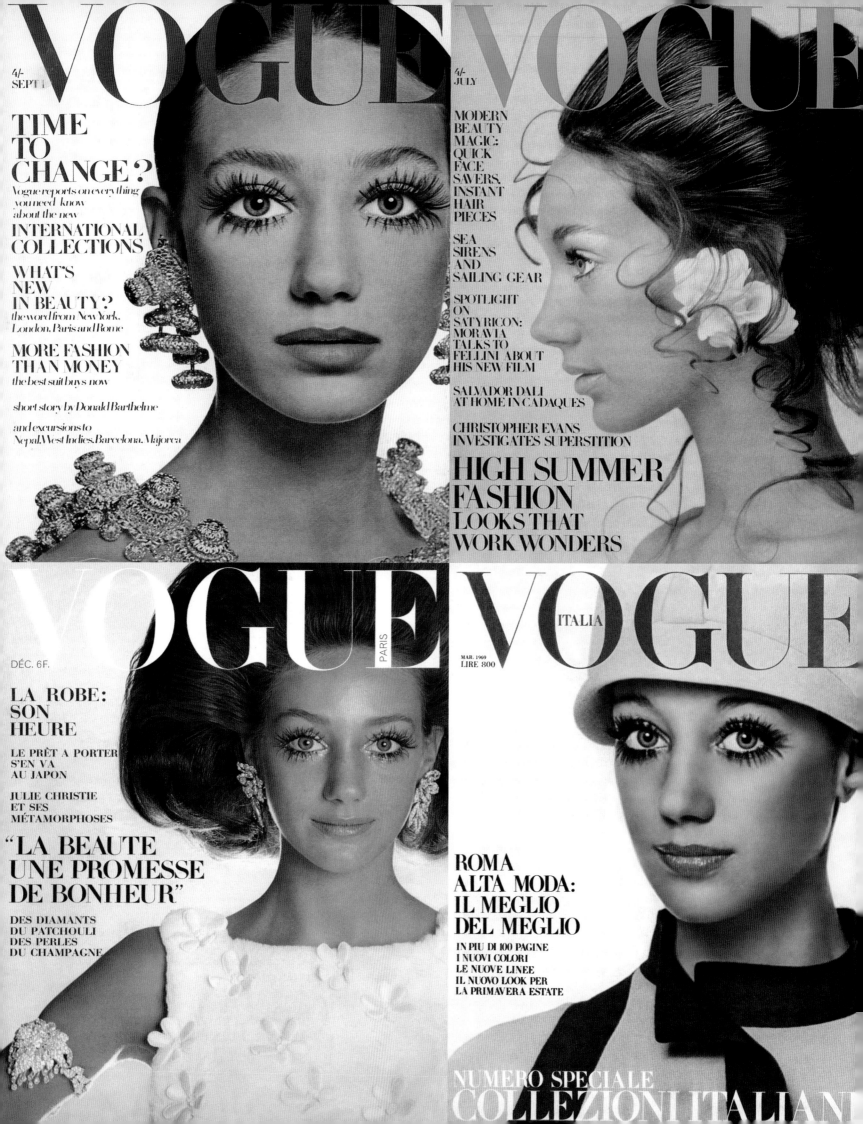

VOGUE

4/- SEPT

TIME TO CHANGE?

Vogue reports on everything you need know about the new

INTERNATIONAL COLLECTIONS

WHAT'S NEW IN BEAUTY?
the word from New York, London, Paris and Rome

MORE FASHION THAN MONEY
the best suit buys now

short story by Donald Barthelme

and excursions to Nepal, West Indies, Barcelona, Majorca

VOGUE

4/- JULY

MODERN BEAUTY MAGIC: QUICK FACE SAVERS, INSTANT HAIR PIECES

SEA SIRENS AND SAILING GEAR

SPOTLIGHT ON SATYRICON: MORAVIA TALKS TO FELLINI ABOUT HIS NEW FILM

SALVADOR DALI AT HOME IN CADAQUES

CHRISTOPHER EVANS INVESTIGATES SUPERSTITION

HIGH SUMMER FASHION
LOOKS THAT WORK WONDERS

VOGUE
PARIS

DÉC. 6F.

LA ROBE: SON HEURE

LE PRÊT A PORTER S'EN VA AU JAPON

JULIE CHRISTIE ET SES MÉTAMORPHOSES

"LA BEAUTE UNE PROMESSE DE BONHEUR"

DES DIAMANTS DU PATCHOULI DES PERLES DU CHAMPAGNE

VOGUE
ITALIA

MAR. 1969
LIRE 800

ROMA ALTA MODA: IL MEGLIO DEL MEGLIO

IN PIU DI 100 PAGINE
I NUOVI COLORI
LE NUOVE LINEE
IL NUOVO LOOK PER
LA PRIMAVERA ESTATE

NUMERO SPECIALE
COLLEZIONI ITALIAN

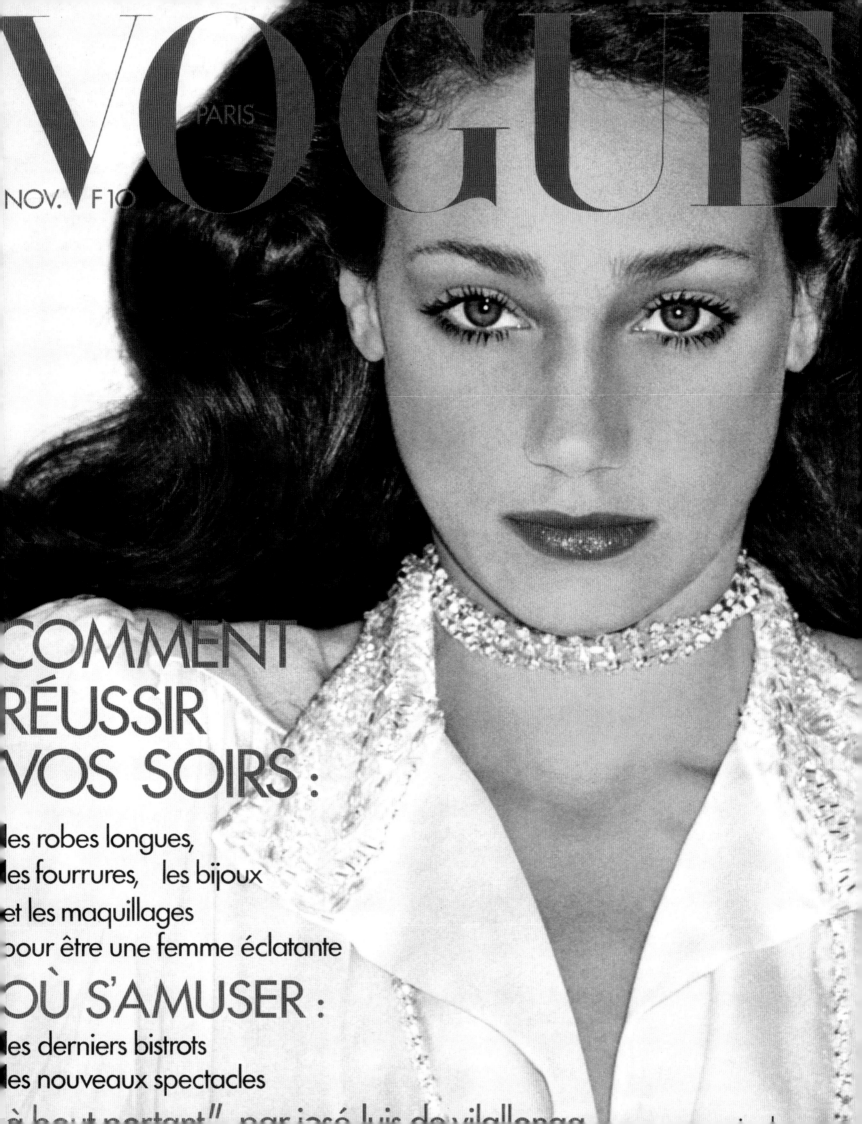

VOGUE

PARIS

NOV. F 10

COMMENT RÉUSSIR VOS SOIRS :

les robes longues,
les fourrures, les bijoux
et les maquillages
pour être une femme éclatante

OÙ S'AMUSER :

les derniers bistrots
les nouveaux spectacles

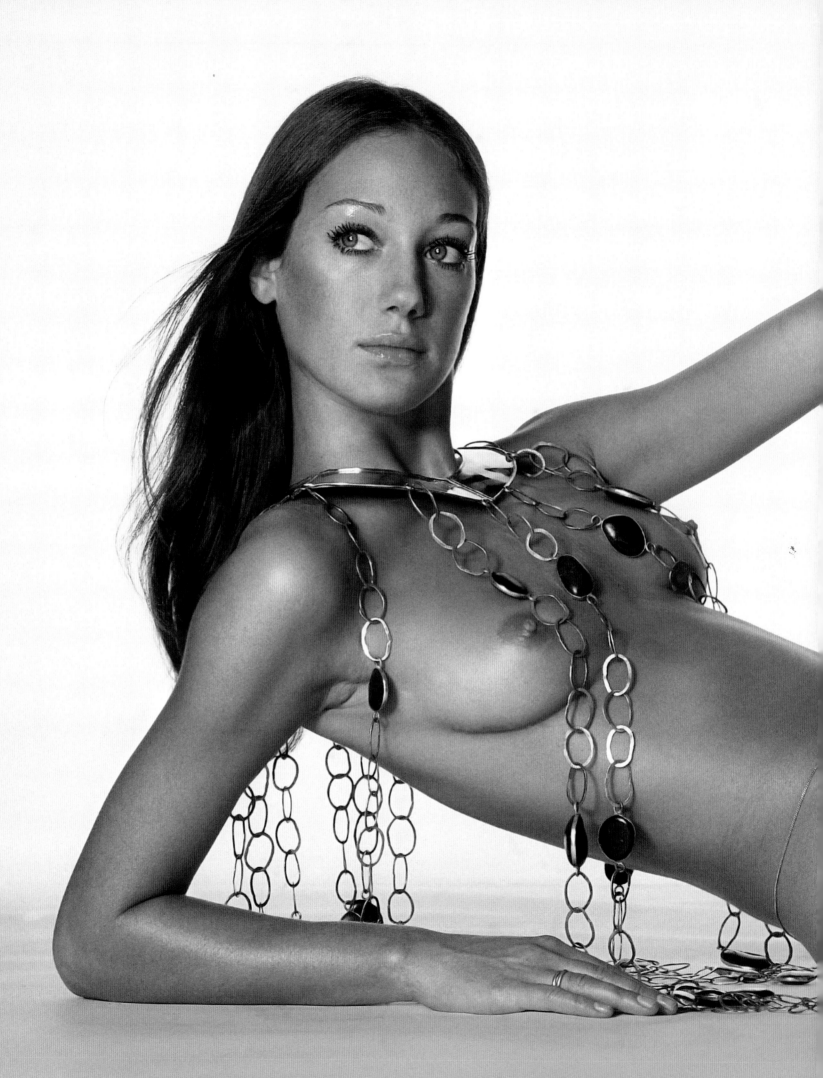

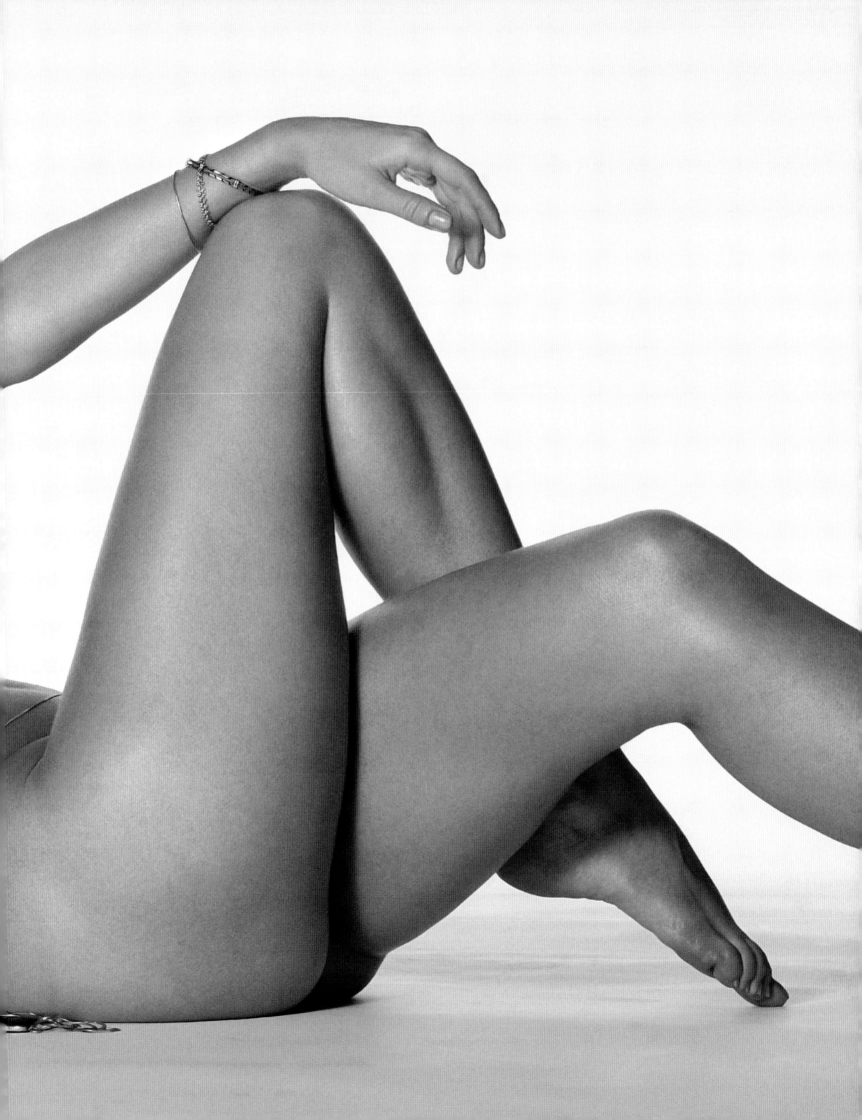

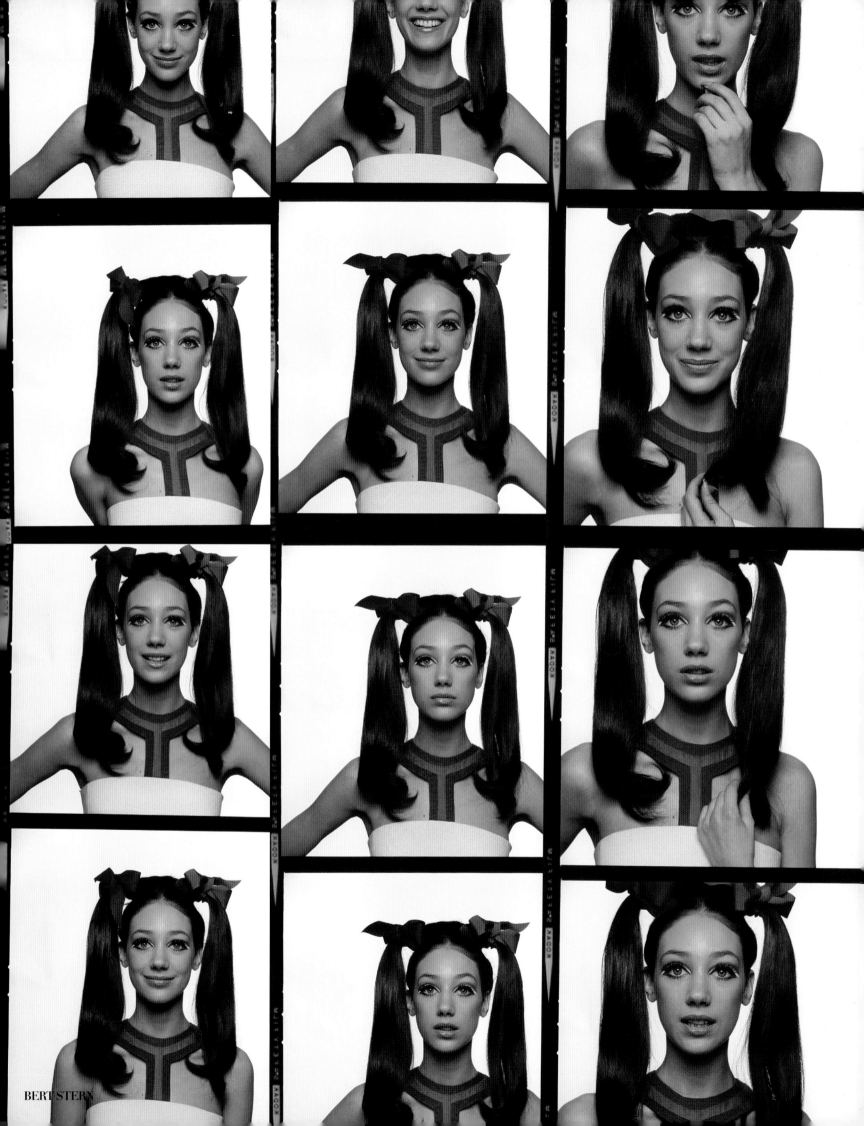

BERT STERN

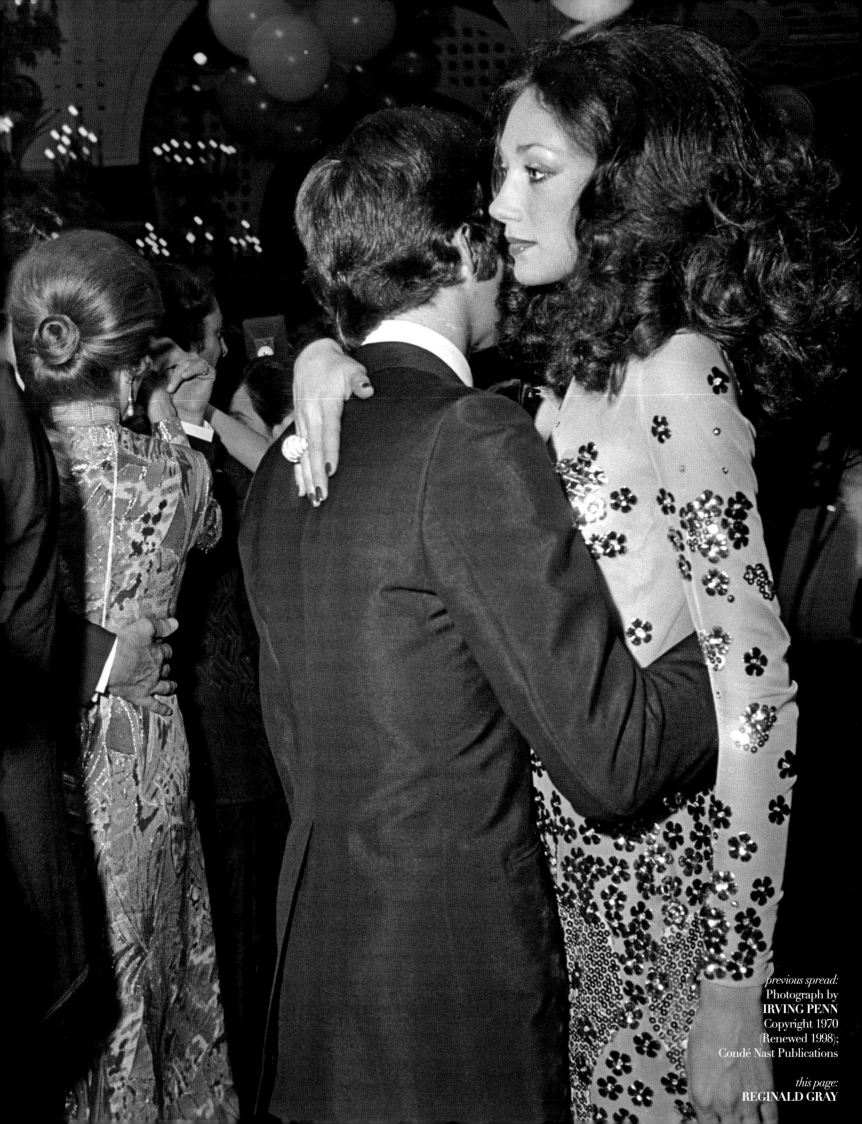

previous spread:
Photograph by
IRVING PENN
Copyright 1970
(Renewed 1998);
Condé Nast Publications

this page:
REGINALD GRAY

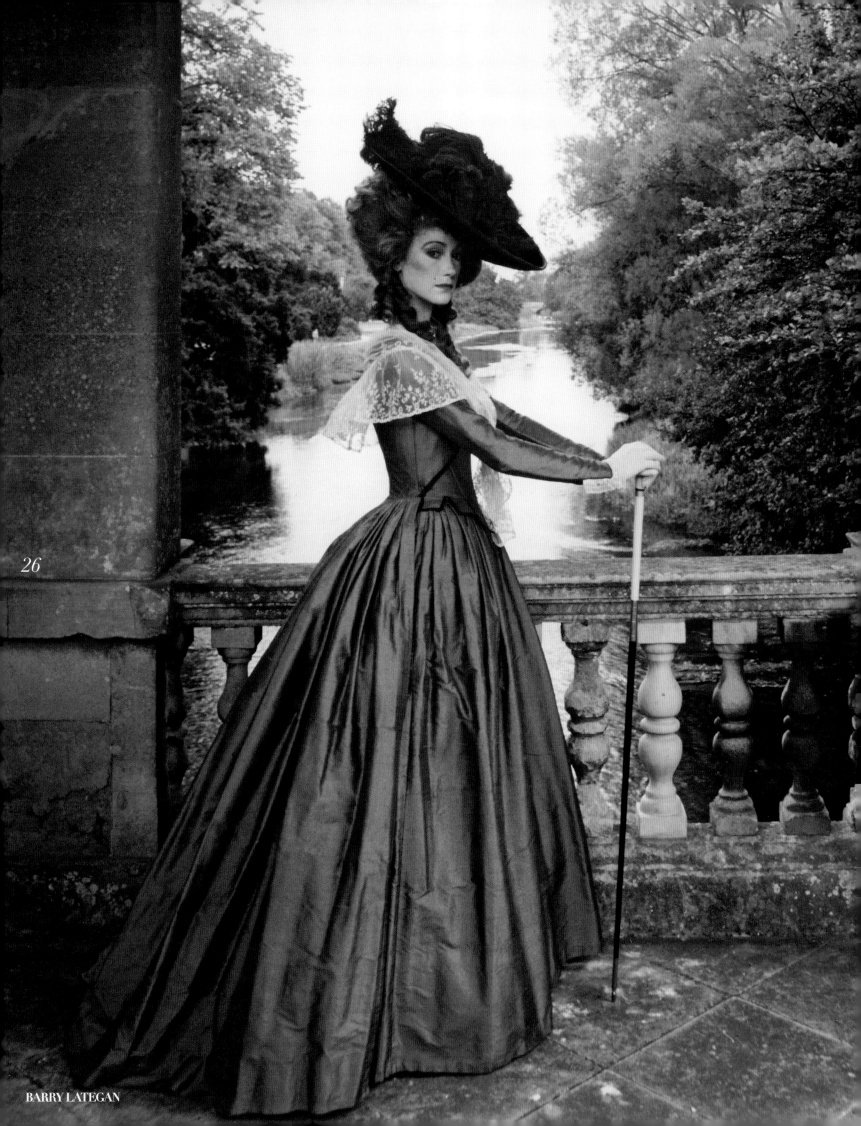

26

BARRY LATEGAN

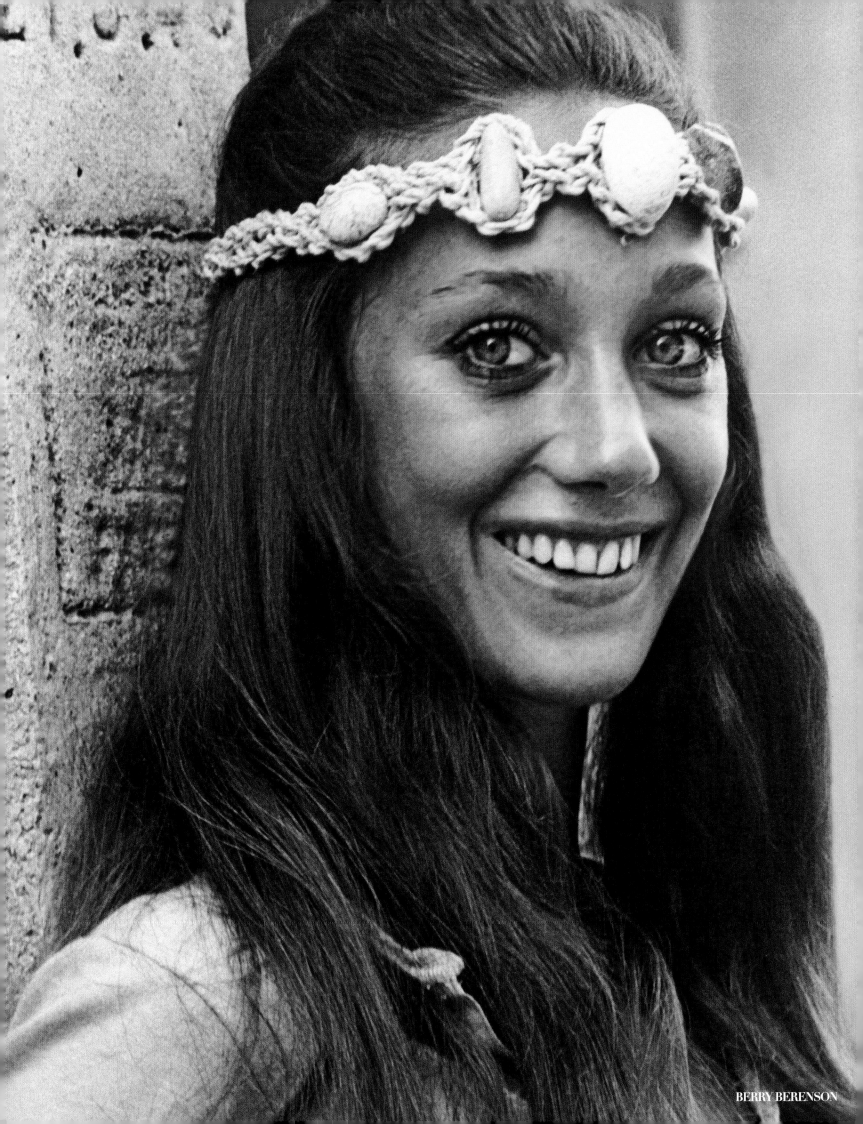

BERRY BERENSON

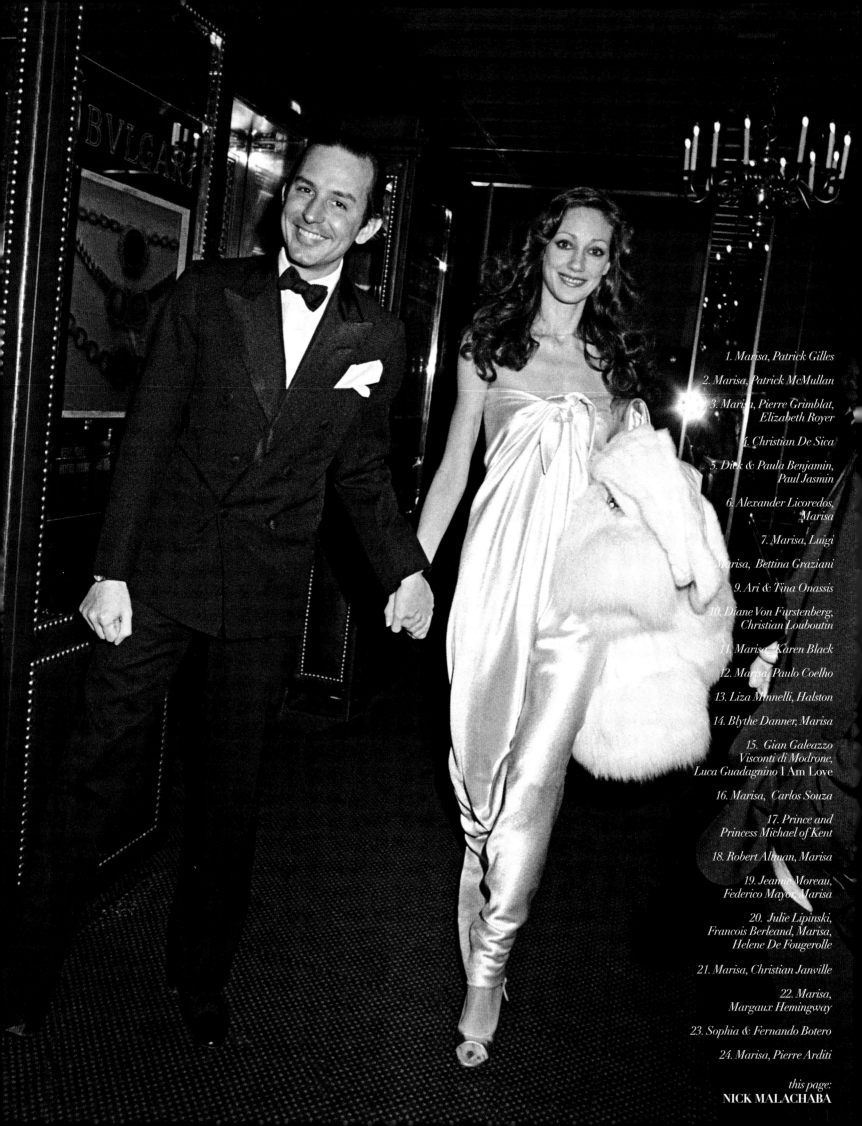

this page:
NICK MALACHABA

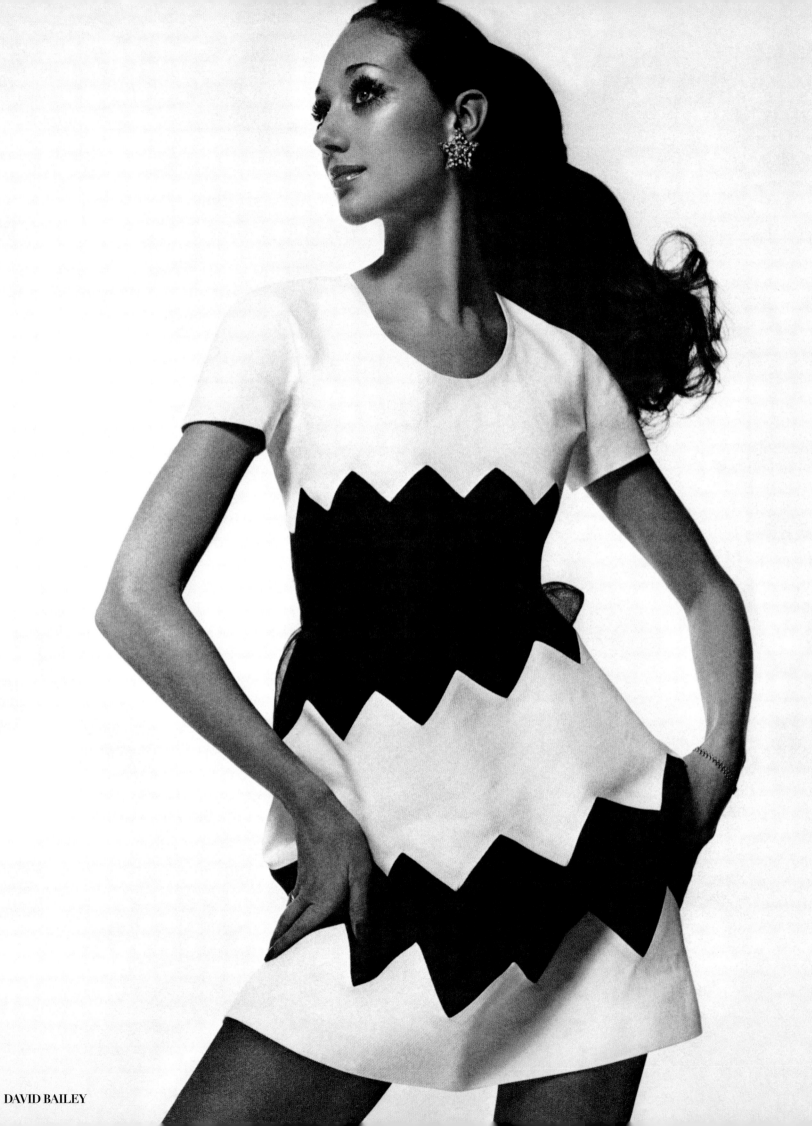

DAVID BAILEY

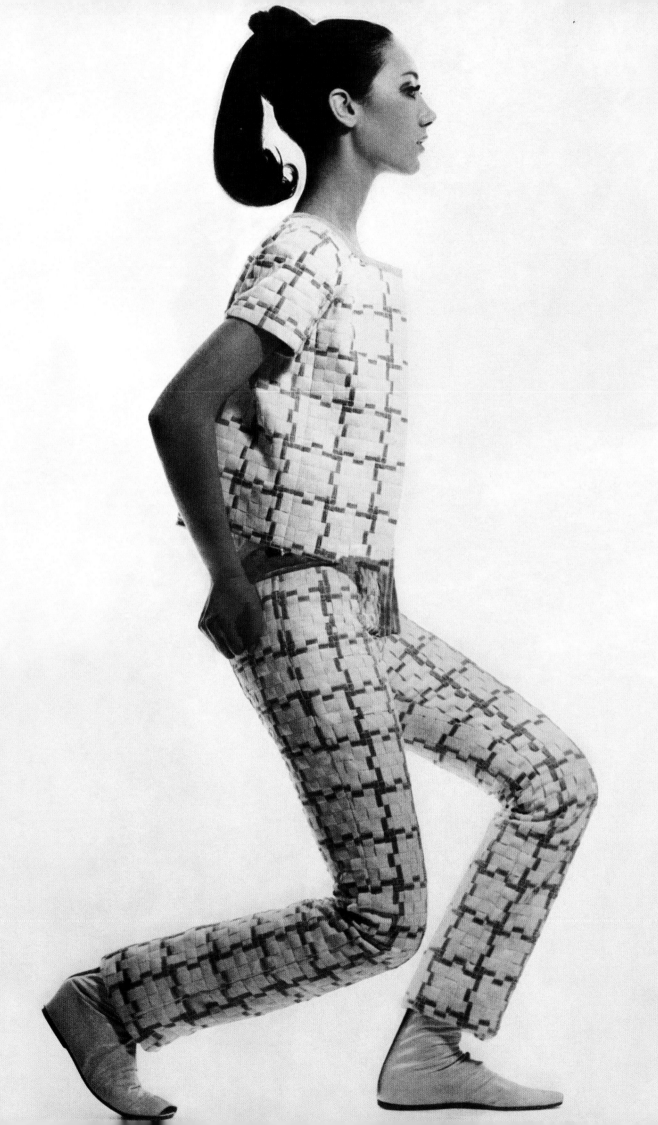

DAVID BAILEY

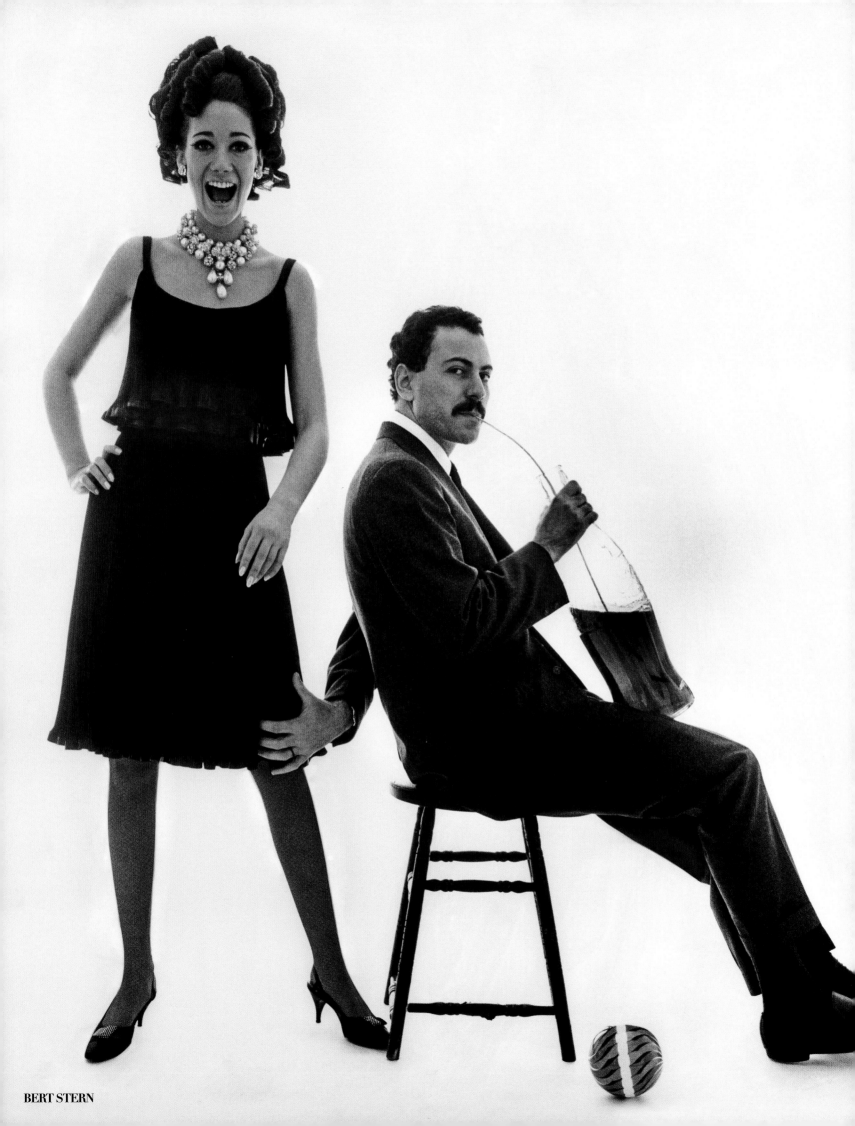

BERT STERN

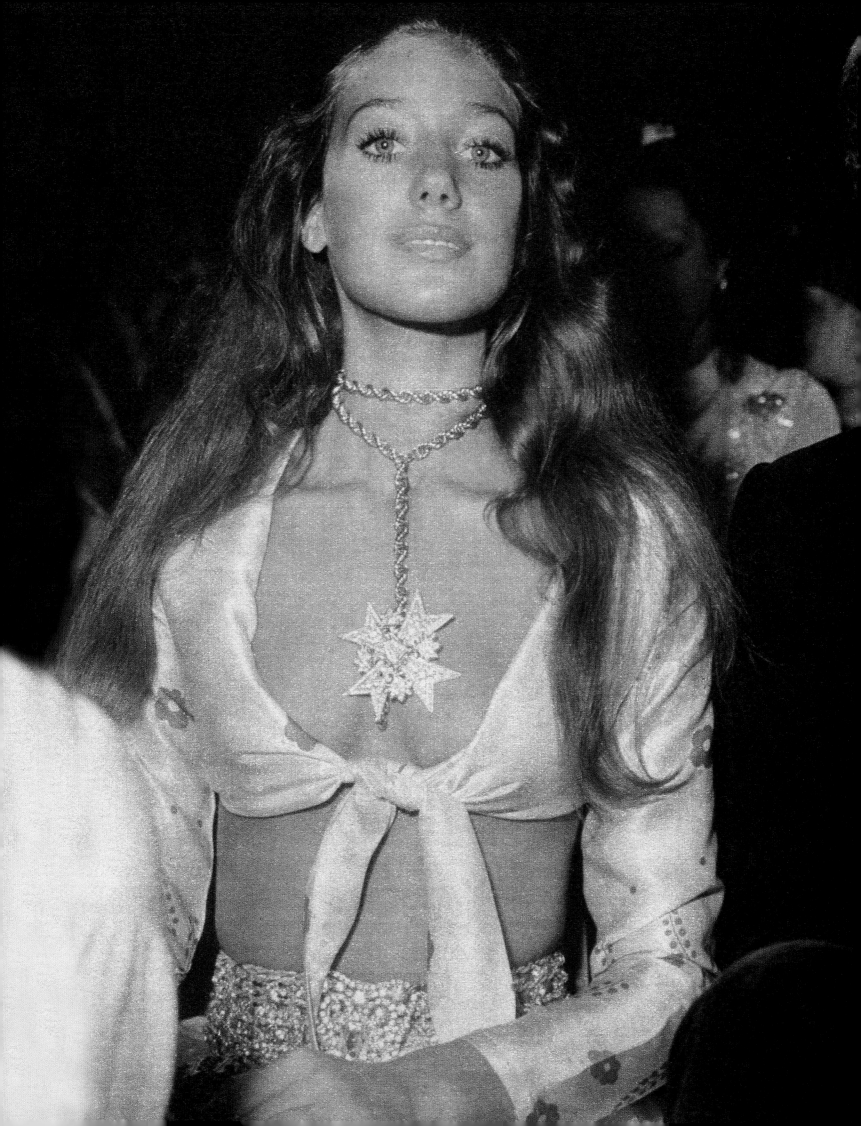

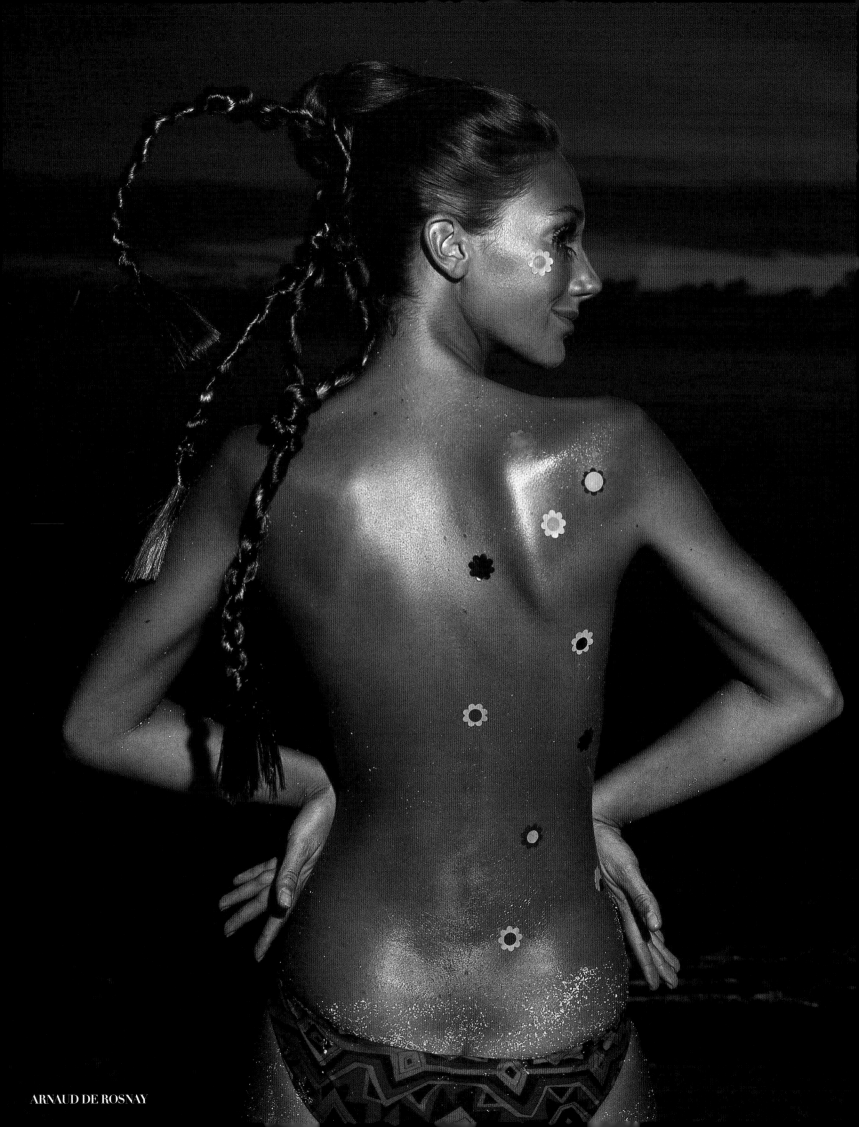

ARNAUD DE ROSNAY

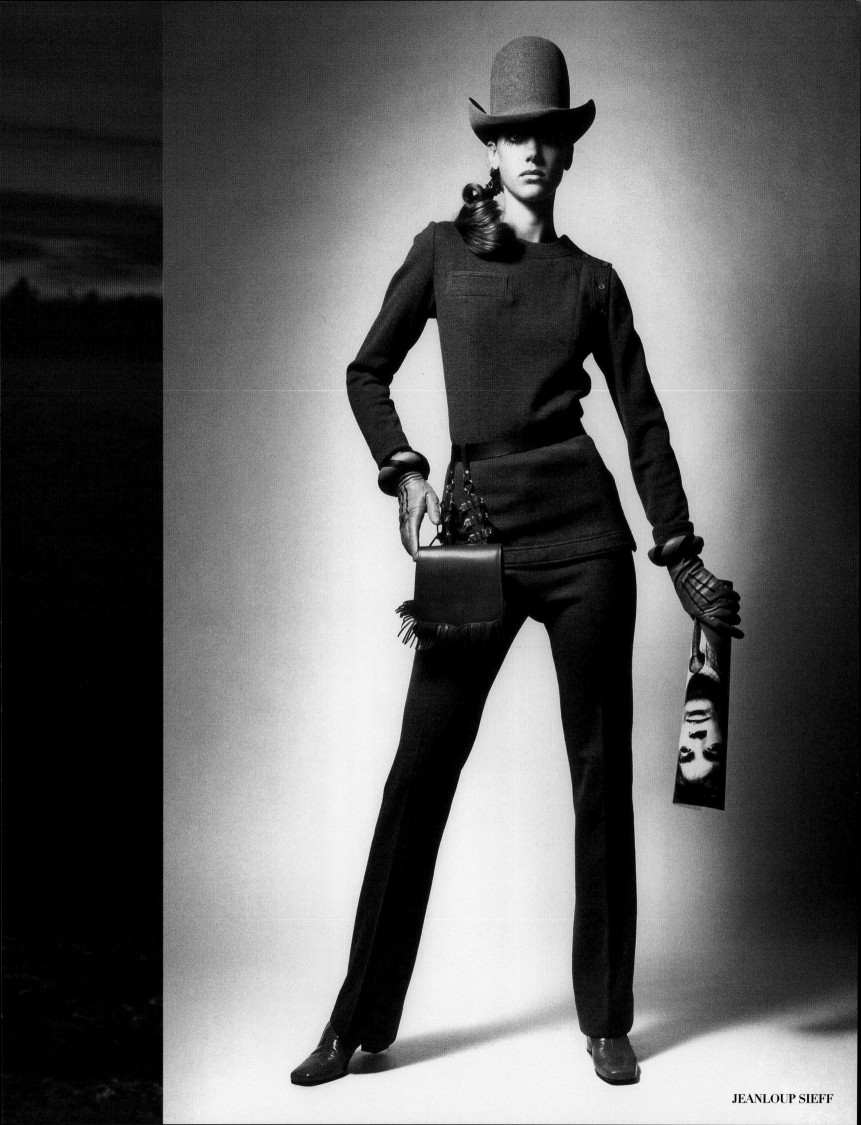

JEANLOUP SIEFF

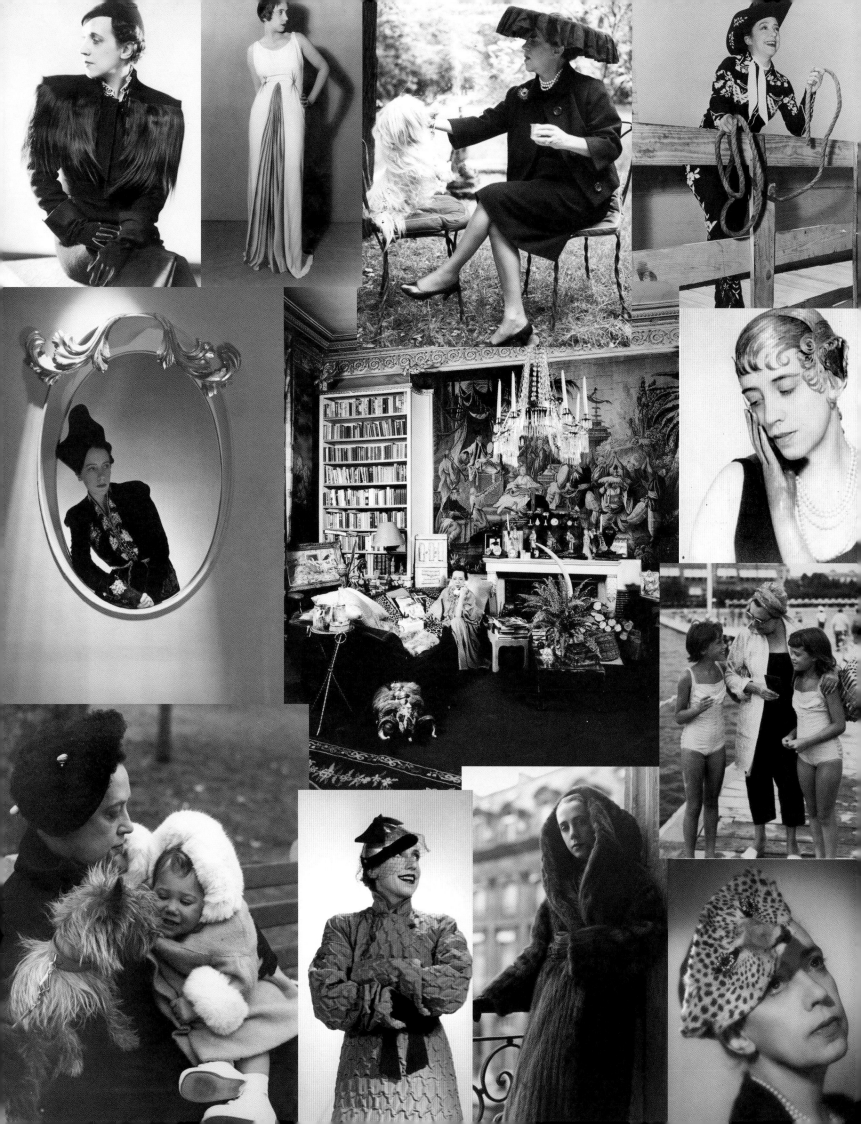

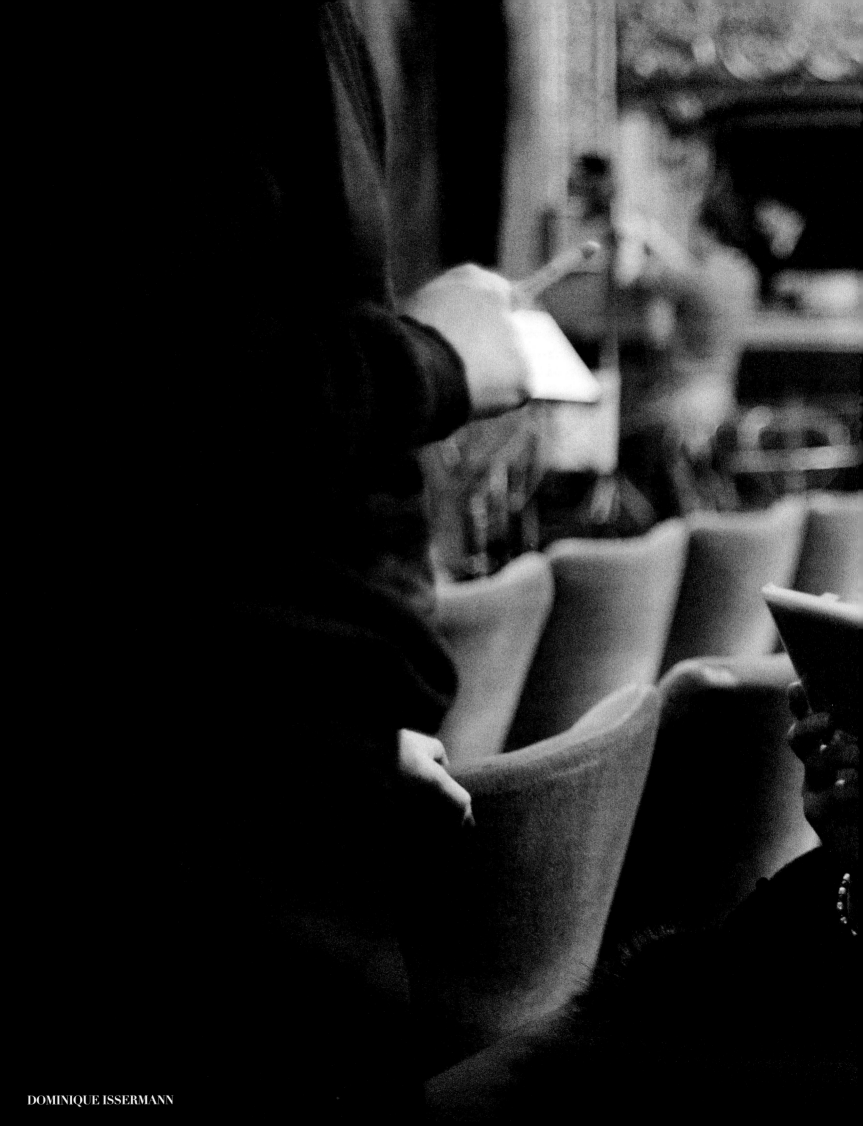

DOMINIQUE ISSERMANN

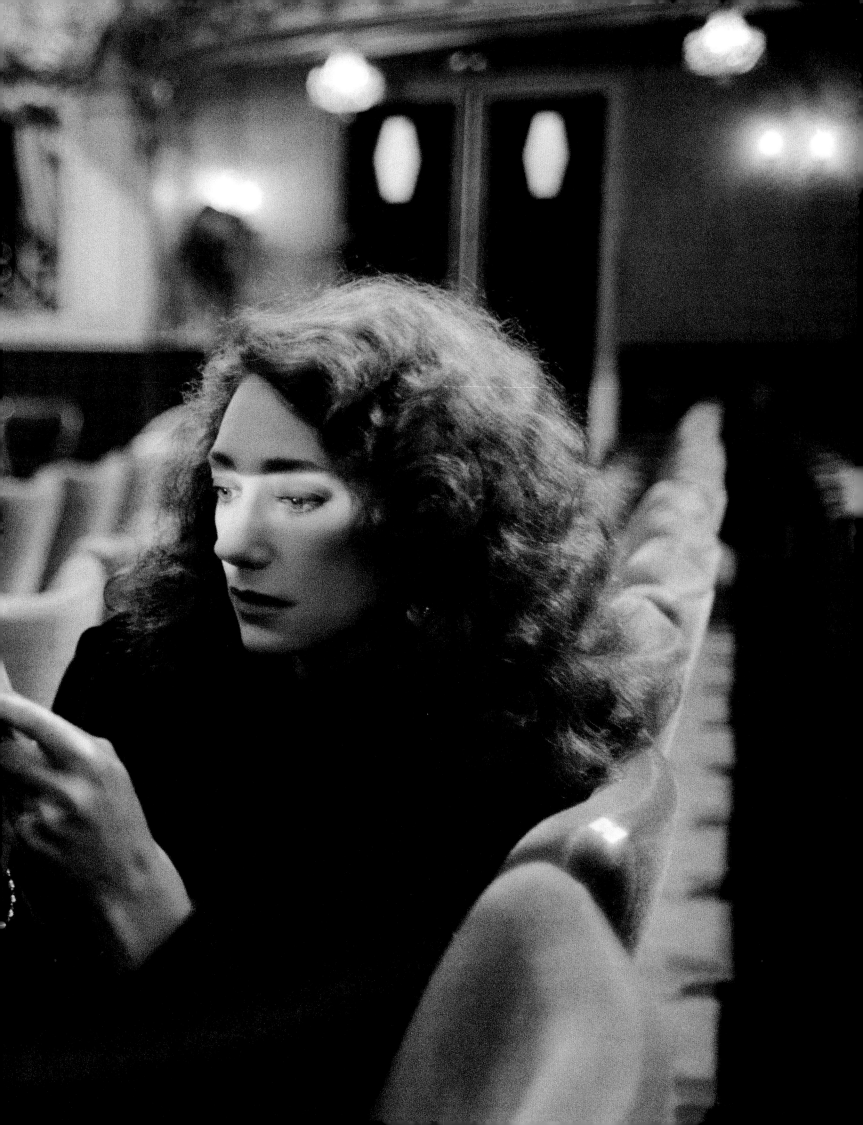

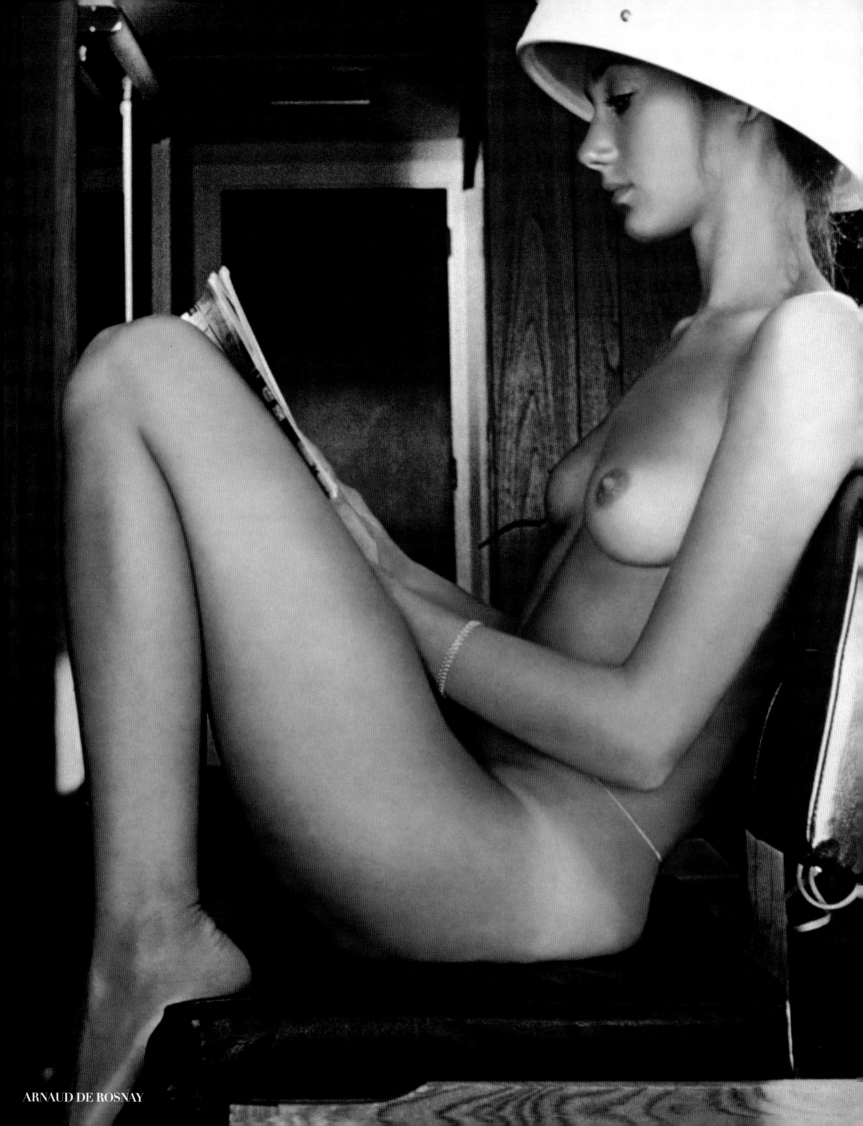

ARNAUD DE ROSNAY

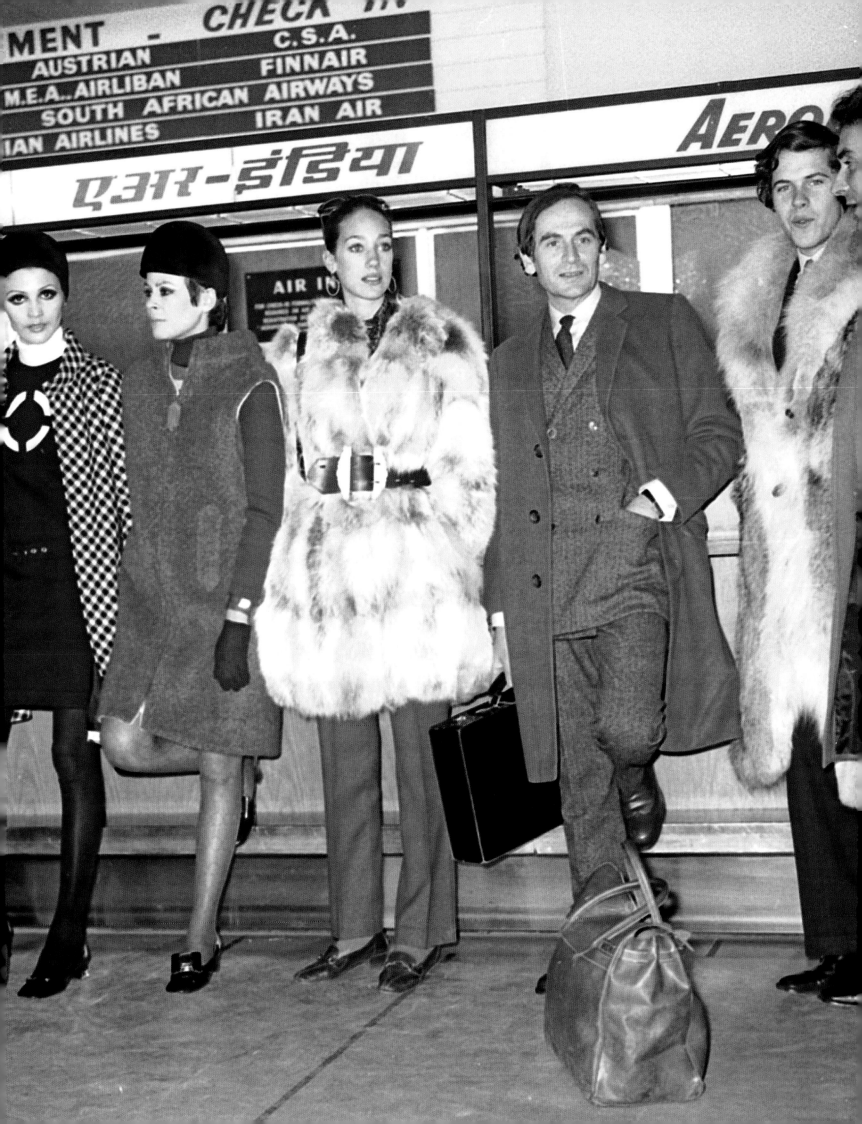

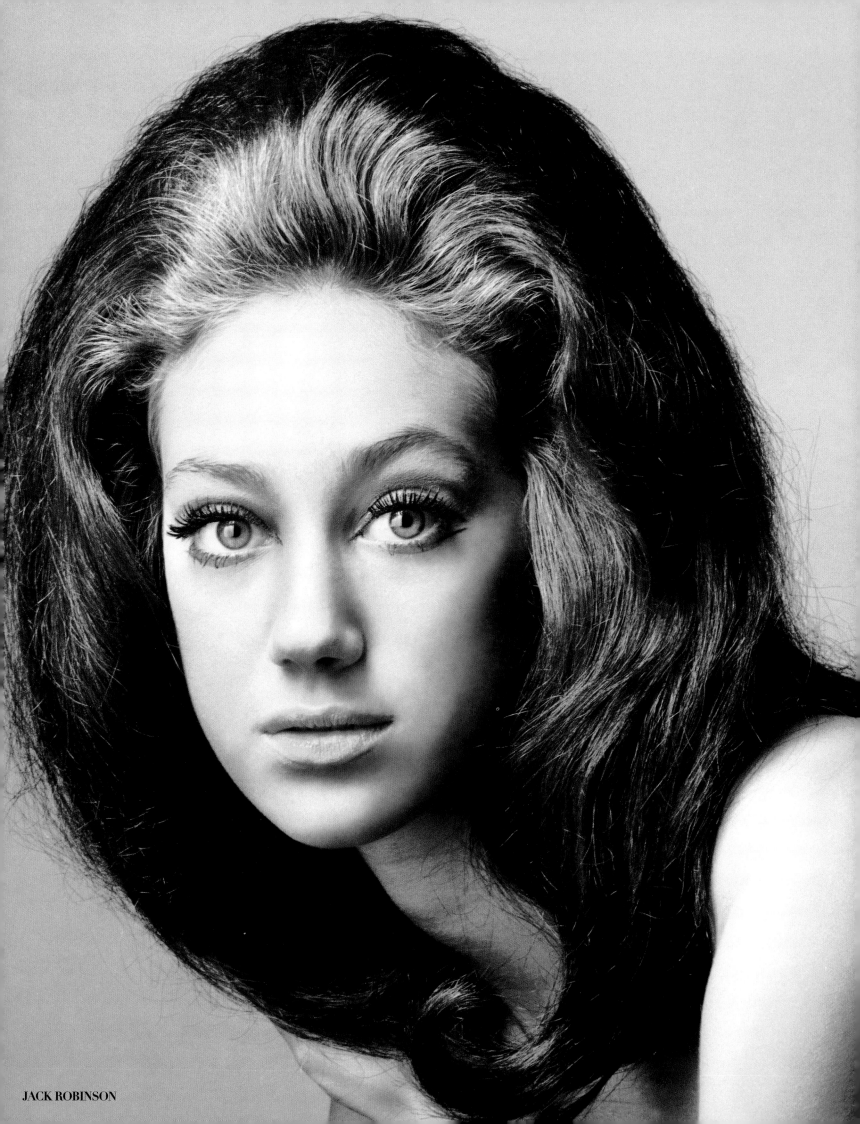

JACK ROBINSON

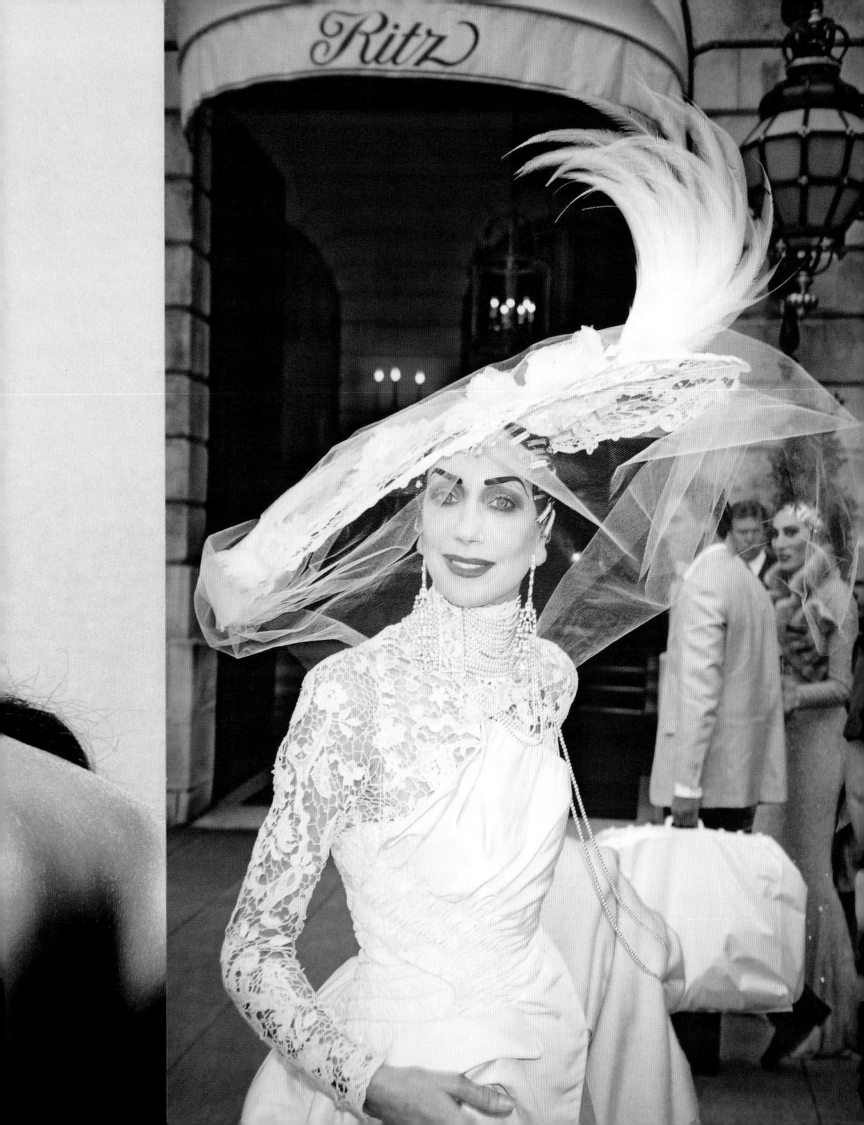

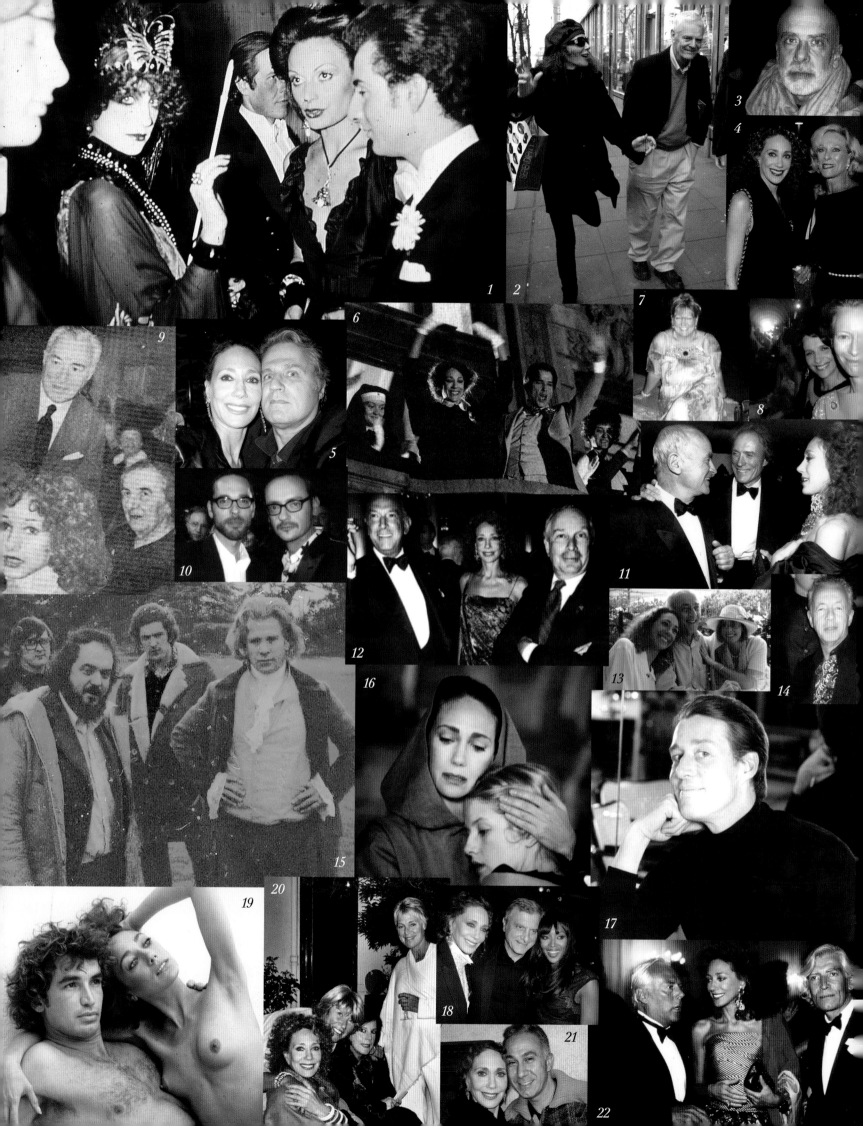

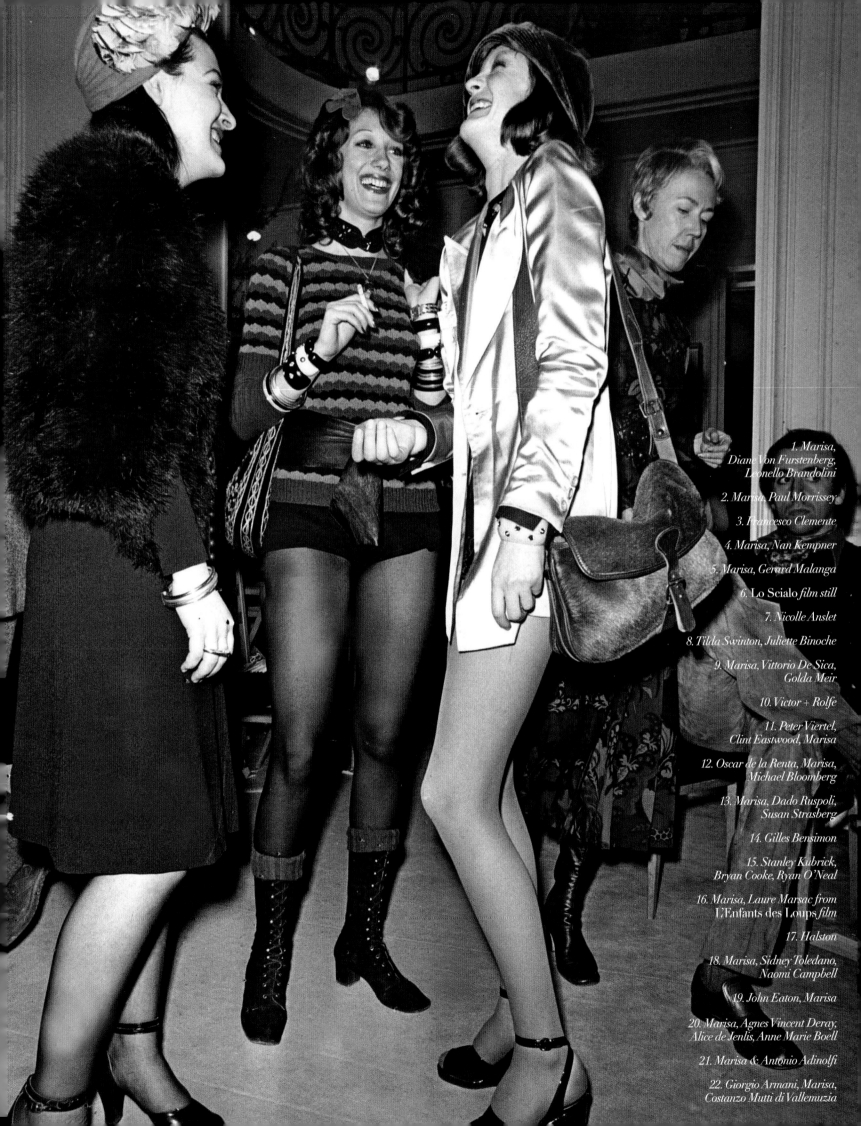

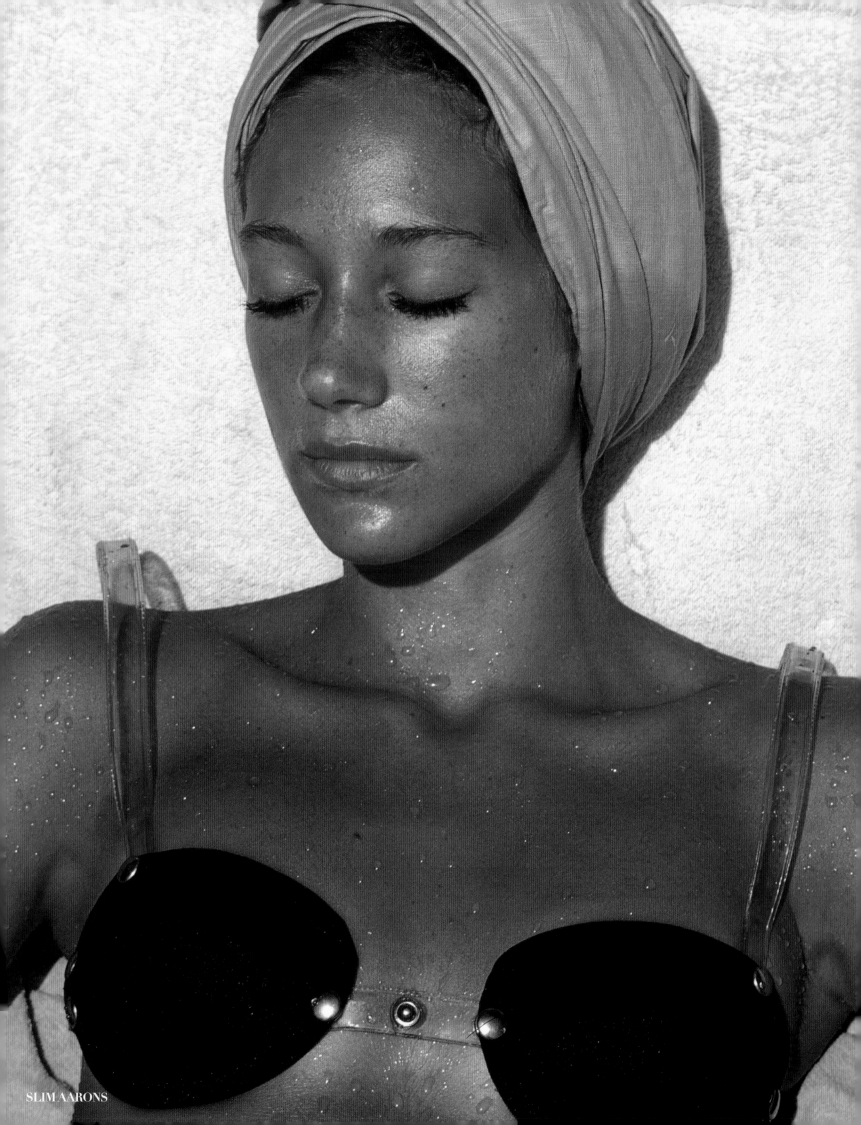

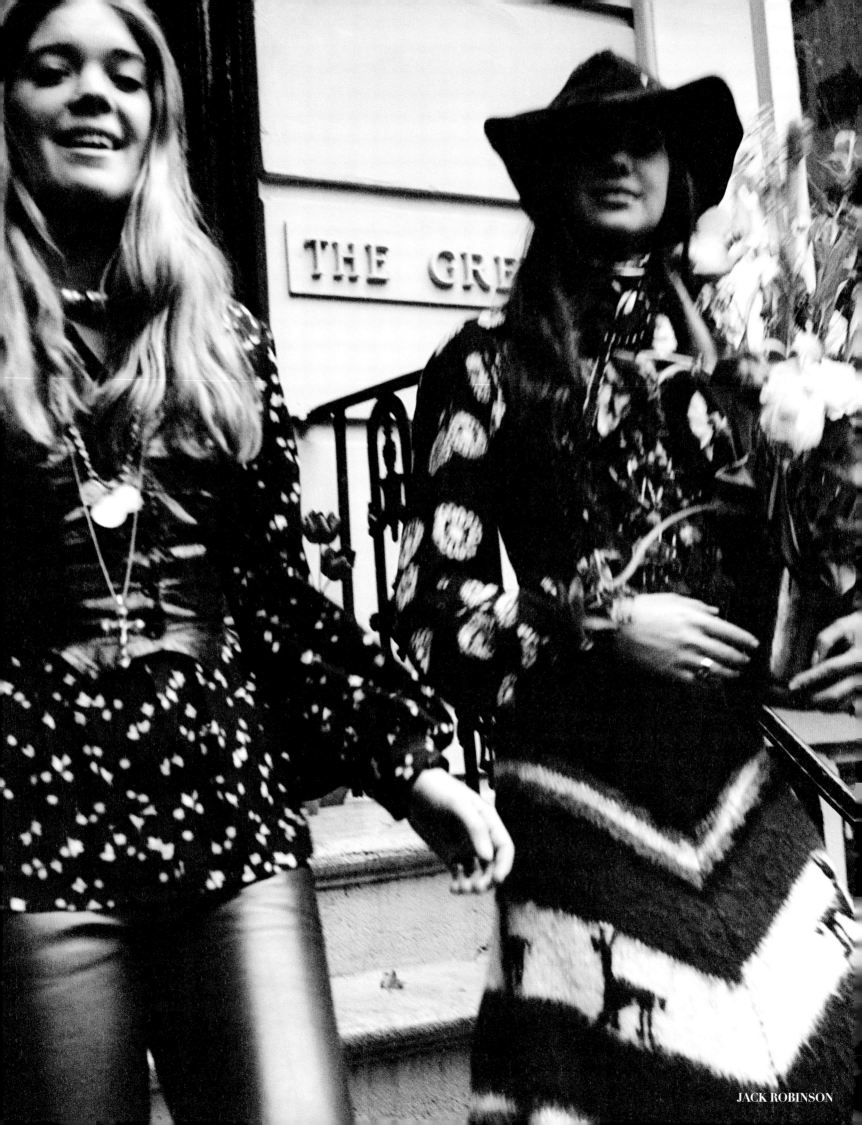

THE GRE

JACK ROBINSON

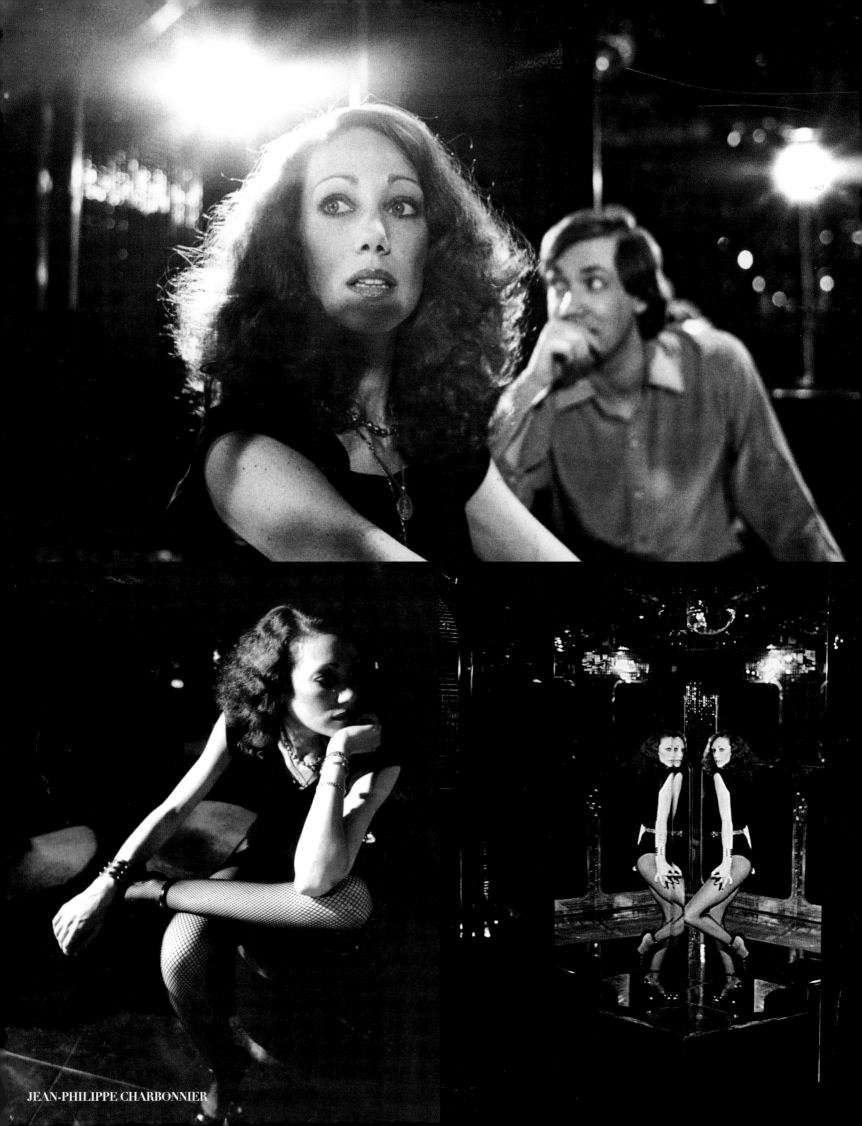

JEAN-PHILIPPE CHARBONNIER

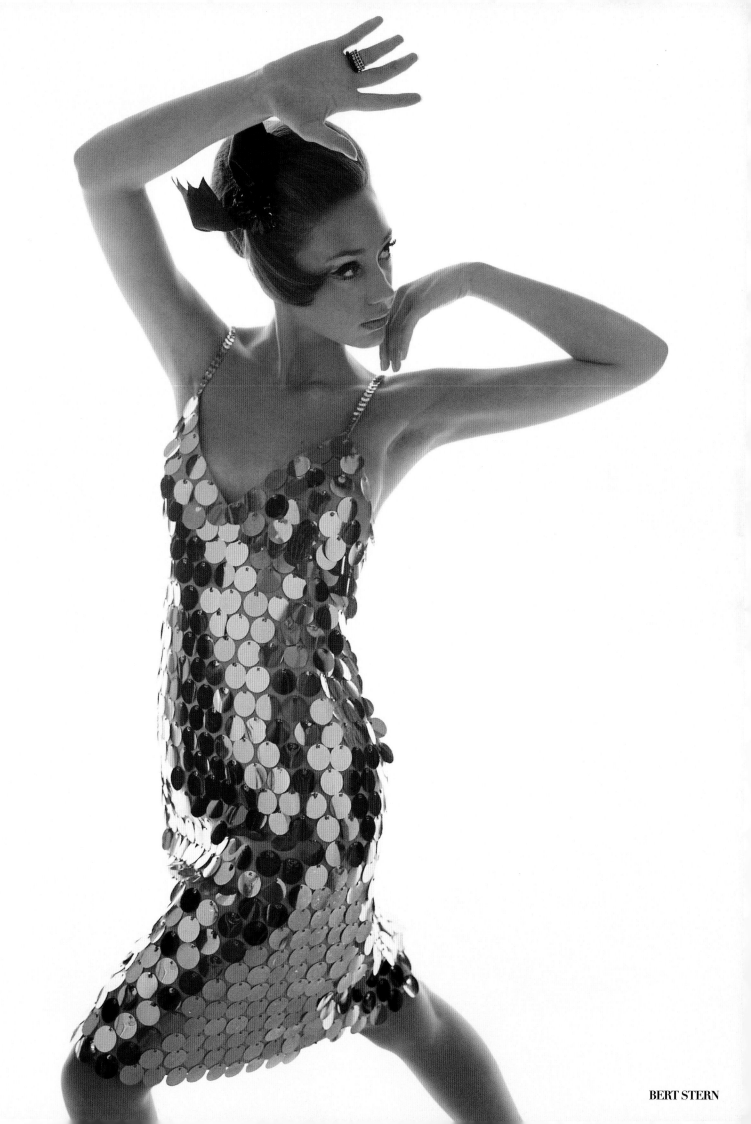

BERT STERN

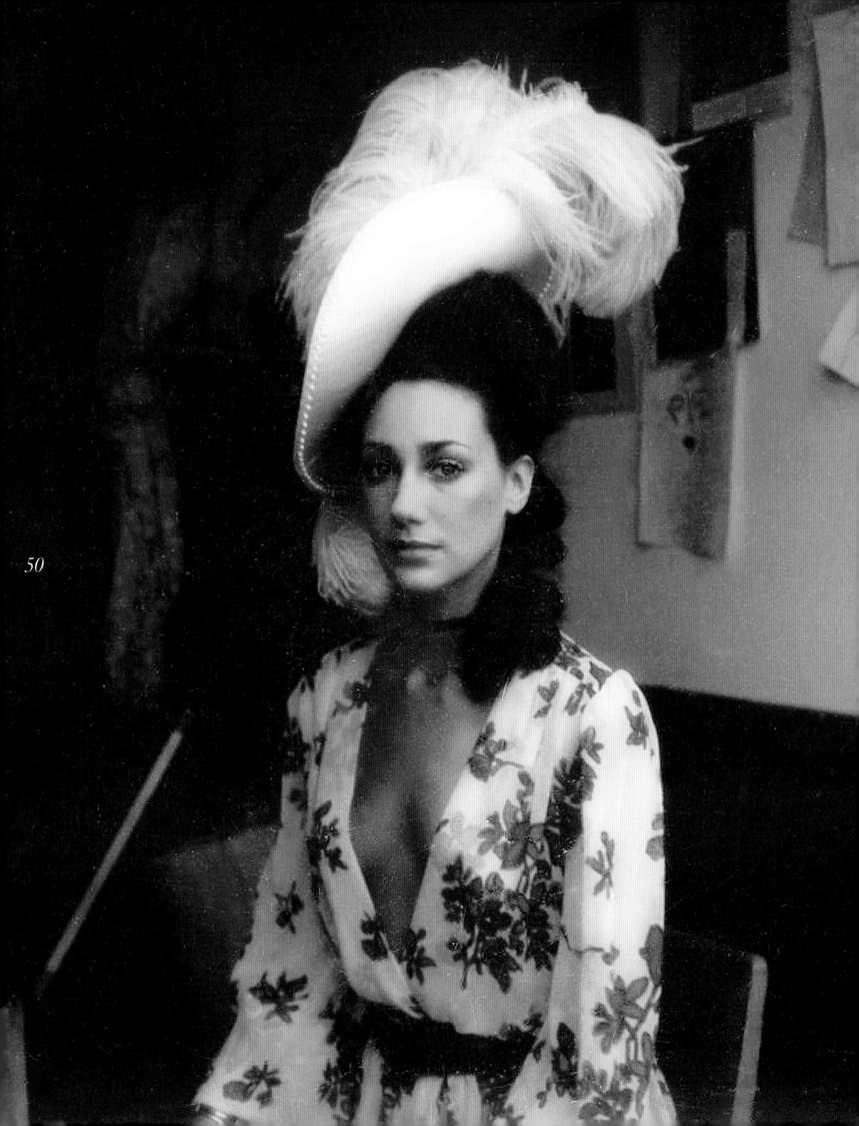

50

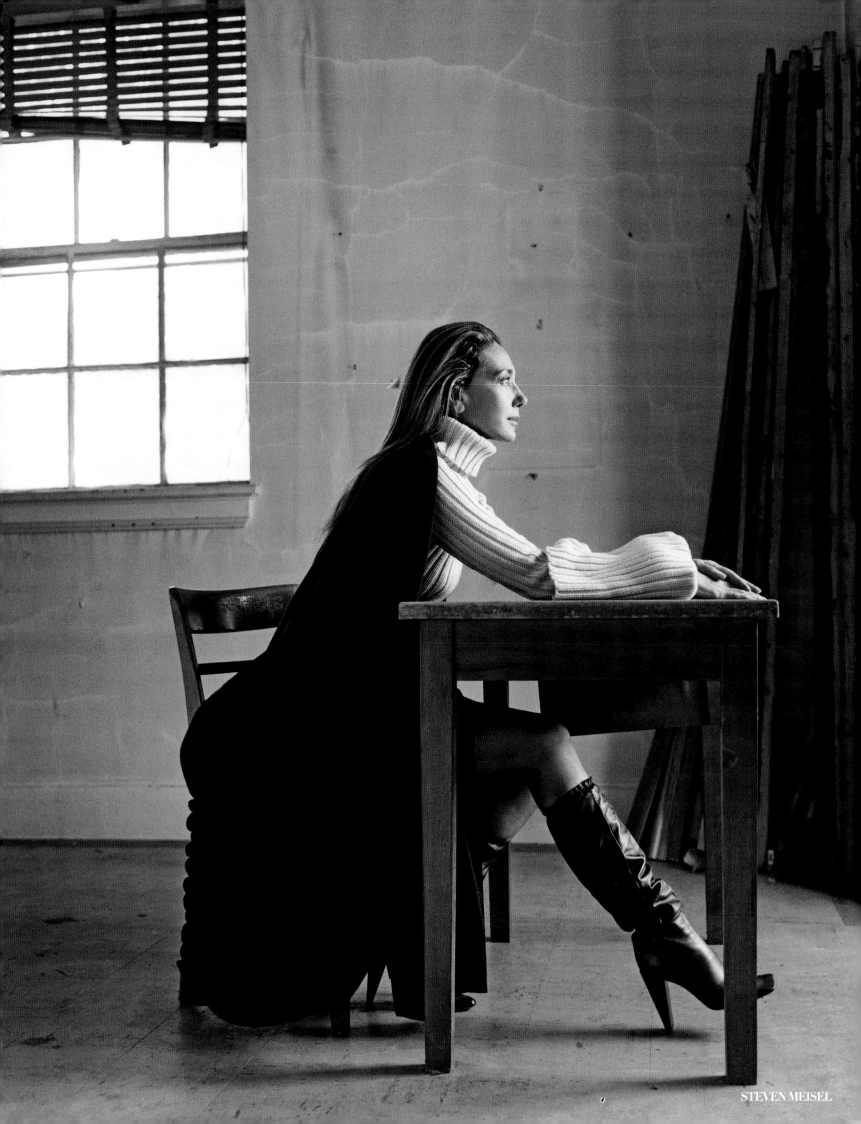

STEVEN MEISEL

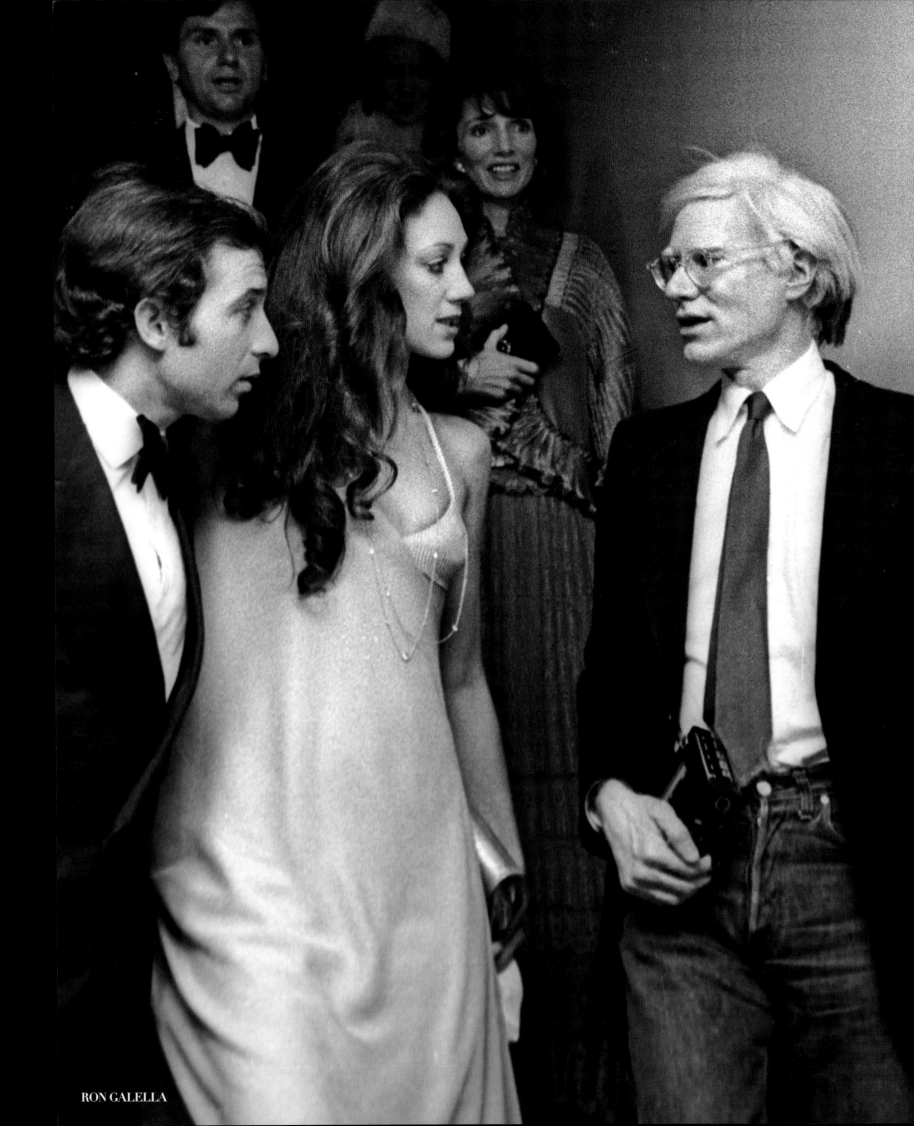

RON GALELLA

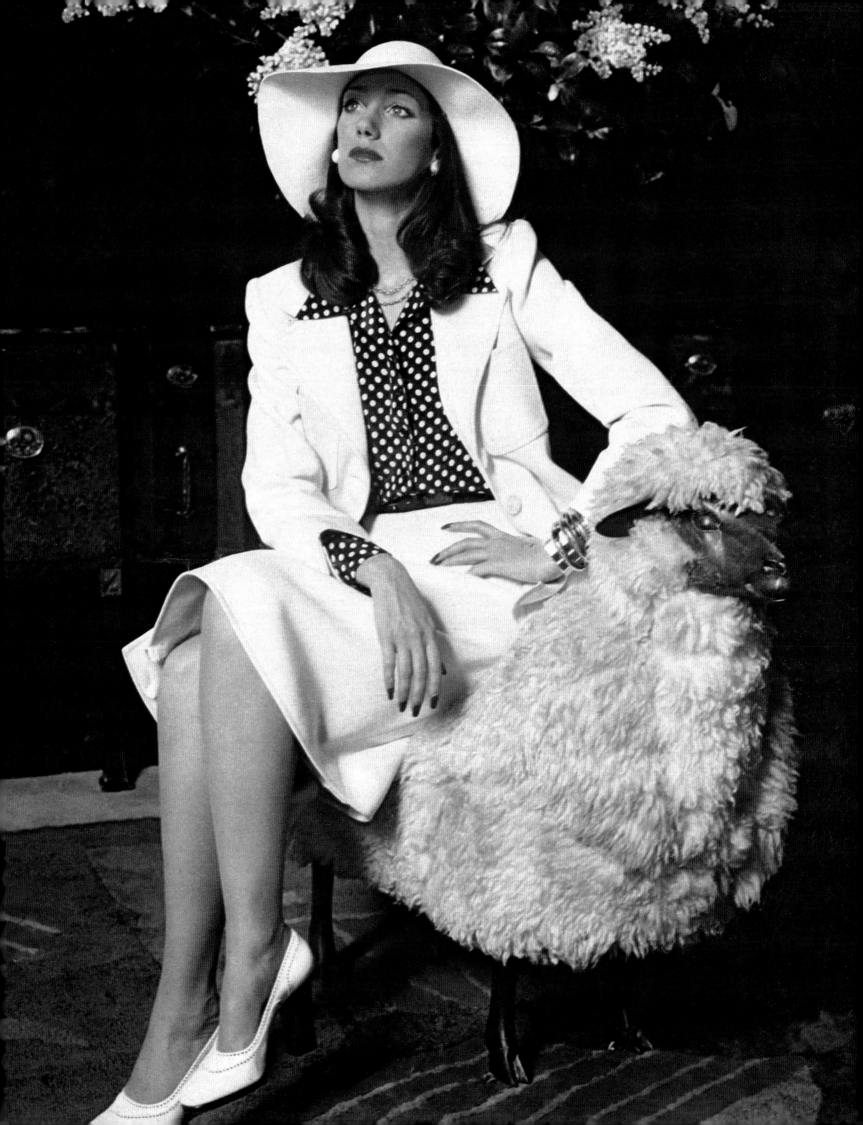

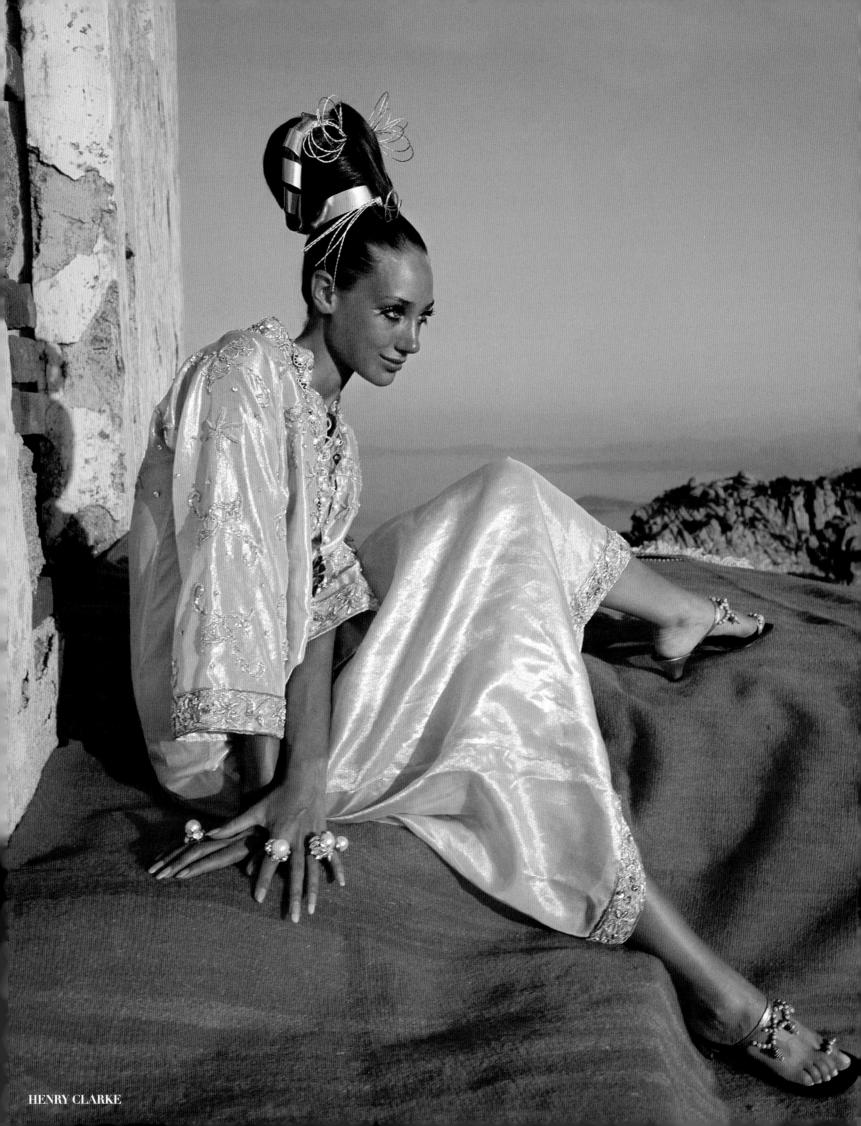

HENRY CLARKE

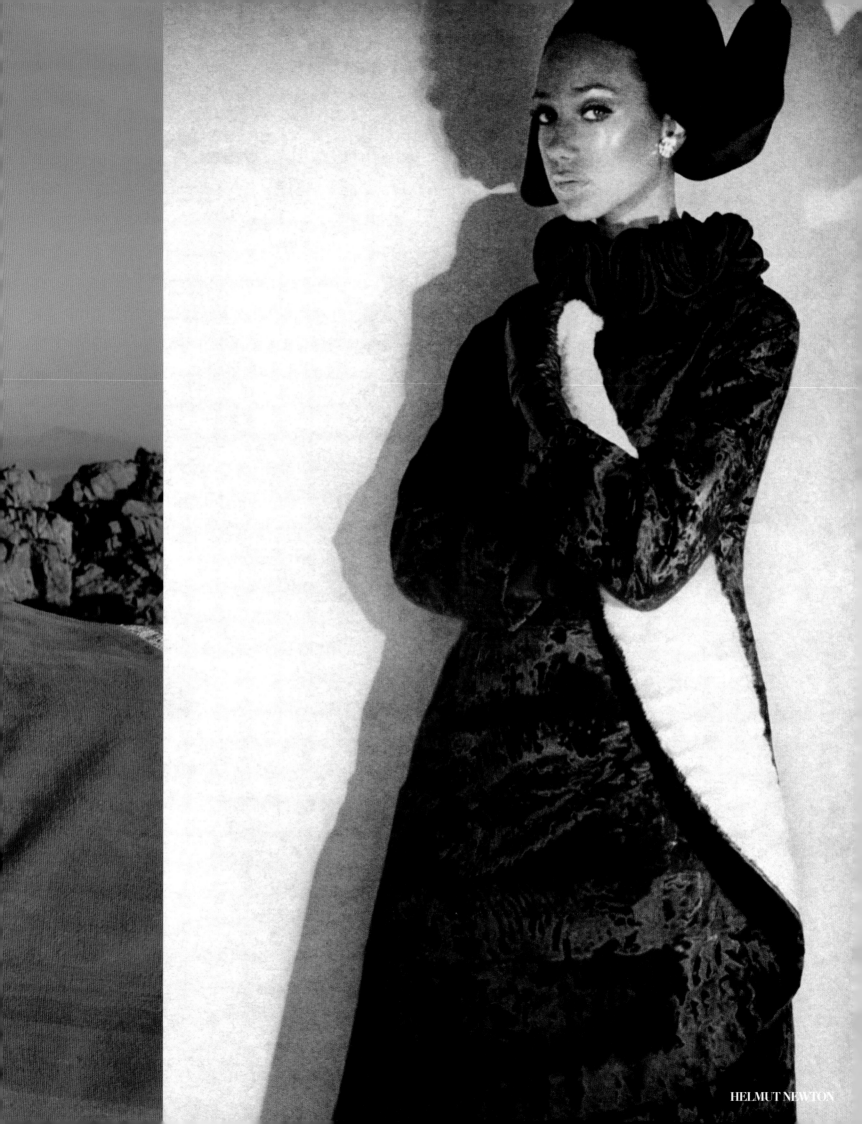

HELMUT NEWTON

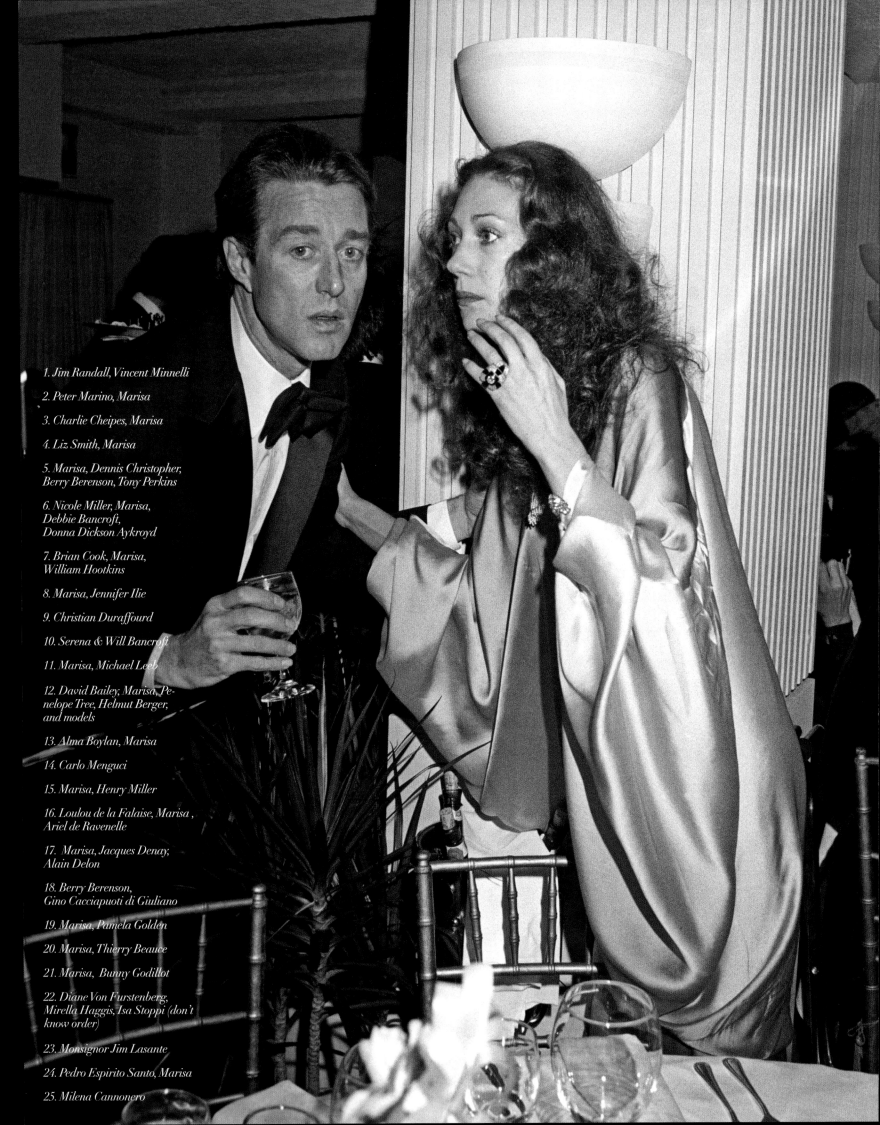

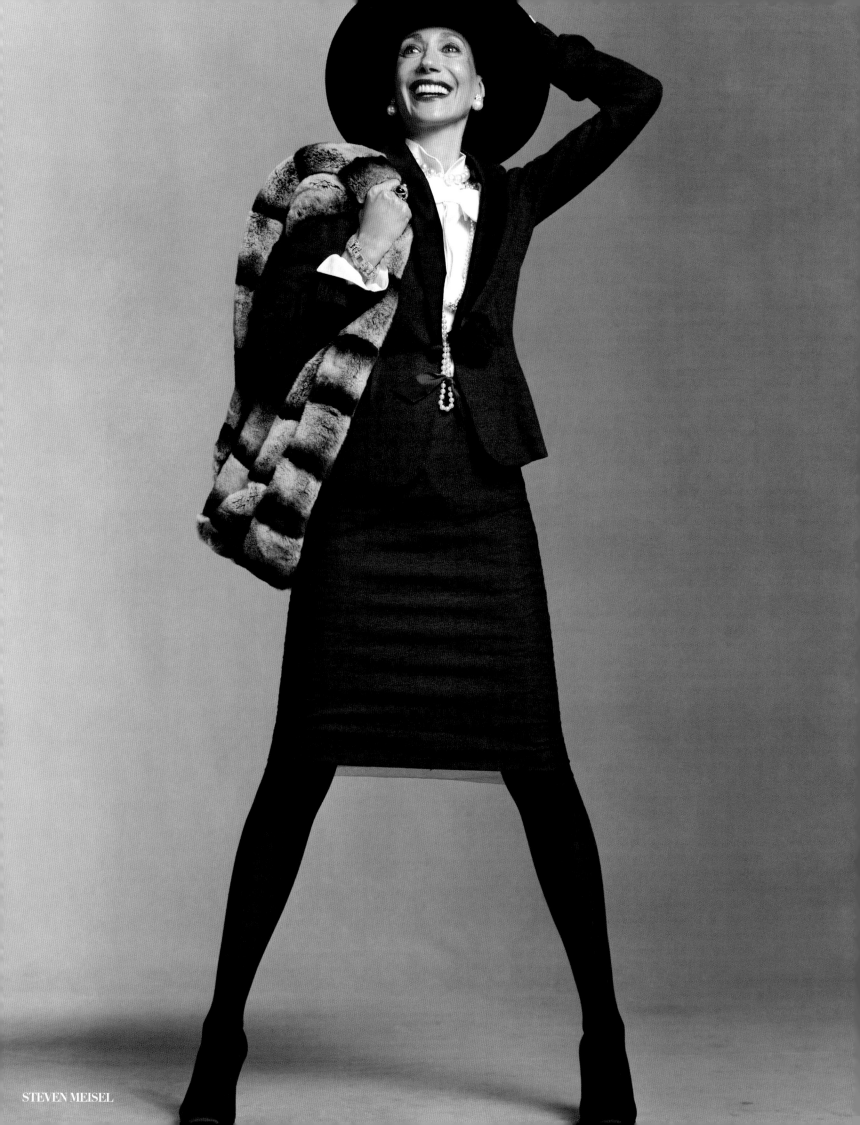

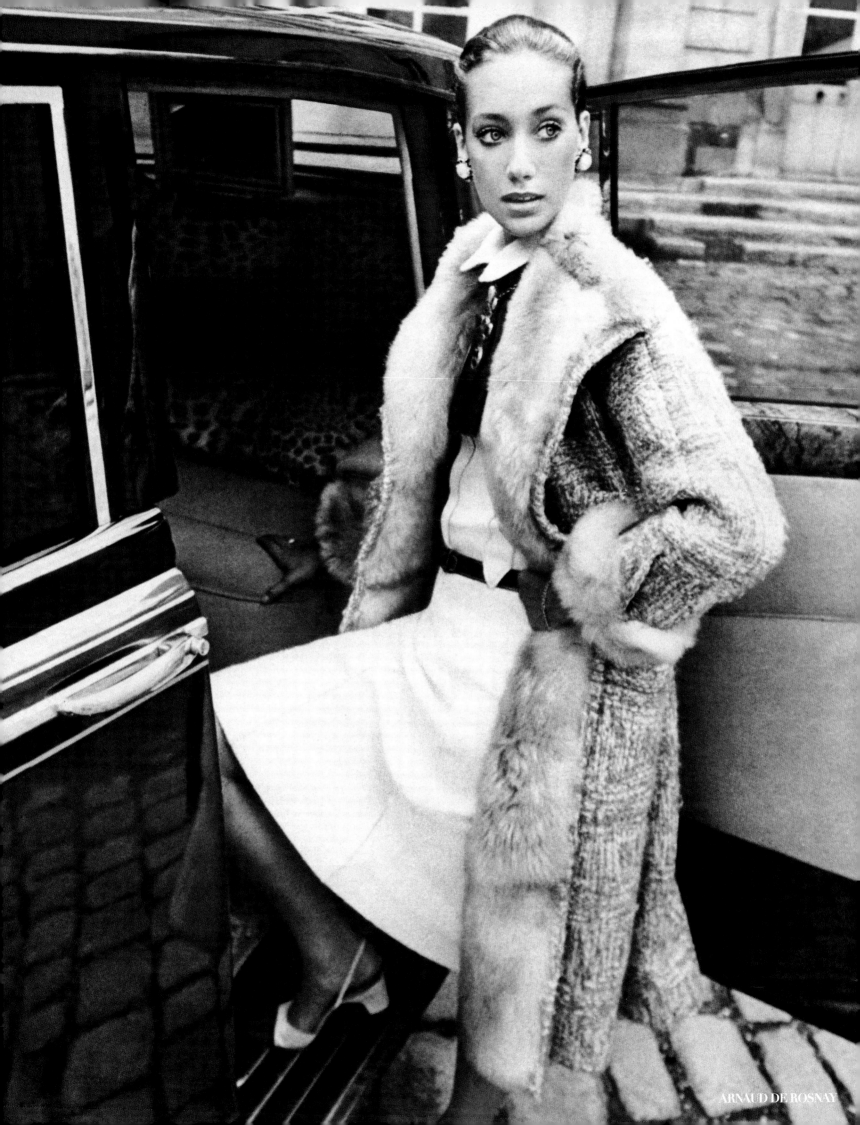

ARNAUD DE ROSNAY

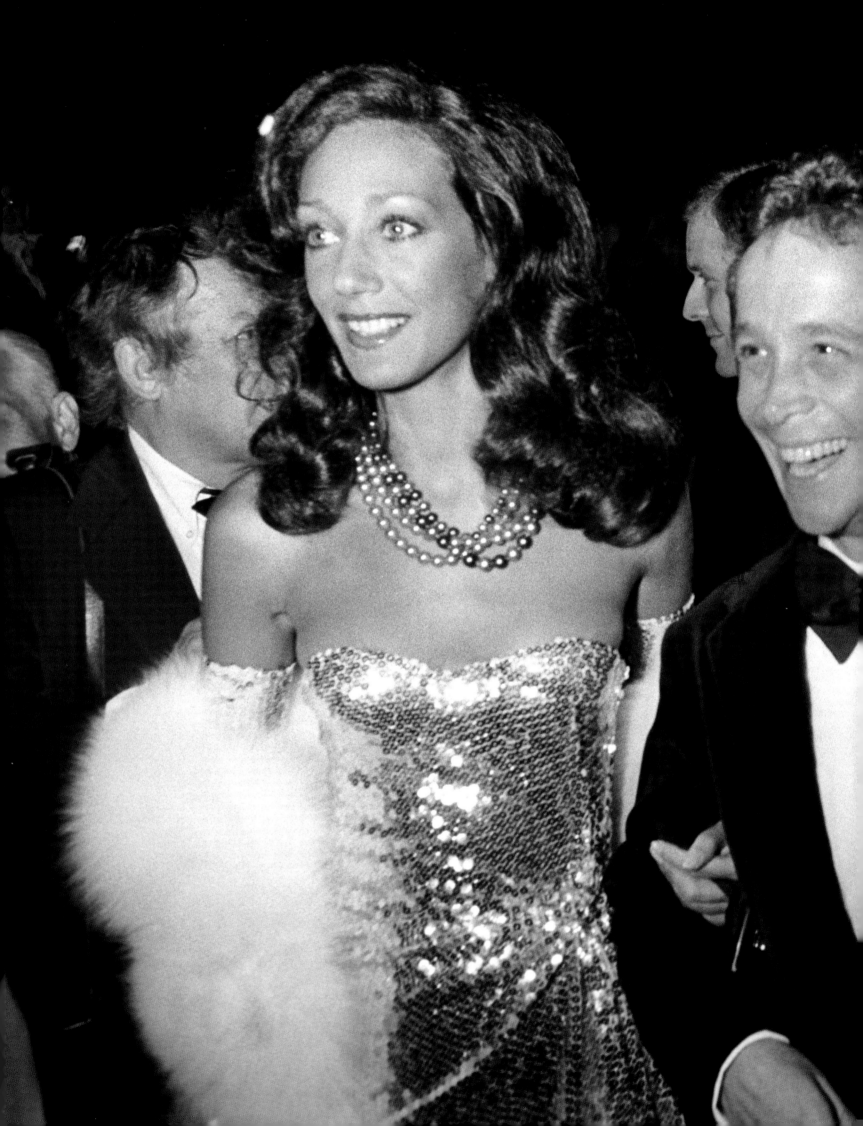

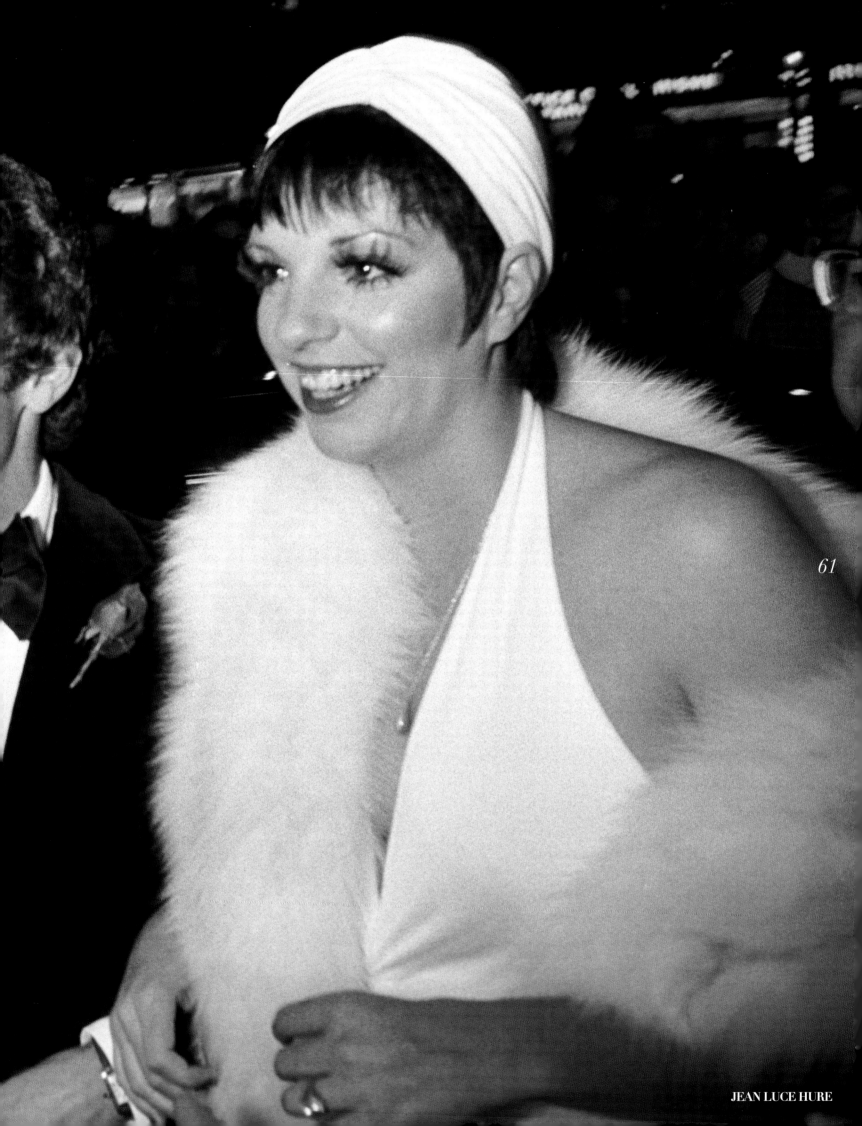

61

JEAN LUCE HURE

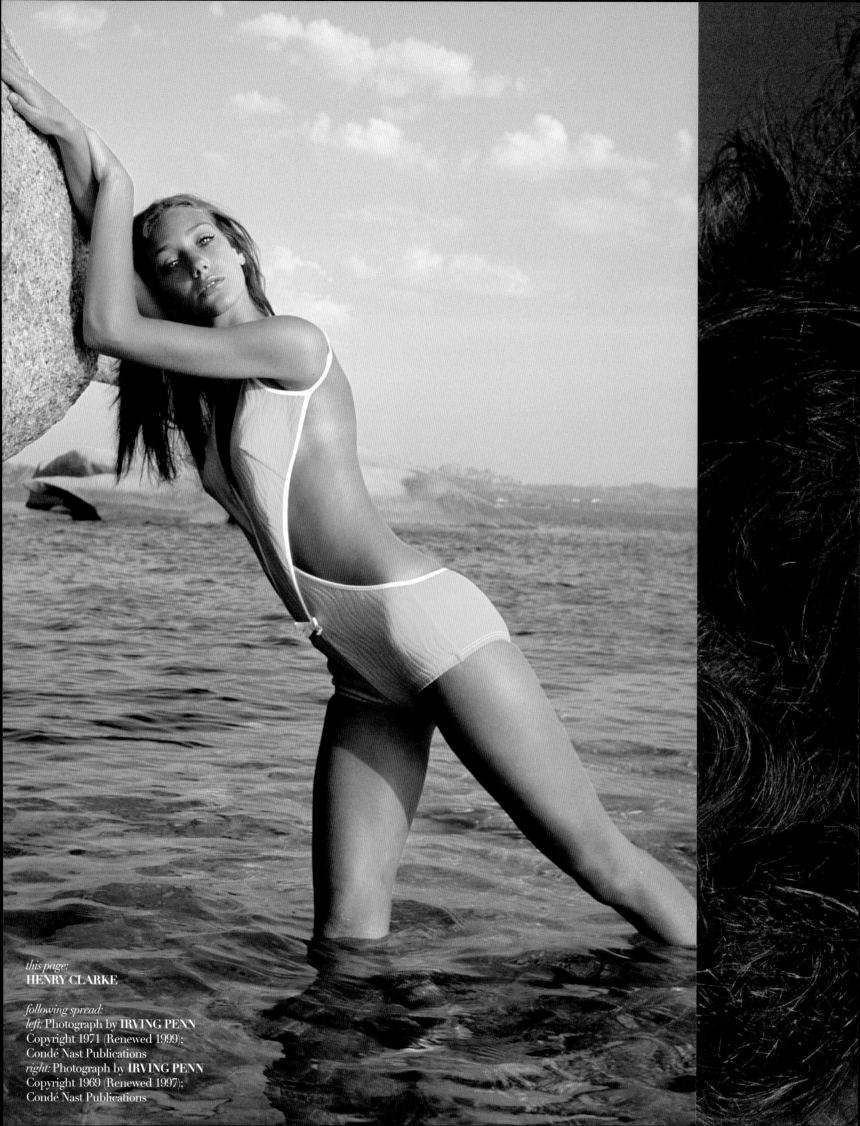

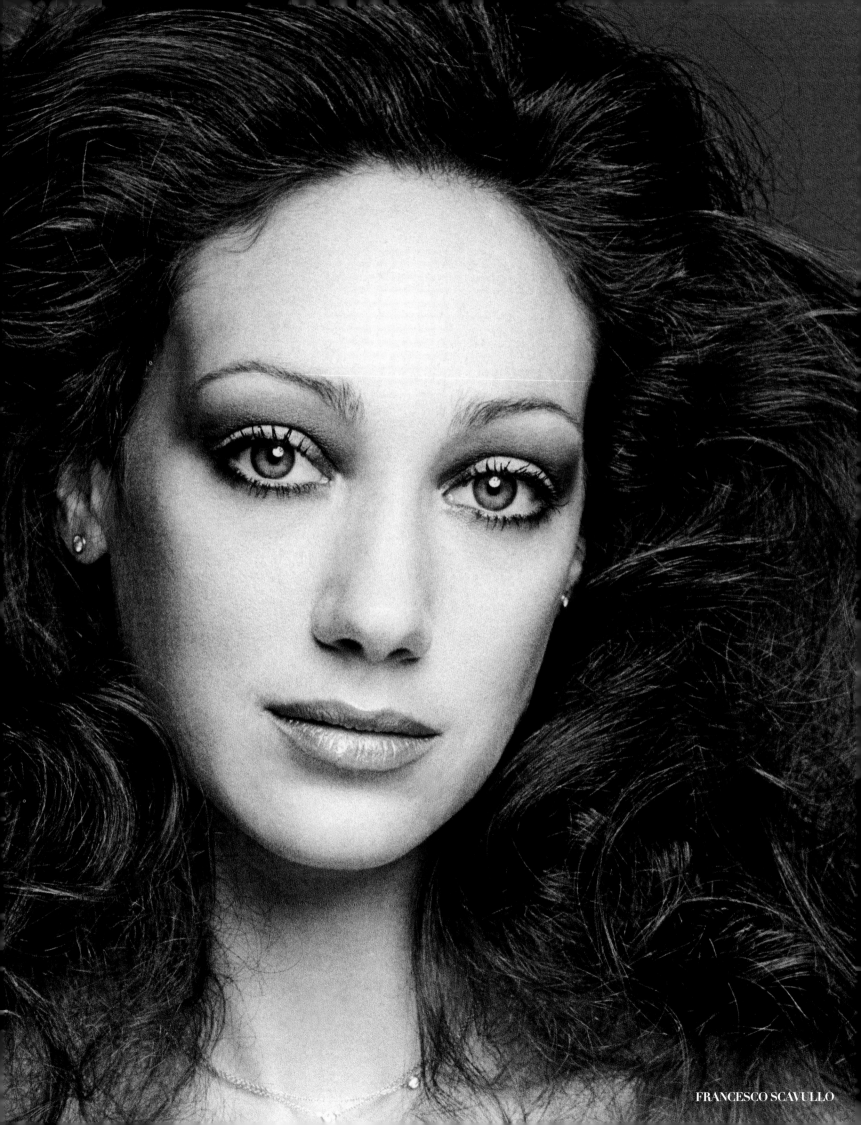

FRANCESCO SCAVULLO

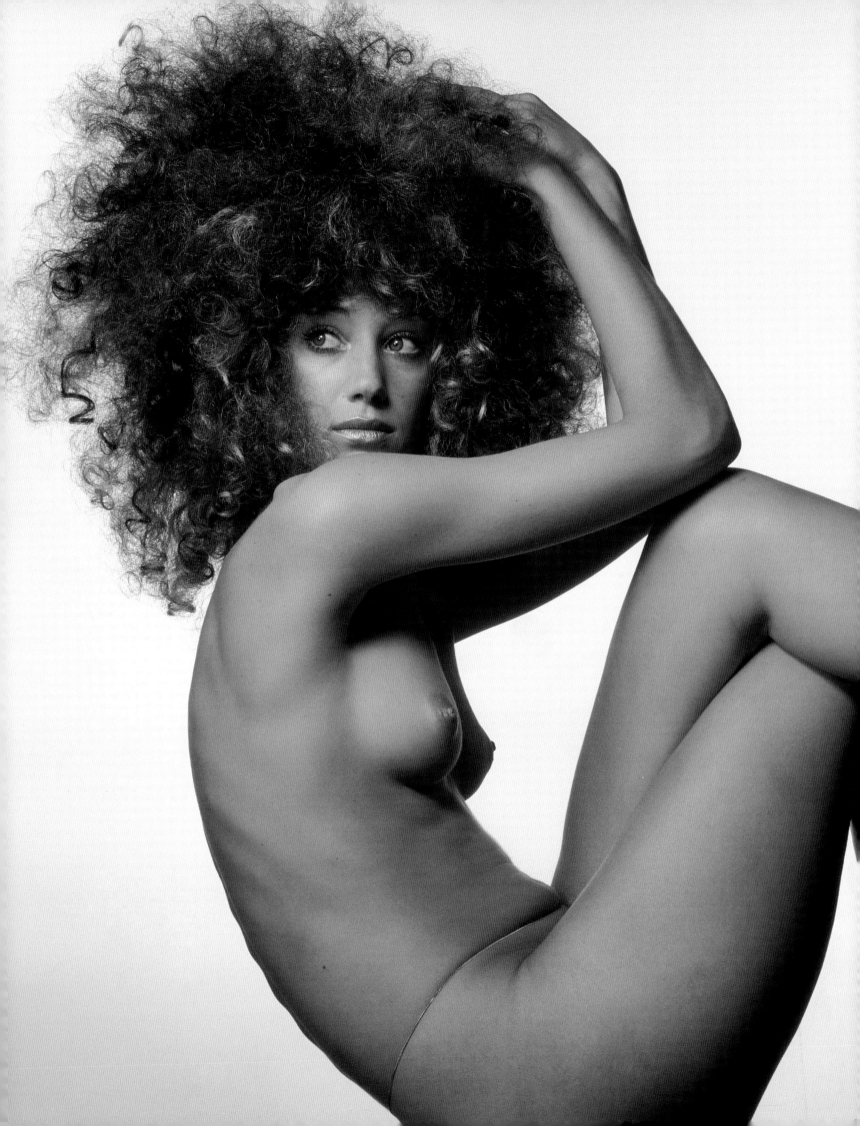

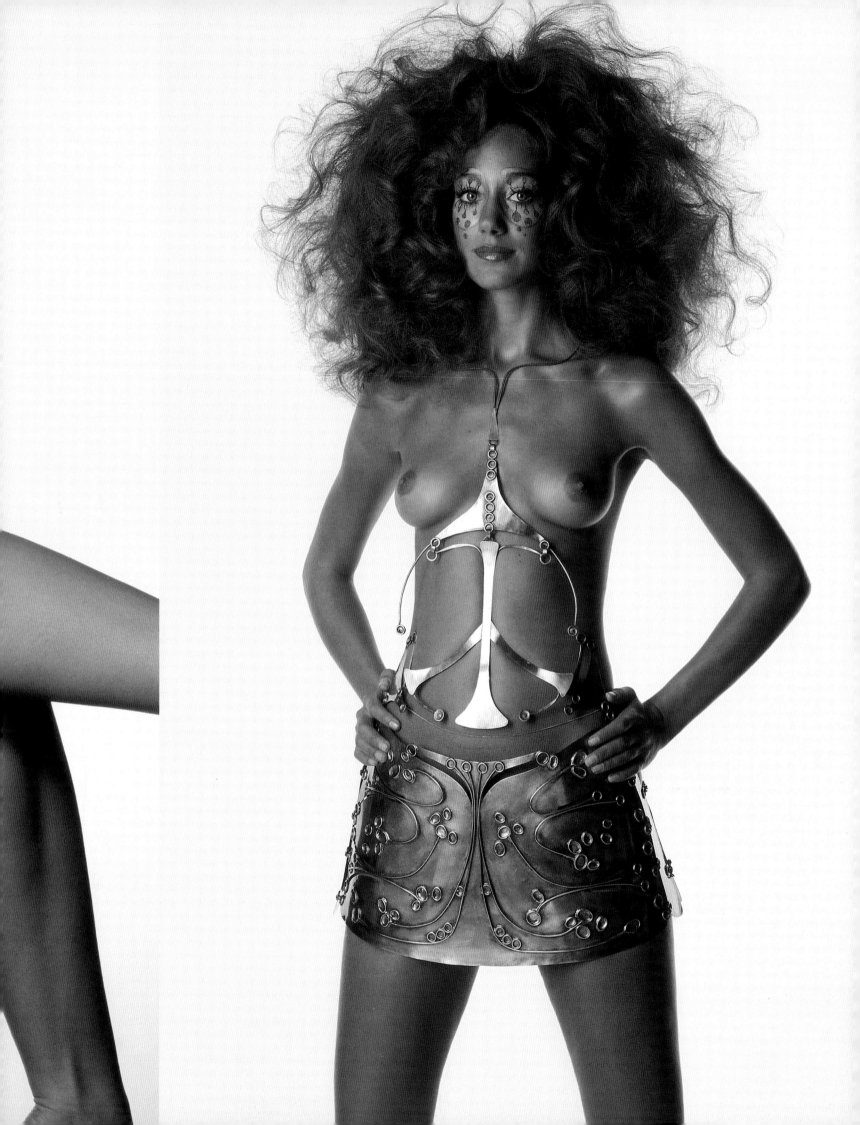

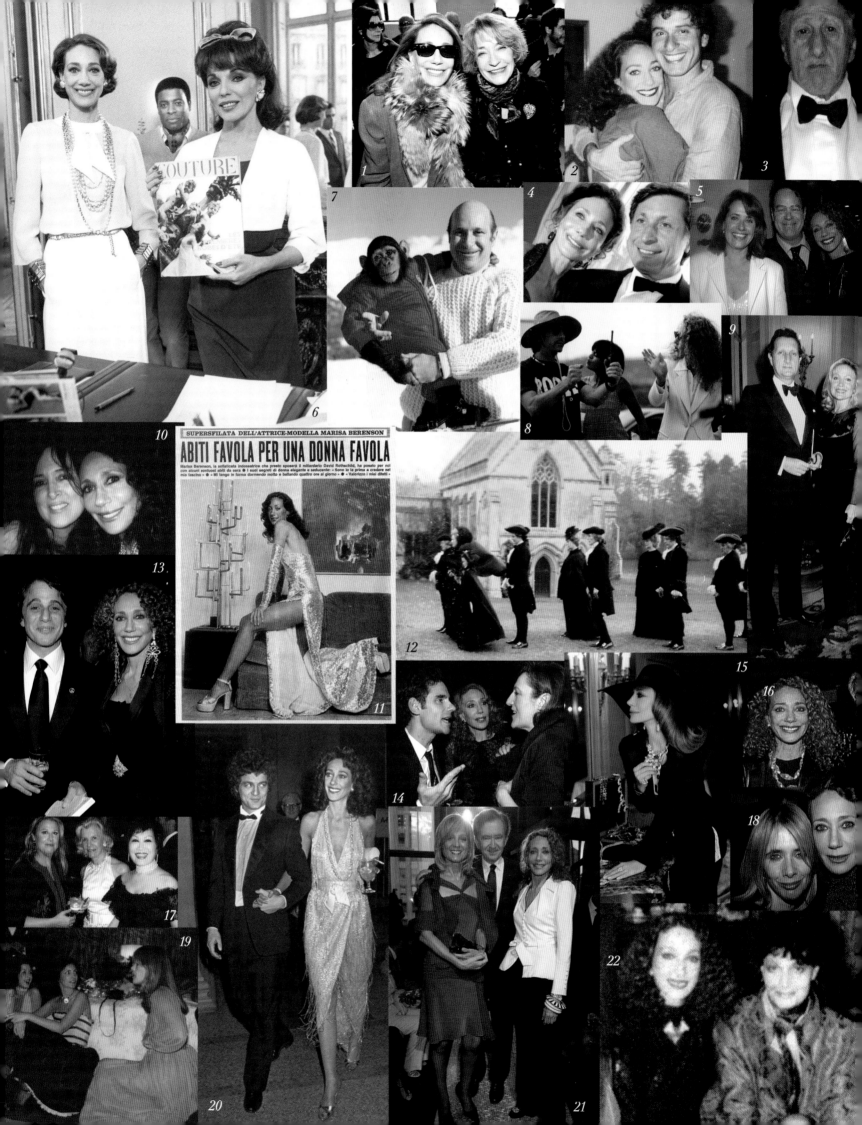

SUPERSFILATA DELL'ATTRICE-MODELLA MARISA BERENSON

ABITI FAVOLA PER UNA DONNA FAVOLA

Marisa Berenson, la socialcreta indossatrice che presto sposerà il miliardario David Rothschild, ha posato per noi con alcuni sontuosi abiti da sera « I suoi segreti di donna elegante e seducente: « Sono io la prima a credere nel mio fascino » ● « Mi tengo in forma dormendo molto e ballando quattro ore al giorno » ● « Valorizzo i miei difetti »

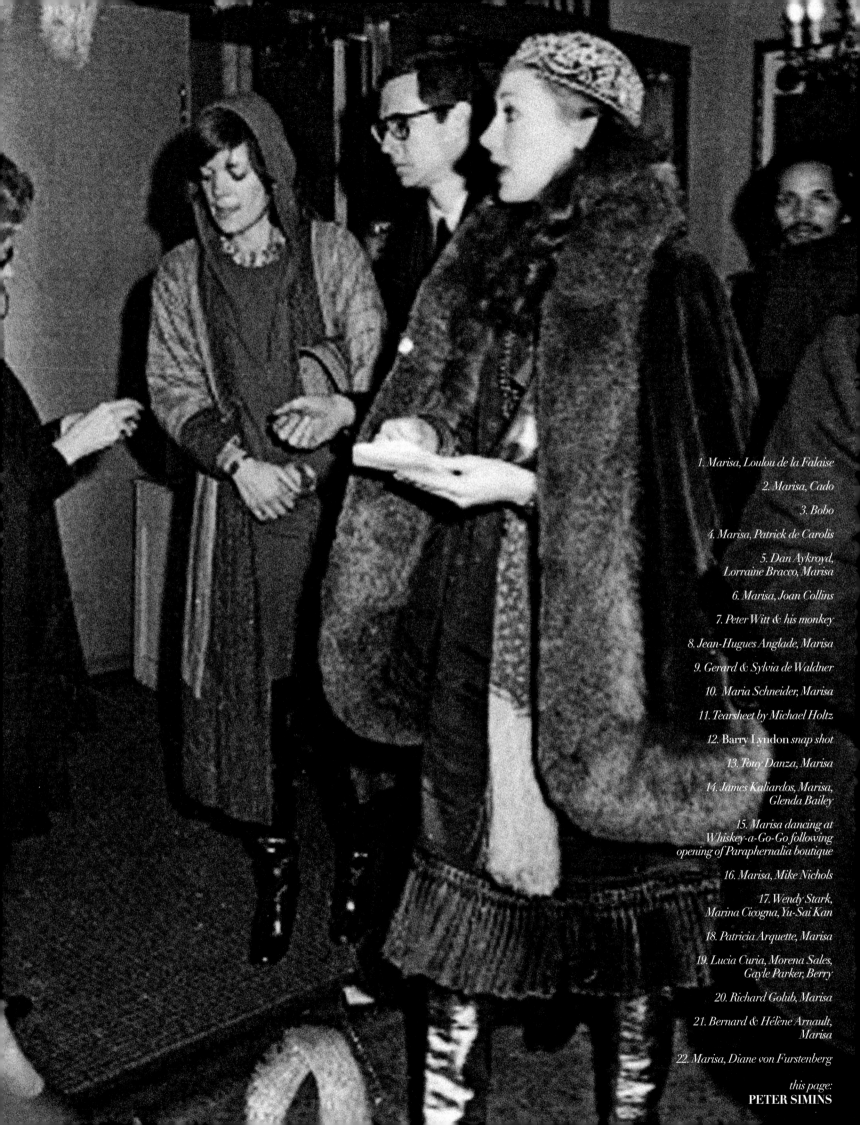

this page:
PETER SIMINS

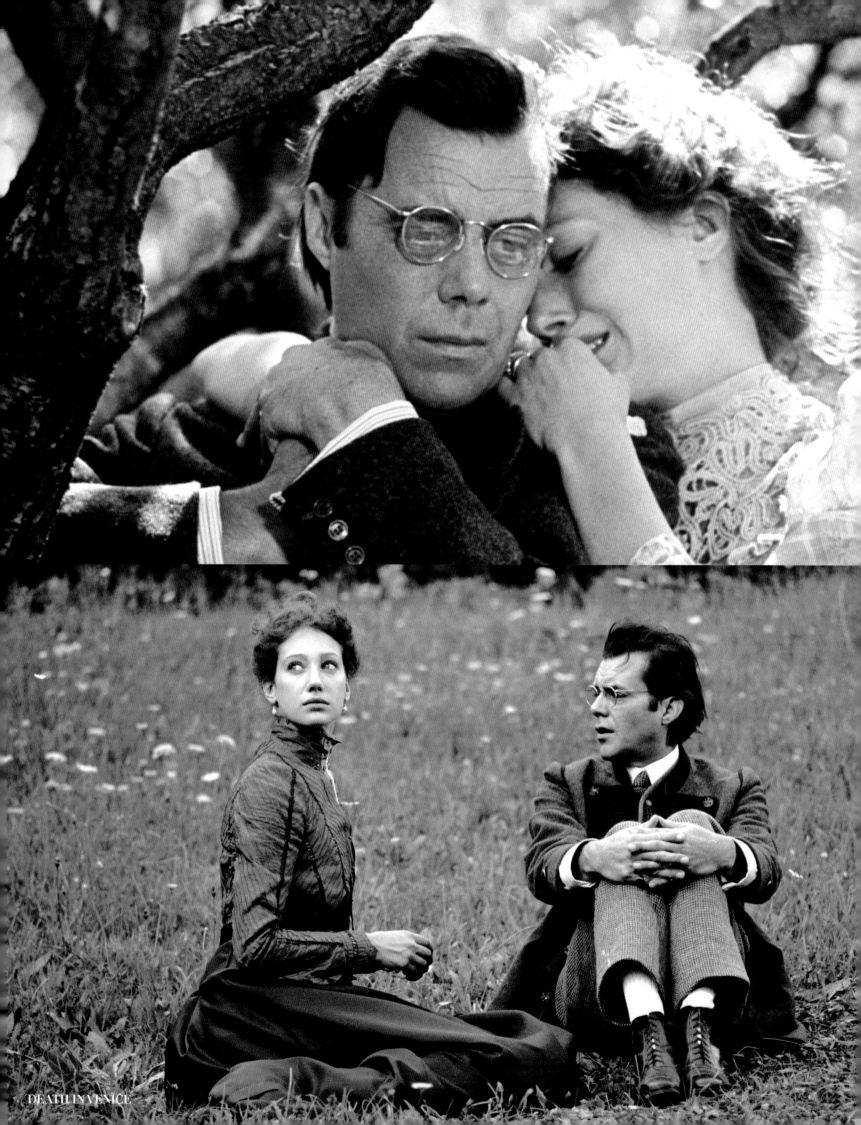

DEATH IN VENICE

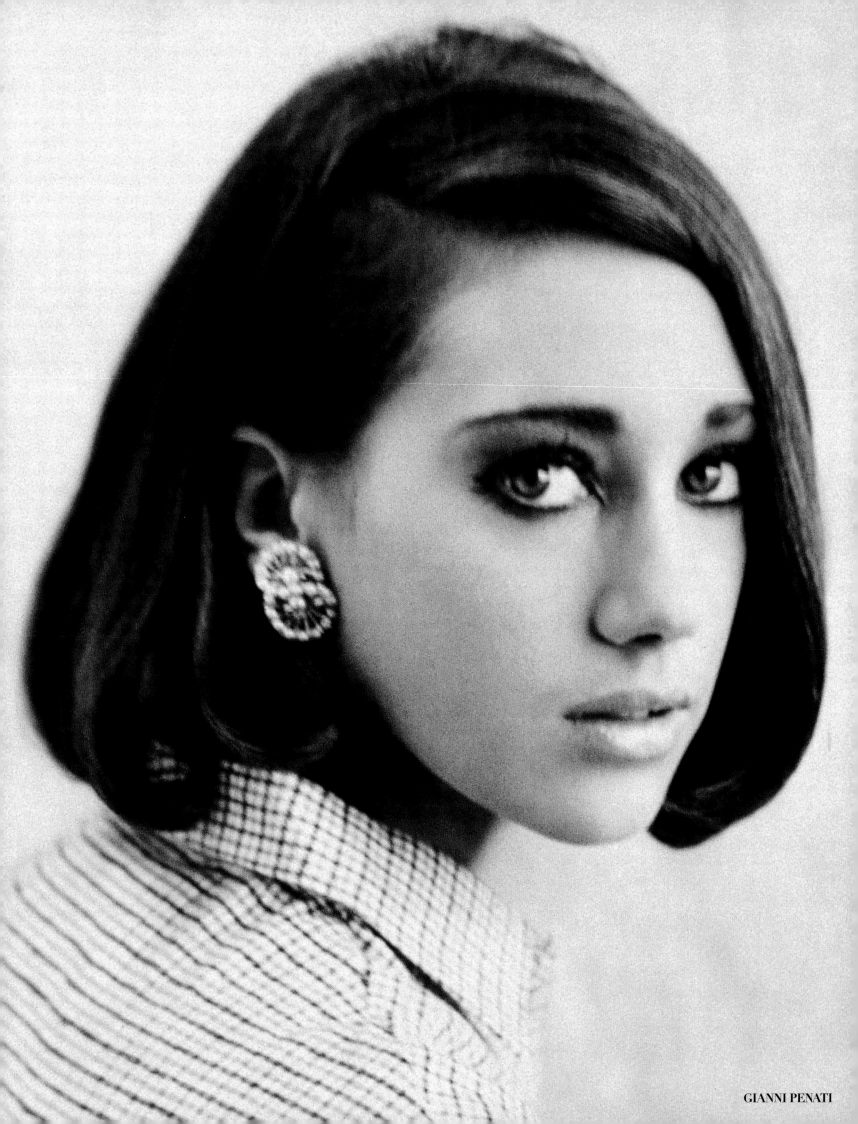

GIANNI PENATI

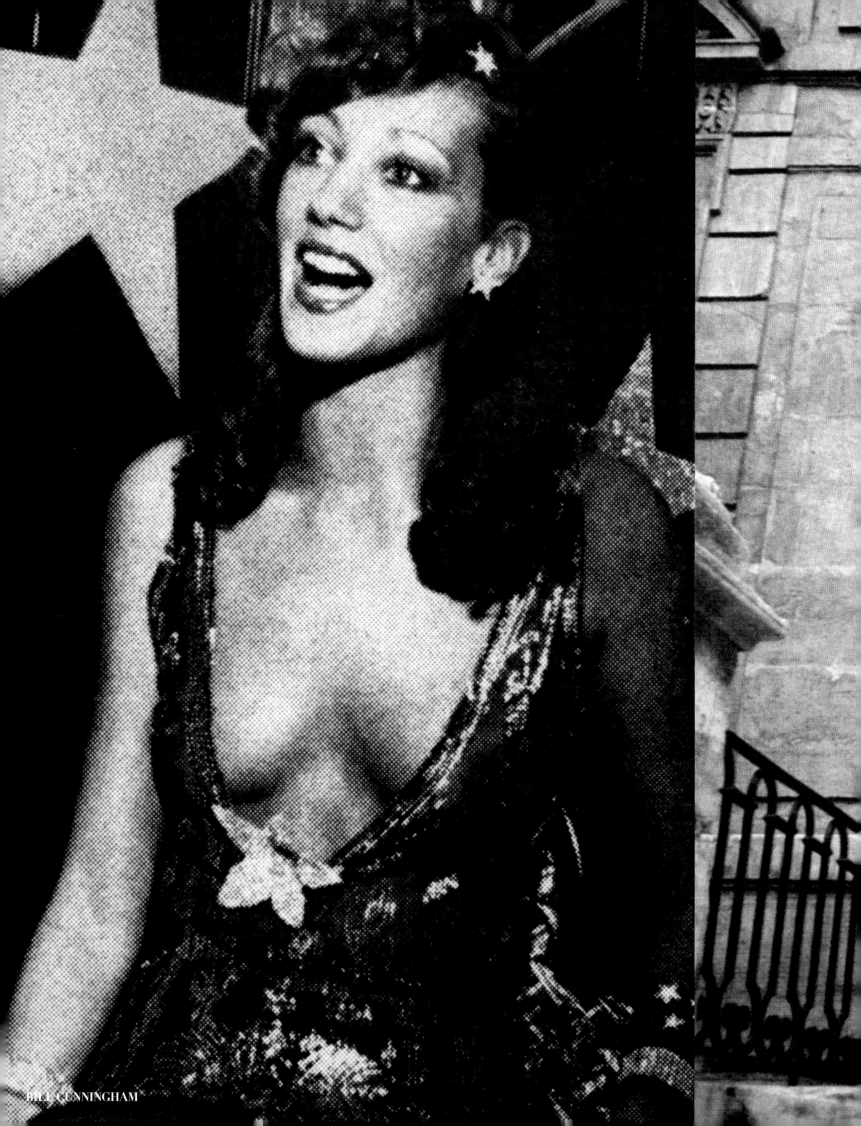

BILL CUNNINGHAM

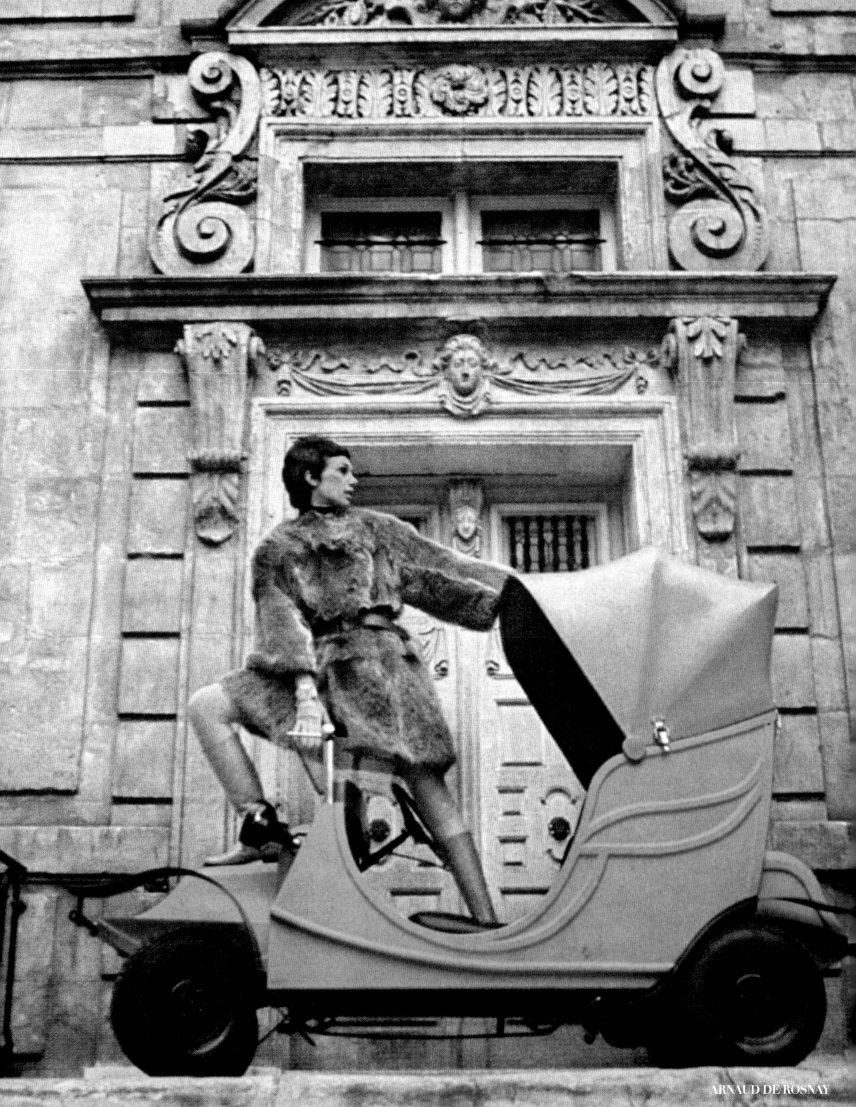

ARNAUD DE ROSNAY

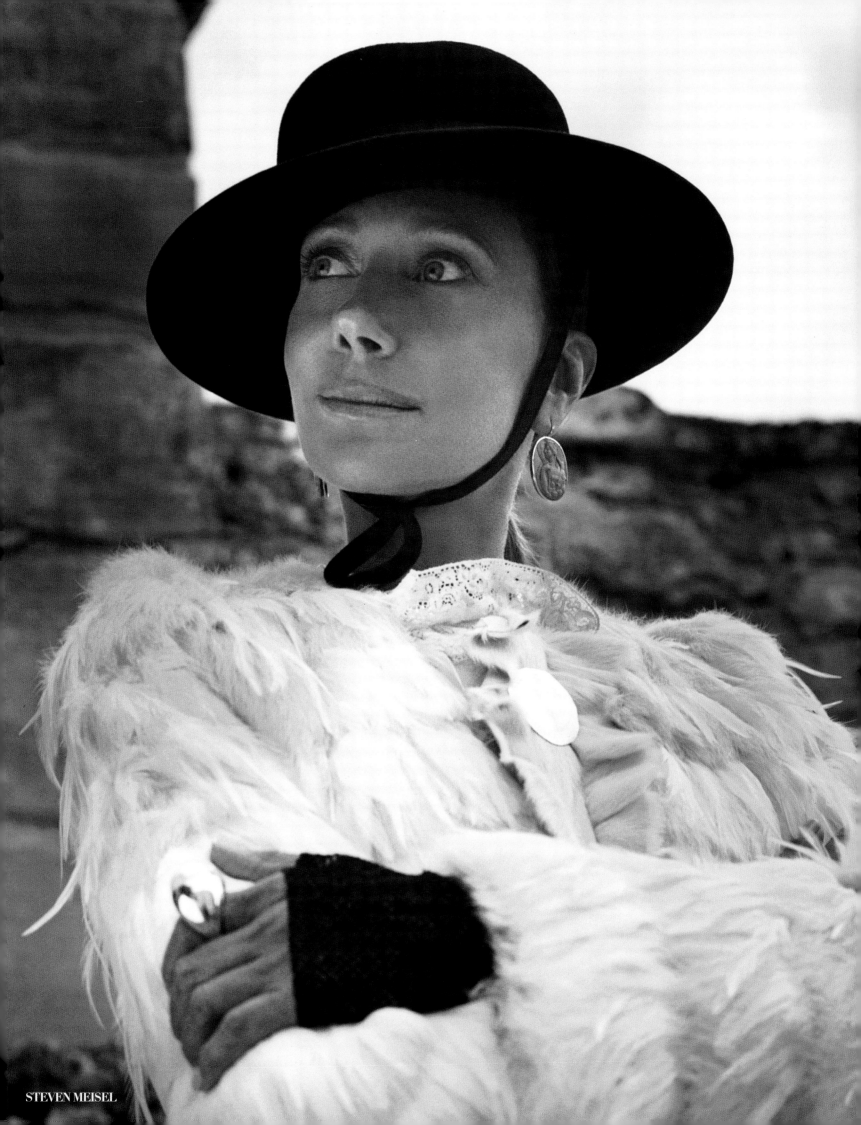

STEVEN MEISEL

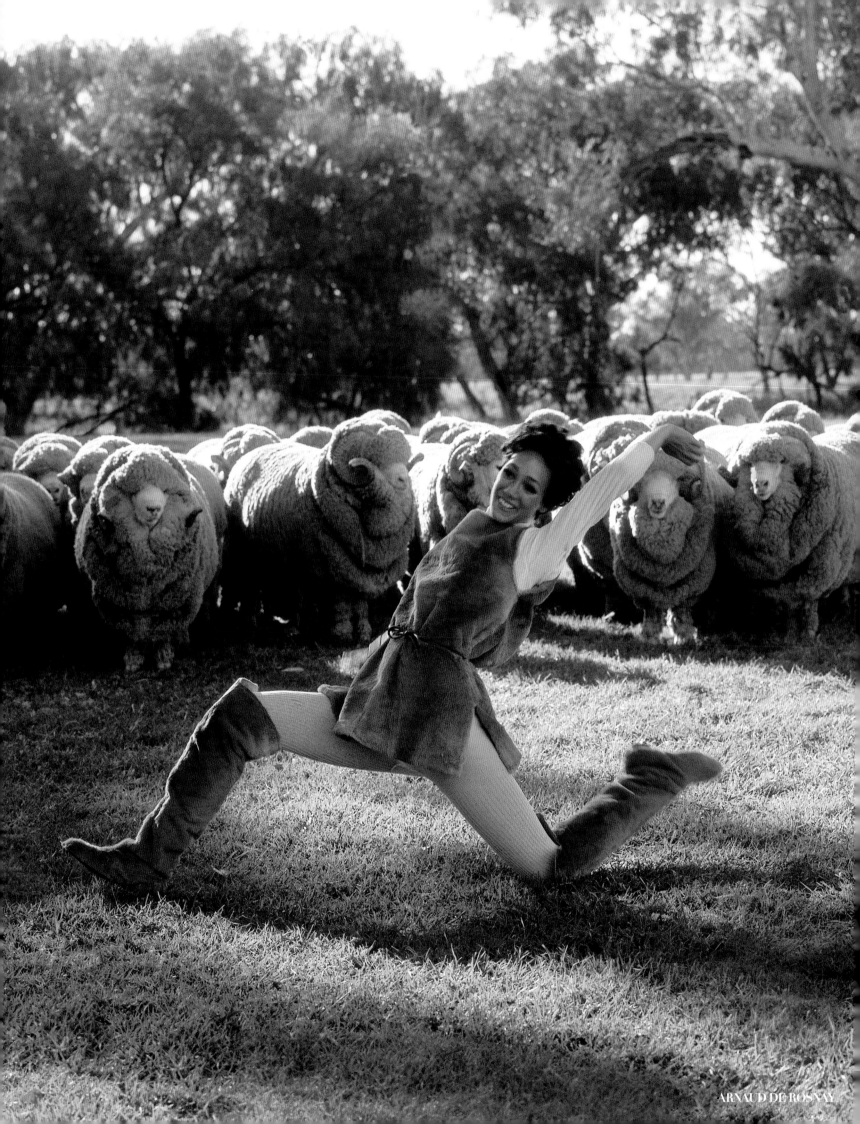

ARNAUD DE ROSNAY

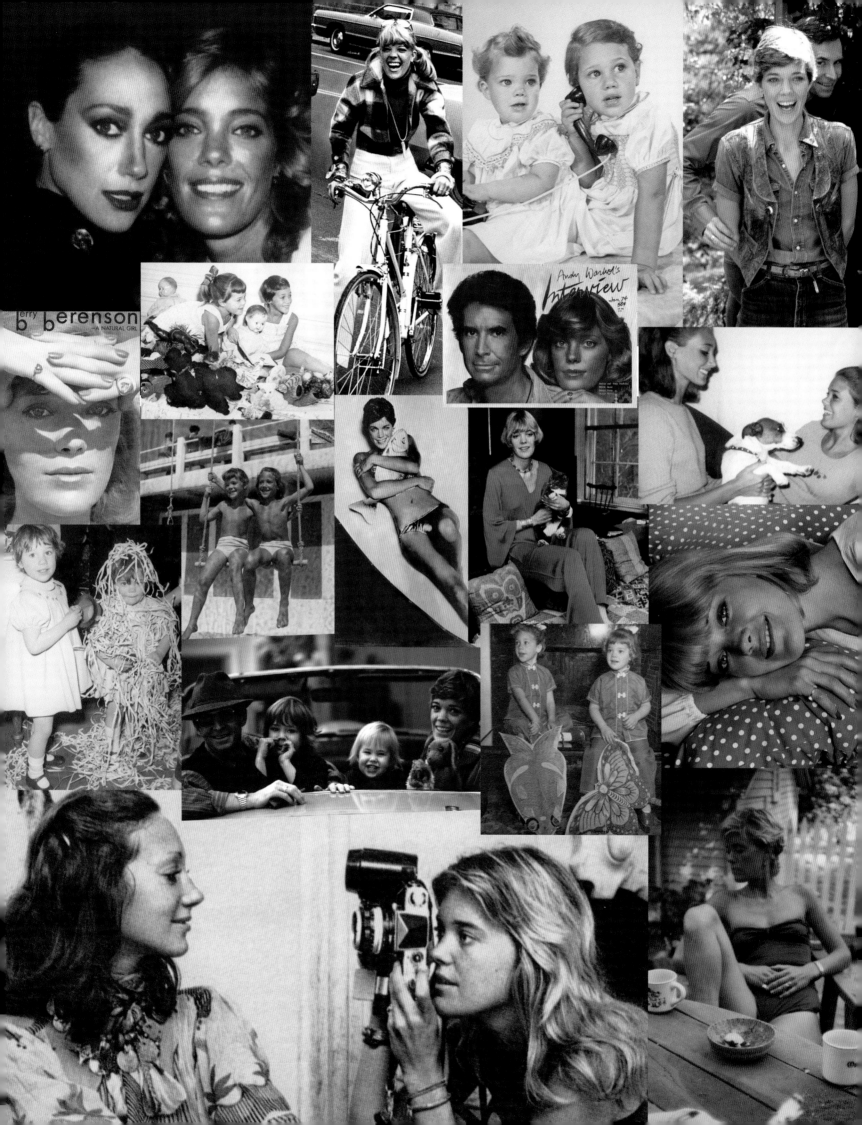

b berenson
—A NATURAL GIRL

Andy Warhol's
Interview
Jan 74
50¢

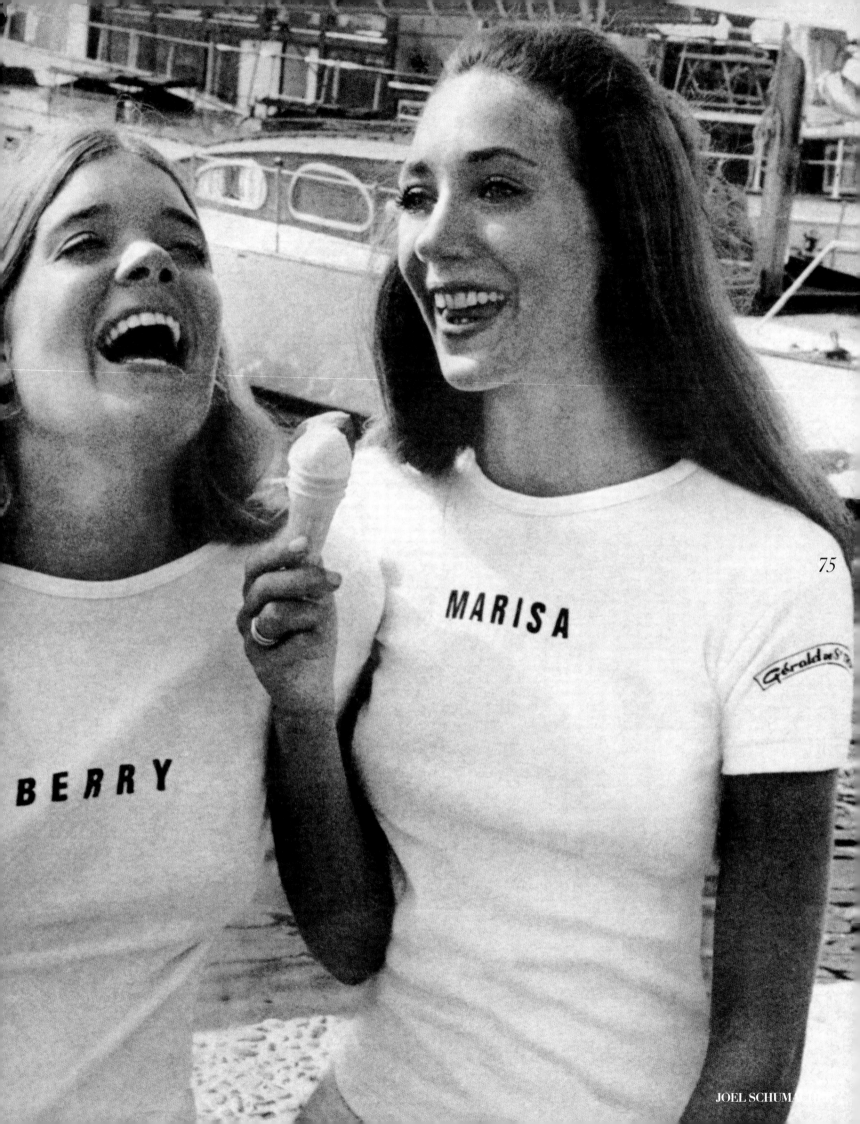

JOEL SCHUMA

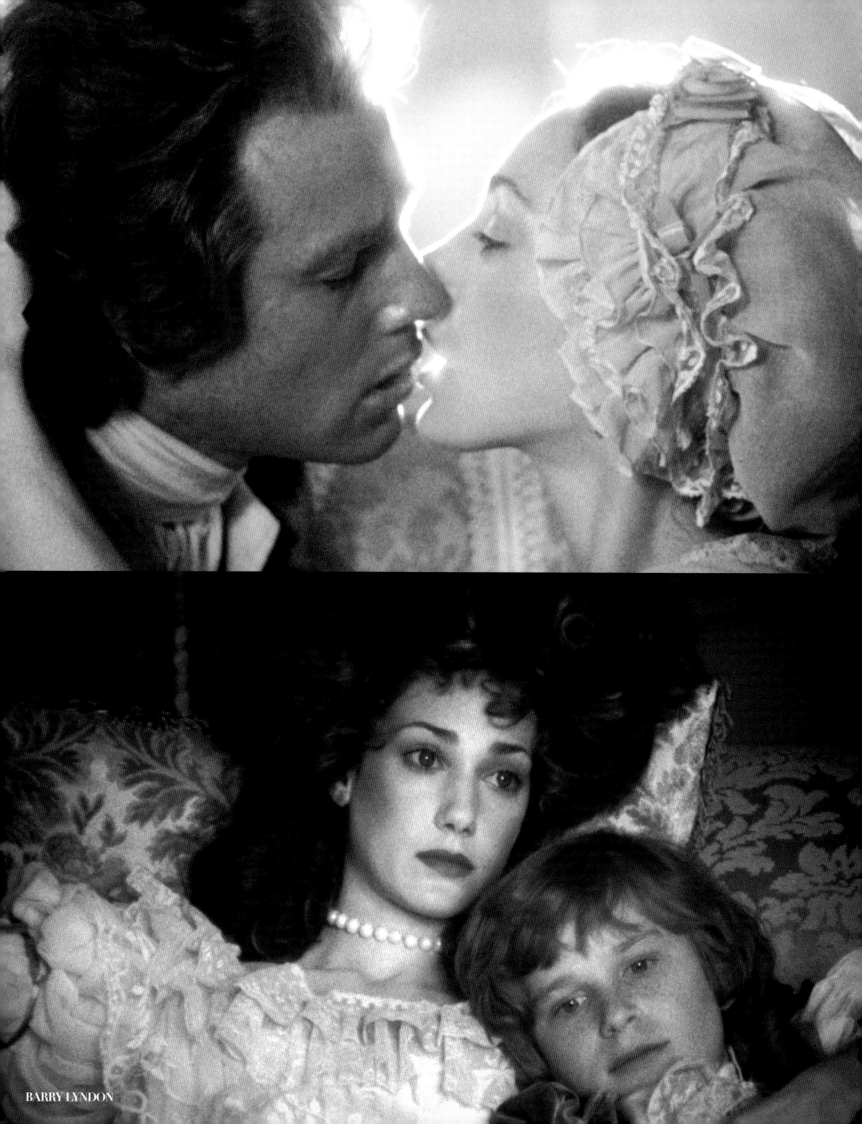

BARRY LYNDON

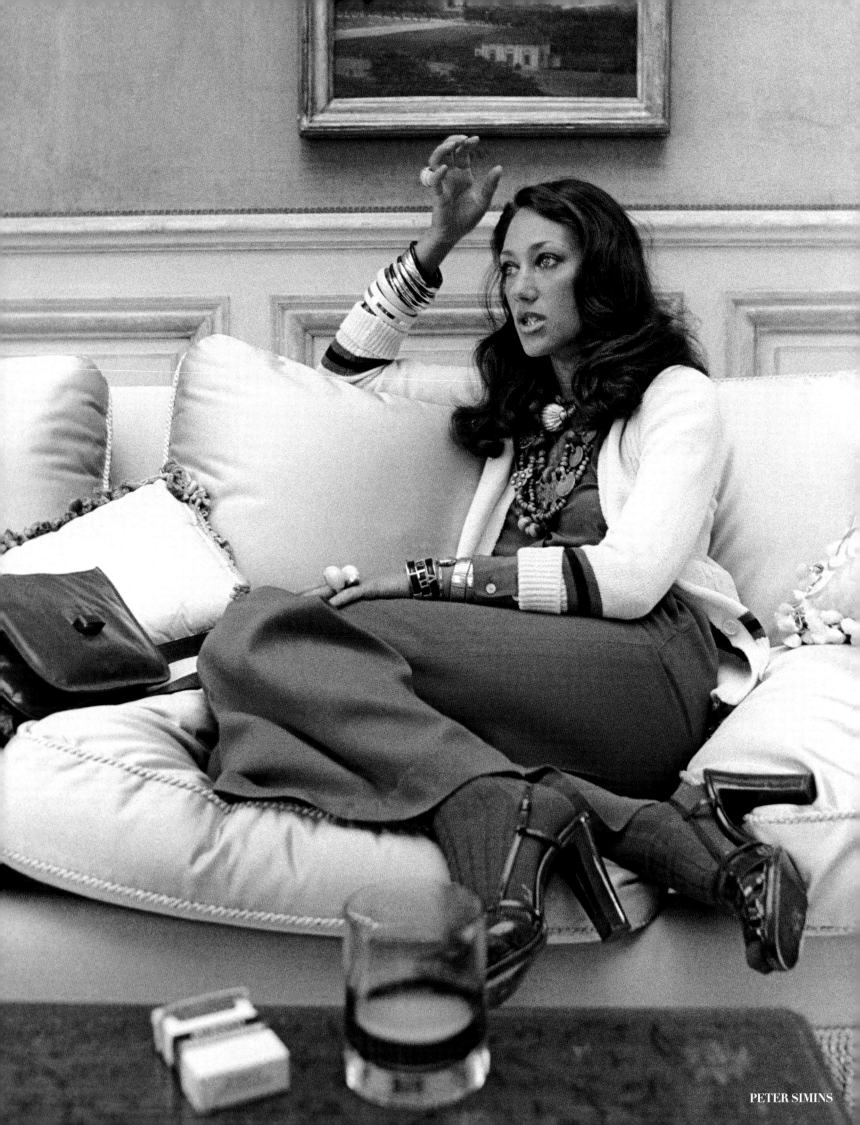

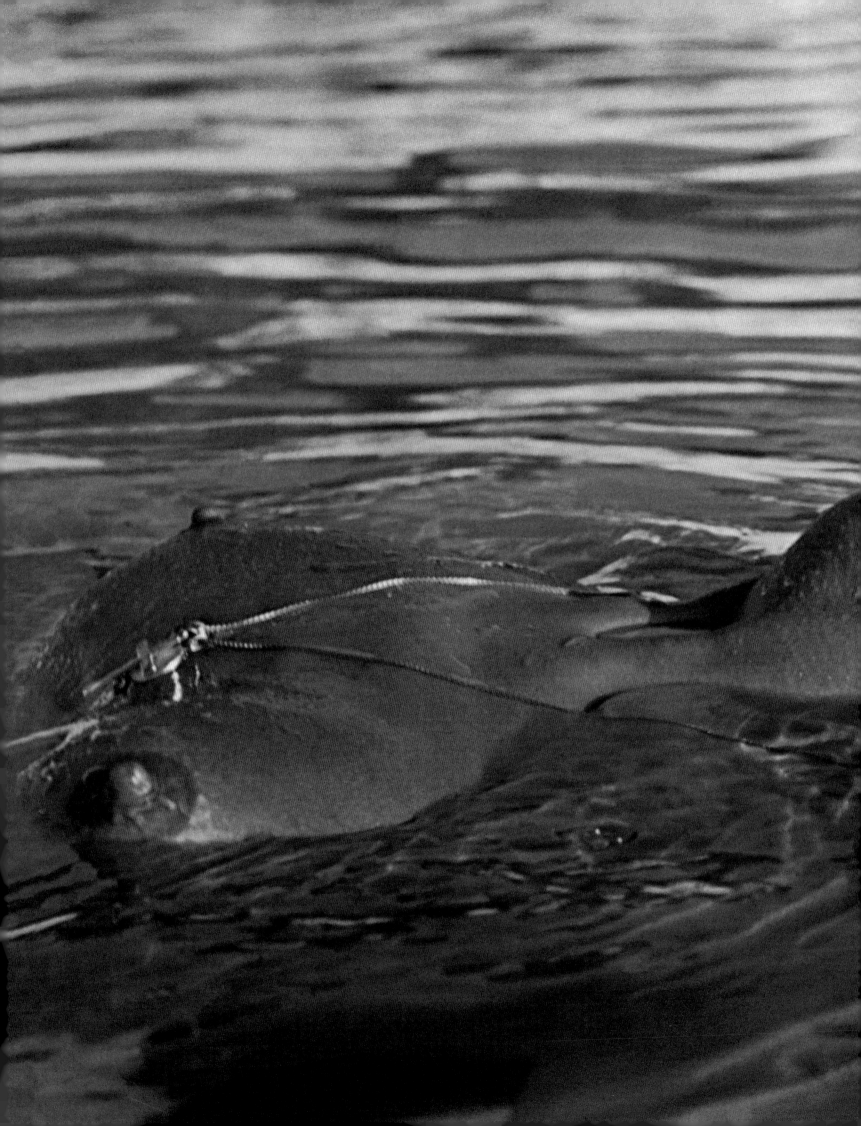

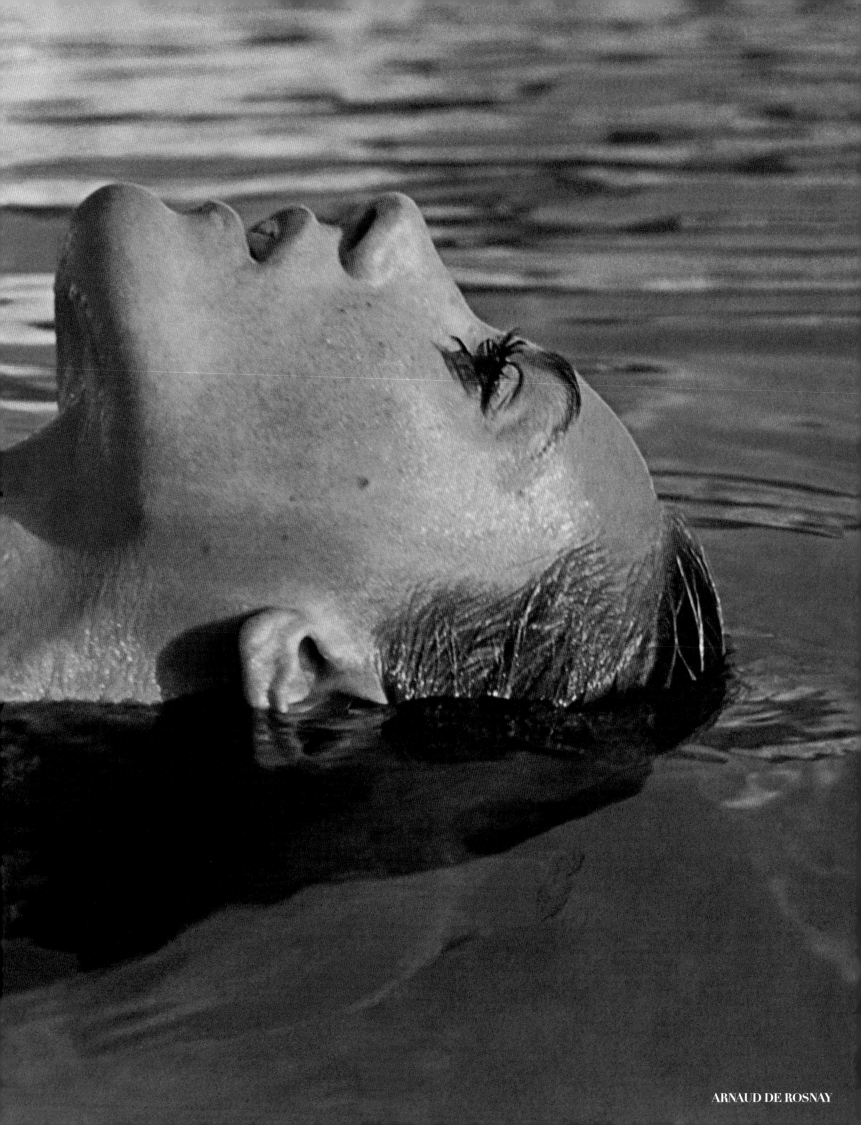

ARNAUD DE ROSNAY

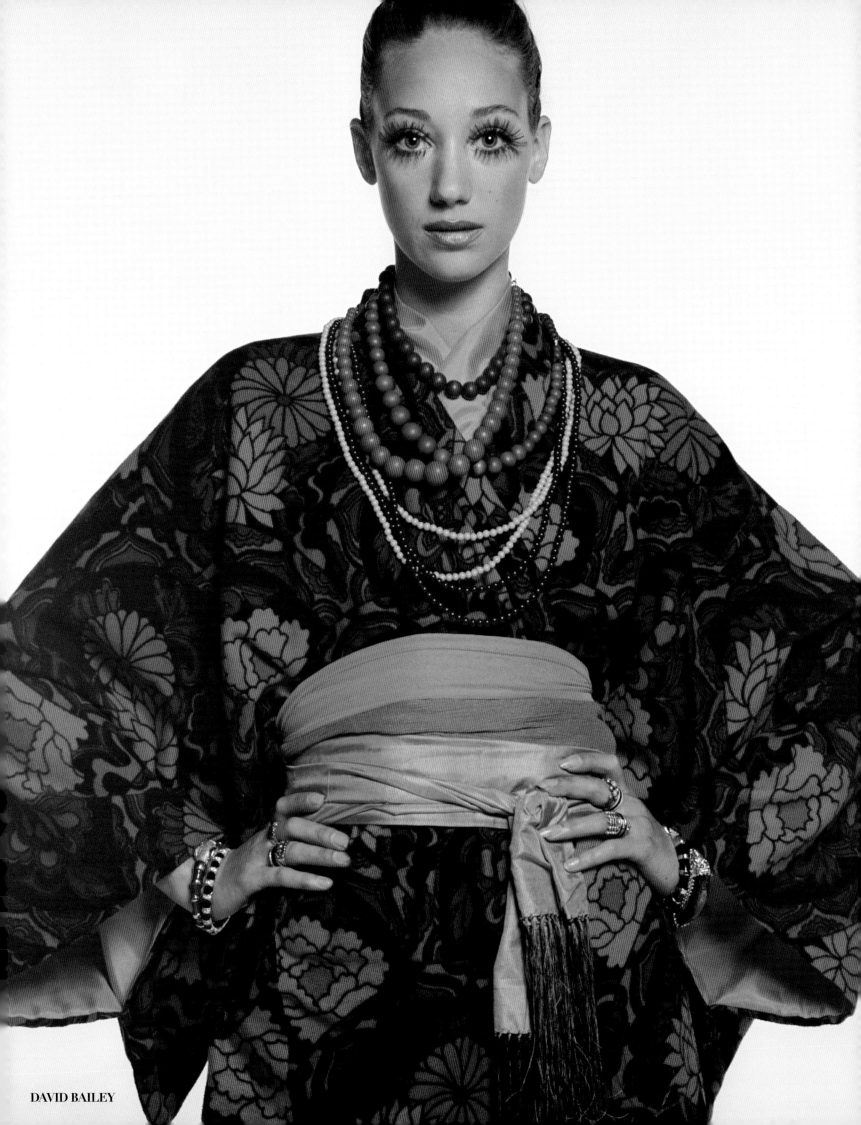

DAVID BAILEY

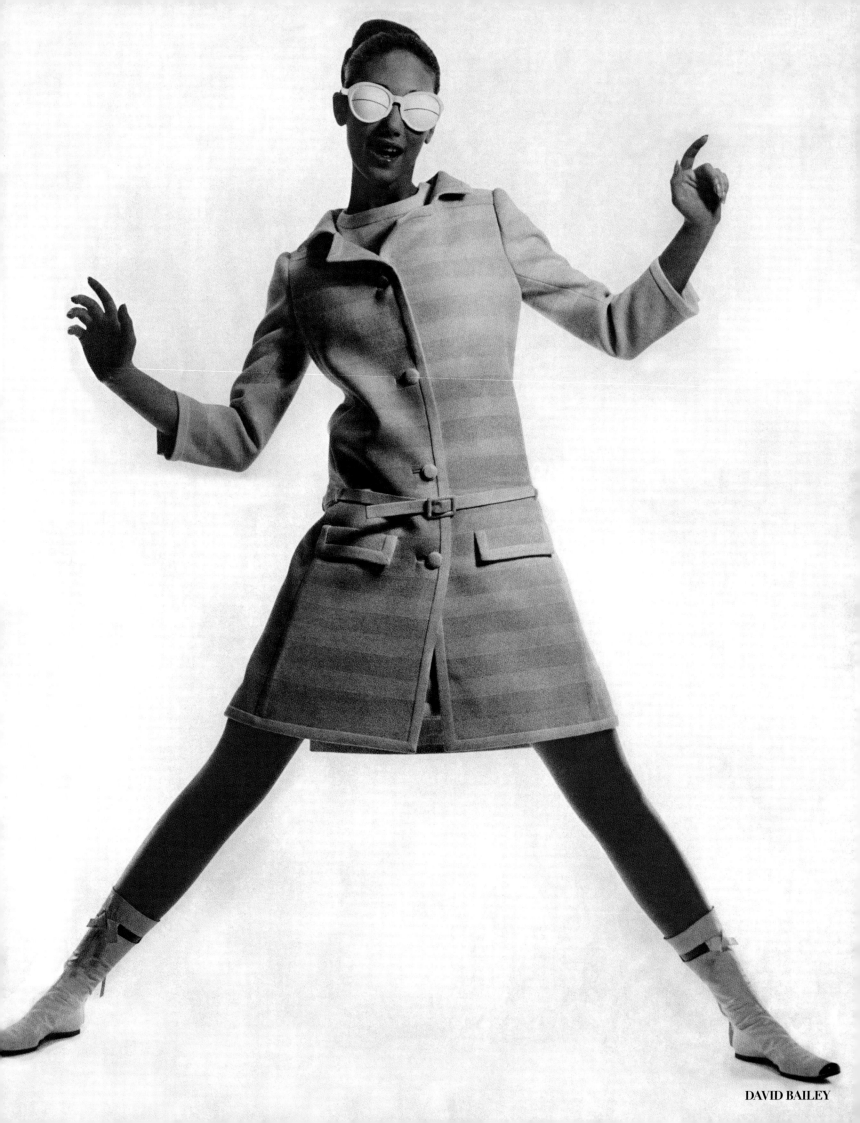

DAVID BAILEY

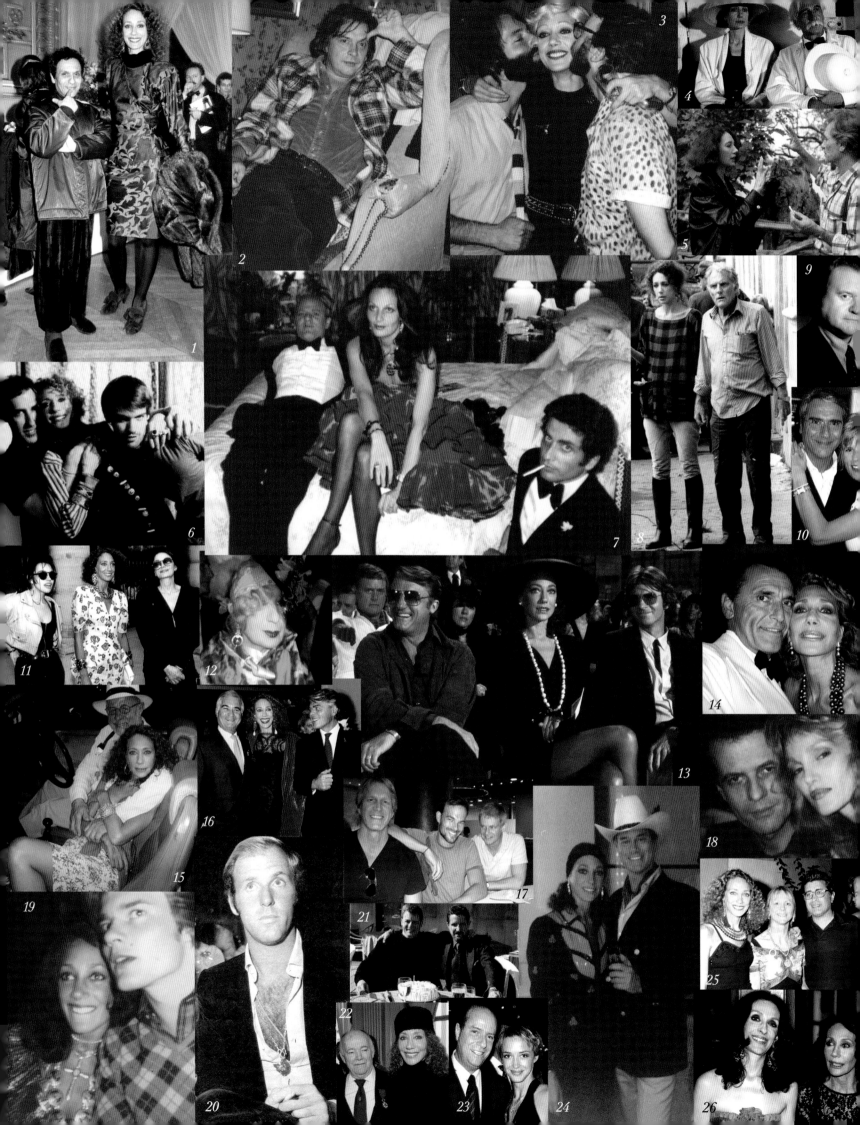

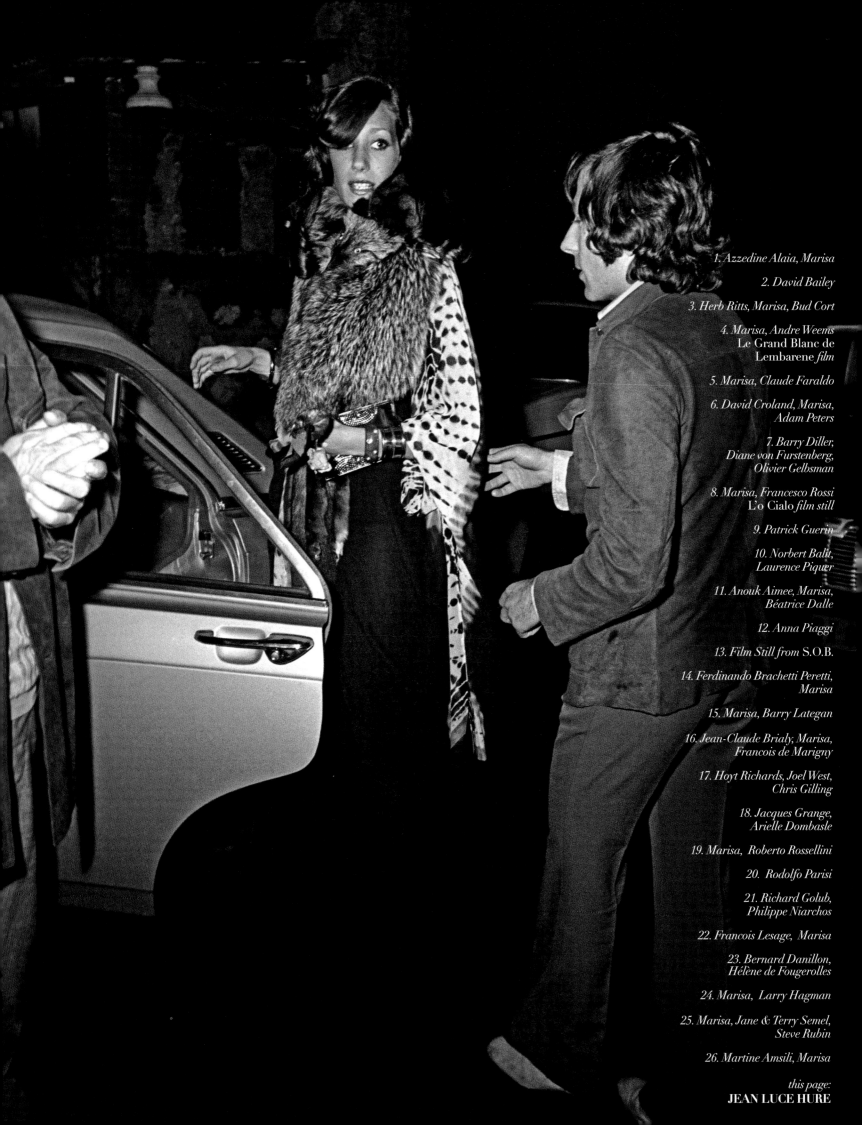

this page:
JEAN LUCE HURE

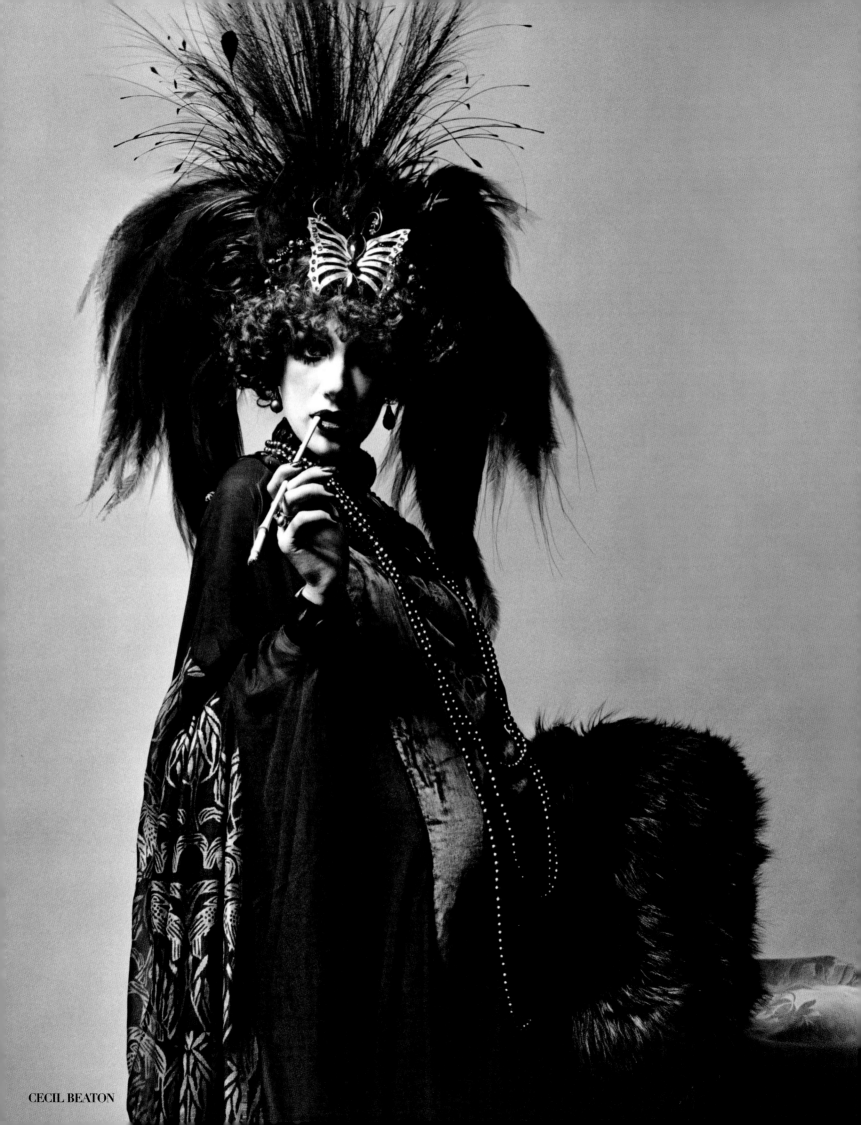

CECIL BEATON

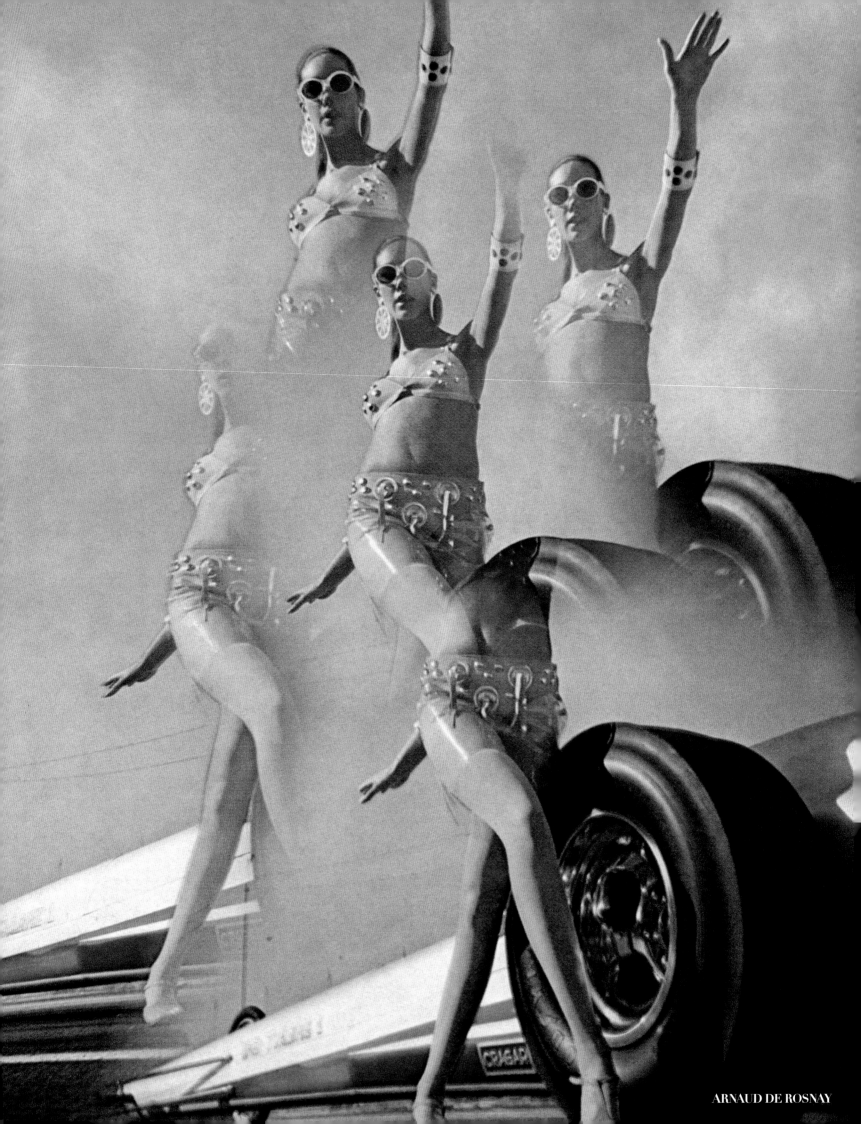

ARNAUD DE ROSNAY

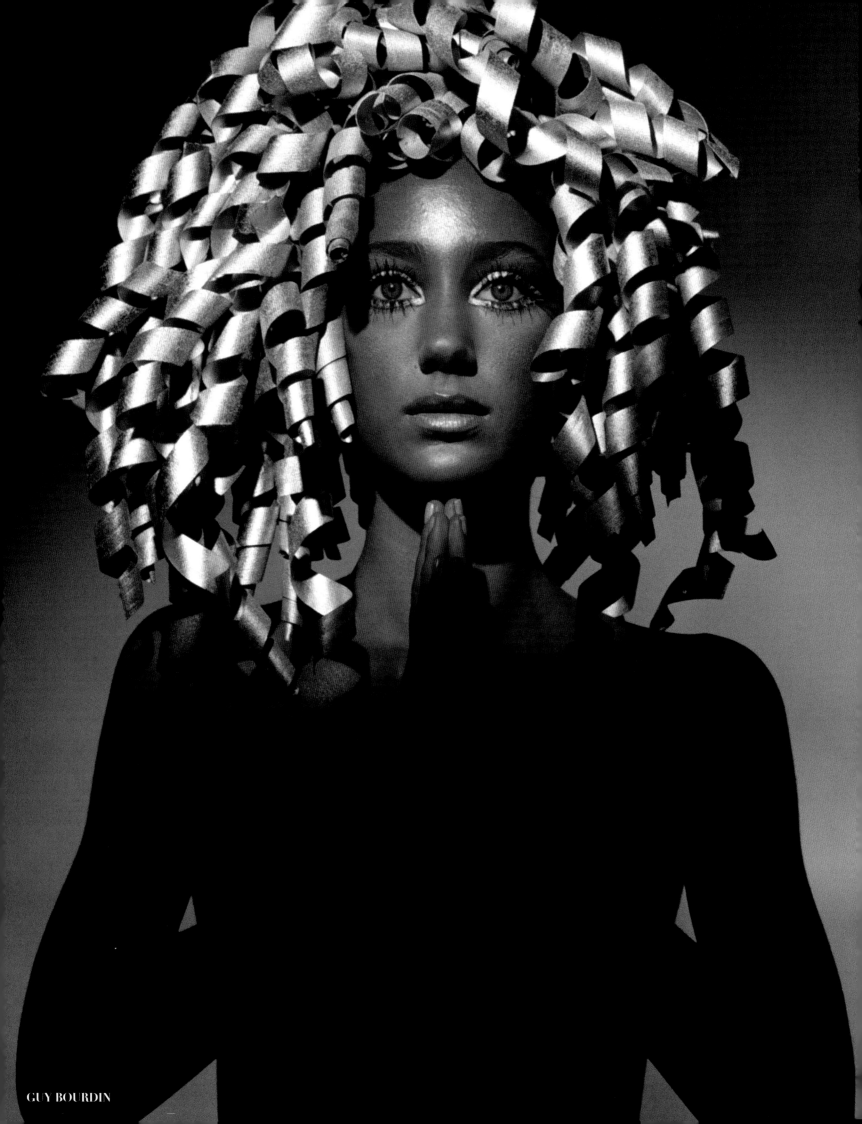

GUY BOURDIN

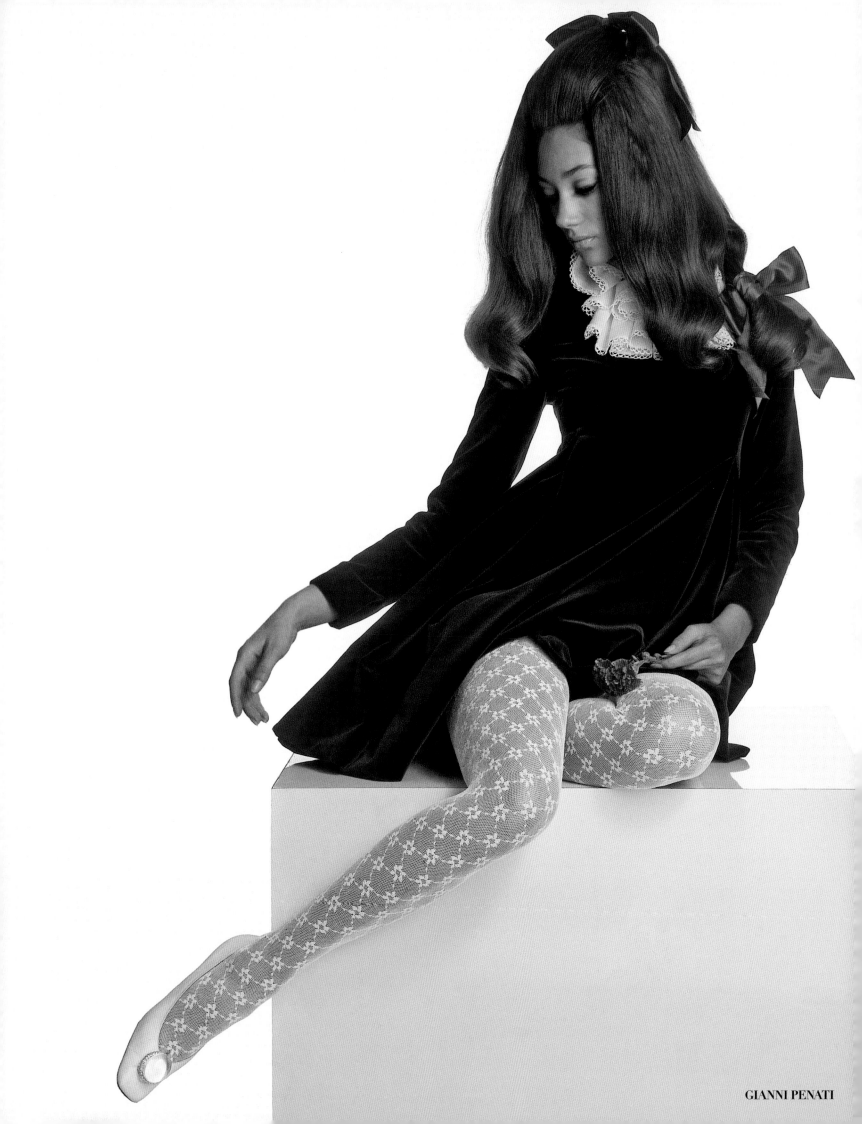

GIANNI PENATI

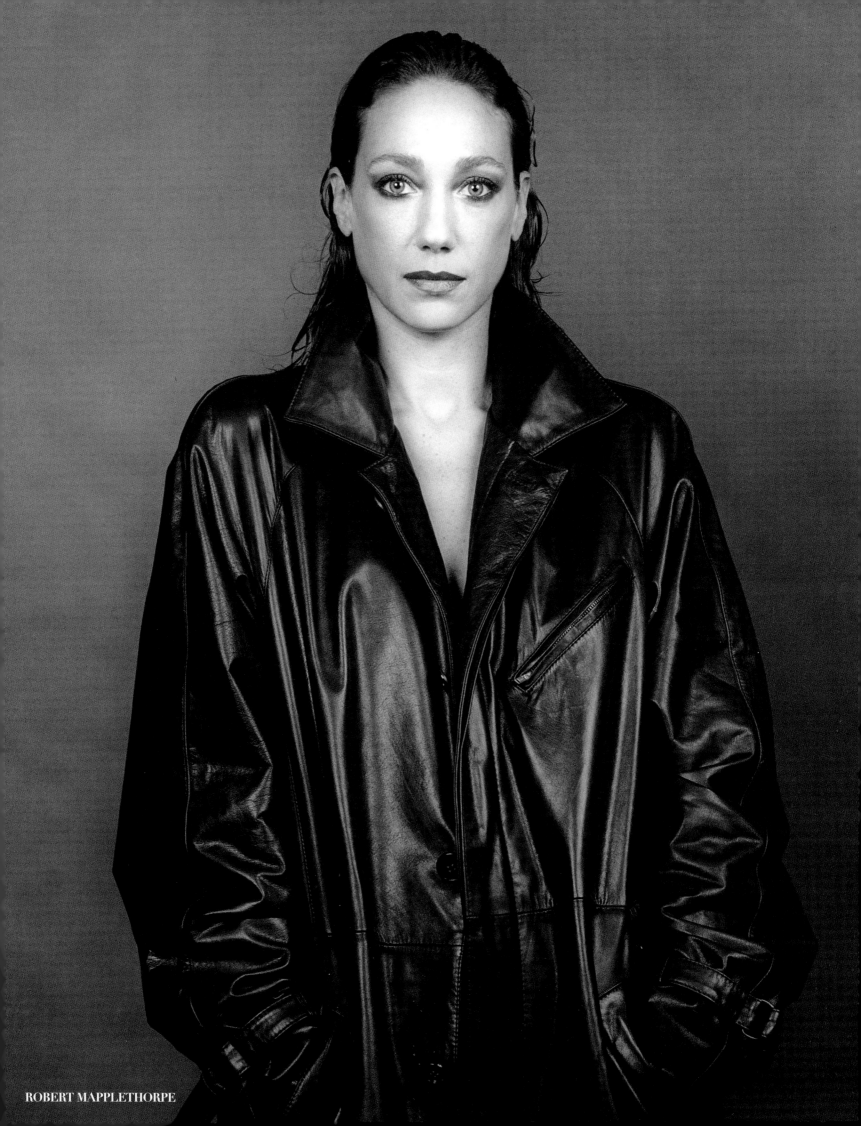

ROBERT MAPPLETHORPE

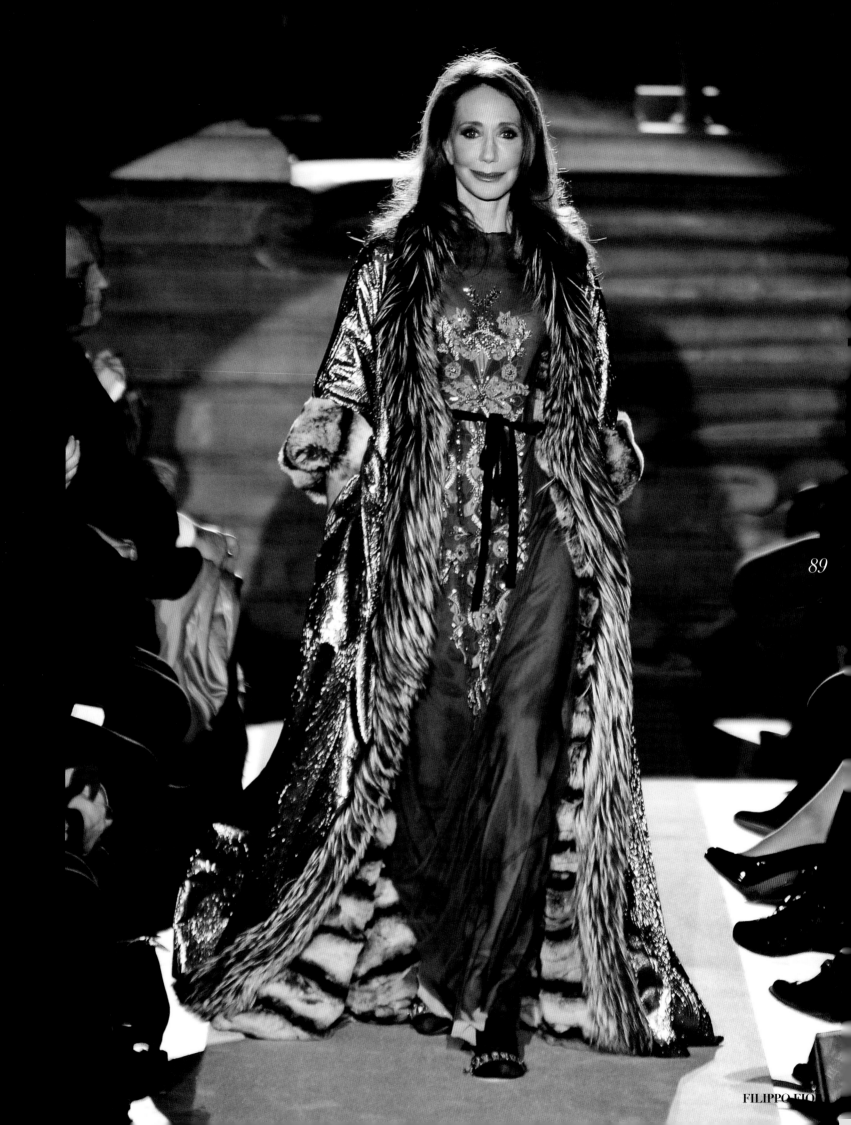

89

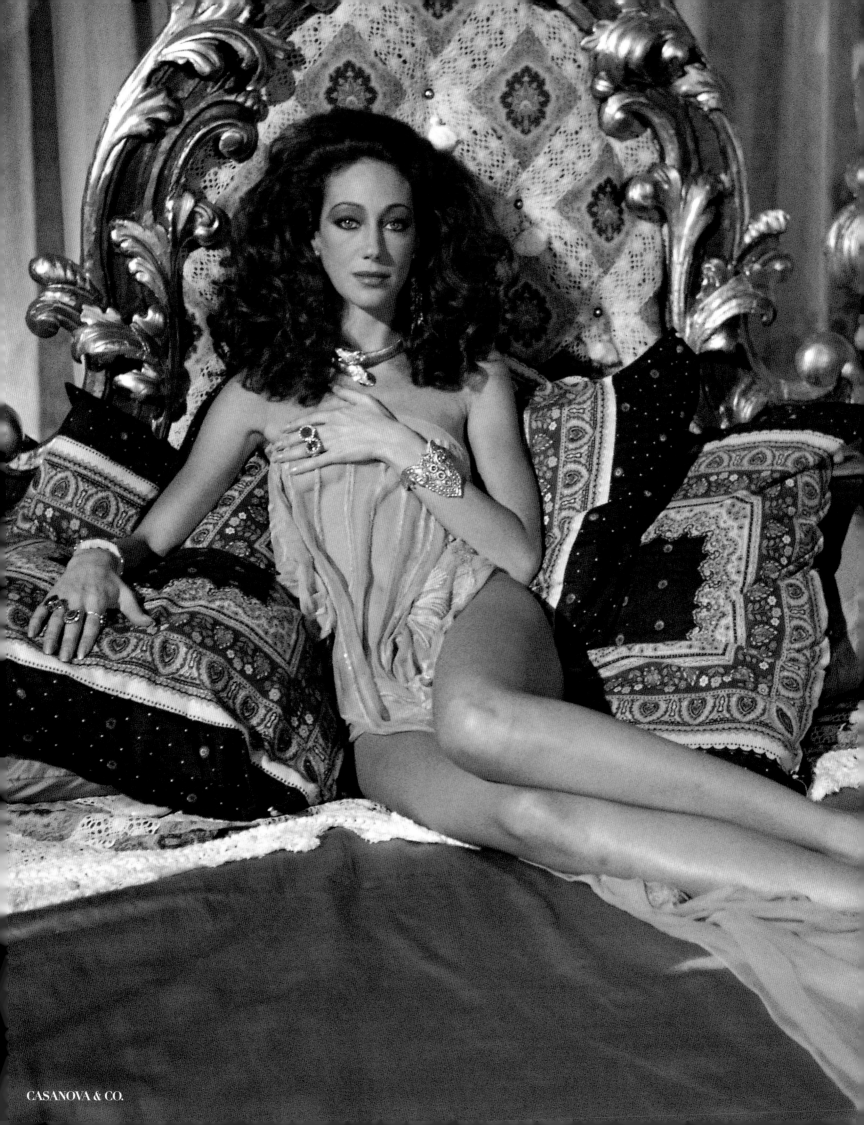

CASANOVA & CO.

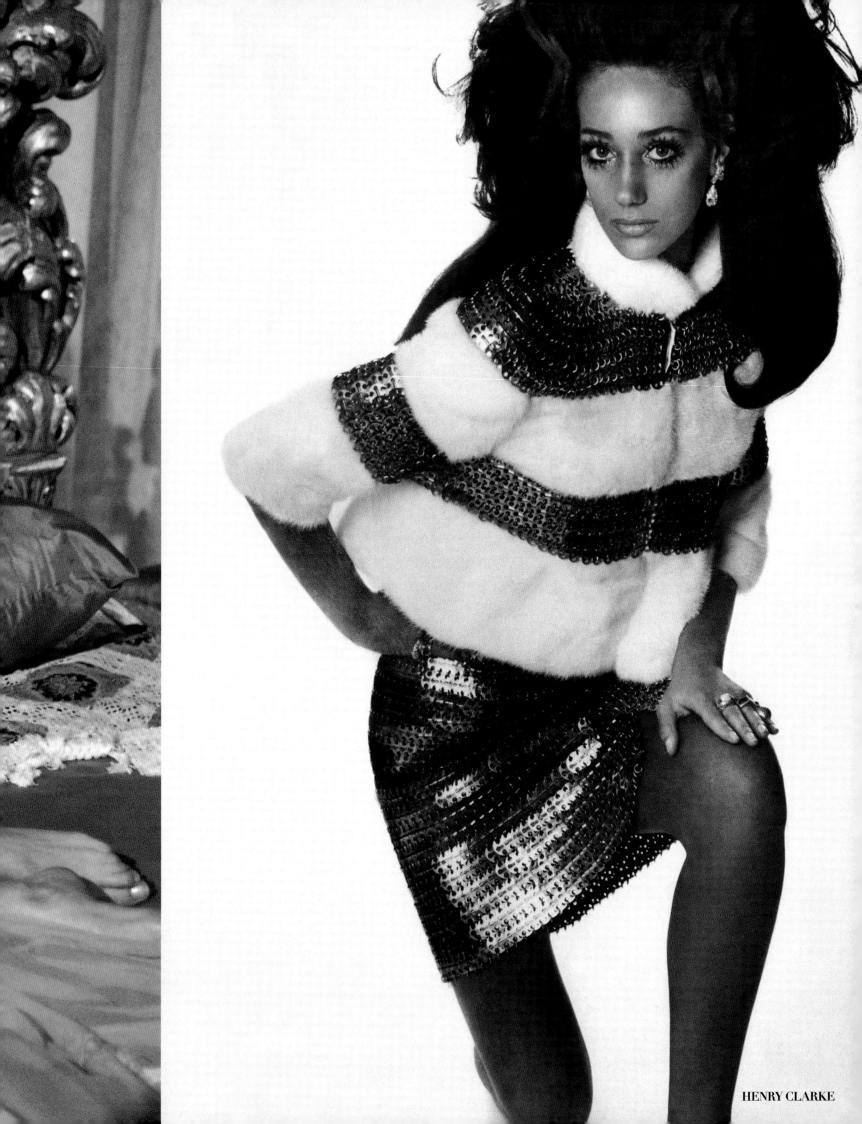

HENRY CLARKE

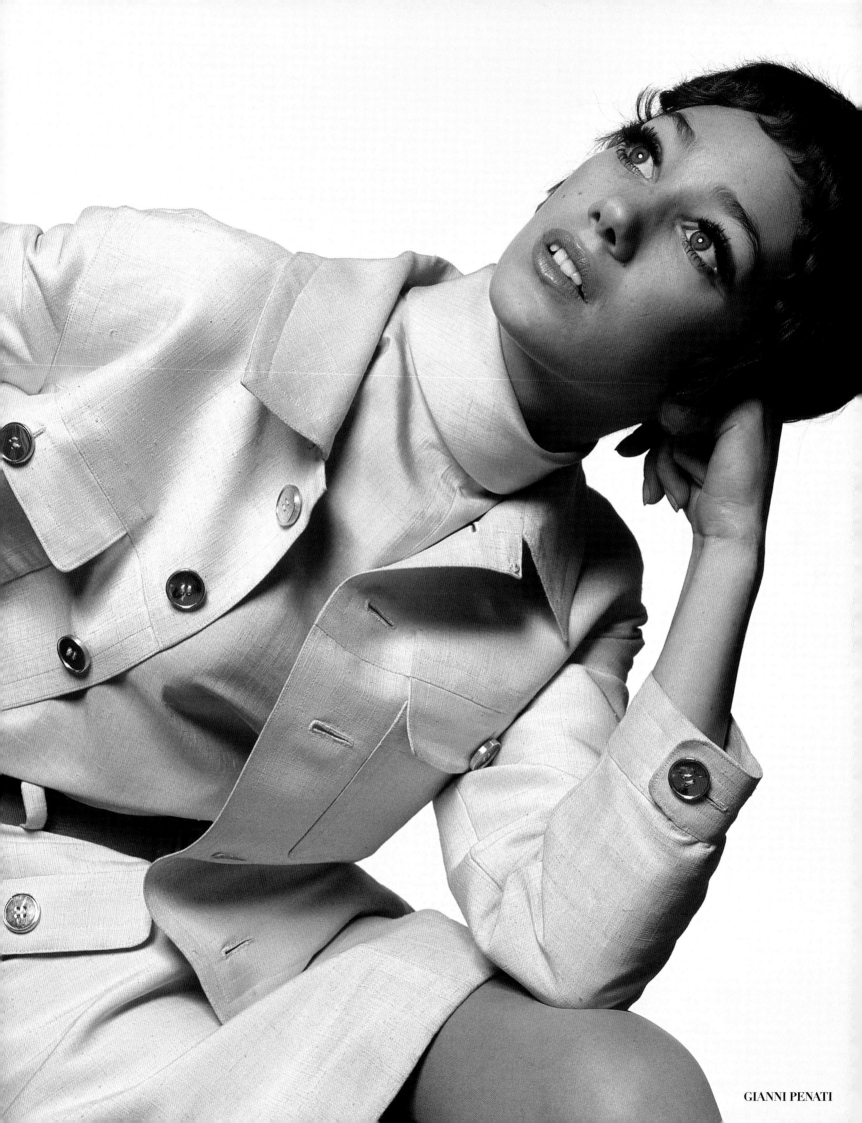

GIANNI PENATI

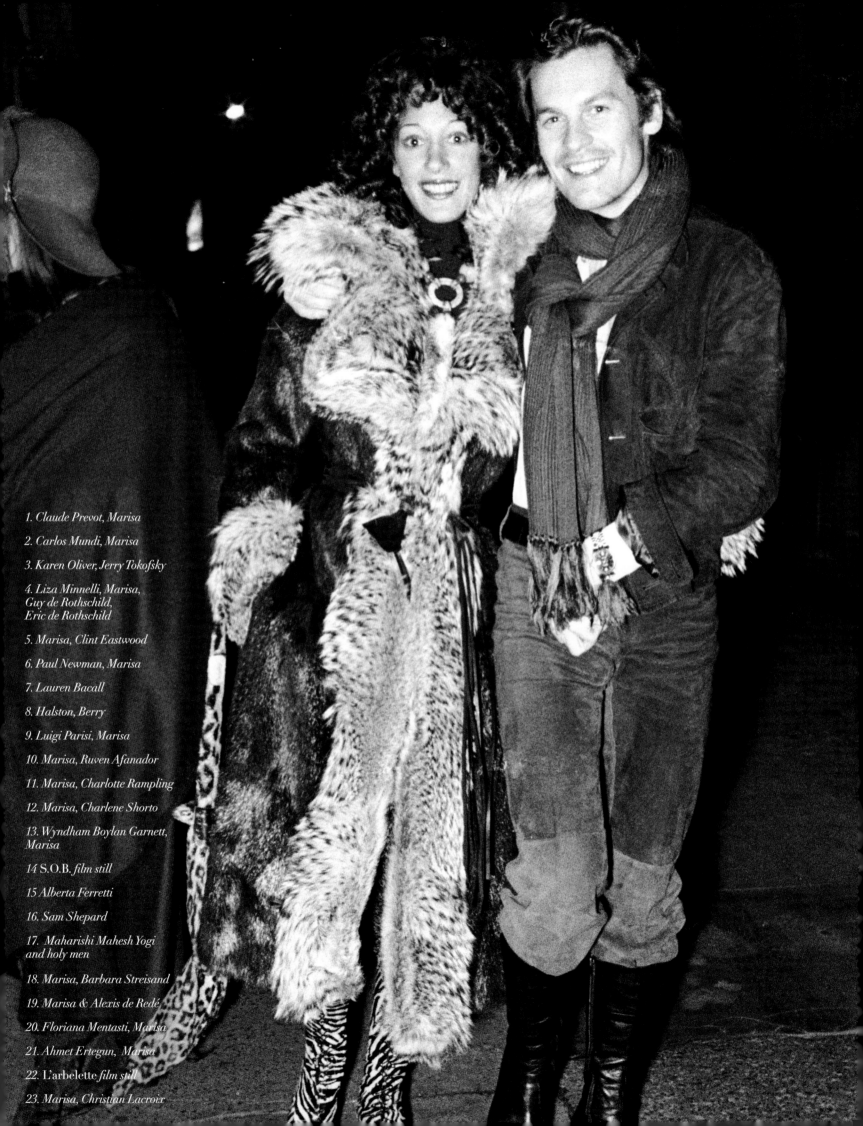

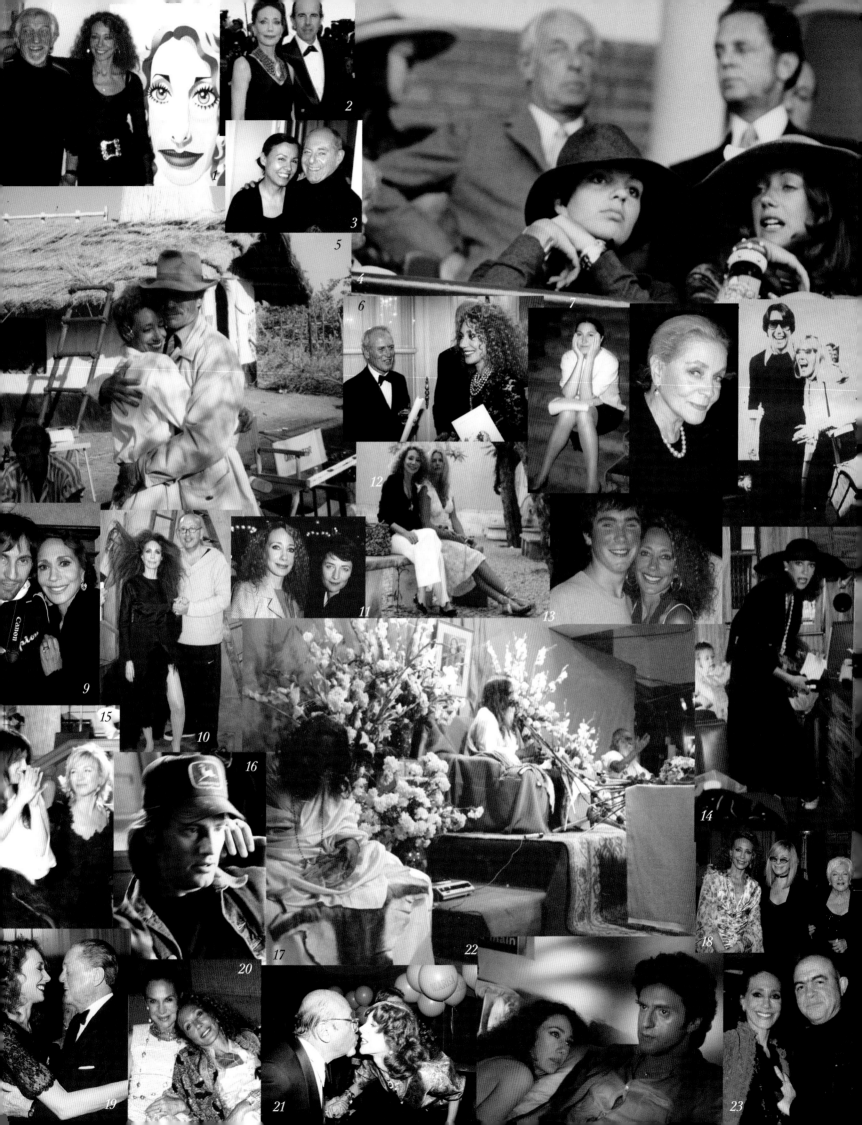

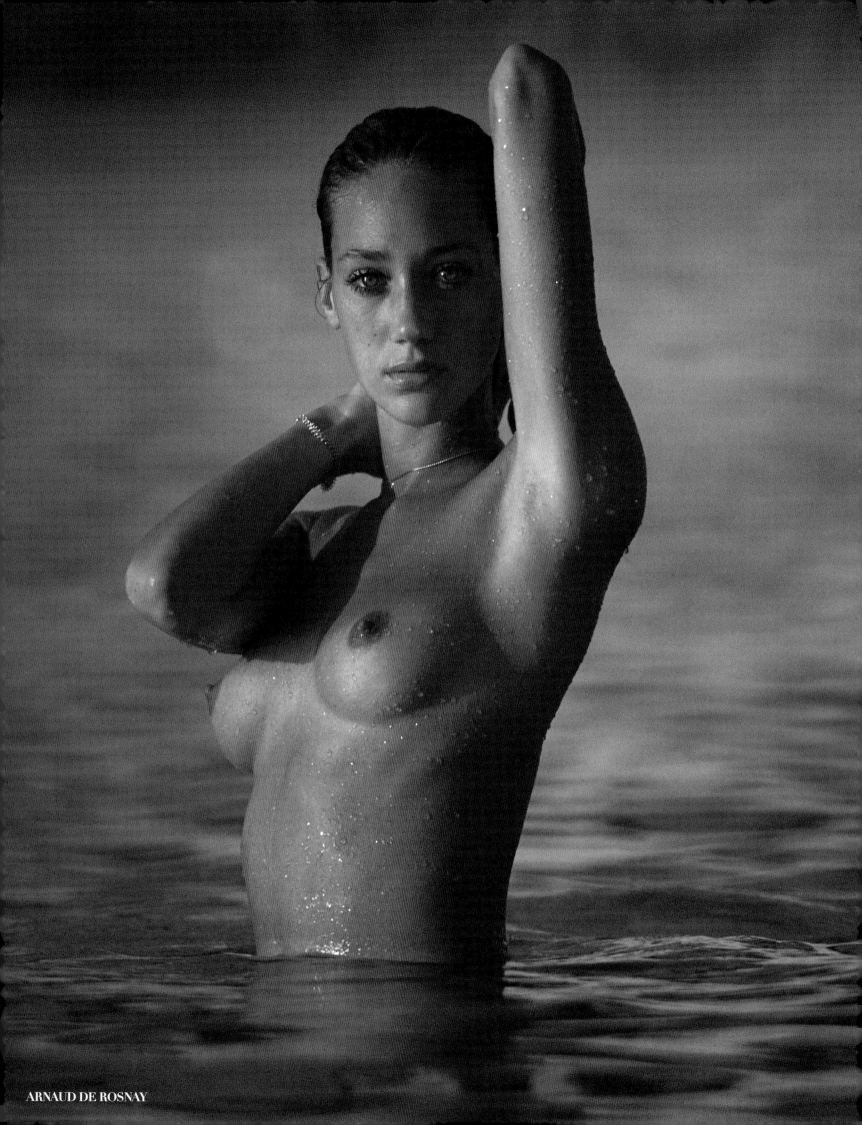

ARNAUD DE ROSNAY

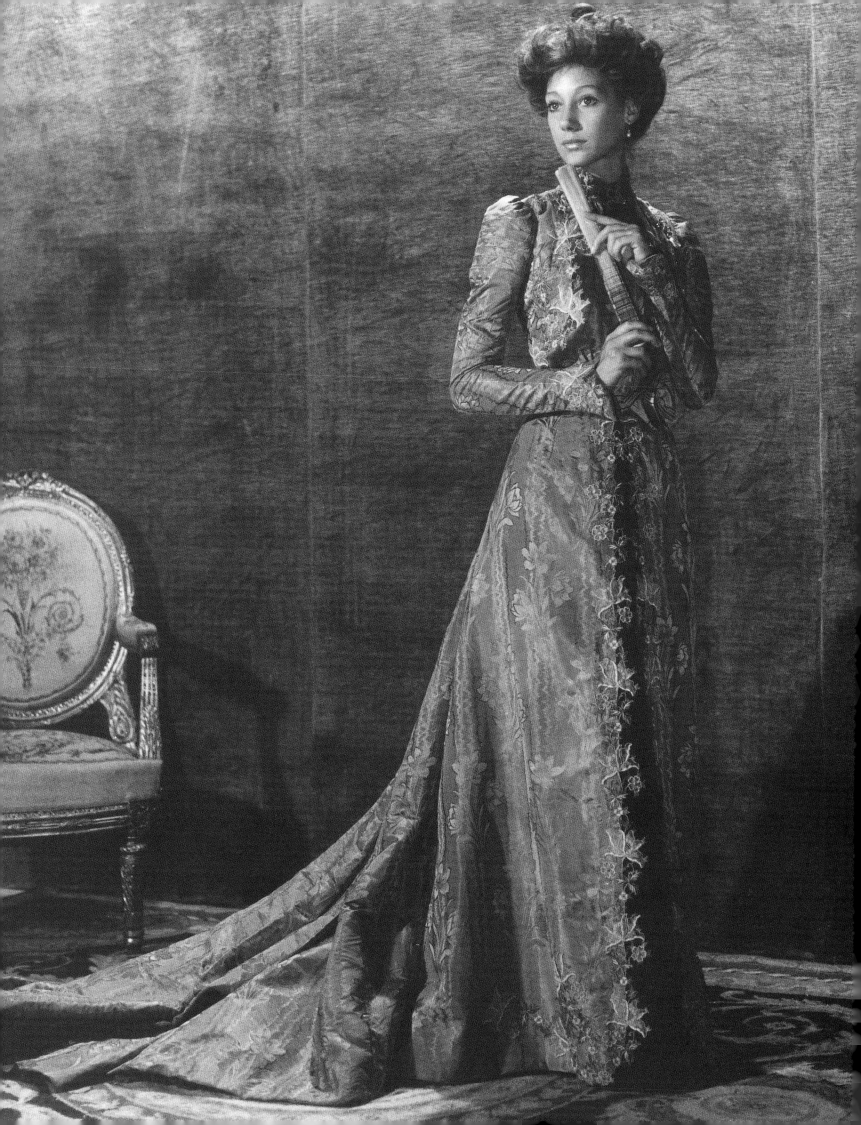

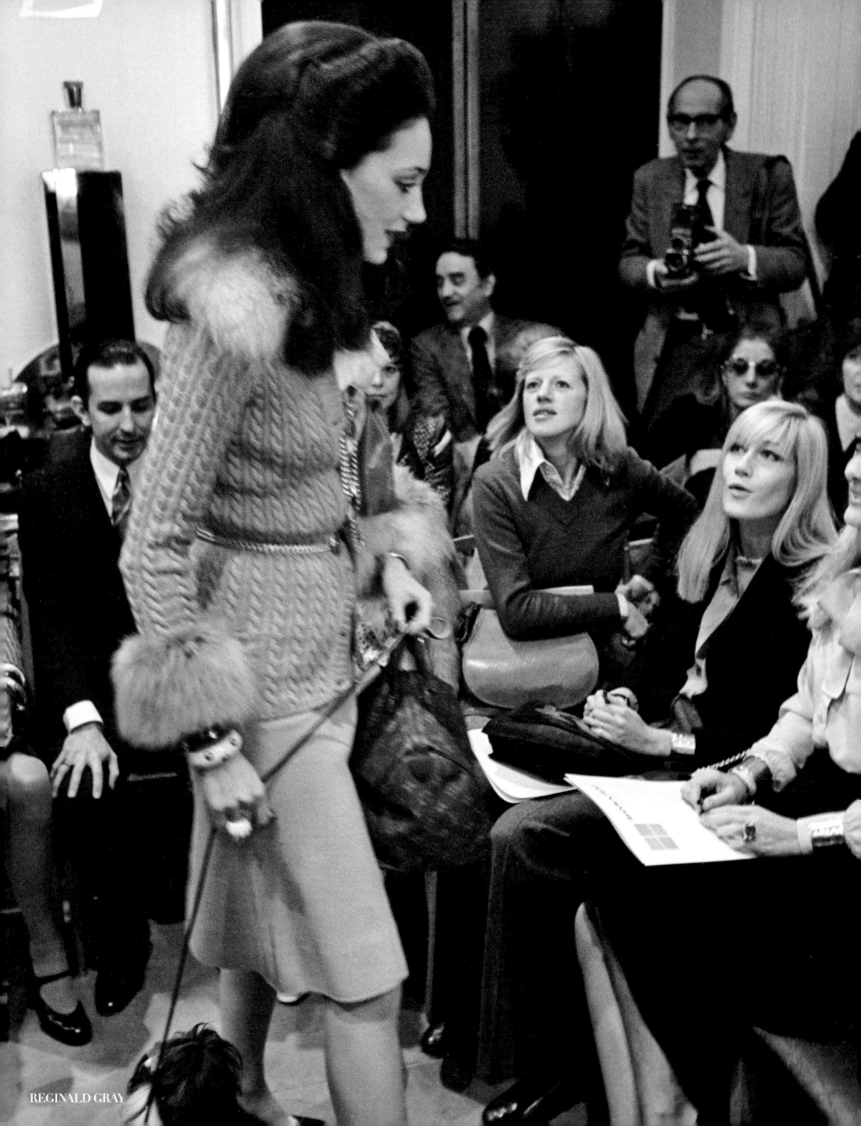

REGINALD GRAY

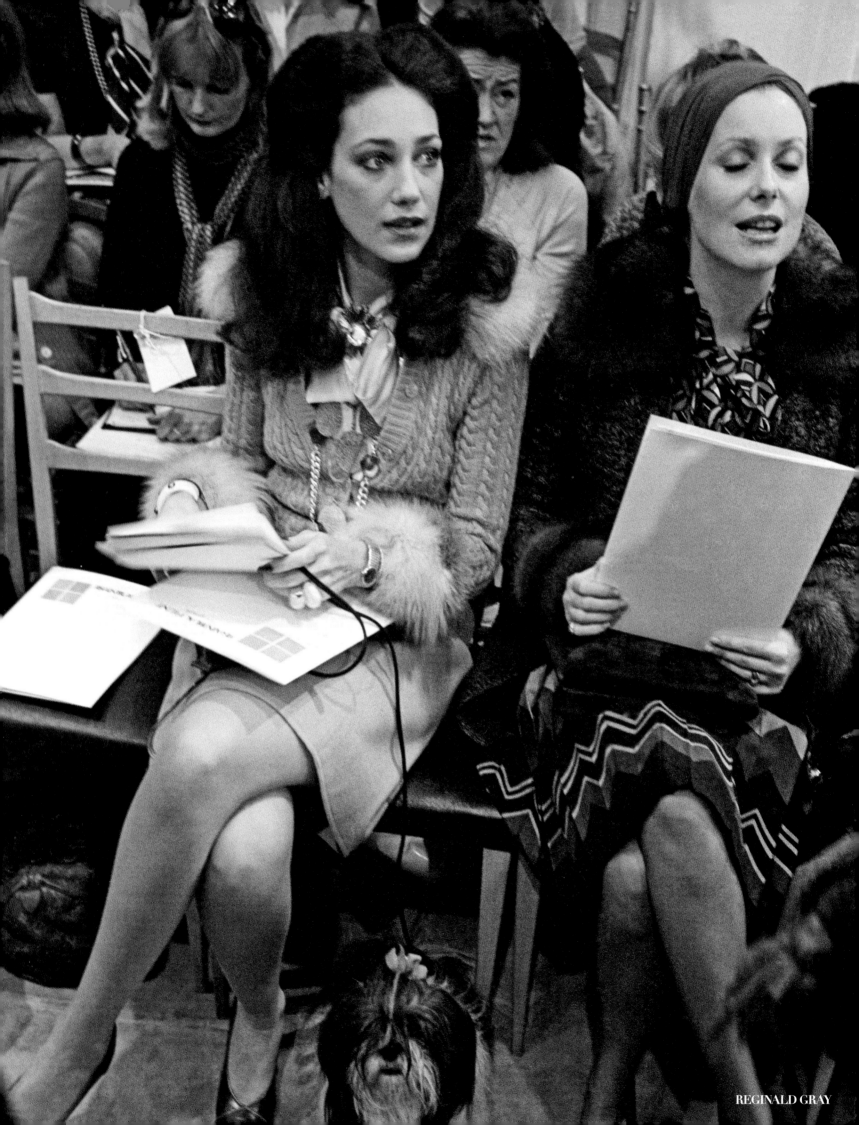

REGINALD GRAY

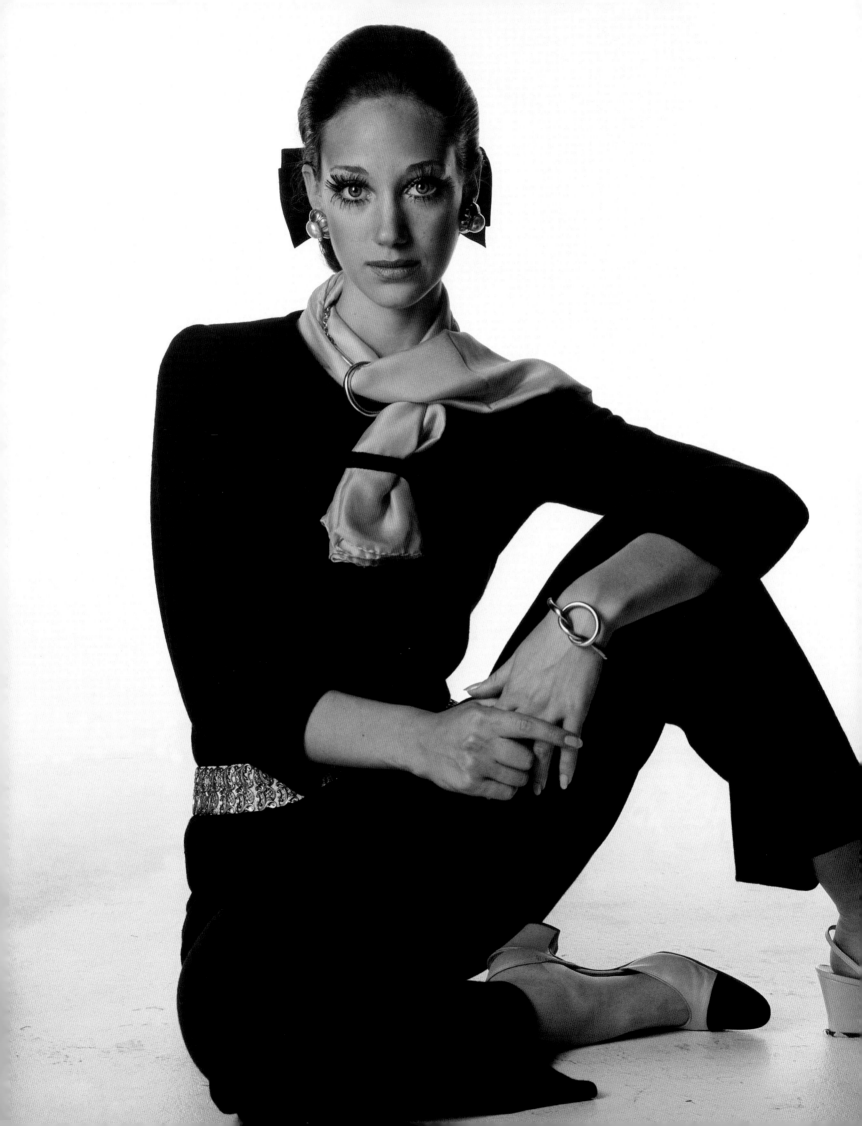

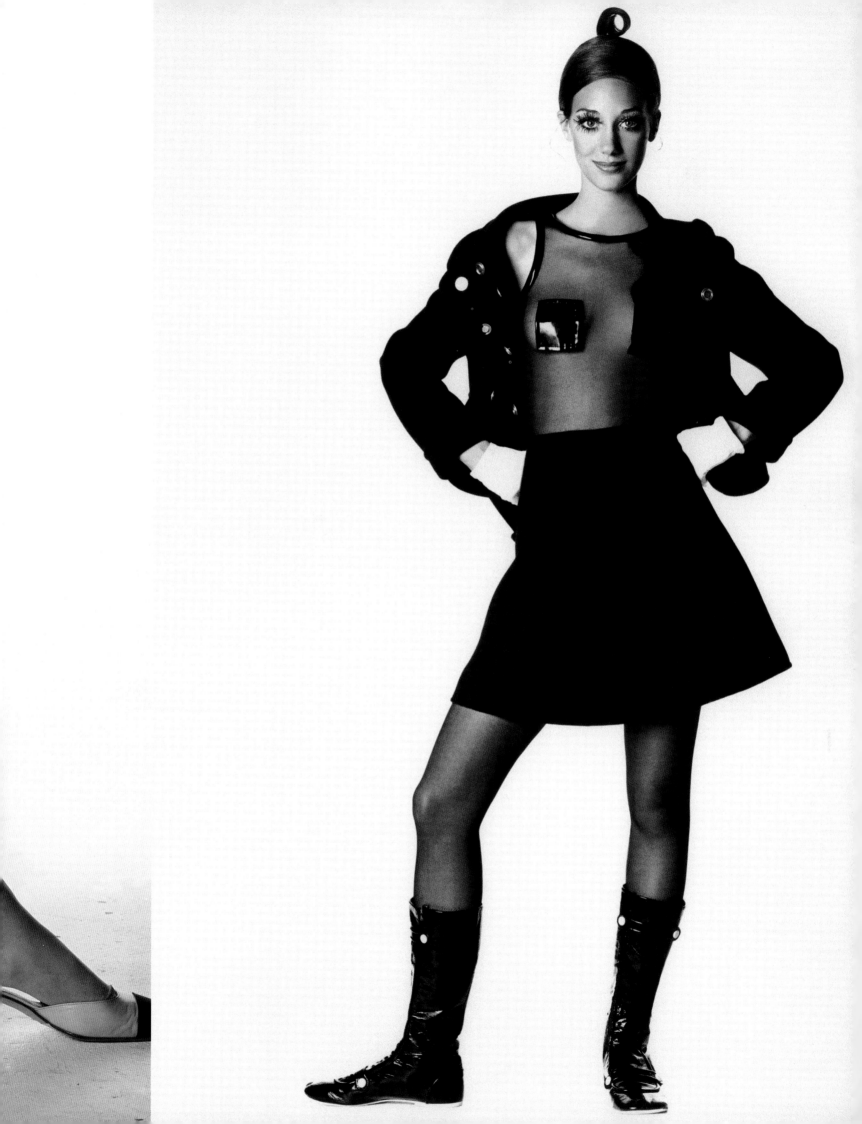

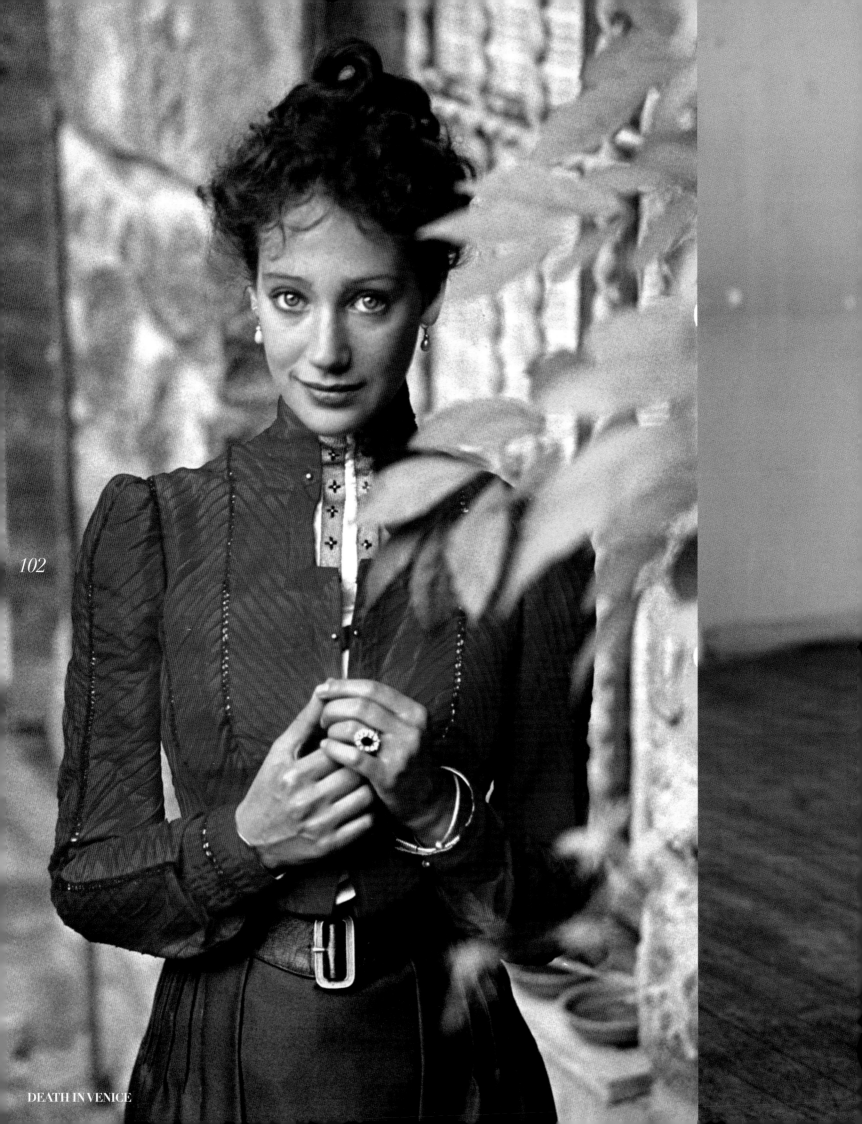

102

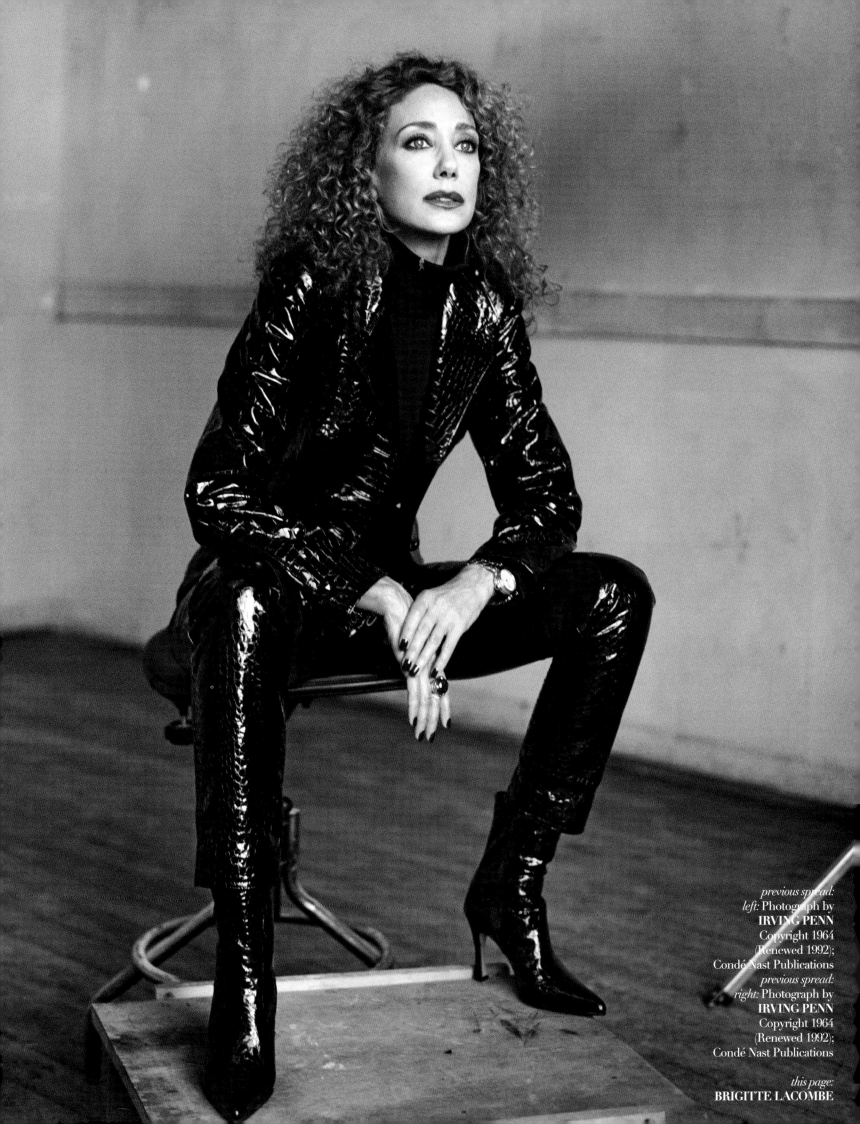

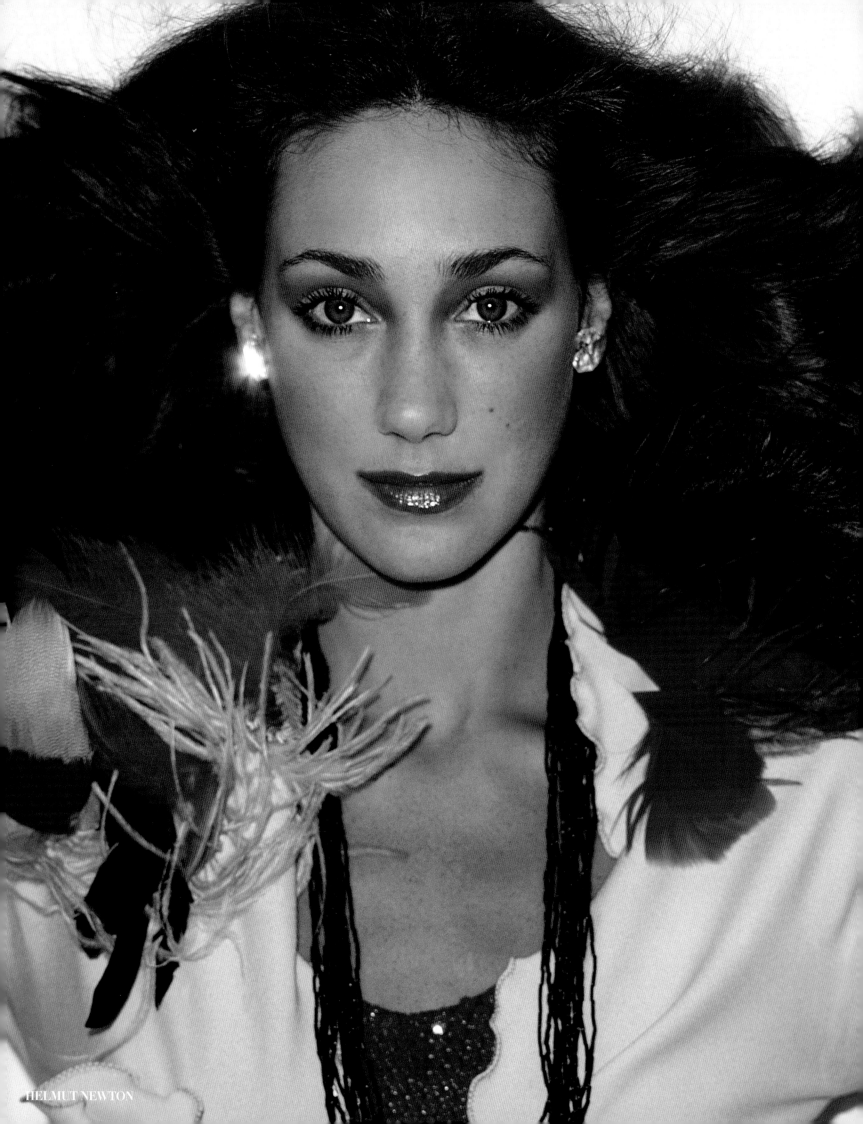

HELMUT NEWTON

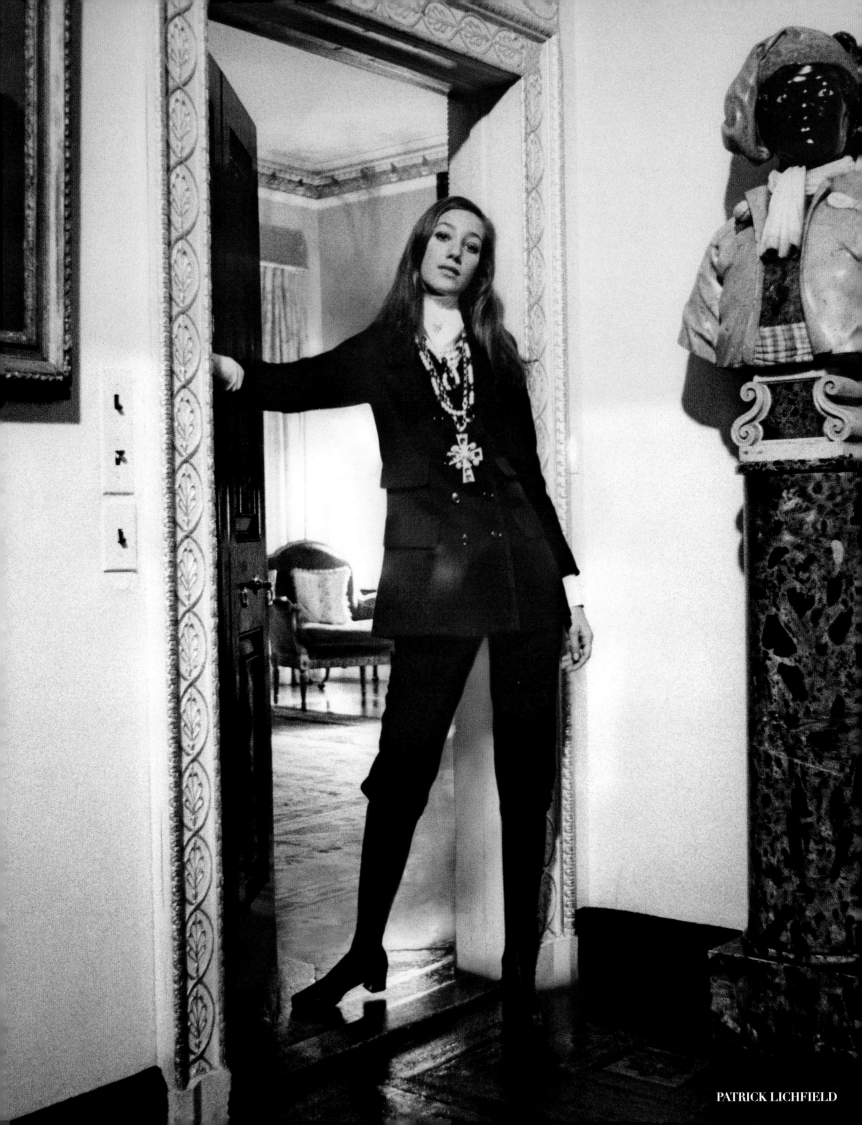

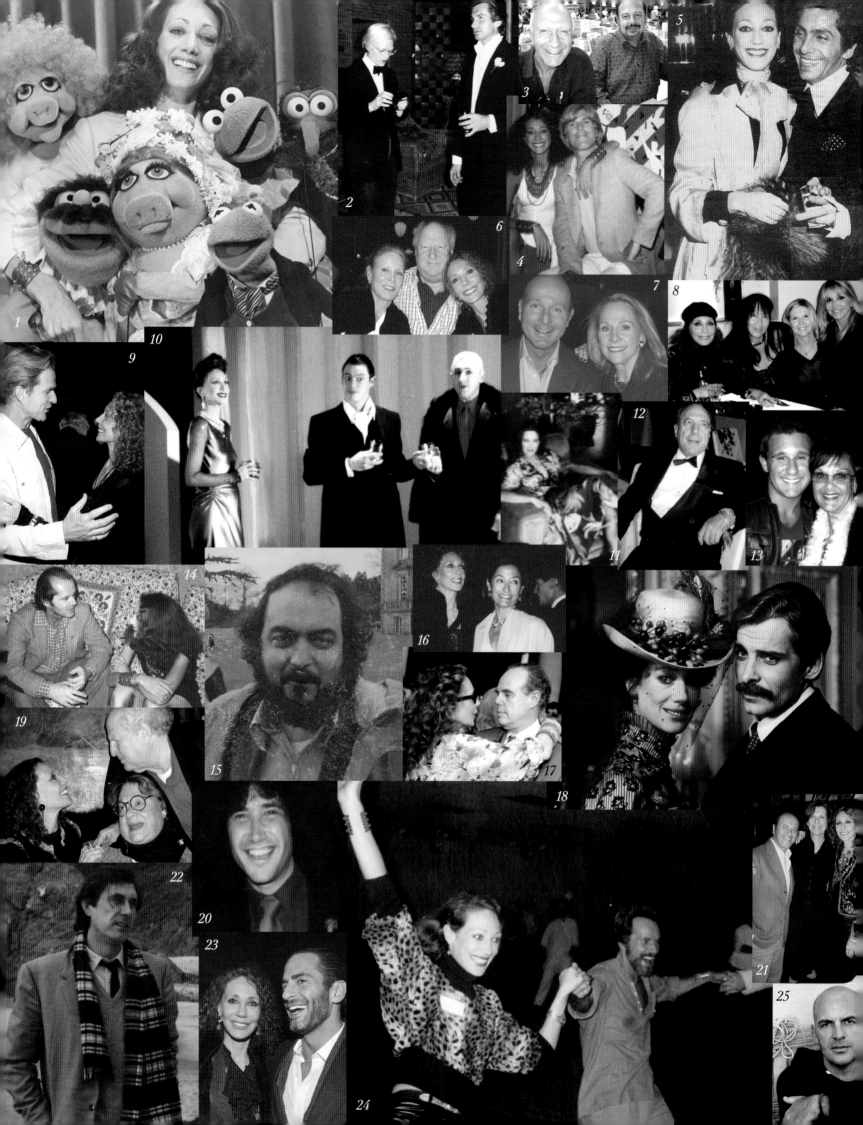

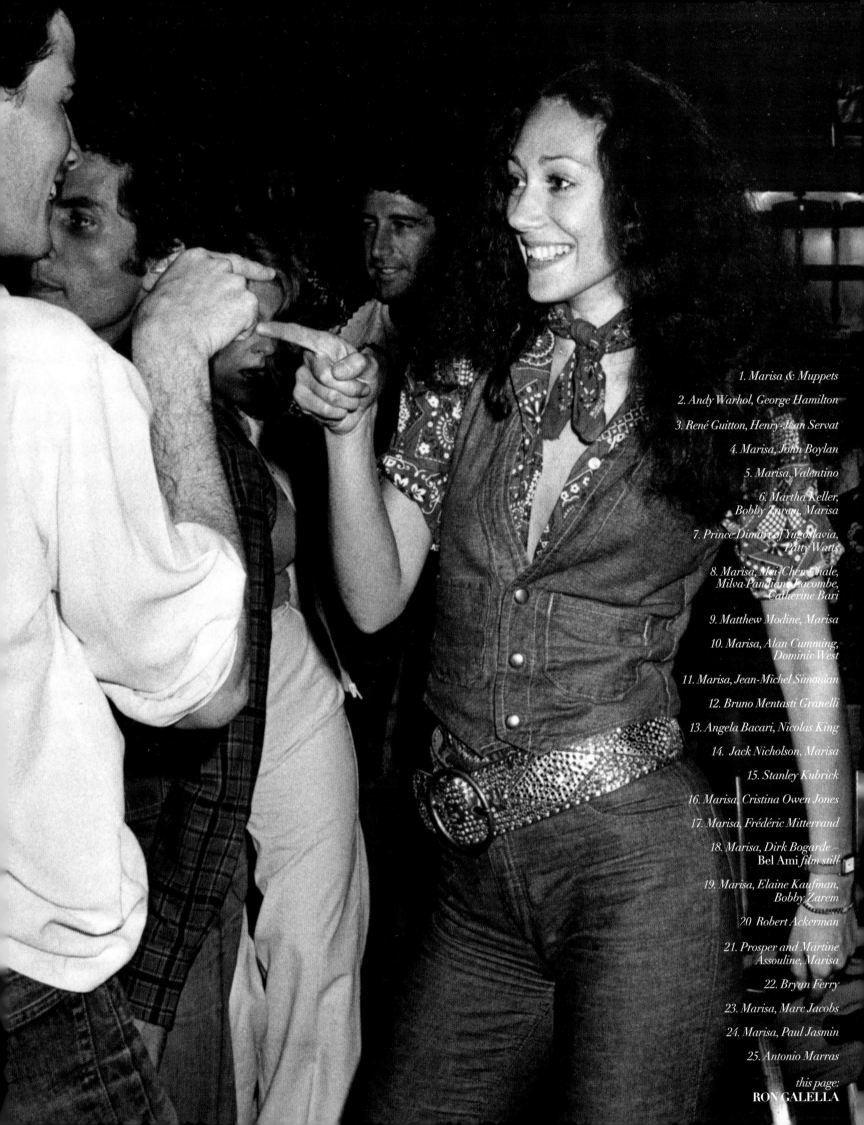

1. Marisa & Muppets

2. Andy Warhol, George Hamilton

3. René Guitton, Henry-Jean Servat

4. Marisa, John Boylan

5. Marisa, Valentino

6. Martha Keller,
Bobby Zarem, Marisa

7. Prince Dimitri of Yugoslavia,
Patty Watts

8. Marisa, Mei-Chen Chale,
Milva Pandiani Lacombe,
Catherine Bari

9. Matthew Modine, Marisa

10. Marisa, Alan Cumming,
Dominic West

11. Marisa, Jean-Michel Simonian

12. Bruno Mentasti Granelli

13. Angela Bacari, Nicolas King

14. Jack Nicholson, Marisa

15. Stanley Kubrick

16. Marisa, Cristina Owen Jones

17. Marisa, Frédéric Mitterrand

18. Marisa, Dirk Bogarde –
Bel Ami *film still*

19. Marisa, Elaine Kaufman,
Bobby Zarem

20 Robert Ackerman

21. Prosper and Martine
Assouline, Marisa

22. Bryan Ferry

23. Marisa, Marc Jacobs

24. Marisa, Paul Jasmin

25. Antonio Marras

this page:
RON GALELLA

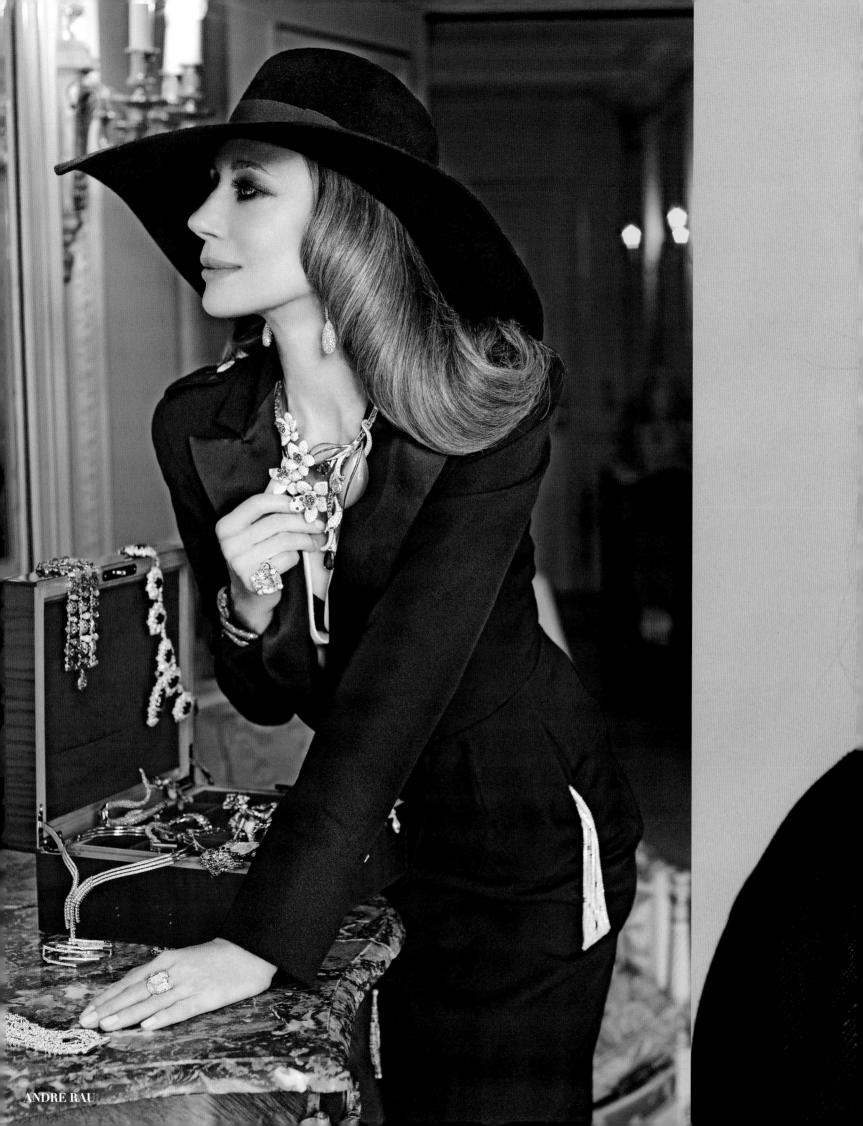

ANDRE RAU

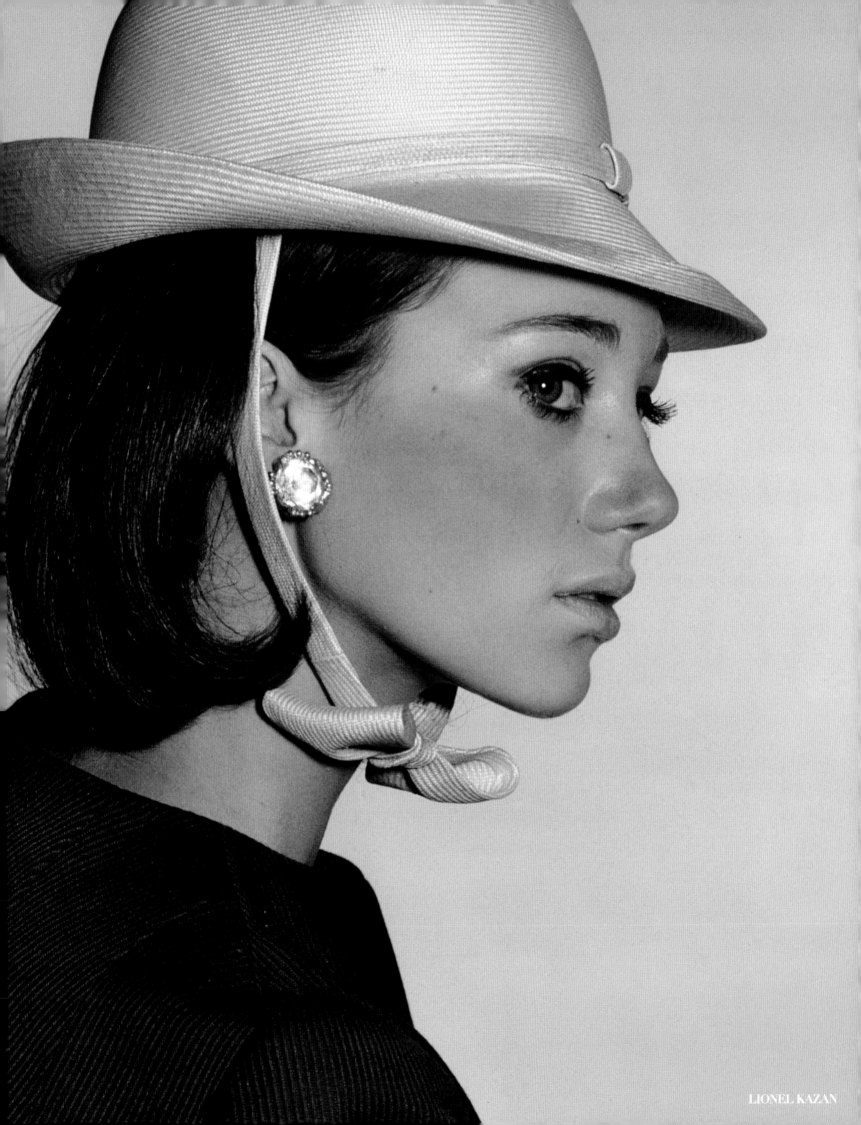

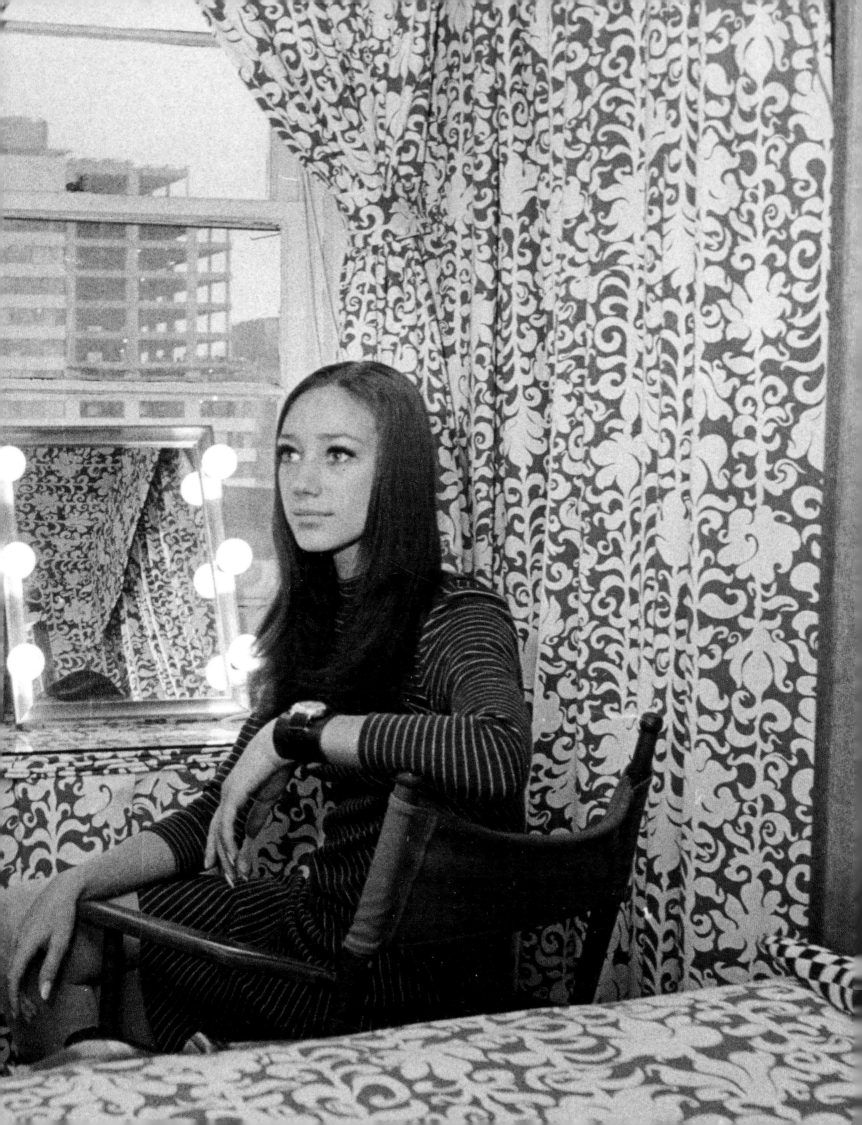

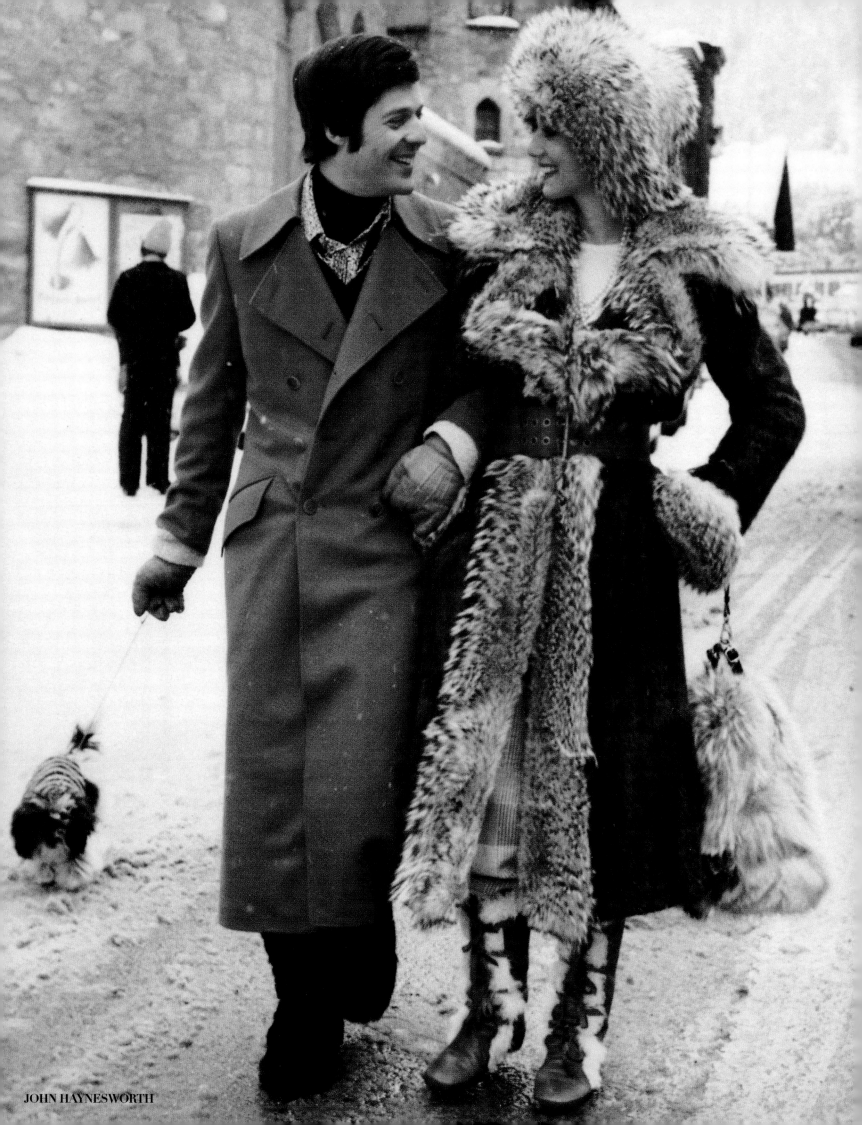

JOHN HAYNESWORTH

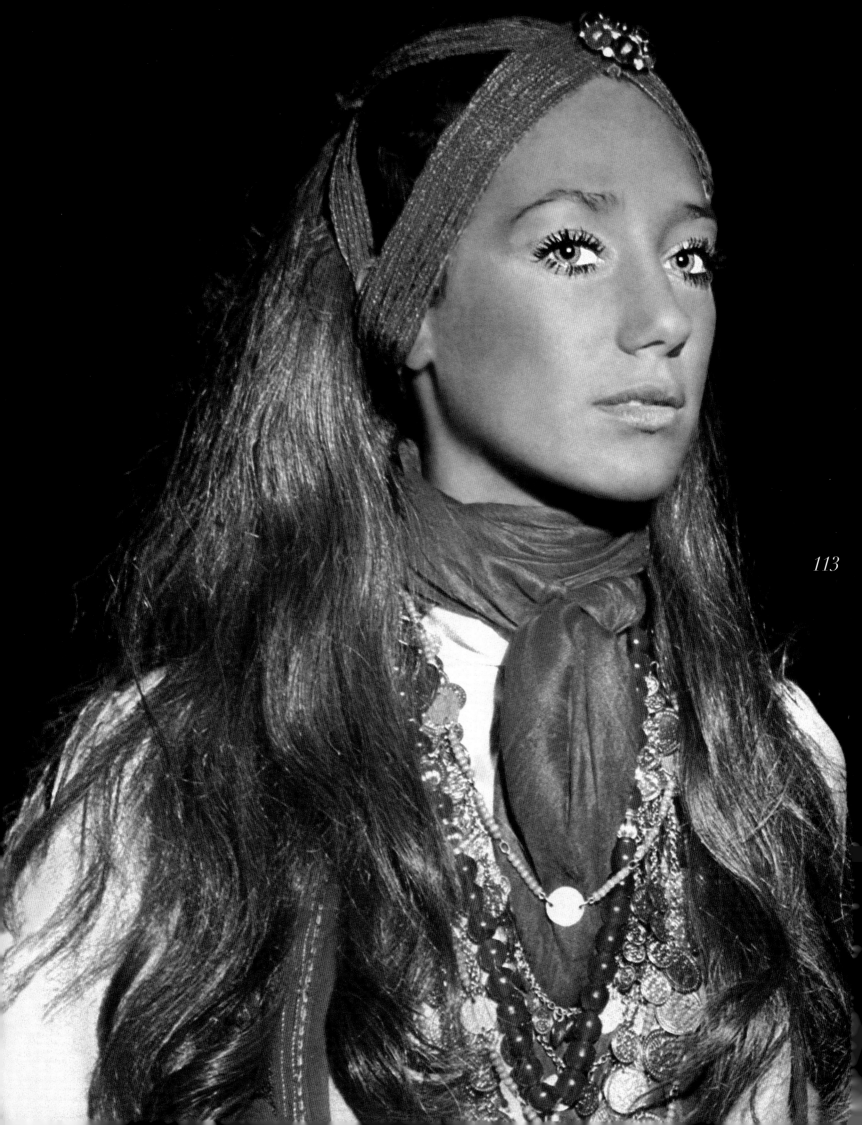

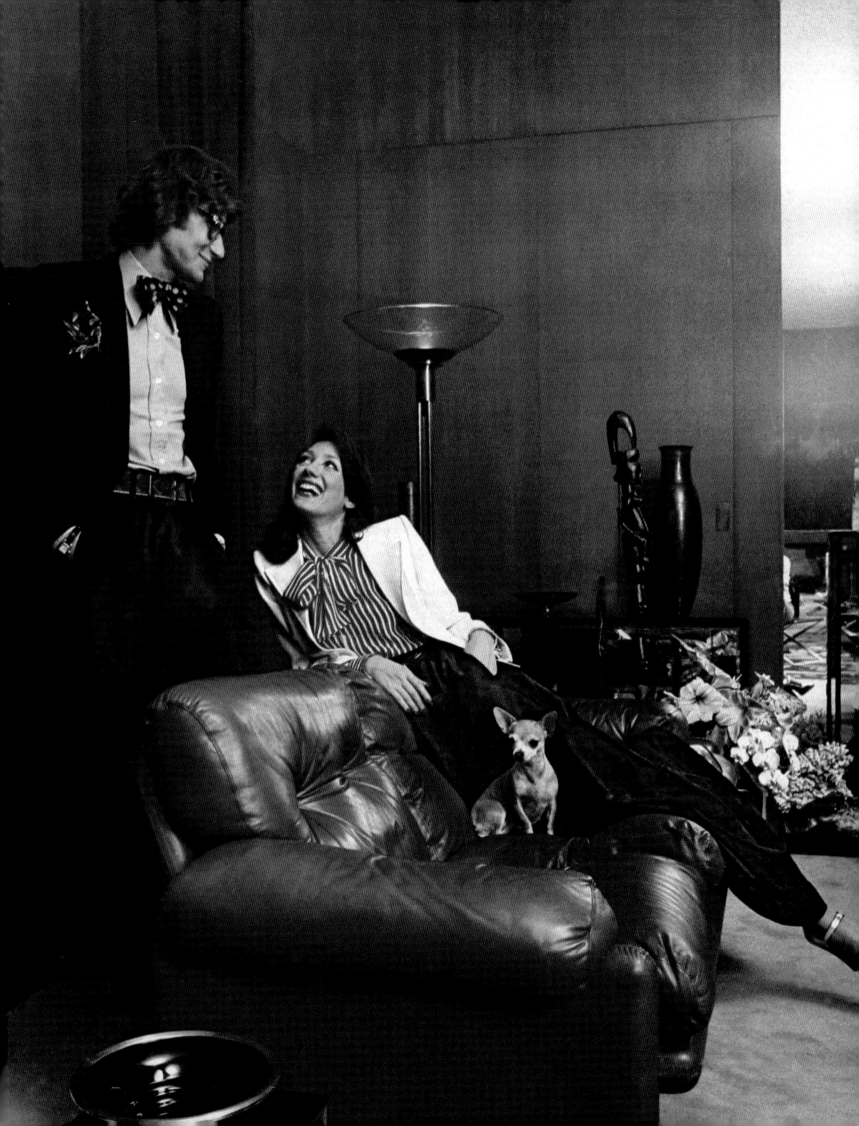

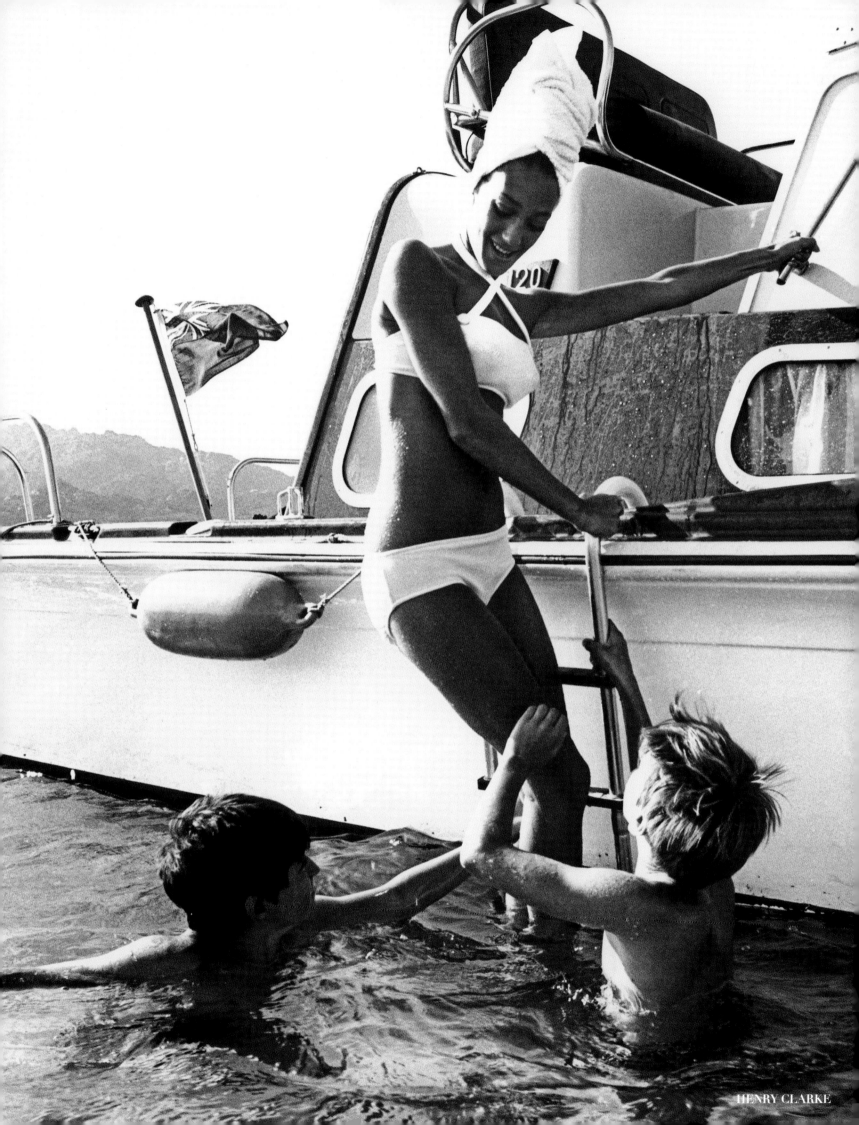

HENRY CLARKE

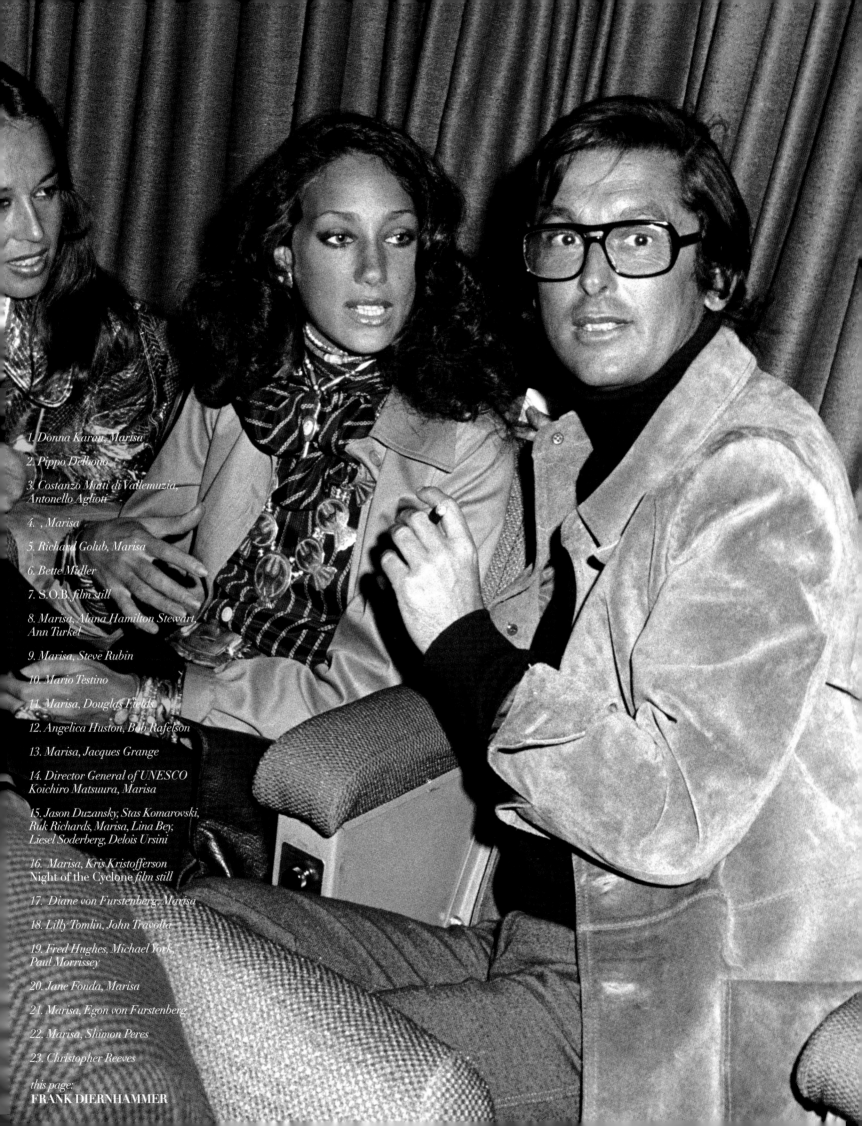

this page:
FRANK DIERNHAMMER

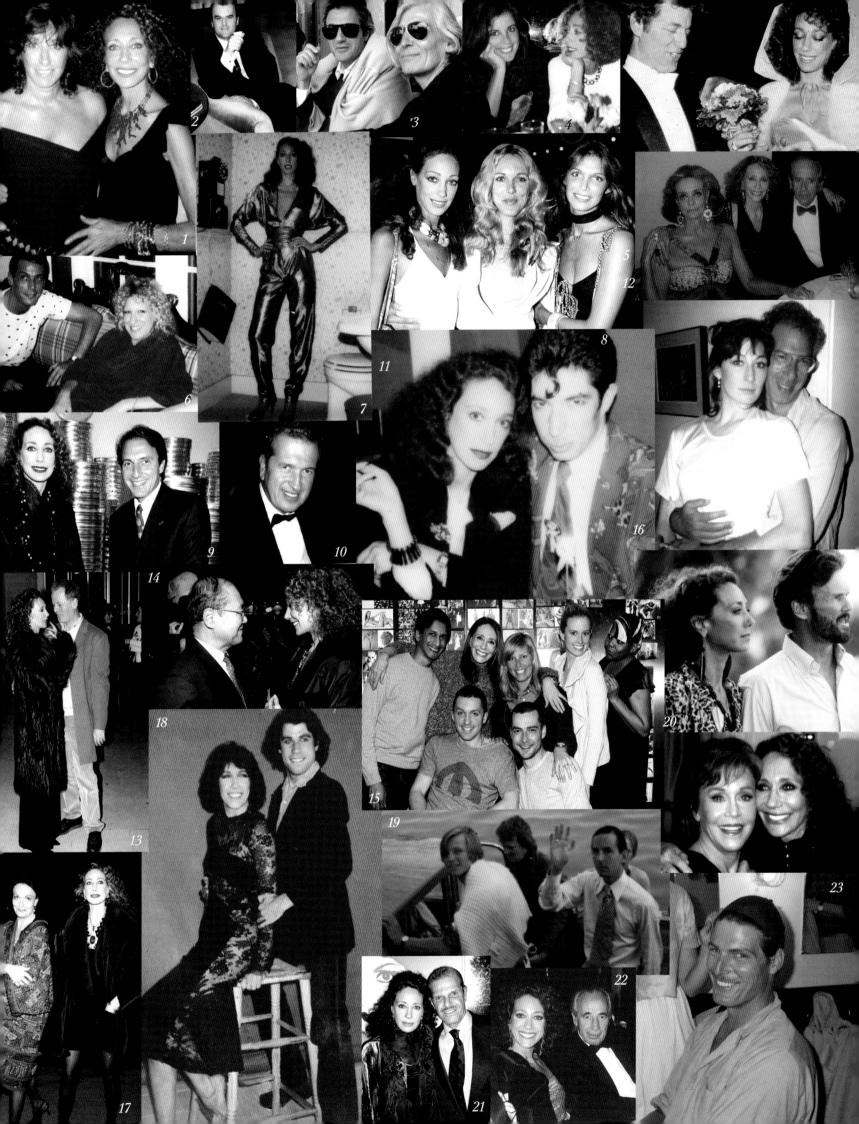

A CONVERSATION BETWEEN MARISA BERENSON AND DIANE VON FURSTENBERG

On March 1, 2011, Marisa Berenson and Diane von Furstenberg met up in Diane's airy office atop her DVF headquarters in the Meatpacking District to look over the preliminary layouts of the book and reminisce on their four-decade-long friendship.

DIANE: When we met, we were two young girls, not even twenty. We were so very young. I was working at Albert Koski [an agency repping photographers] and Marisa was already a very successful, glamorous model. My first real wonderful souvenir with Marisa was a trip with her—there was something in Capri called Mare e Moda, which means "sea and fashion." Marisa was invited to attend, and she asked me to go with her. And I said, "Well, I'd like to but I really don't have the money." And I remember Marisa going into her handbag and coming out with all this cash. [laughs] She gave me some money for the trip, and you know, I will never forget that time. We ended up going together and having a great time. After that we went to St. Moritz together, and lots of other places together; we became best friends. When I got married, Marisa became the godmother of my son and then she came and lived with me.

MARISA: We have been family since the beginning.

DIANE: But a big influence for the both of us was Diana Vreeland. [looking at the James Karales photo of Vreeland with Marisa] So this is Diana Vreeland, of course. For both Marisa and for me, Diana Vreeland was an enormously important person. She invented Marisa, or at least Diana showed Marisa at a very young age what she may not know that she had, and brought it out. And she did the same thing with me. That's why this woman was so extraordinary— she invented people.

MARISA: She loved young people and helping them.

DIANE: My God, she completely helped me. When I started my business, I went to see her and she started my career. She immediately photographed the clothes for *Vogue* and she pushed me. She was totally instrumental with me.

MARISA: She loved doing that, too. She was such a spirit—

DIANE: She was amazing. [looking at the Berenson family collage] So this is Marisa's family, her grandmother, whom actually I never met, and Berry [Berenson] and Tony [Perkins]—

MARISA: You never met my grandmother?

DIANE: No! To tell you the truth, at the time I'm not even sure that I knew who she was. I just knew she was this very intimidating grand lady living up there in that *hôtel particulier* on the rue de Berri. I knew of the name but I wasn't that familiar with what actually she represented— her influence. But Berry took all the pictures at my wedding. [looking at Marisa's family pictures] This is Gogo, Marisa's mother, whom I knew very well, but I never met the grandmother.

When I first met Marisa, she seemed so very glamorous. But when you get to know her, she was always just a great and very, very simple girl who loved to eat and laugh...

[Laughter]

MARISA: And we did a lot of that.

DIANE: We did a lot of laughing and eating together. At the time she looked a lot older than her age. They would make her up looking like so many different personalities, but she was really a very, very young girl.

MARISA: [looking at the Irving Penn nude] Diane, do you know the story of this picture here, the nude? I just recently did some pictures with Ruven [Afanador], and his studio found the artist who designed this necklace and he actually sent it up again for the new shoot. The artist said that this is the necklace that started his career. Someone saw this necklace and showed it to [Alexander] Liberman, who took it up to Diana Vreeland and Diana bounced out of her chair and said, you know, "How did you envision this?" And he said, "On skin." And she said, "That's it—Marisa will do it." And that's how that picture got shot by Irving Penn—isn't that a cute story?

DIANE: That's an amazing story.

MARISA: And it made his career and his life, you know.

DIANE: [looking at the Avedon photo] Oh, I remember that, when Marisa was dressed up as Josephine Baker. I remember that picture. I love that picture. But all of Marisa's pictures are just incredible. I mean, there are so many, so many, so many of them. I remember this photo shoot with Andy Warhol, with the both of us. He wanted to do this exhibition called "Beauties," which he actually never did, and he called quite a few of us. He made us wear very white makeup on our skin, like Kabuki. That was in 1982.

Interviewer: Diane, did you ever ask Marisa to model for your clothing line?

DIANE: No, but she did some editorials, I remember. With Ara Gallant, I think, for a magazine called *Viva*.

DIANE: And this film still is from *Barry Lyndon*. But you did *Cabaret* first, right?

MARISA: *Death in Venice* was the first film. The transition of becoming an actress after being a model was never easy because people never trusted that you could act if you were a model, you know.

DIANE: [looking at the Arnaud de Rosnay nude photo] Okay, this was a big deal.

MARISA: This was a big deal.

DIANE: She got in so much in trouble with her grandmother.

[Laughter]

MARISA: My grandmother was so furious that she practically threw me out of the house and disowned me because I always did nude pictures.

Interviewer: This was your first nude?

DIANE: No, but that's the one she got upset about. That was an Arnaud de Rosnay photo, by the way.

MARISA: I was quite scandalous. In fact my mother always says, you know, "You're too much!" She always used to say, "Your grandmother wrote that book *Shocking Life*. But you're much more shocking than she ever was."

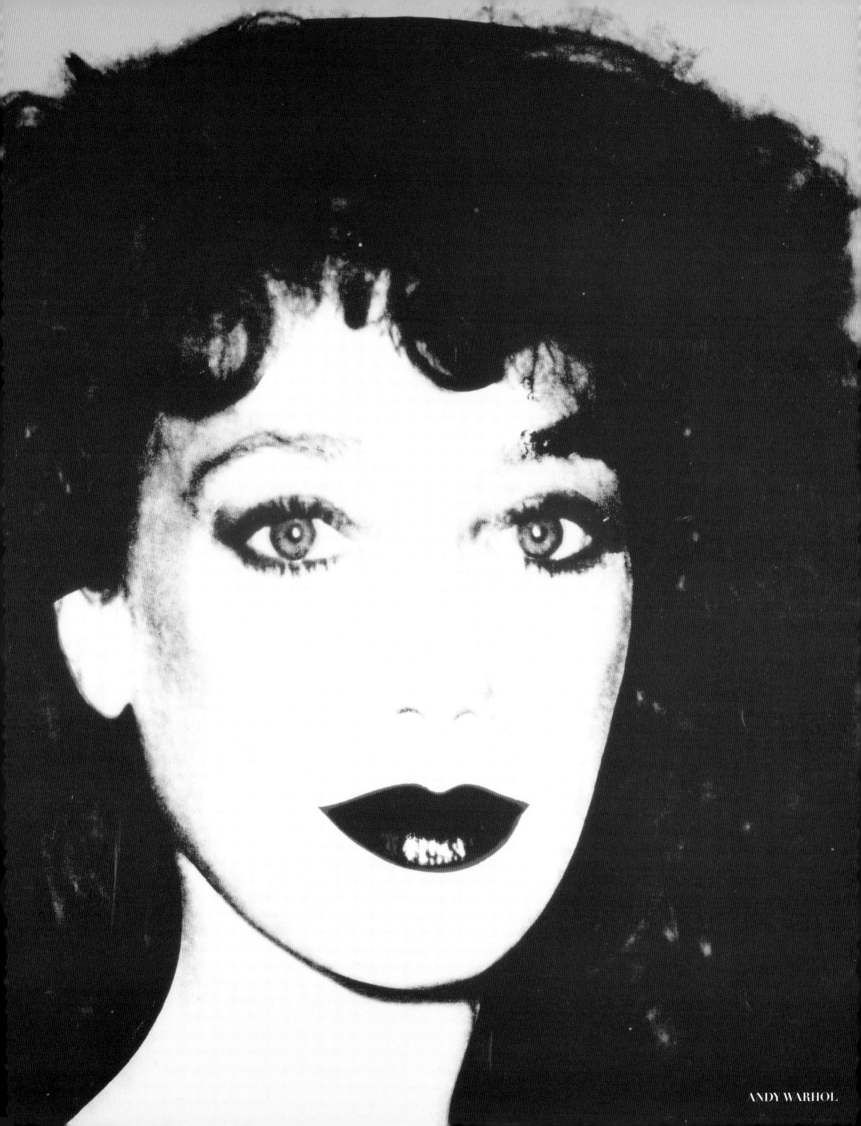

ANDY WARHOL

DIANE: But you were not scandalous, really. And frankly, to show your tits was not a big deal at the time. To be young in the seventies was quite different.

[looking at the Henry Clark photo for *Vogue*] This is beautiful. This is a Diana Vreeland shot if you can wish for one. She would take these people and throw them in amazing landscapes and put tons of jewels on them. This is such an inspiration—this is very much an iconic Diana Vreeland image.

And here's Marisa with her men. So this is Jimmy Randall, her first husband. And this is Rikky von Opel, a big love of hers. And this is Kenny Lane, who made all this jewelry. [looking at the Cecil Beaton photo] Oh, and here she is at the Bal Proust, at the Rothschild estate Château de Ferrières, before they closed it. They gave a ball in honor of Proust and Marisa came with David de Rothschild, whom she was engaged to at the time, as the Marchesa Casati.

MARISA: And nobody recognized me. Including Marie-Hélène [de Rothschild]. She said to David, "Who is this person?"

DIANE: This was taken by Joel Schumacher, who at the time was a window-display person, and now he's a big director. And this, this is again another classic Diana Vreeland shot. [looking at the Henry Clarke photo of Marisa with mussel shells in her hair]

MARISA: Yes, and you know the story of this picture? This was in Sardinia, and Alexandre of Paris did the hair; Alexandre and I went around to all of the bins, the trash bins, at five o'clock in the morning, of all the restaurants to get the shells for the photo shoot.
[Laughter]
Can you imagine nowadays doing something like that? It would be impossible.

DIANE: This is a great image from *Death in Venice*, directed by [Luchino] Visconti.

MARISA: He started my career. Oh, he was just so important—a mentor, as Diana was.

DIANE: You see, the thing is, you have old pictures of Marisa and recent pictures of Marisa and actually she looks the same.

MARISA: Well, thank you, darling.

DIANE: There's no change at all. That's fantastic, this shoot by Steven Meisel. You see, you can't tell. This is her first husband again, Jimmy Randall, who didn't like me at all.

[Laughter]

MARISA: You know why? Because we had purchased these purple satin couches that arrived on the day of the wedding—

DIANE: And I walked on it.

MARISA: —and she walked in her stiletto heels on them.

[Laughter]

DIANE: This is K.K., the Pekingese, who stayed in my house—

MARISA: I stayed with Diane for a time. Diane being such an important part throughout my life. Always there. She helped me a lot, in many ways, as a friend and as a—

DIANE: We are very, very good friends.

Interviewer: You two look like you could be cousins or sisters.

DIANE: Well, we are. That was taken by Berry, no? Berry was a good photographer.

MARISA: She was a great photographer. This is my first agent, Peter Witt. And these are Diana Vreeland's grandsons, Nicky and Sasha. aren't they cute? So sweet.

DIANE: Nicky is now a Tibetan monk.

Interviewer: Marisa and Diane, talk about what it was like in the seventies and being the "It" Girls of the moment.

MARISA: It was so much fun. We had a ball, didn't we? We were so green!

DIANE: One year we went to St. Moritz together, and they would give us a very cheap rate because we were two pretty girls.

MARISA: It was the Palace Hotel, so we'd share a room.

DIANE: We would order a big breakfast, and then okay, we won't eat the rest of the day.

MARISA: We'll go down and get massaged and swim and then we'll ski and we won't eat.

DIANE: But then we didn't ski and then we had a big meal and another big meal!

[Laughter]

MARISA: One time we went to St. Moritz for the New Year's Eve party, the big party with everybody there. And Diane and I—

DIANE: —we had promised each other that at twelve o'clock we had to be together so we could wish each other Happy New Year—

MARISA: —and kiss each other and all of that.

DIANE: But then close to midnight we lost each other and then the room got dark and I was looking for her and I was laughing so much that I actually peed—

MARISA: And then you found me. She peed on the floor.

DIANE: —on the floor.

MARISA: The lights went up and Diane had peed on the floor, she was laughing so much. And we had moments like that all the time, didn't we?

DIANE: Yes. What we did the most is laugh. We laughed a lot. Our relationship is about laughter—laughter and love.

right
RICHARD AVEDON
Marisa Berenson as Josephine Baker
New York, December 1972

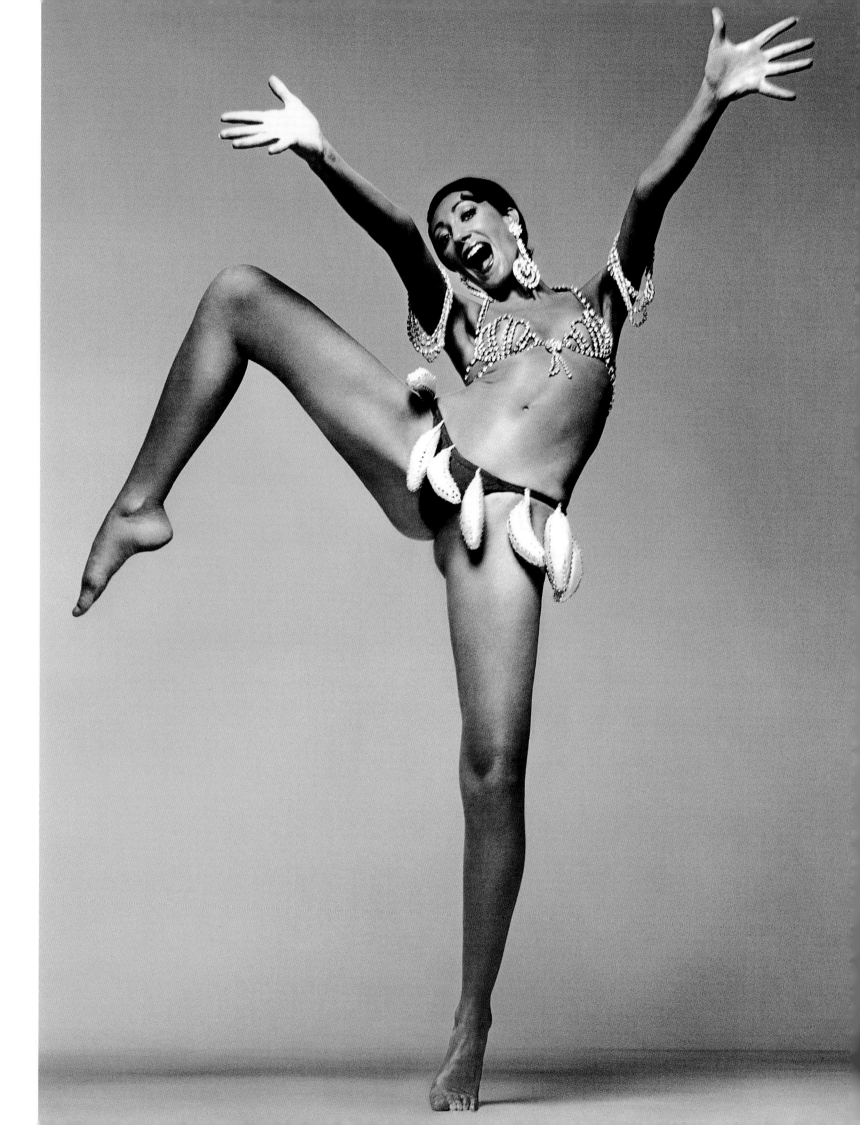

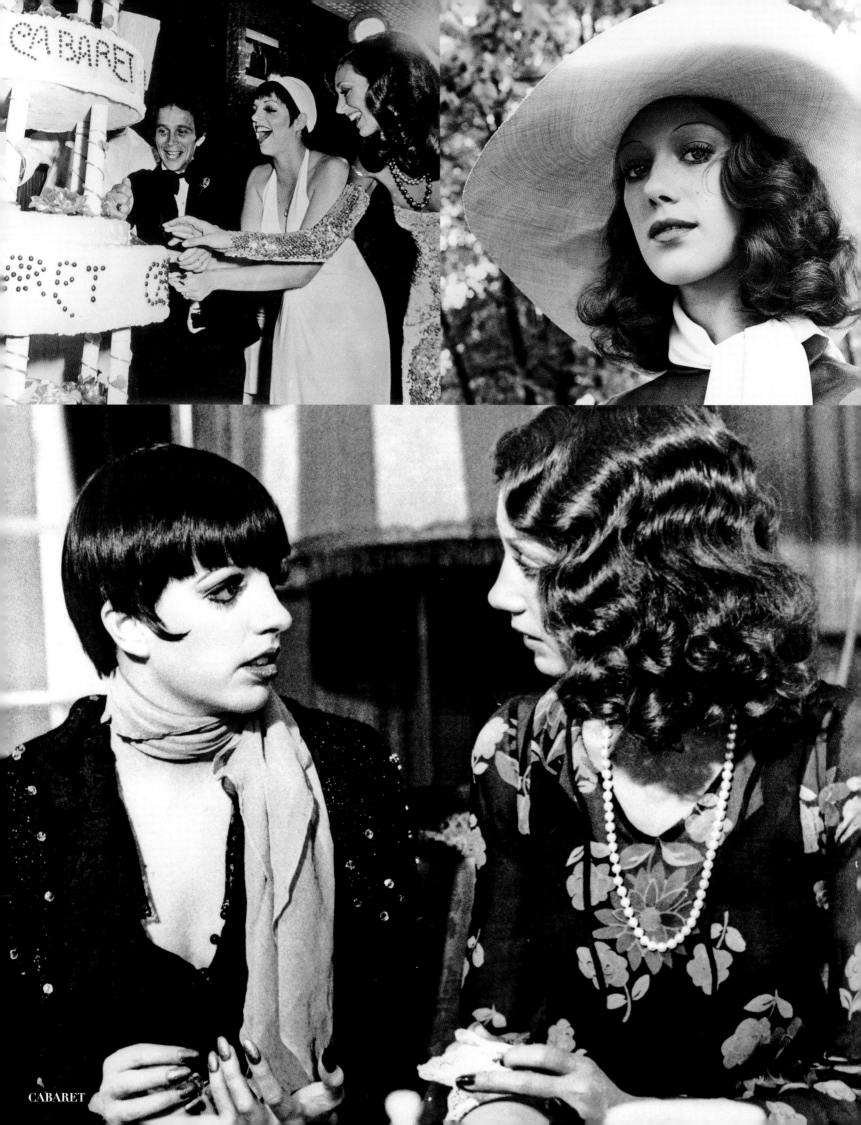

CABARET

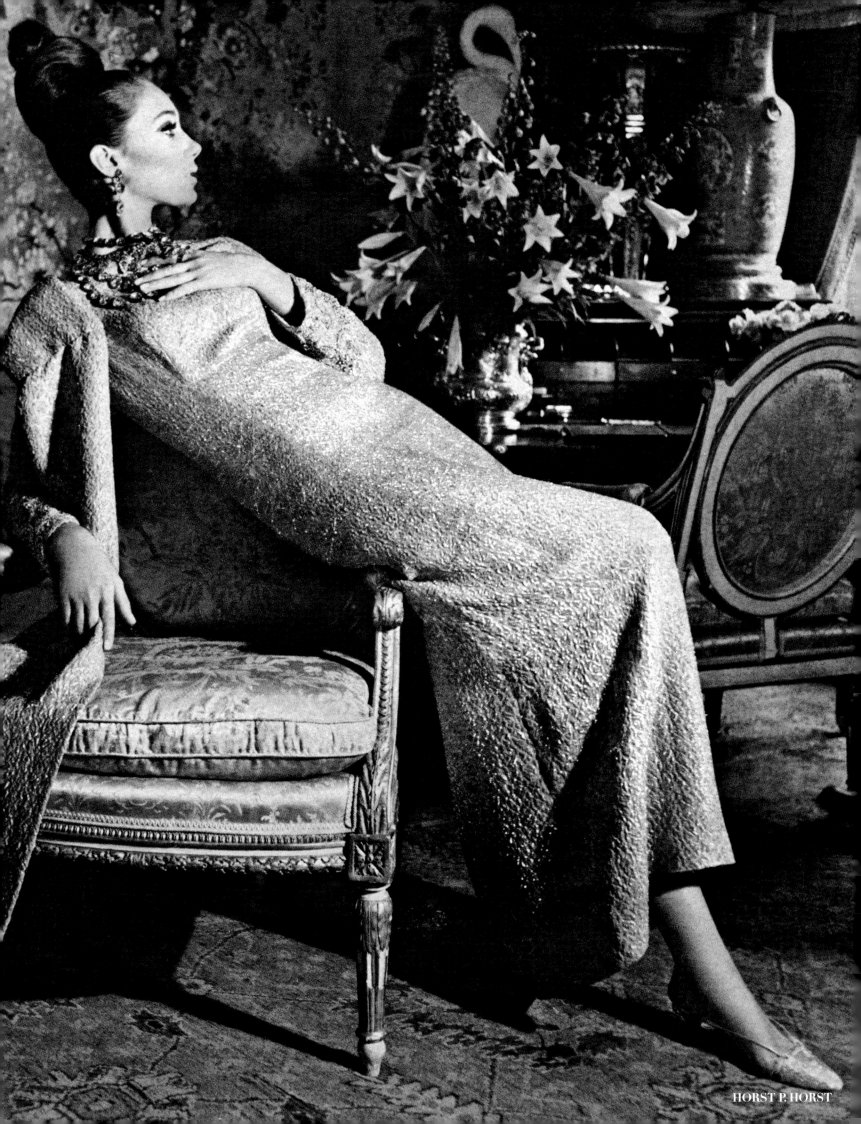

HORST P. HORST

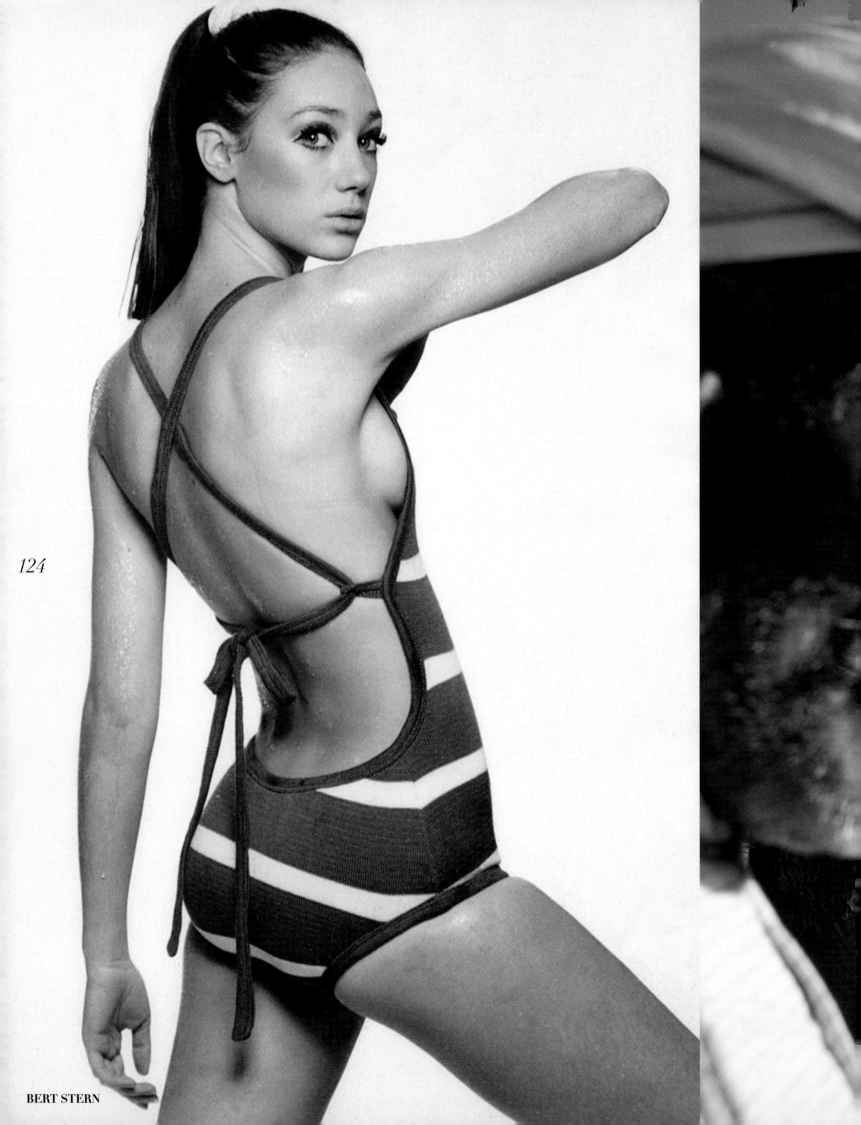

124

BERT STERN

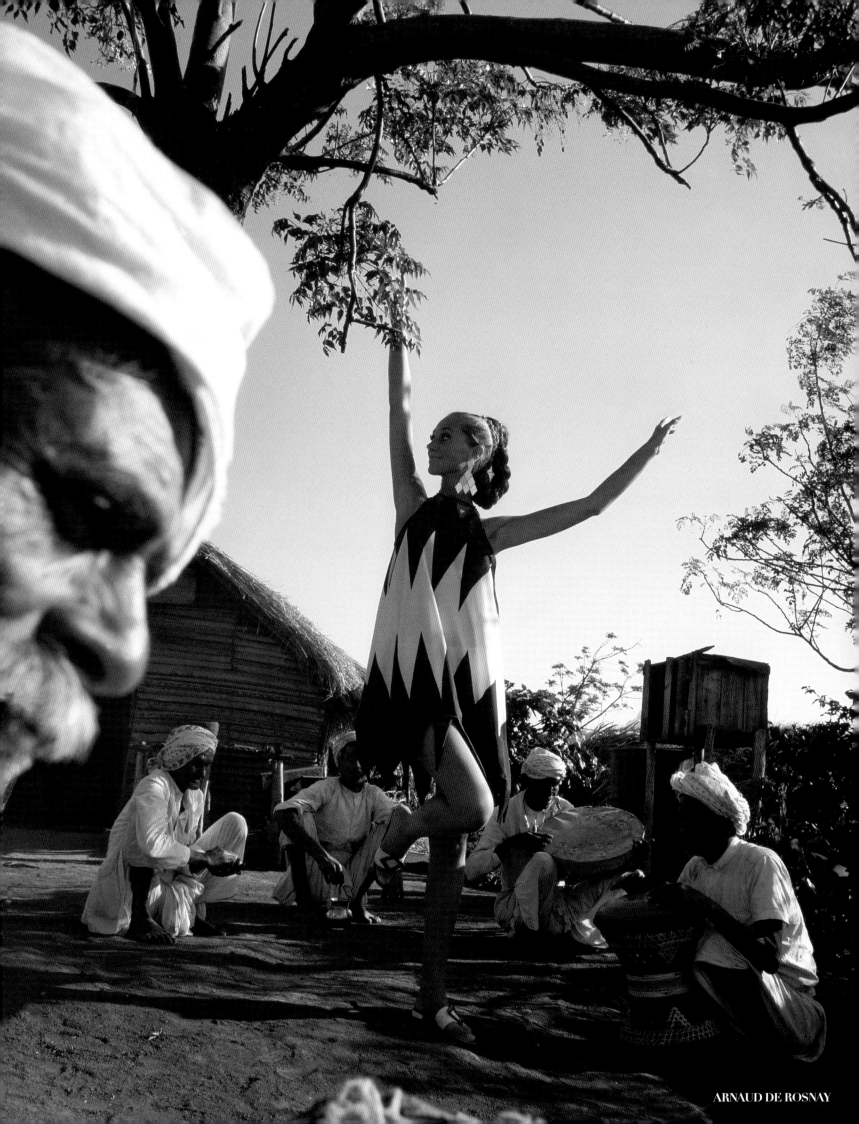

ARNAUD DE ROSNAY

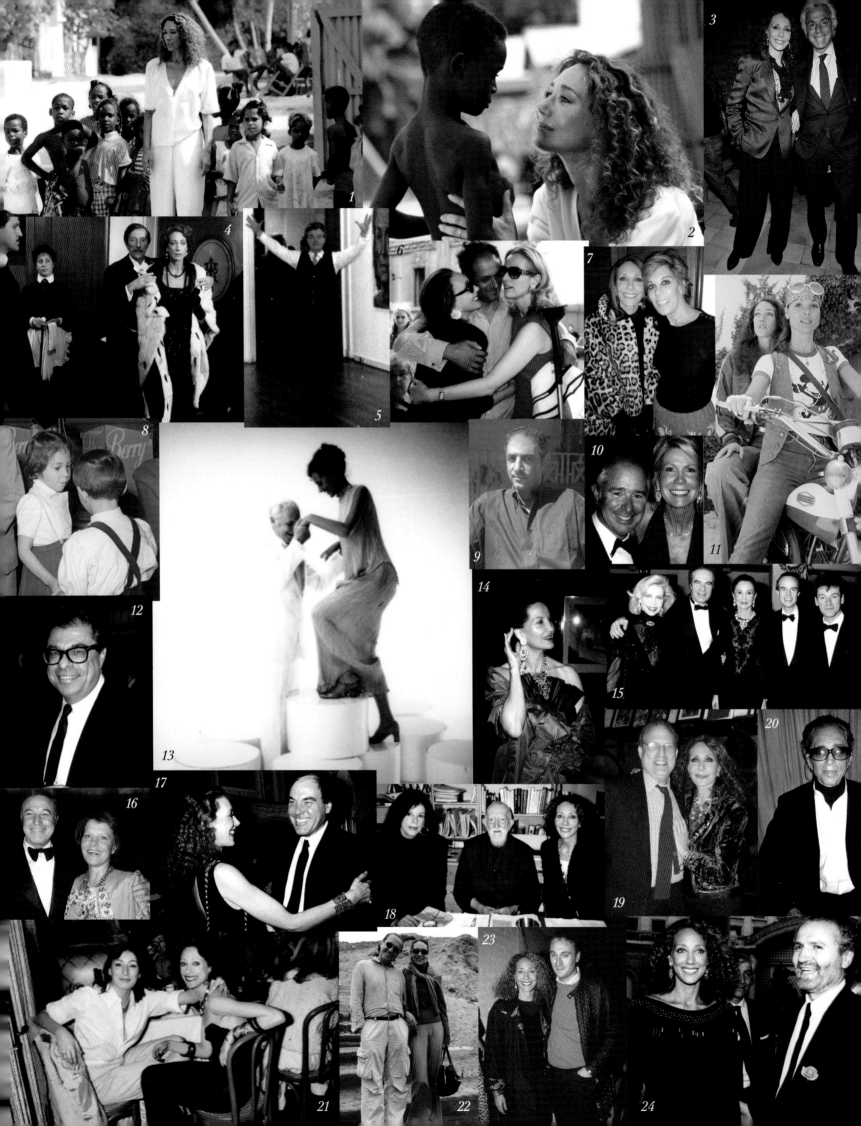

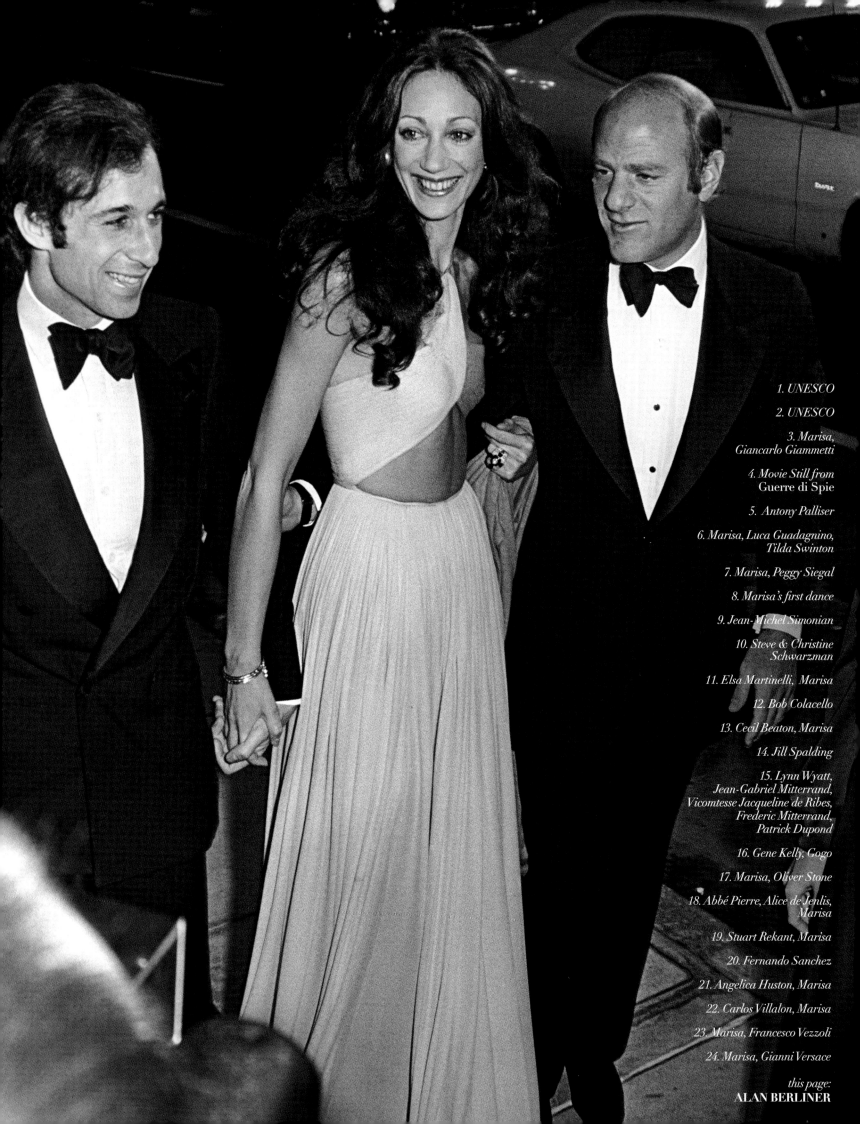

this page:
ALAN BERLINER

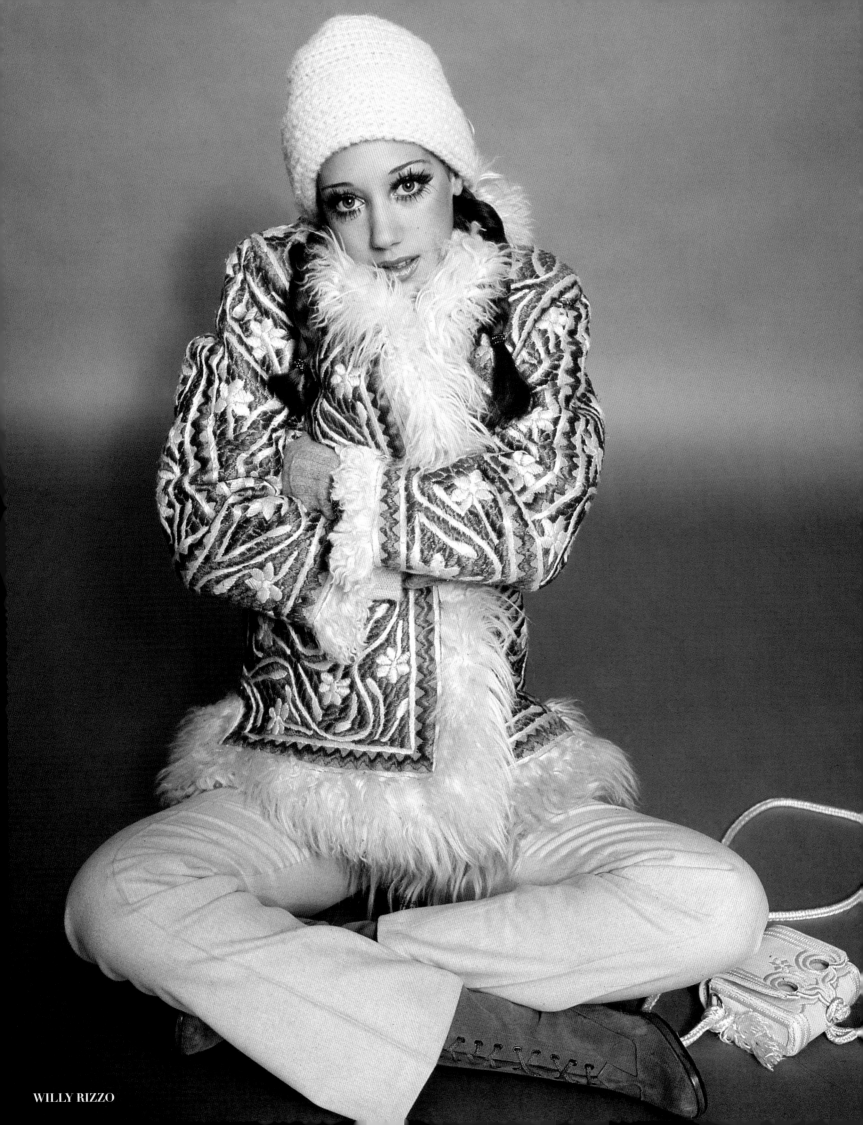

WILLY RIZZO

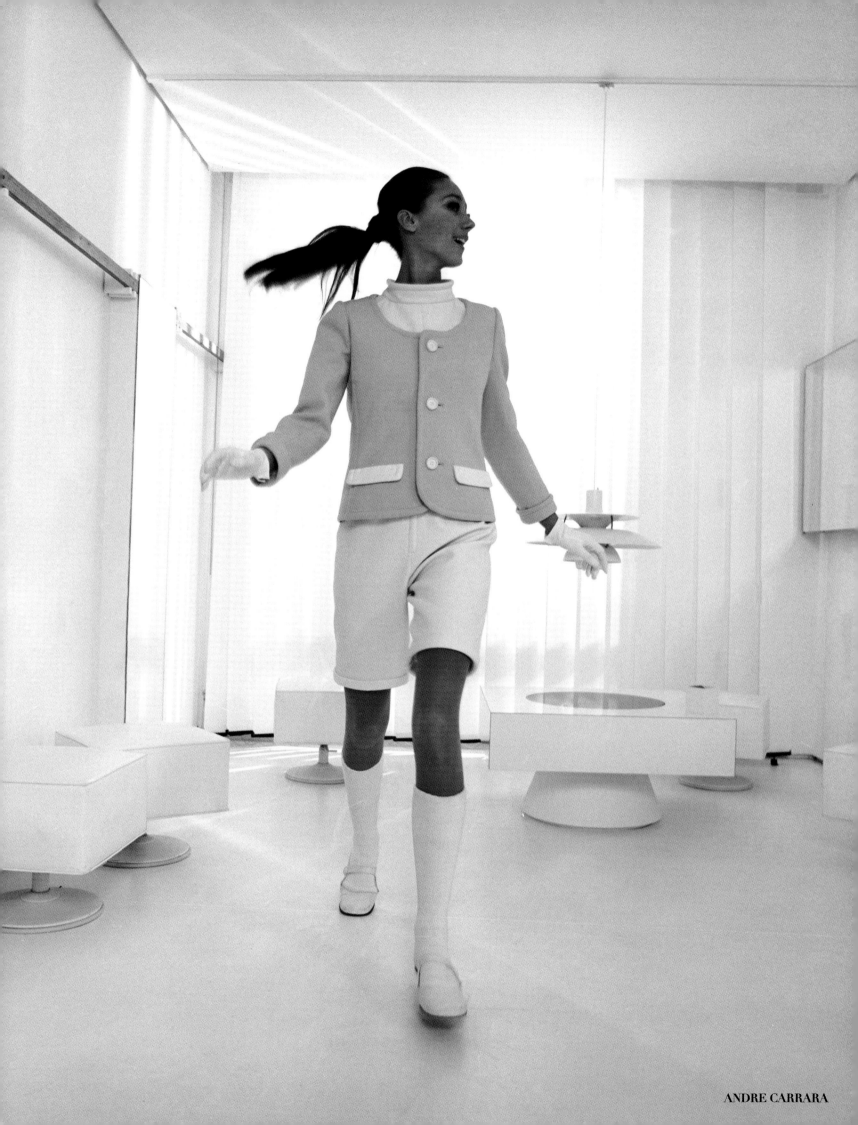

ANDRE CARRARA

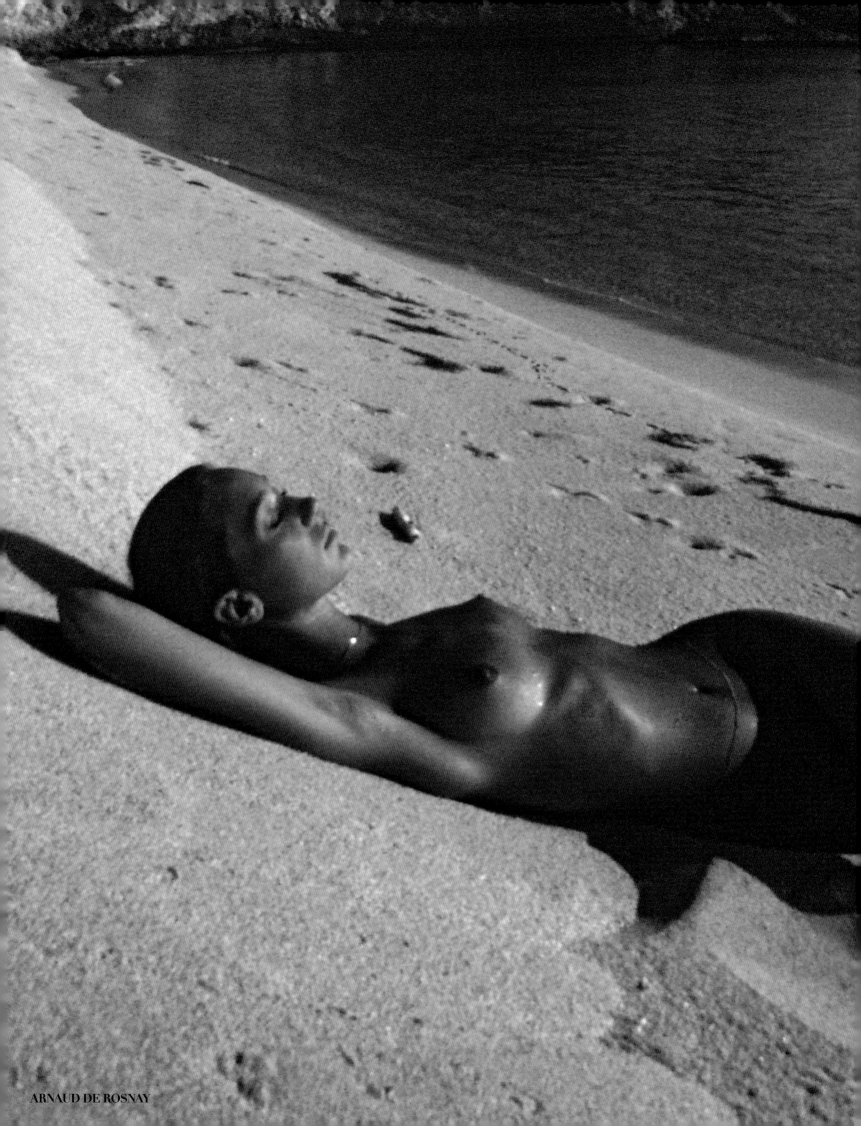

ARNAUD DE ROSNAY

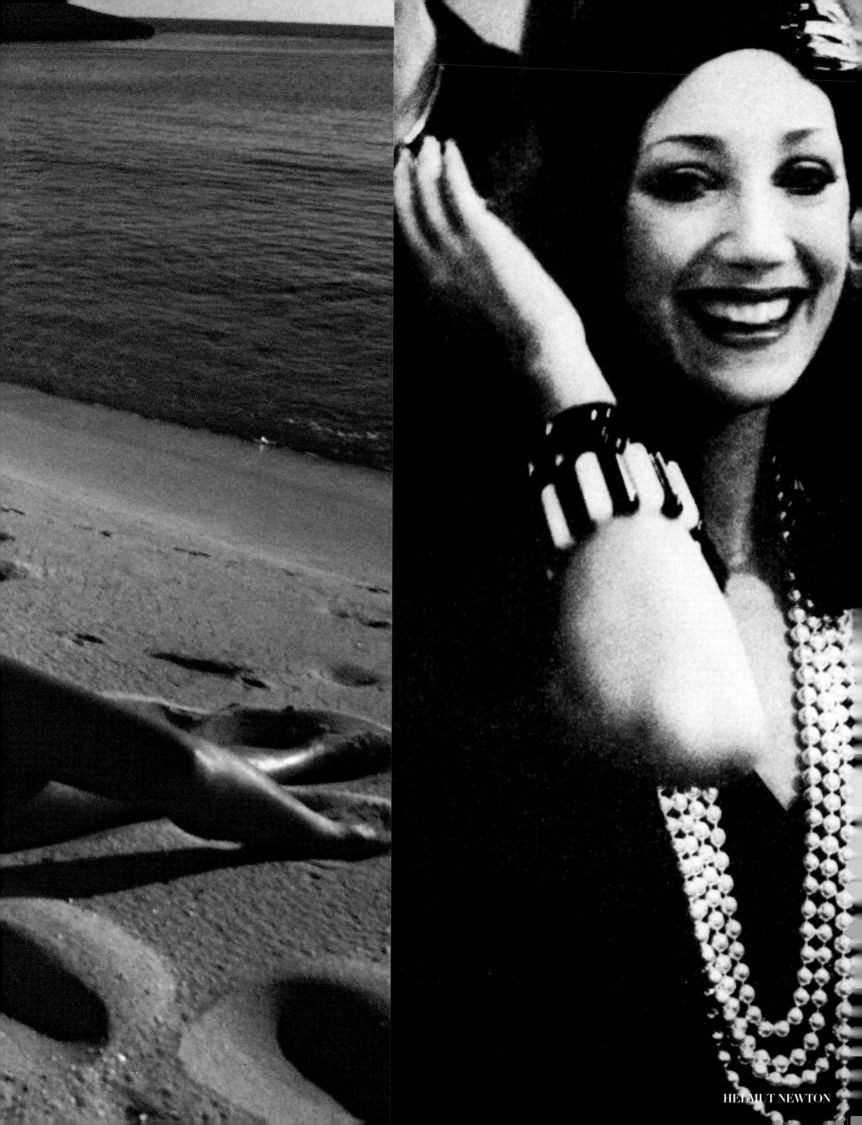

HELMUT NEWTON

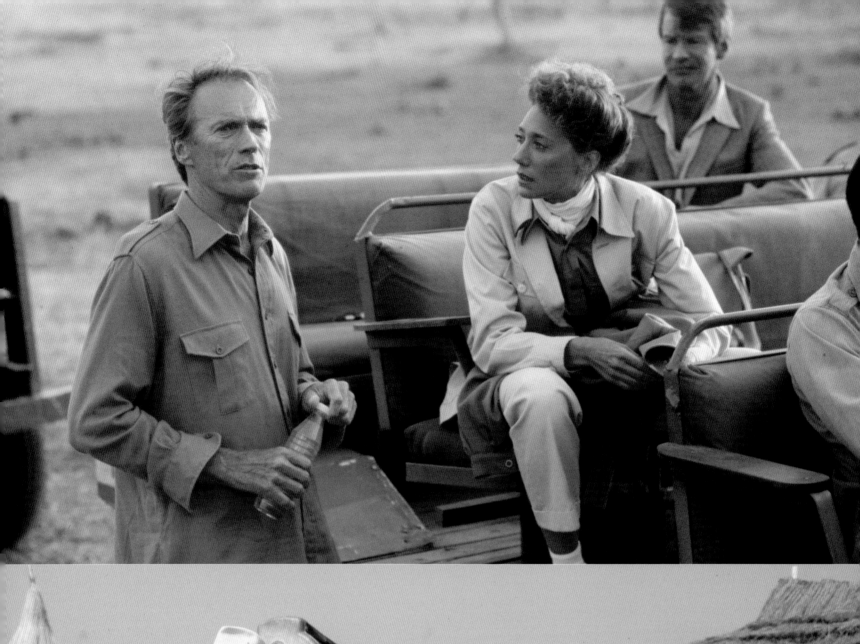
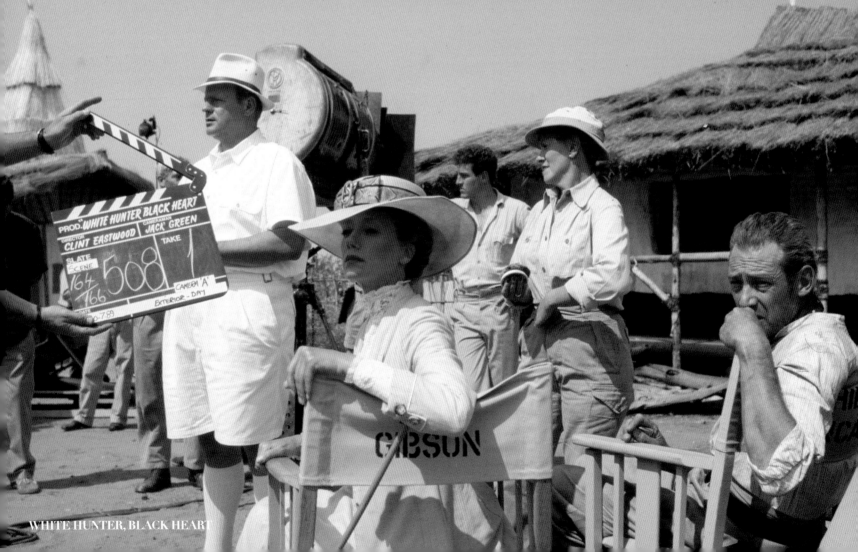

WHITE HUNTER, BLACK HEART

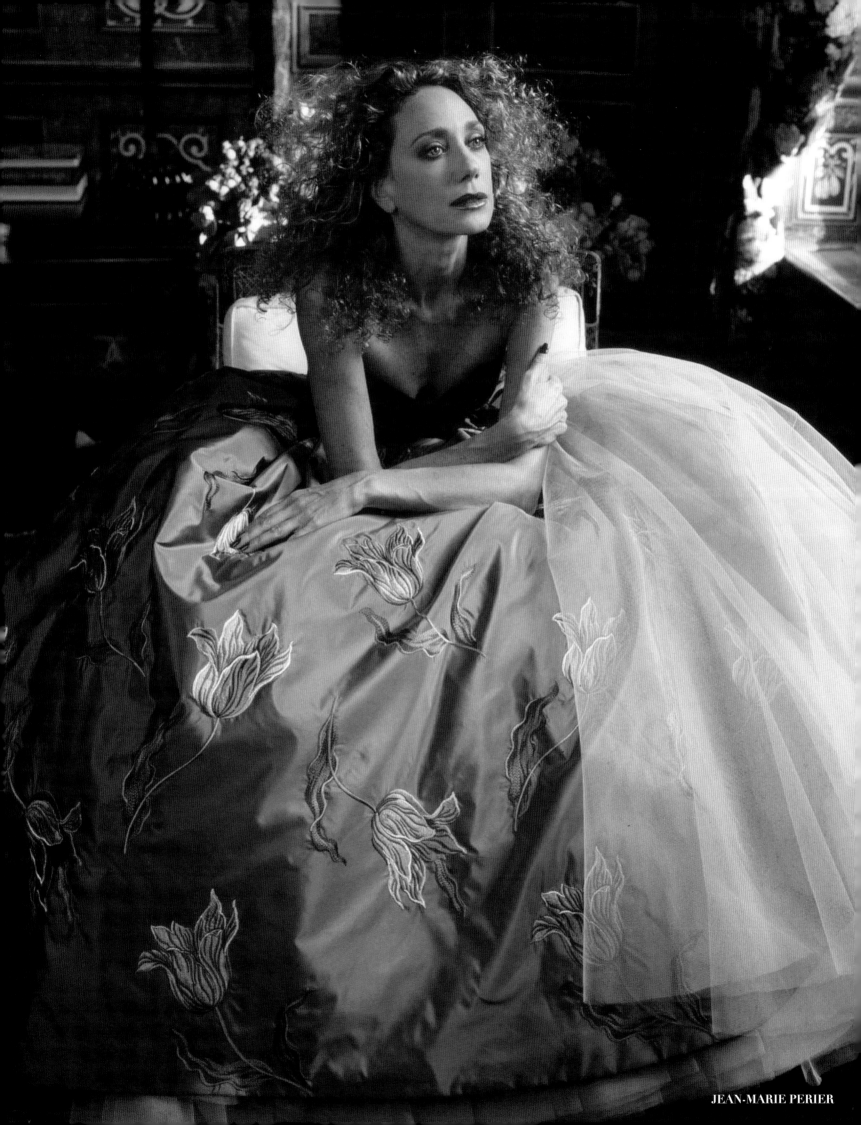

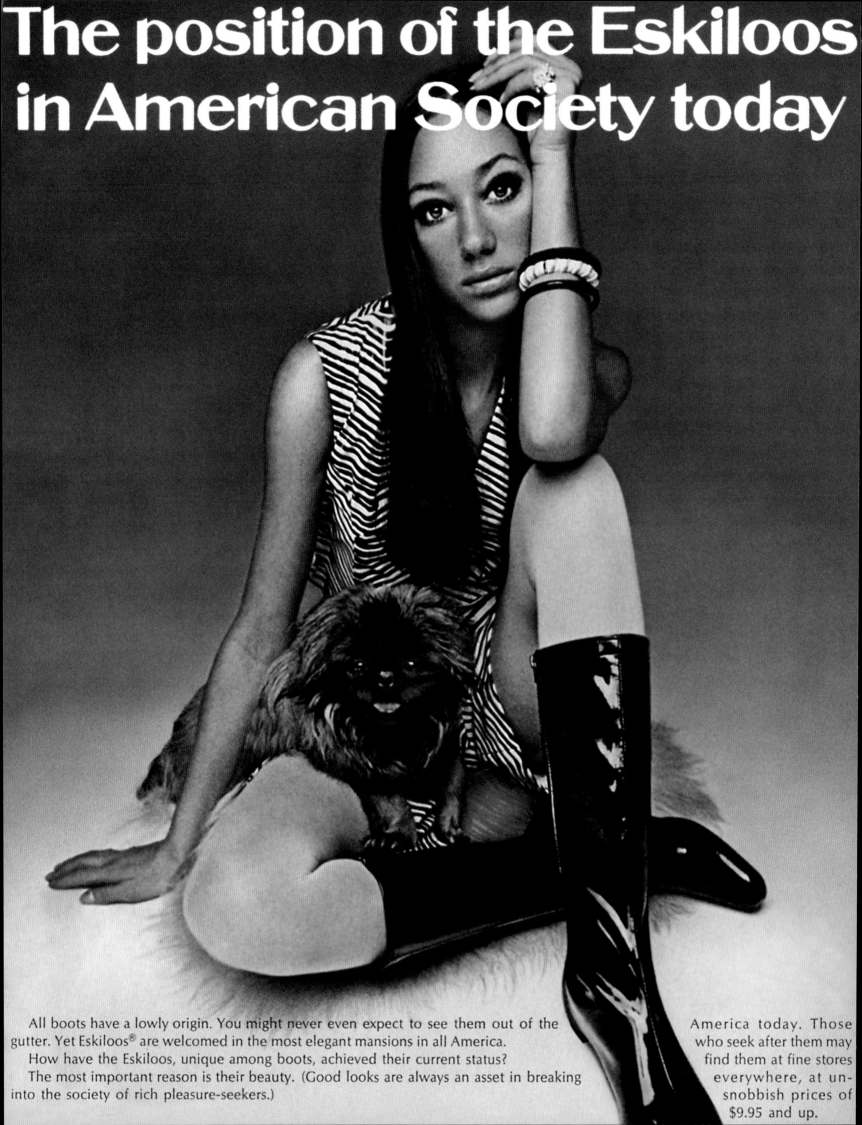

The position of the Eskiloos in American Society today

All boots have a lowly origin. You might never even expect to see them out of the gutter. Yet Eskiloos® are welcomed in the most elegant mansions in all America.
How have the Eskiloos, unique among boots, achieved their current status?
The most important reason is their beauty. (Good looks are always an asset in breaking into the society of rich pleasure-seekers.)
America today. Those who seek after them may find them at fine stores everywhere, at un-snobbish prices of $9.95 and up.

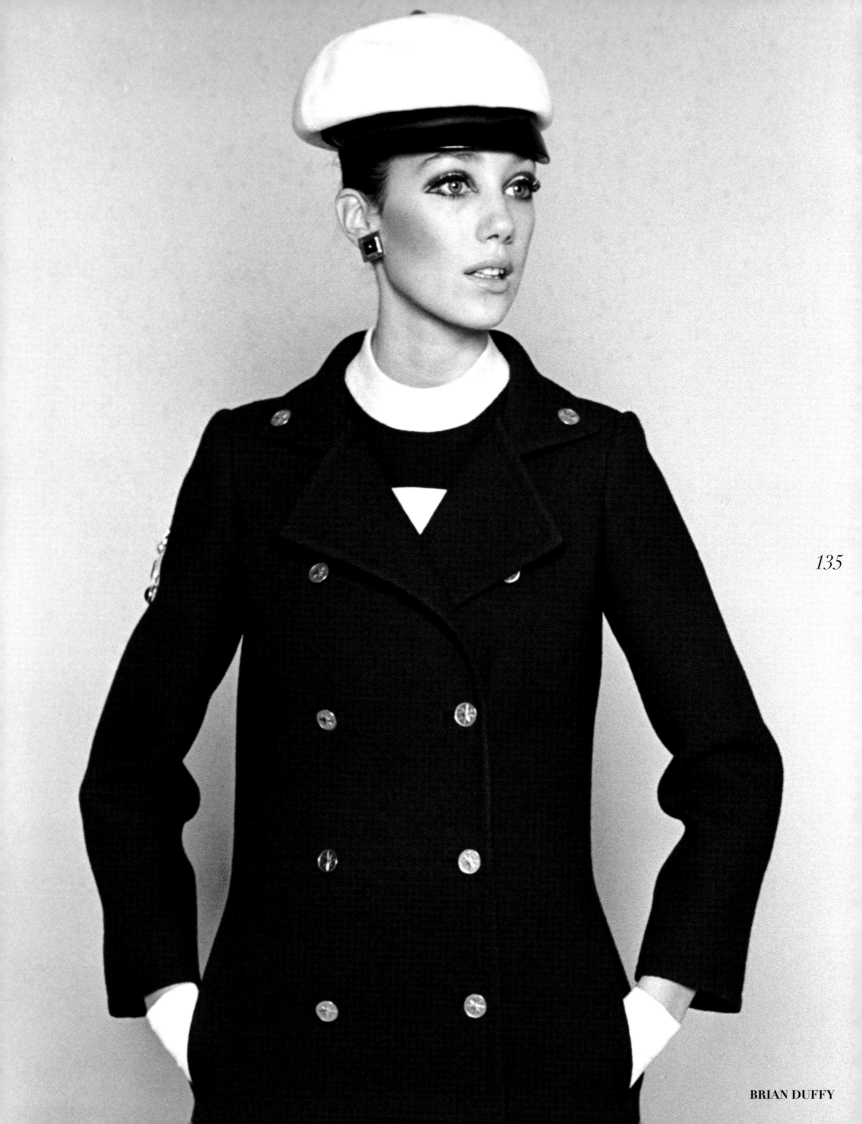

135

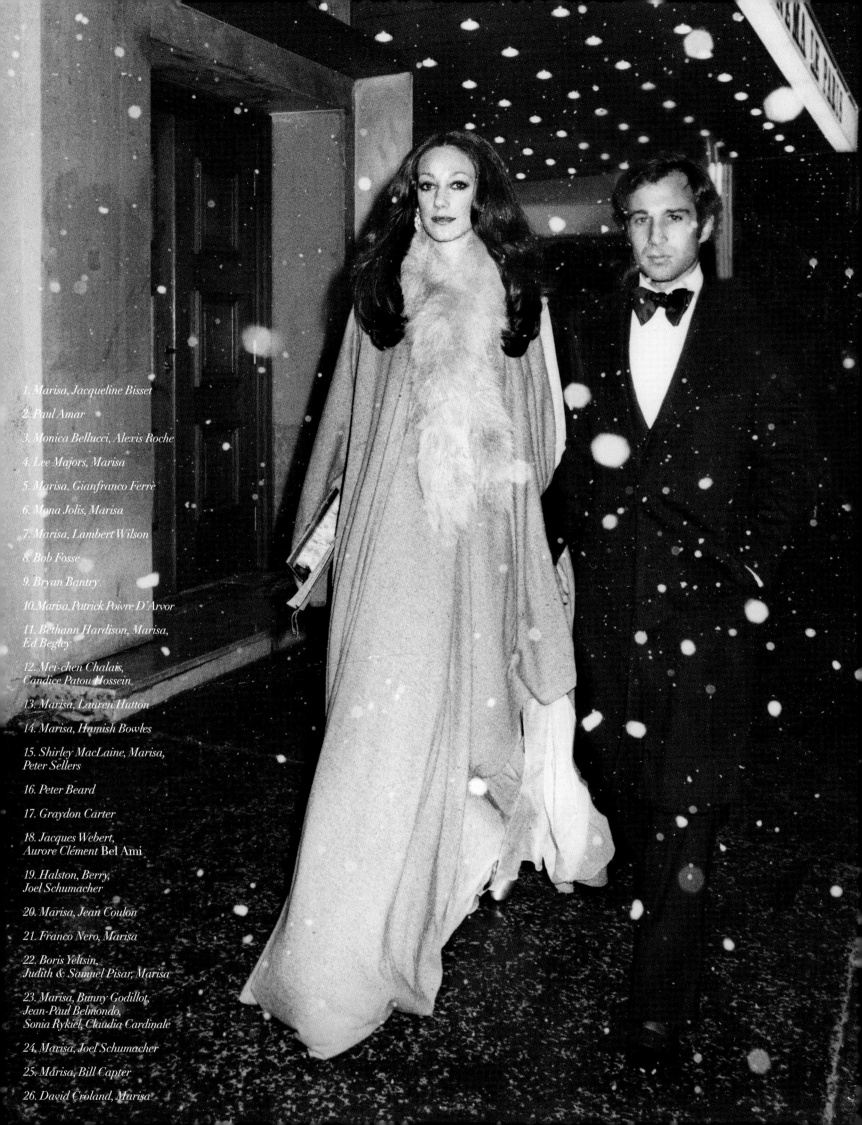

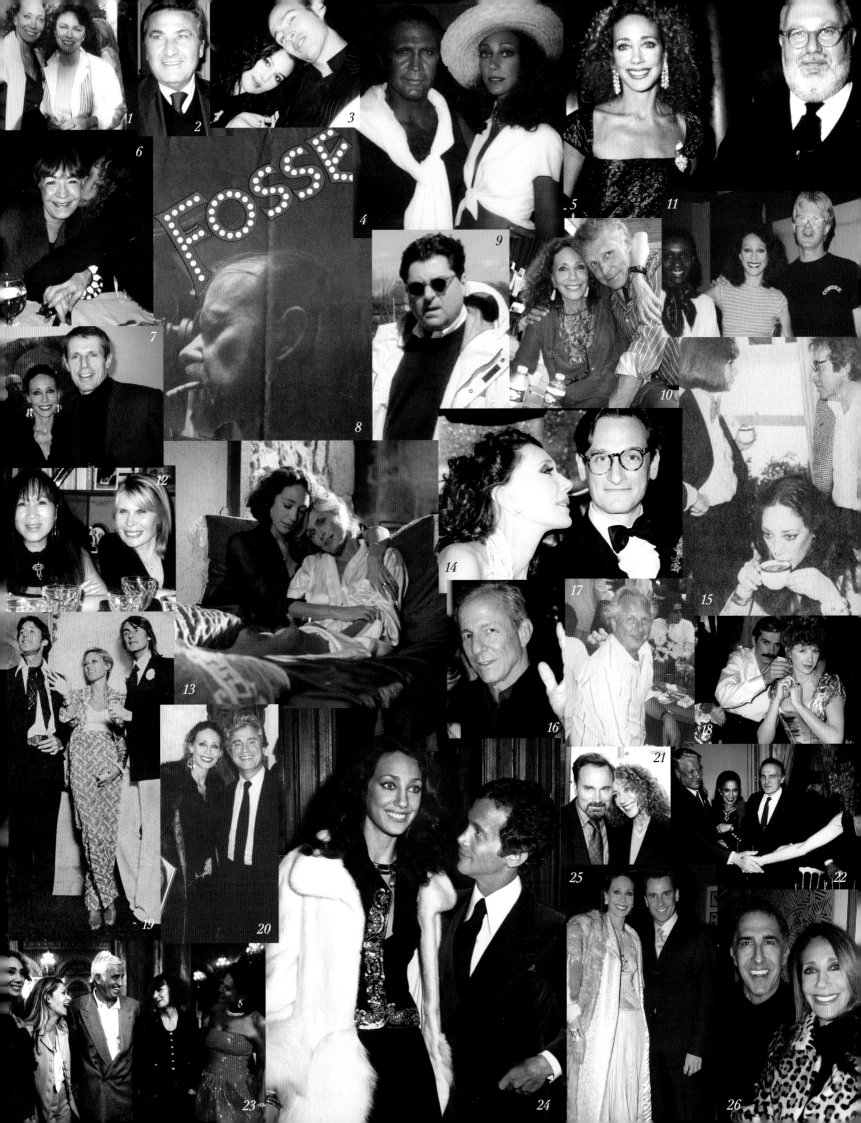

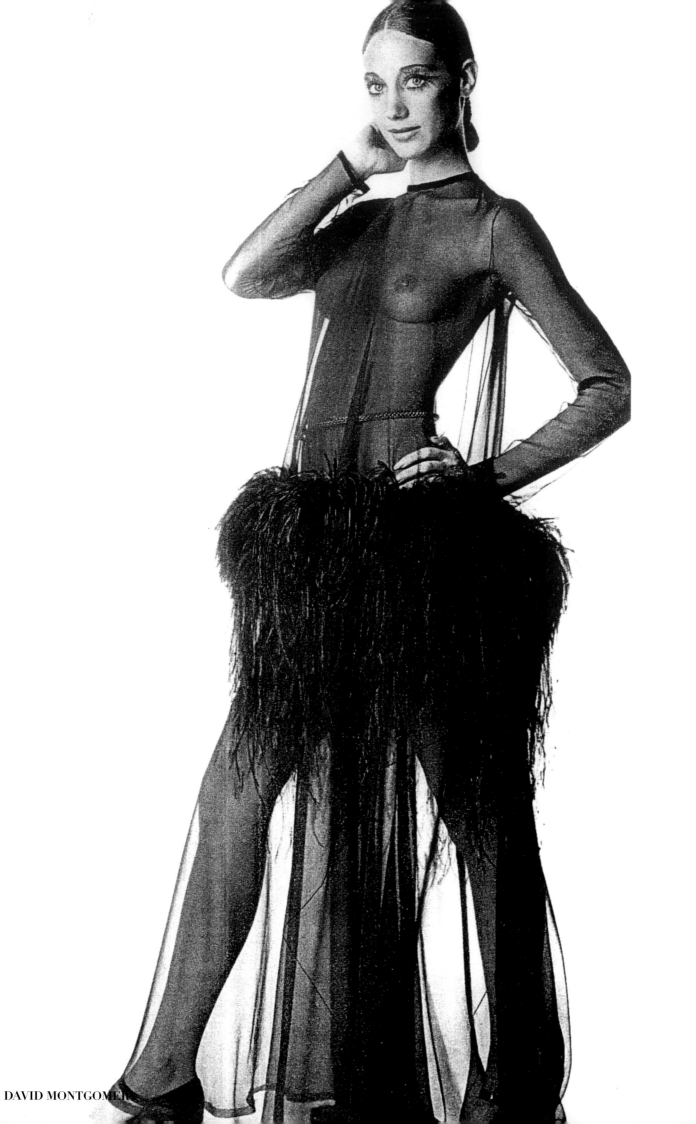

DAVID MONTGOMERY

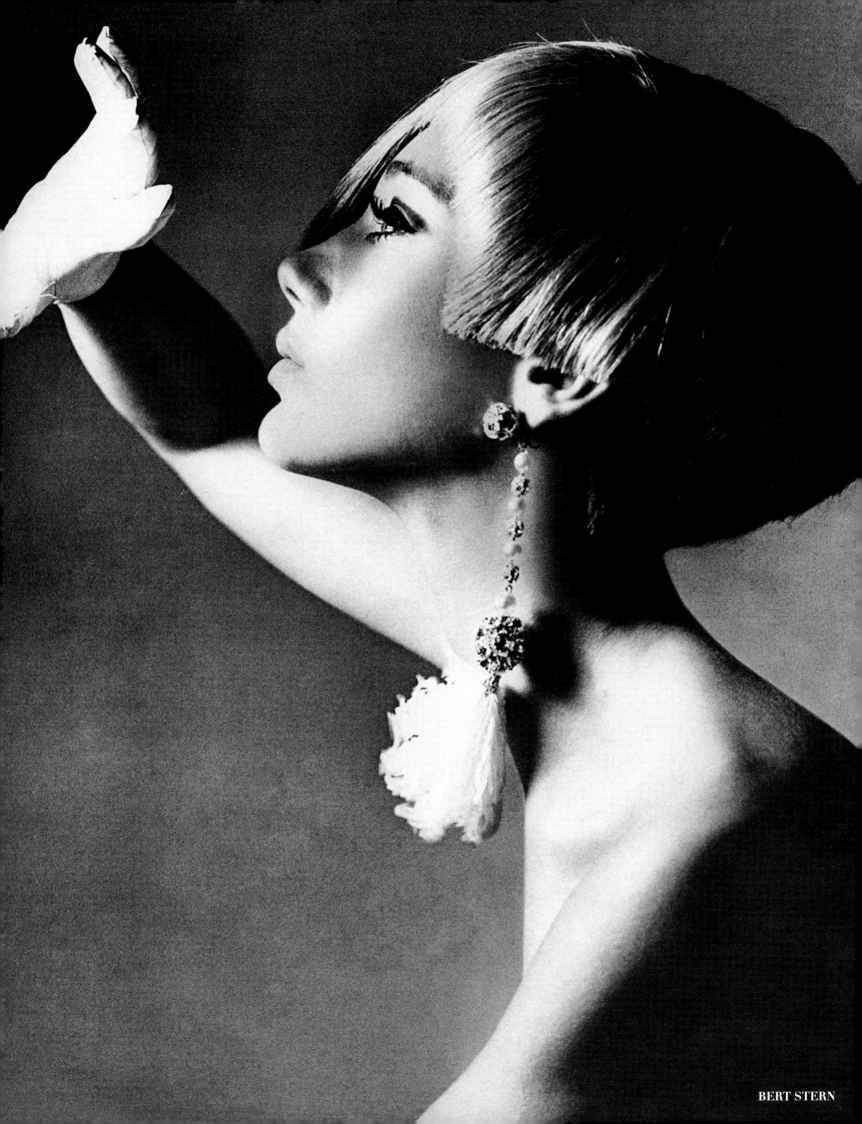

BERT STERN

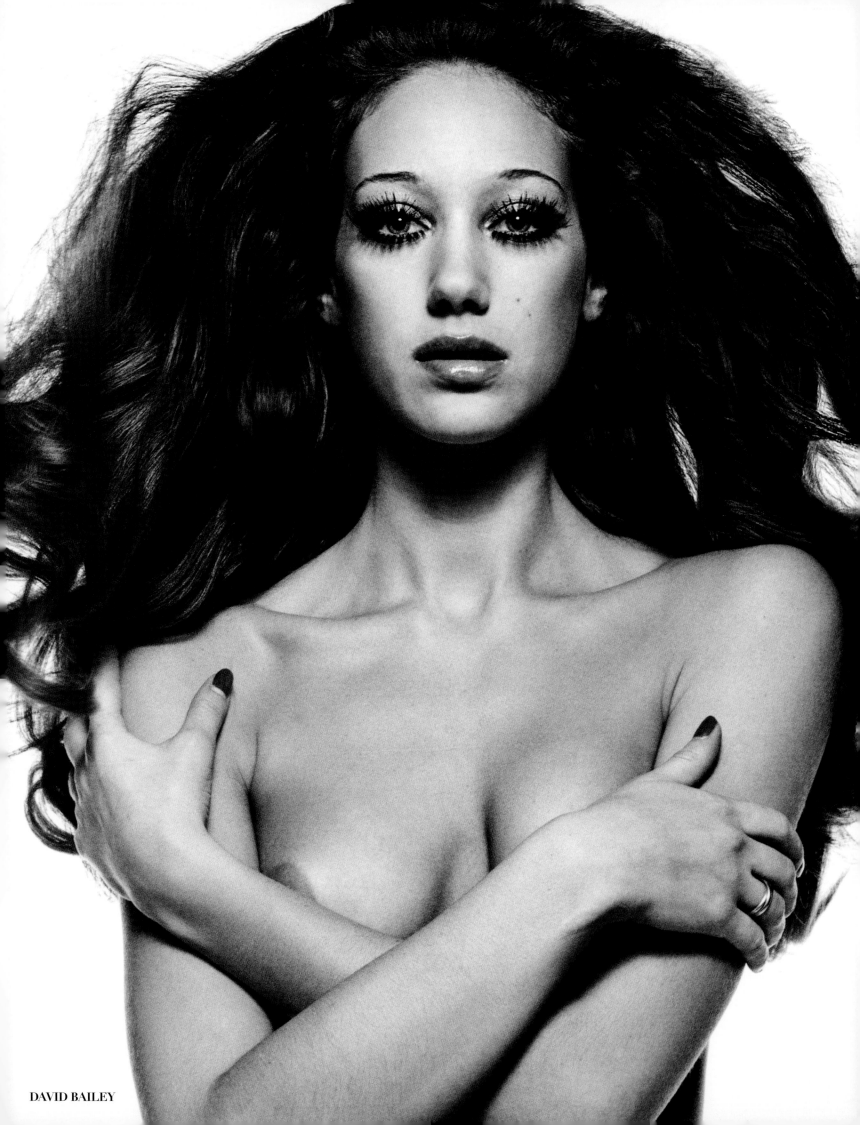

DAVID BAILEY

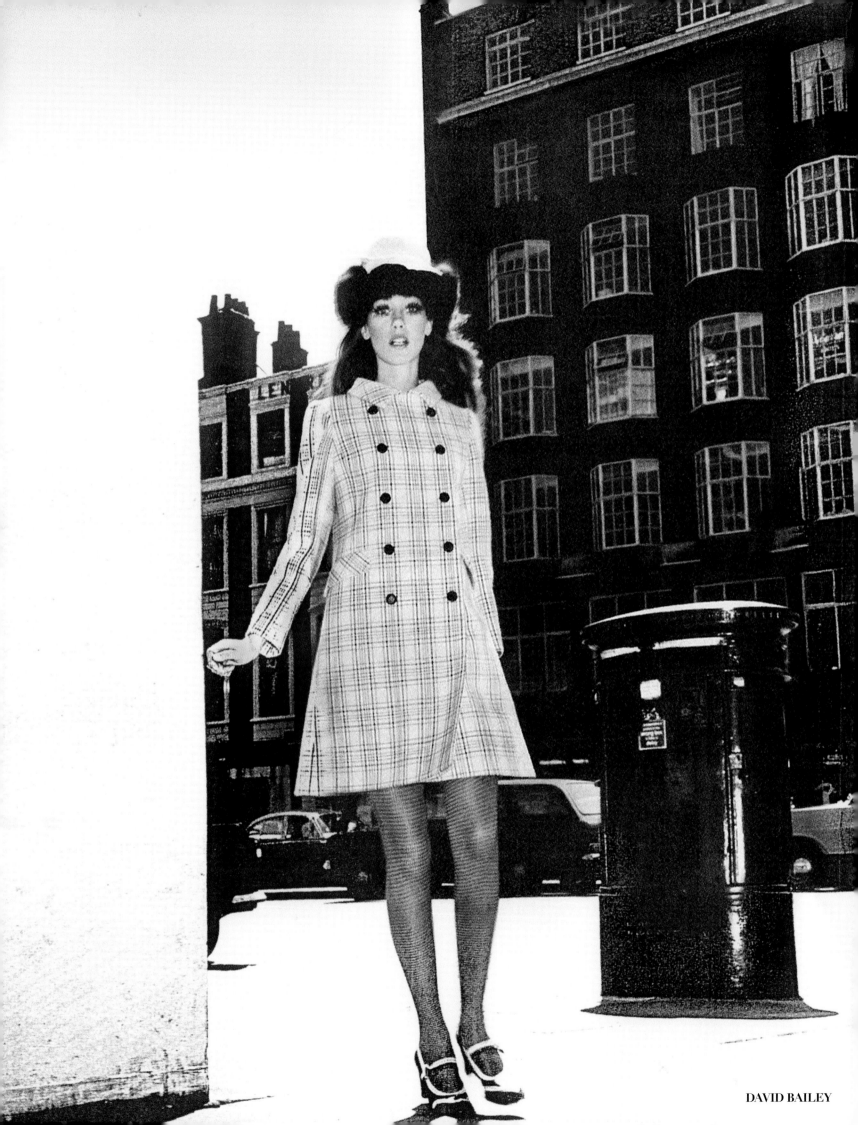

DAVID BAILEY

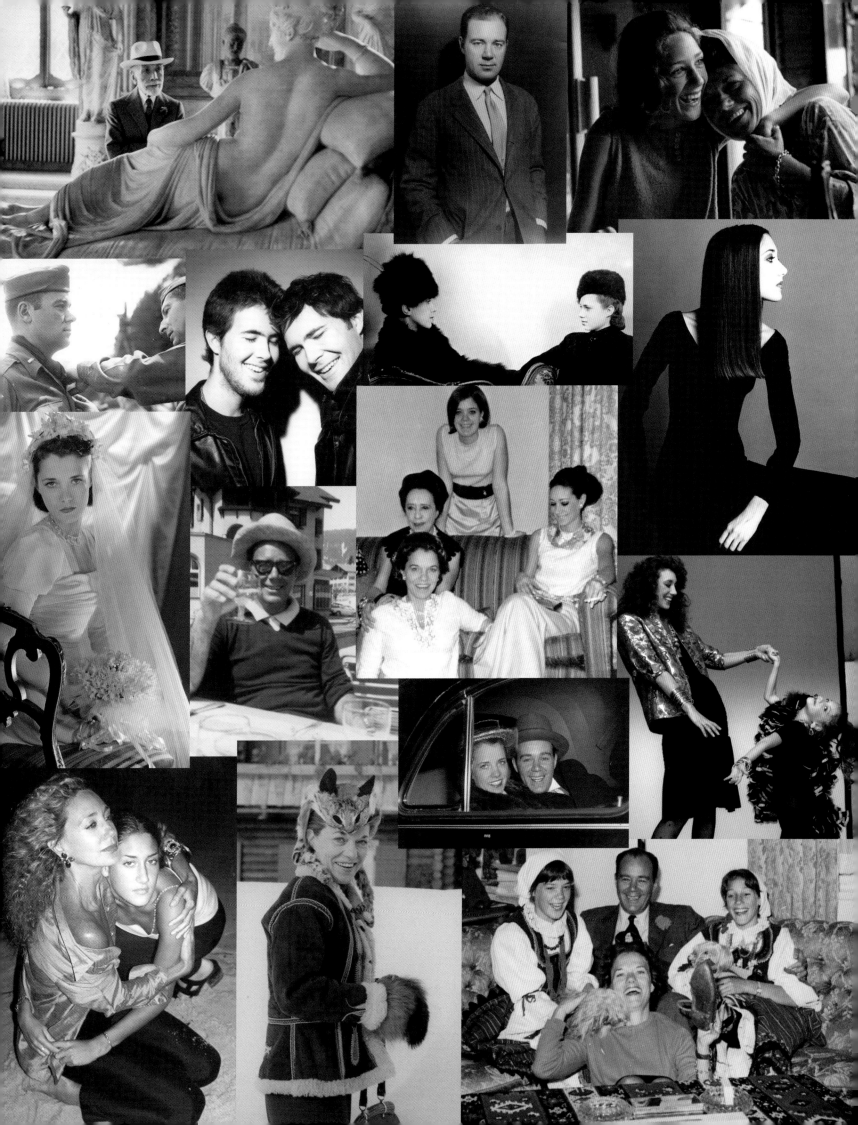

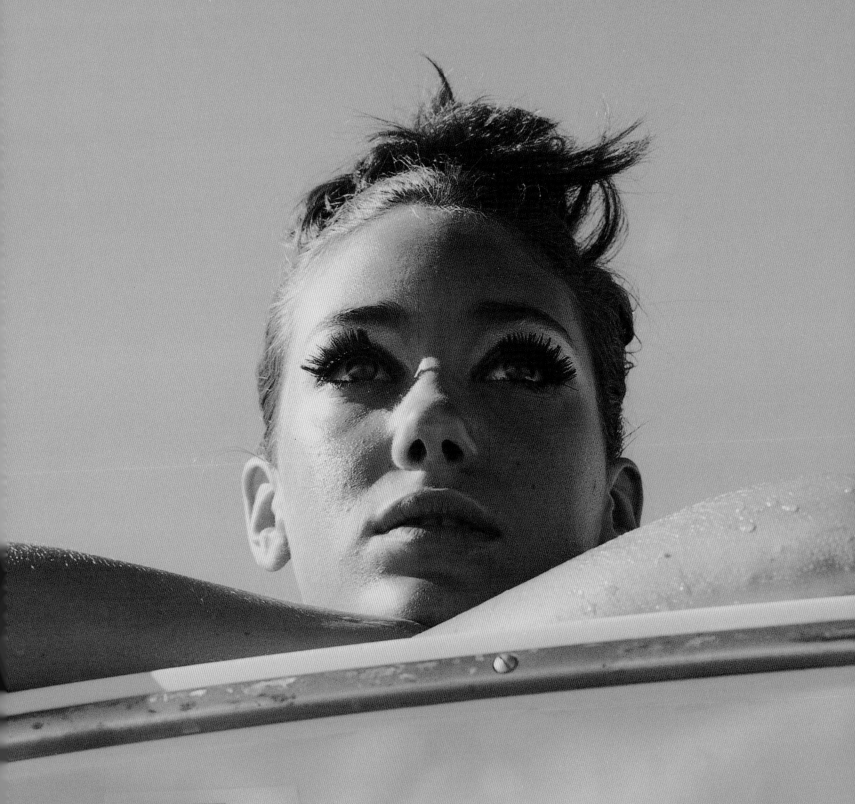

1965
UTAH BOAT
16275
REGISTRATION

JOHN COWAN

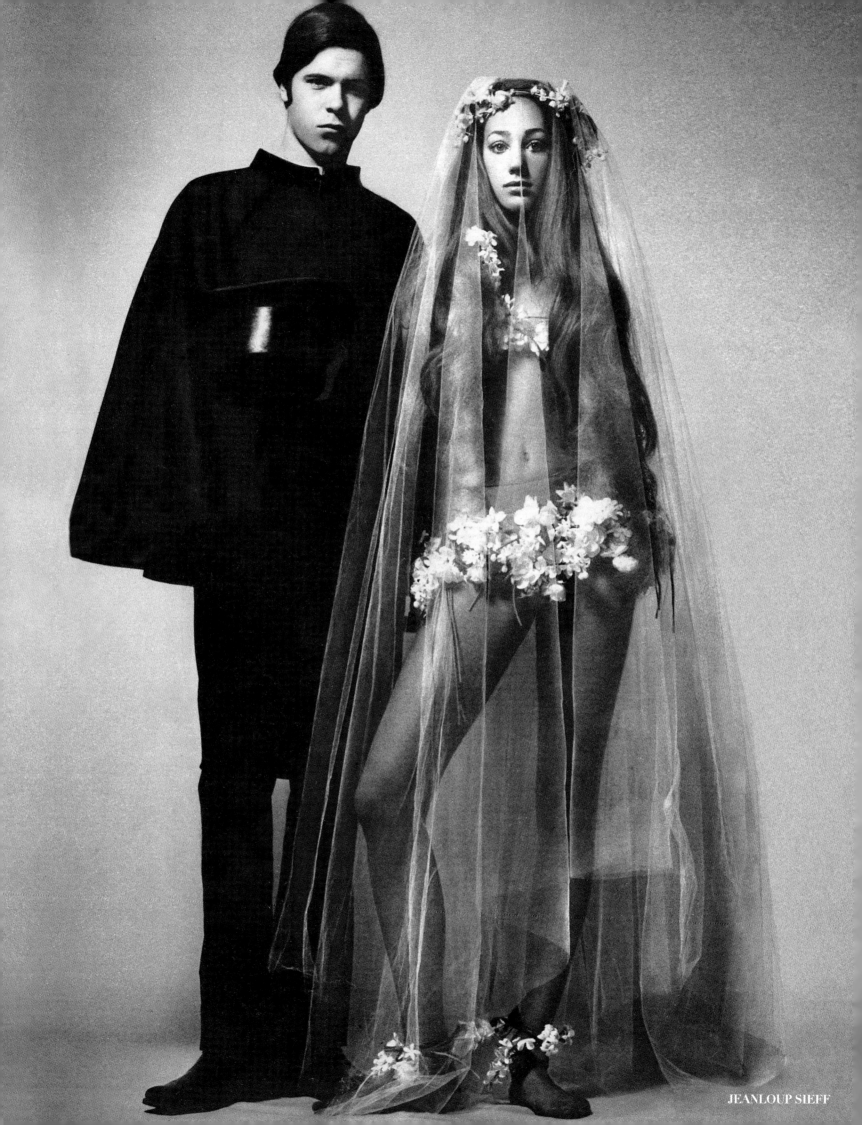

JEANLOUP SIEFF

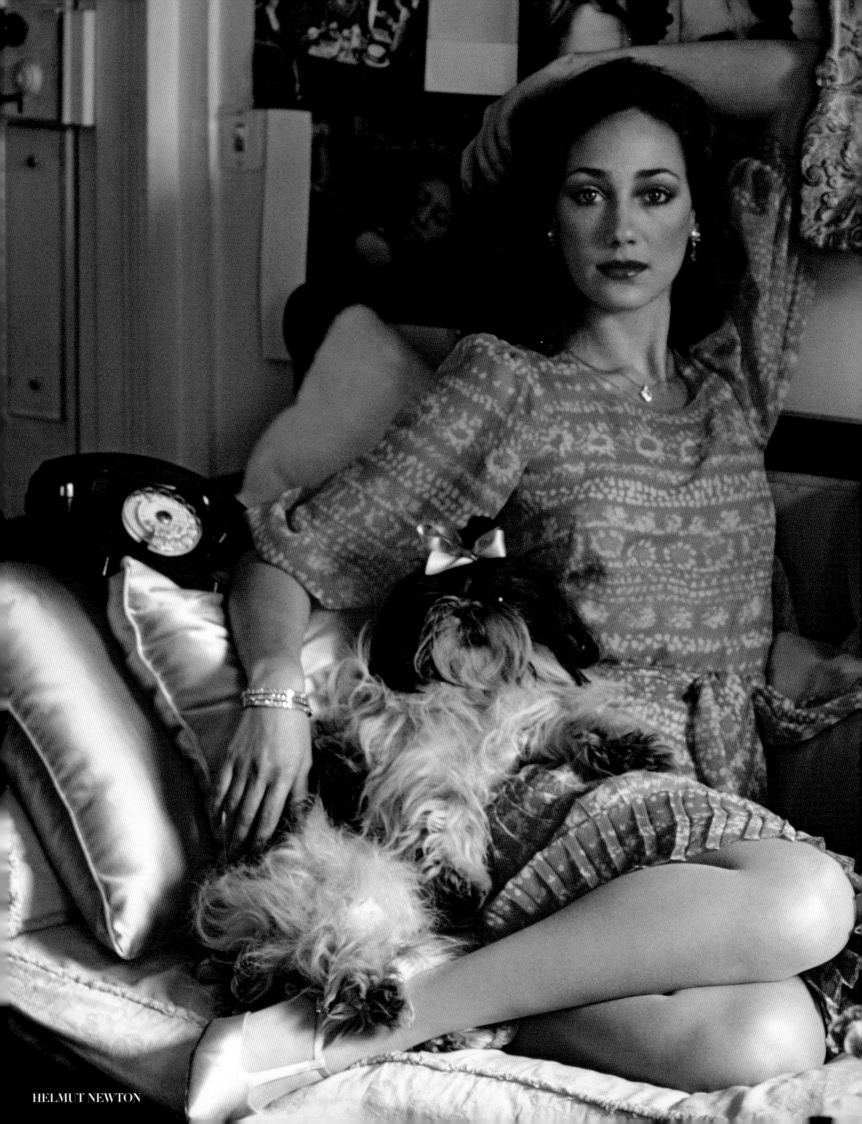

HELMUT NEWTON

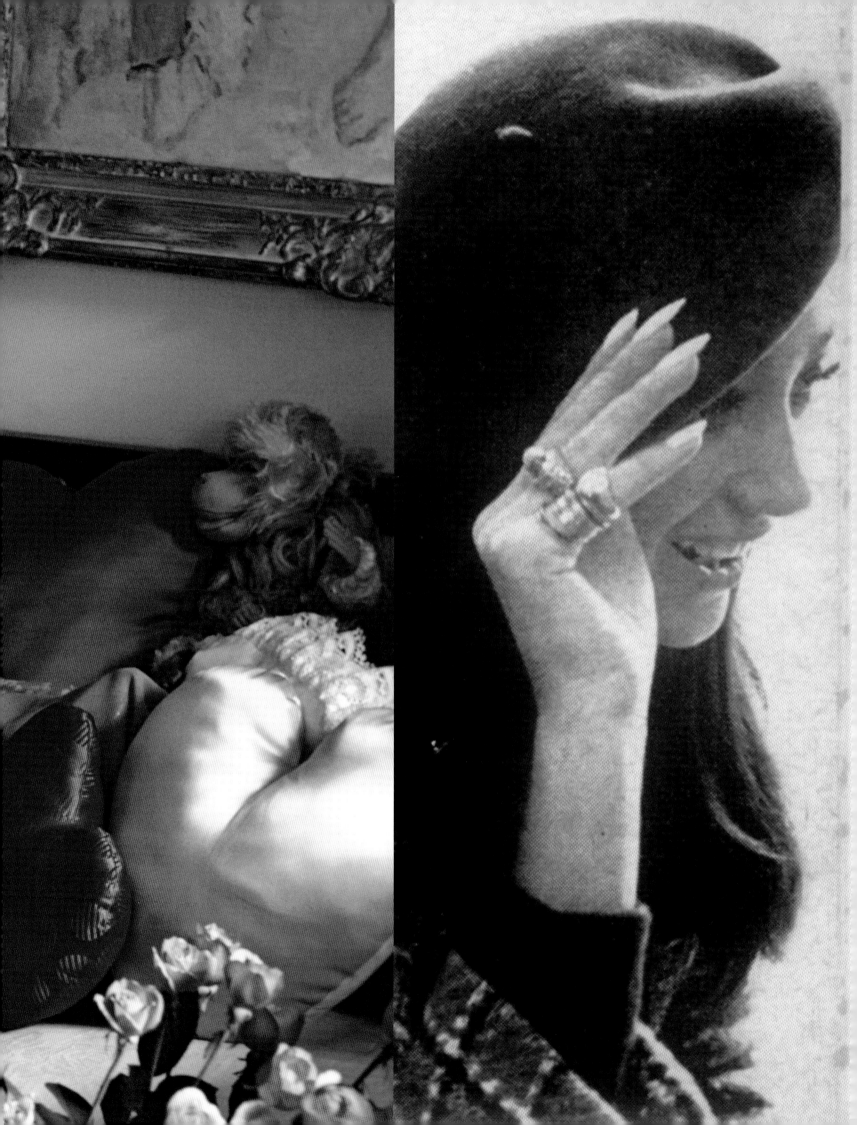

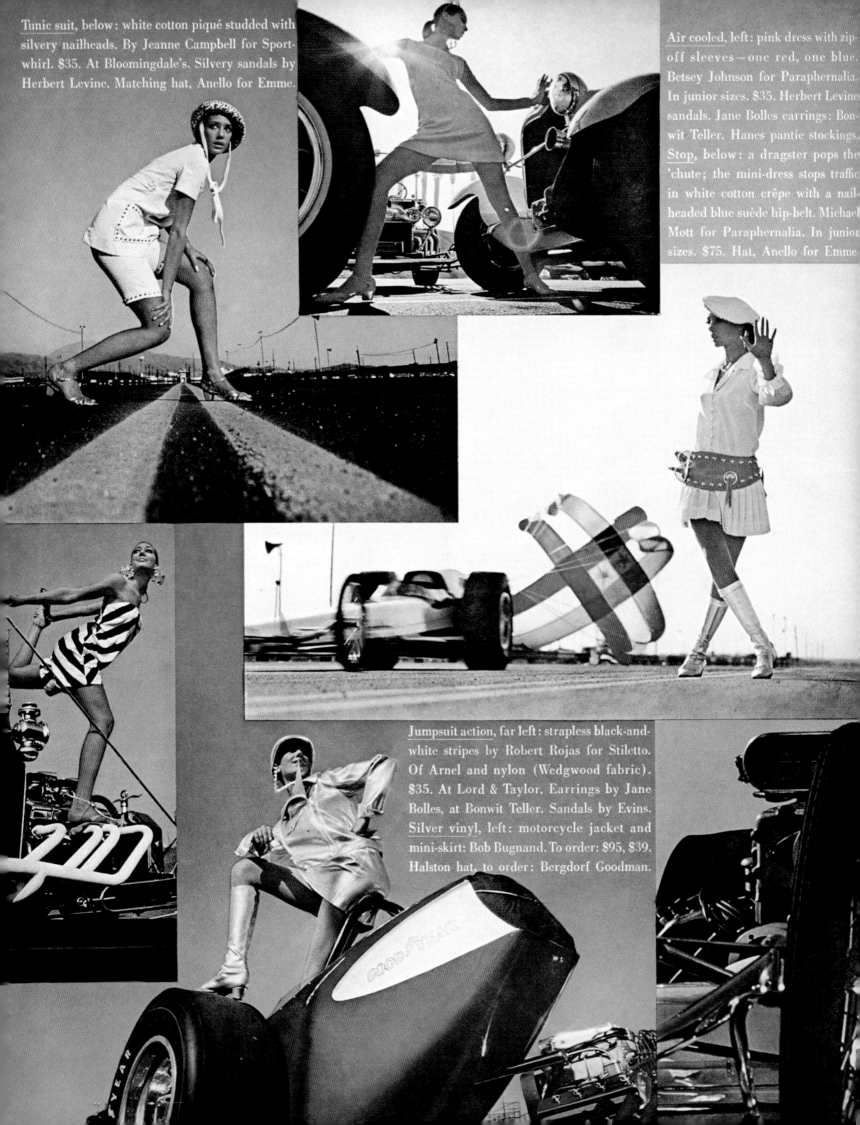

Tunic suit, below: white cotton piqué studded with silvery nailheads. By Jeanne Campbell for Sportwhirl. $35. At Bloomingdale's. Silvery sandals by Herbert Levine. Matching hat, Anello for Emme.

Air cooled, left: pink dress with zip-off sleeves—one red, one blue. Betsey Johnson for Paraphernalia. In junior sizes. $35. Herbert Levine sandals. Jane Bolles earrings: Bonwit Teller. Hanes pantie stockings. Stop, below: a dragster pops the 'chute; the mini-dress stops traffic in white cotton crêpe with a nail-headed blue suède hip-belt. Michael Mott for Paraphernalia. In junior sizes. $75. Hat, Anello for Emme.

Jumpsuit action, far left: strapless black-and-white stripes by Robert Rojas for Stiletto. Of Arnel and nylon (Wedgwood fabric). $35. At Lord & Taylor. Earrings by Jane Bolles, at Bonwit Teller. Sandals by Evins. Silver vinyl, left: motorcycle jacket and mini-skirt: Bob Bugnand. To order: $95, $39. Halston hat, to order: Bergdorf Goodman.

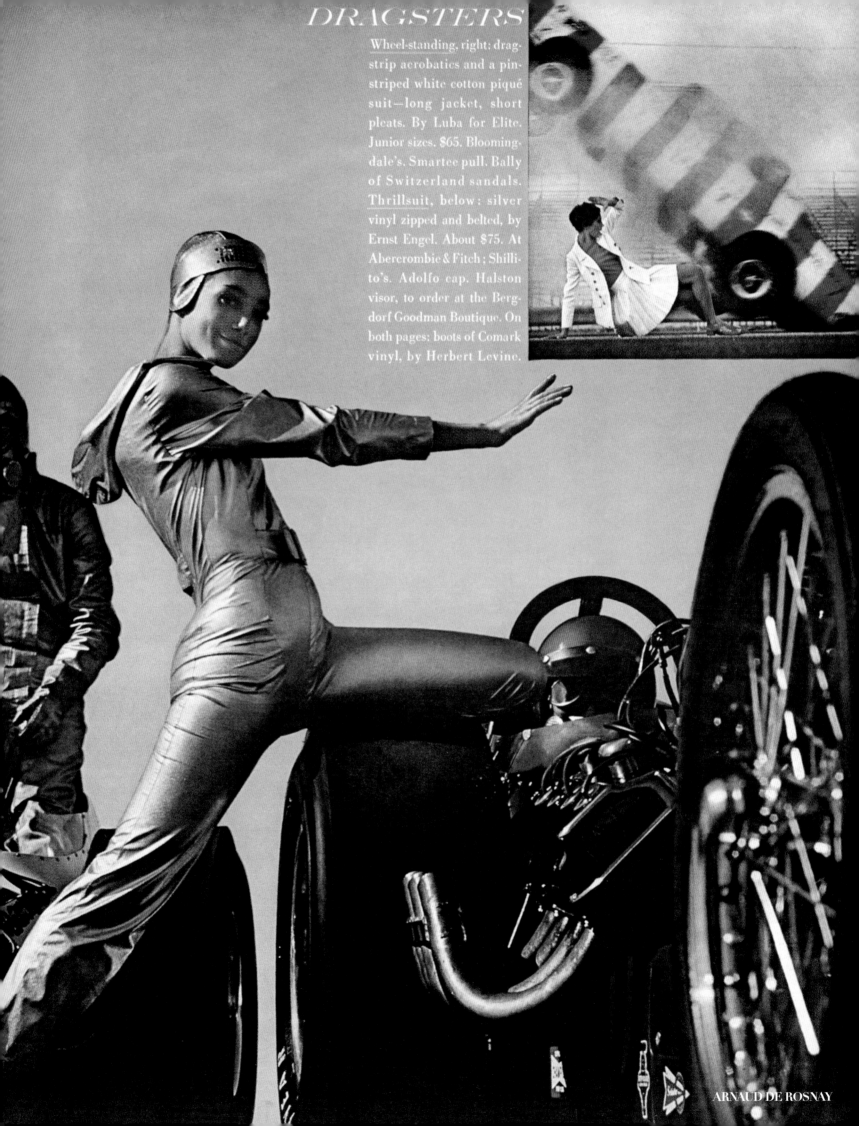

DRAGSTERS

Wheel-standing, right: drag-strip acrobatics and a pin-striped white cotton piqué suit—long jacket, short pleats. By Luba for Elite. Junior sizes. $65. Blooming-dale's. Smartee pull. Bally of Switzerland sandals. Thrillsuit, below: silver vinyl zipped and belted, by Ernst Engel. About $75. At Abercrombie & Fitch; Shilli-to's. Adolfo cap. Halston visor, to order at the Berg-dorf Goodman Boutique. On both pages: boots of Comark vinyl, by Herbert Levine.

ARNAUD DE ROSNAY

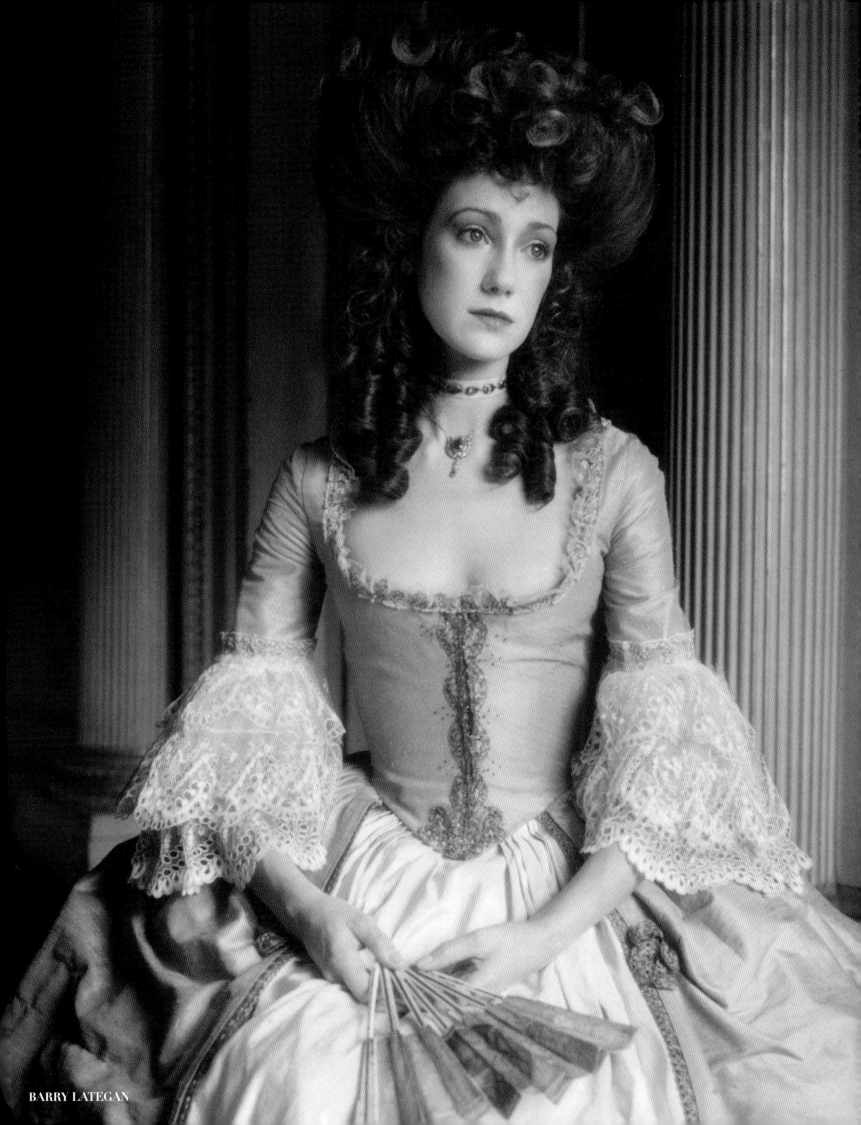

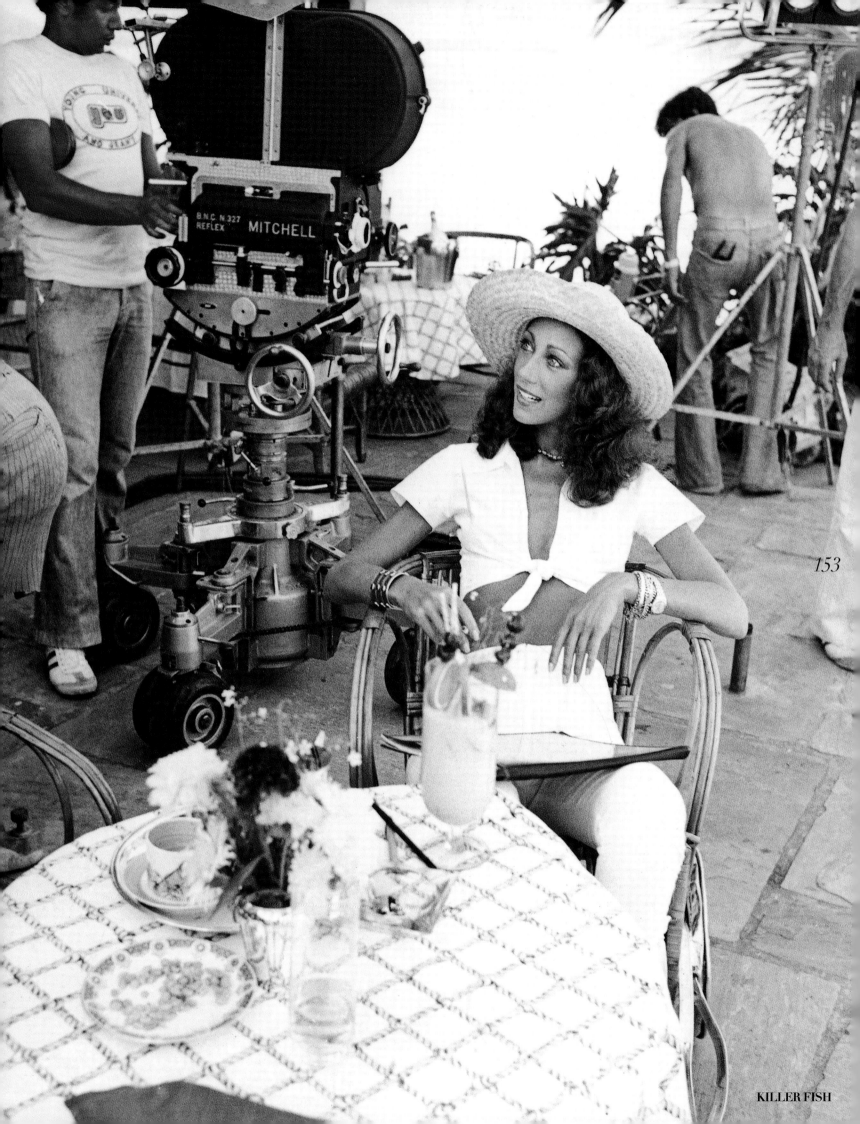

153

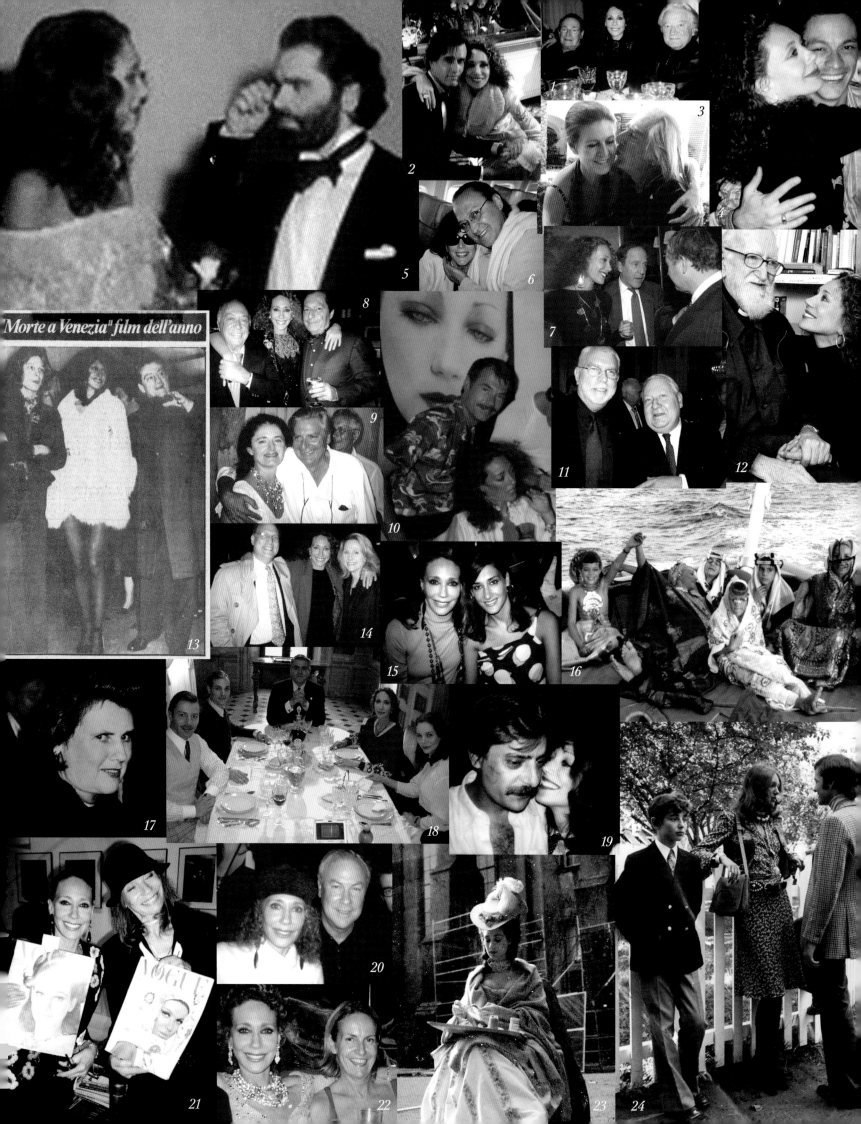

Morte a Venezia" film dell'anno

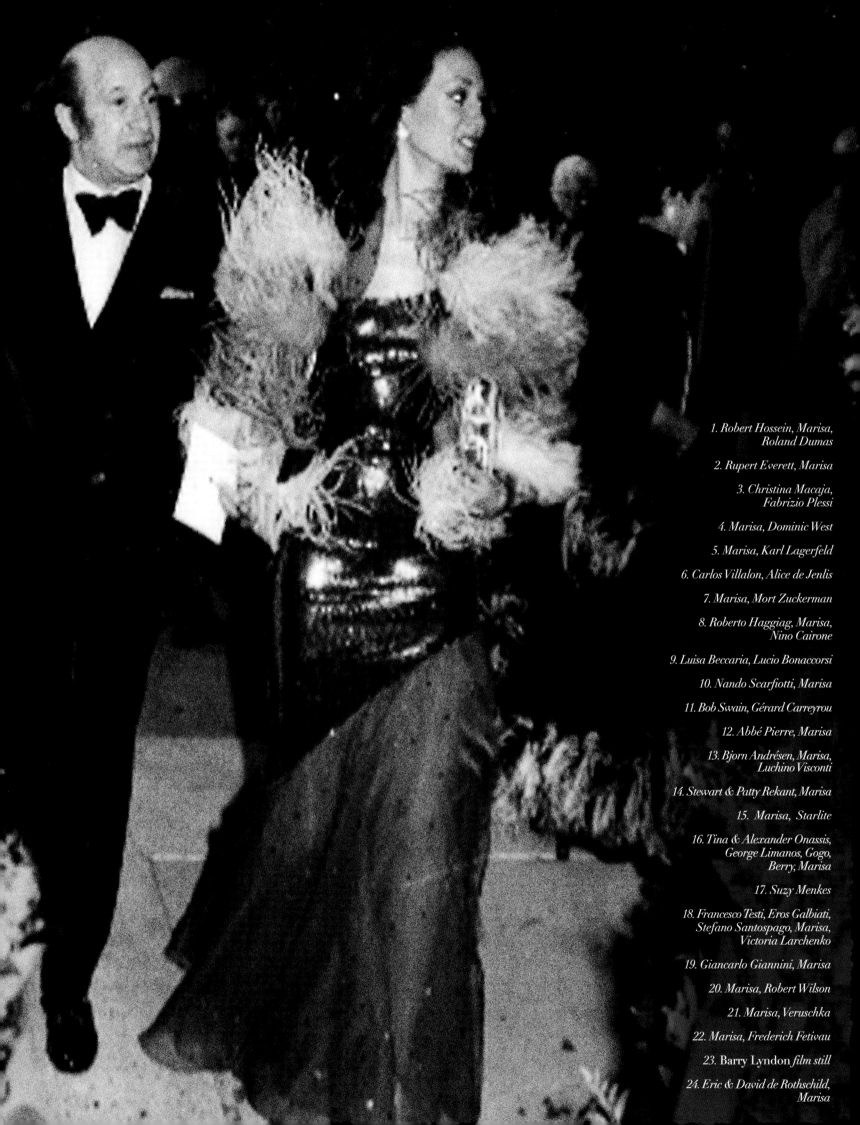

GERARD MALANGA
& ANDY WARHOL

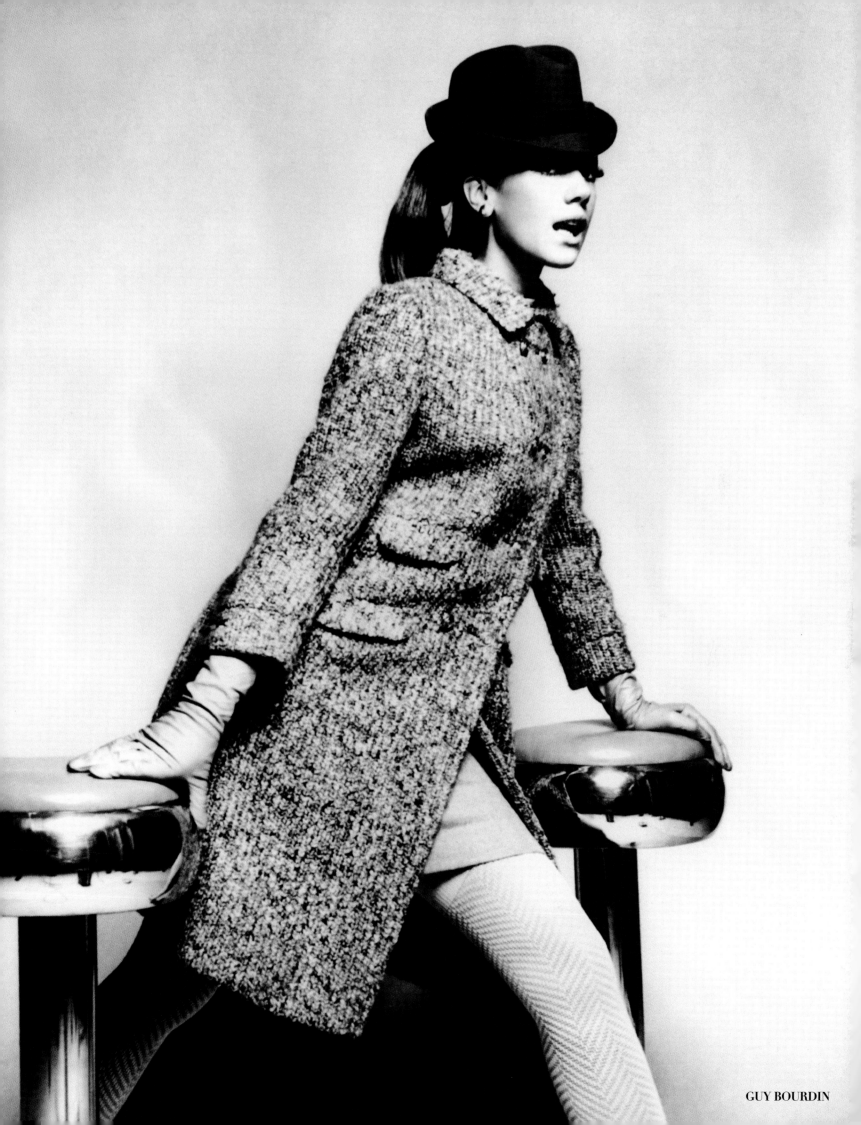

GUY BOURDIN

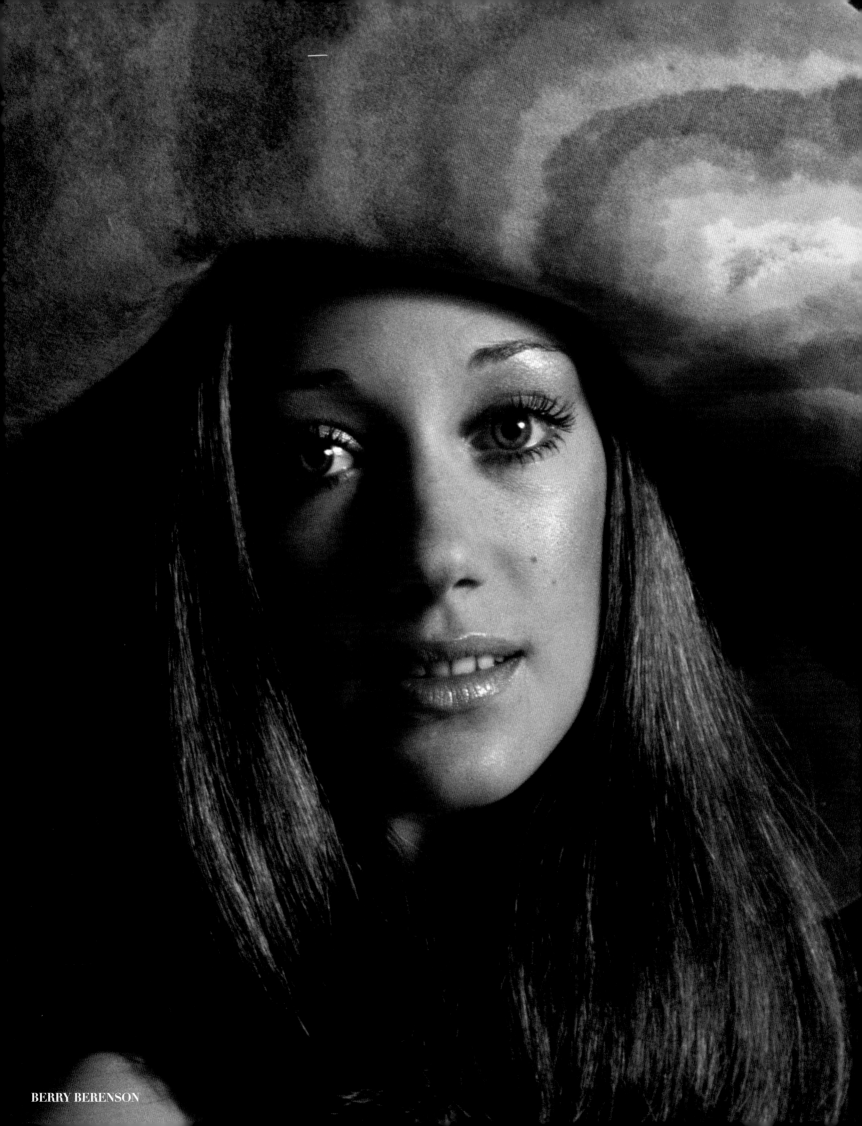

BERRY BERENSON

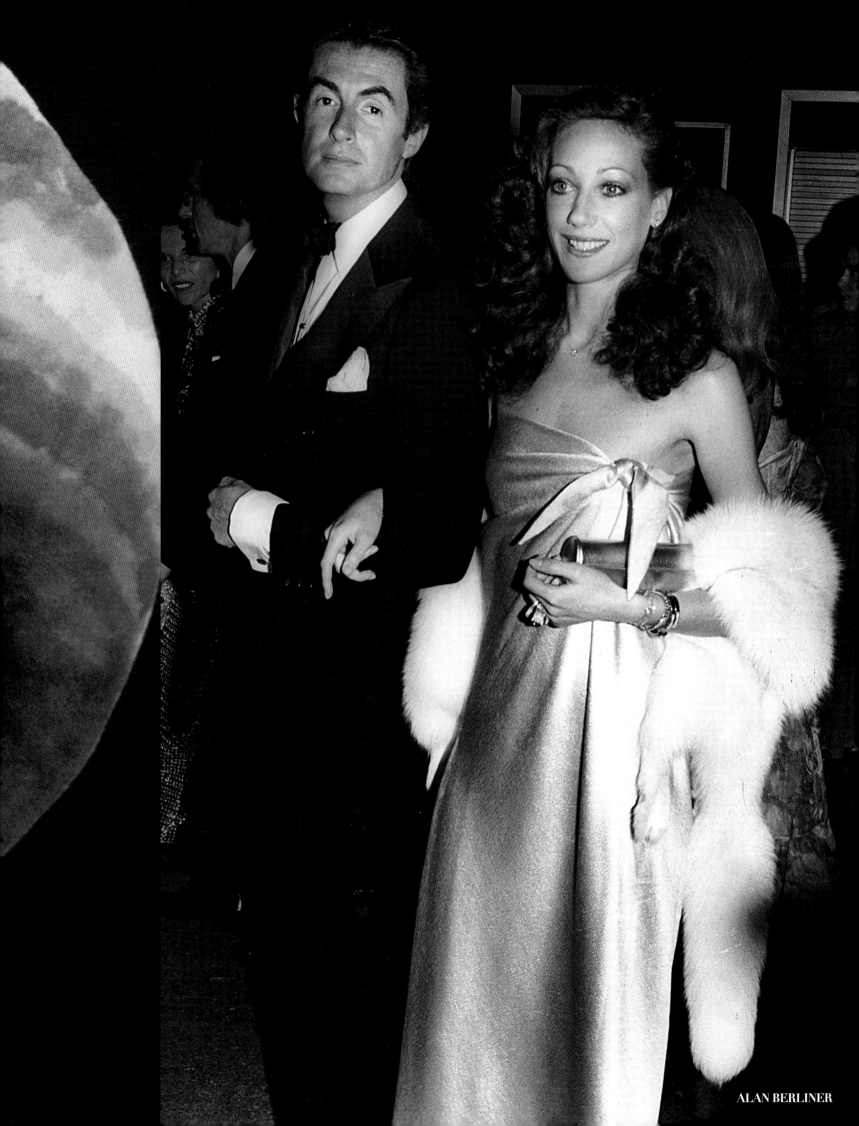

ALAN BERLINER

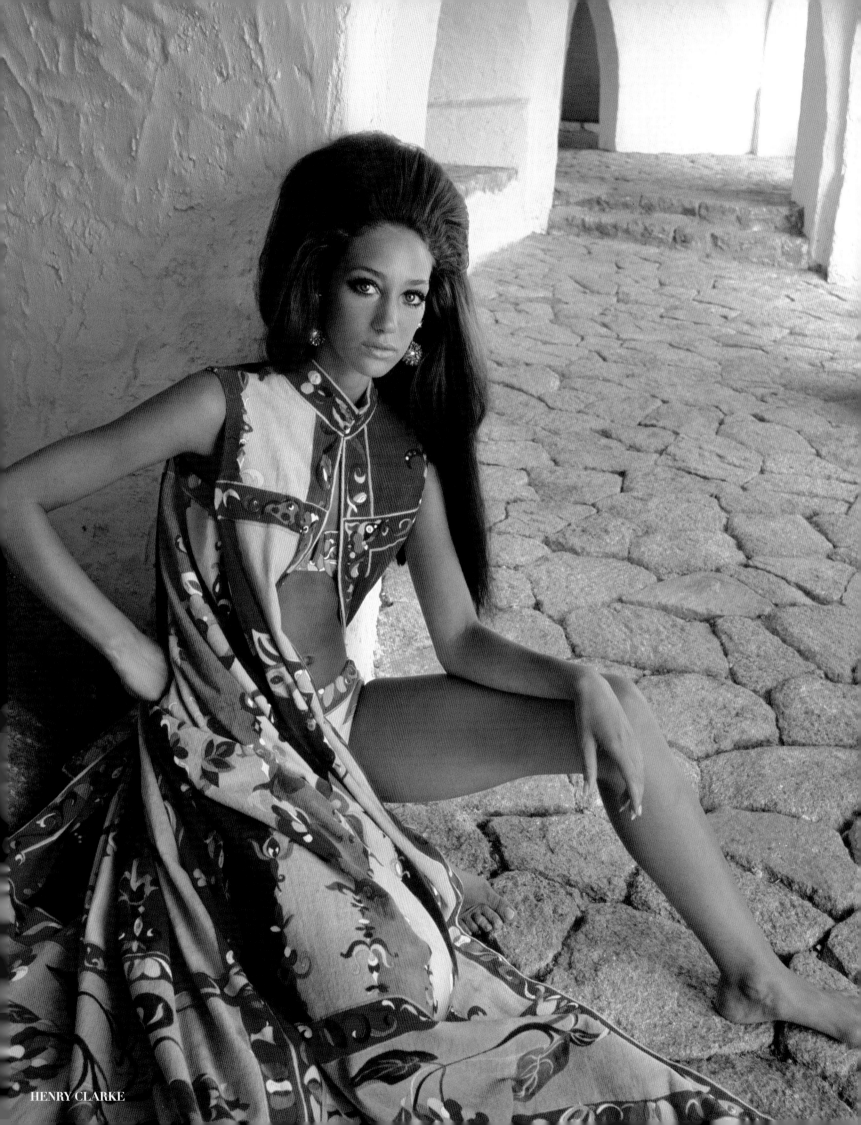

HENRY CLARKE

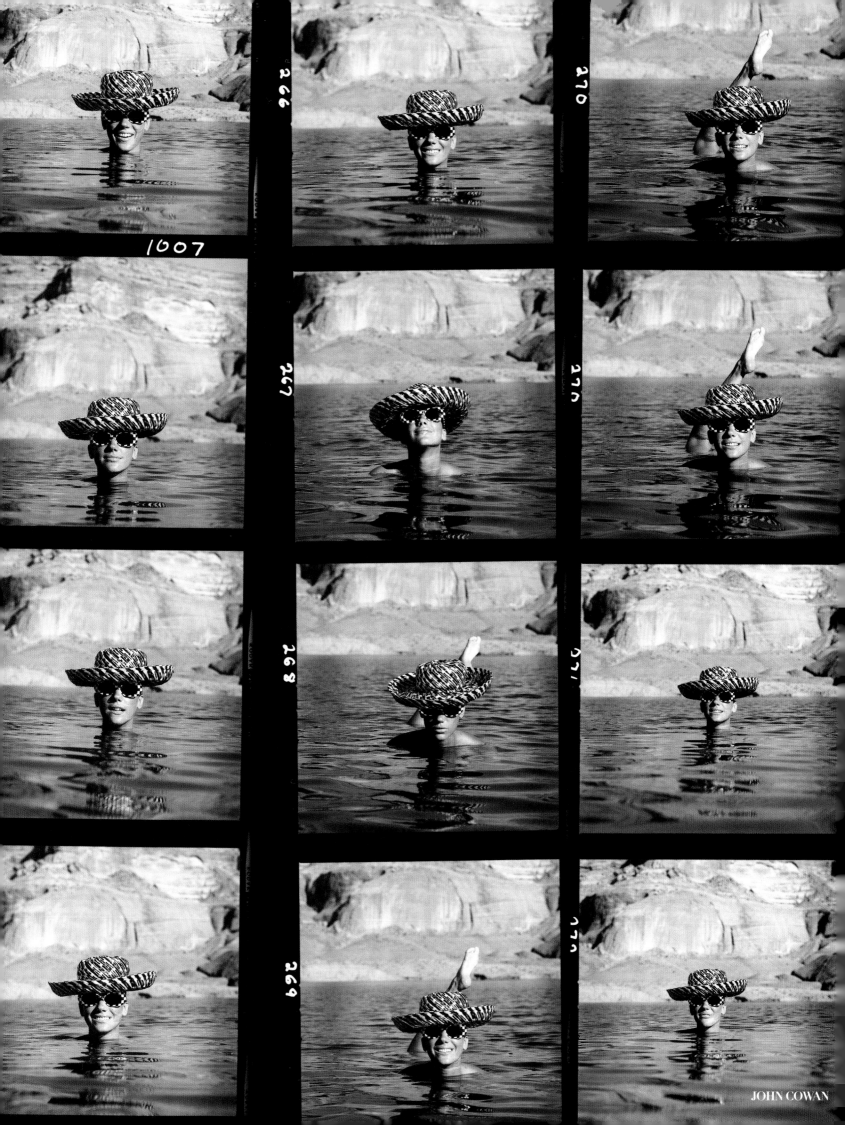

JOHN COWAN

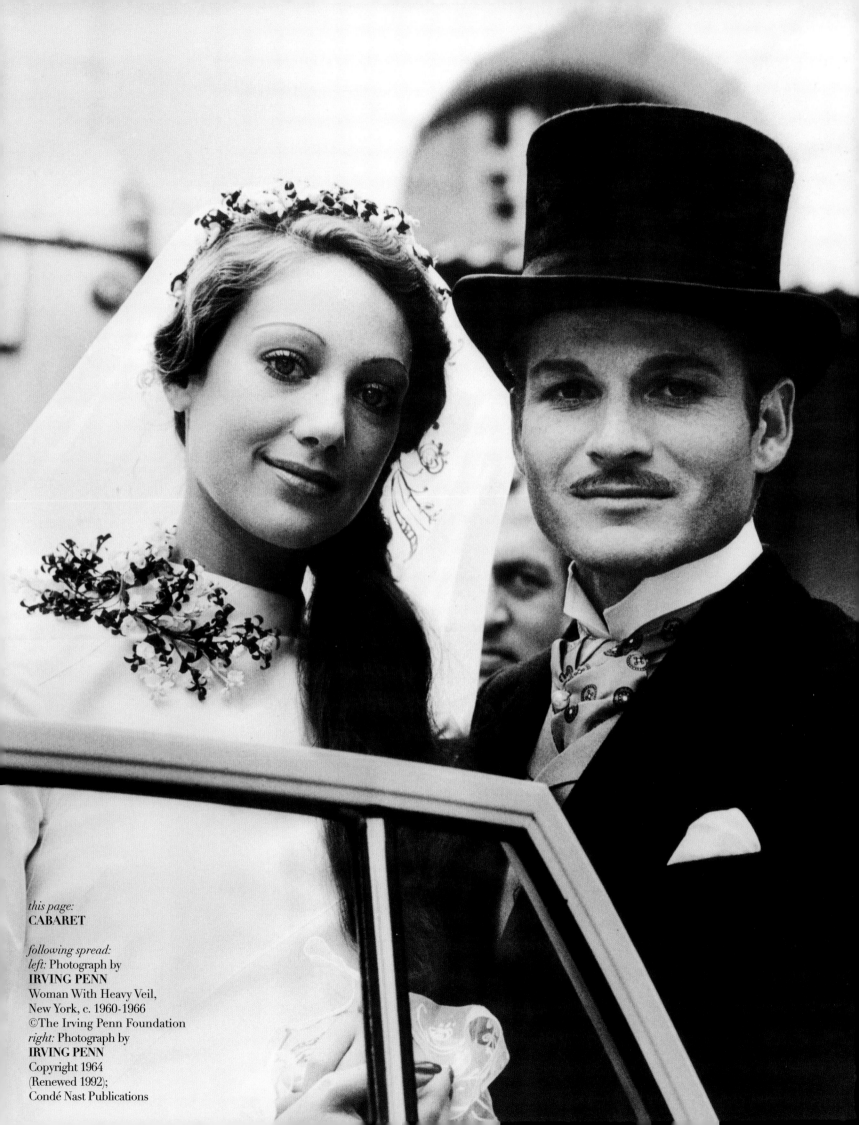

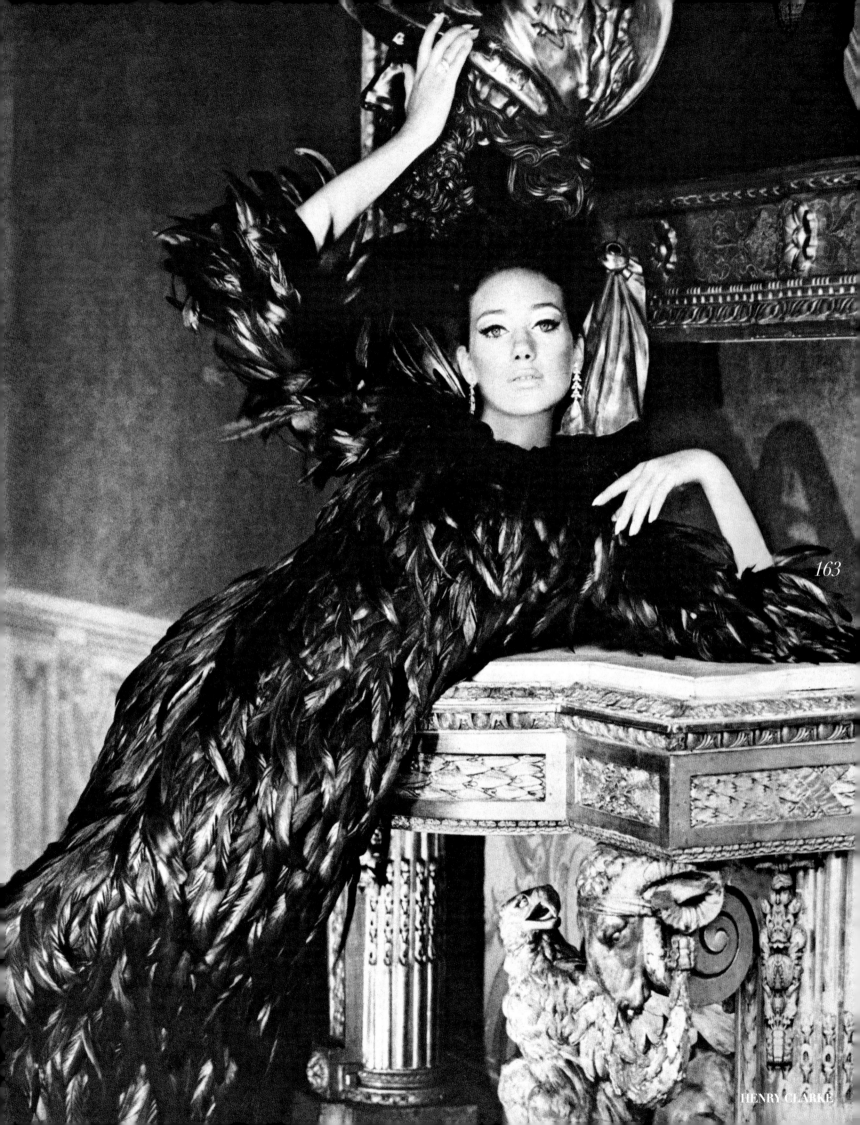

163

HENRY CLARKE

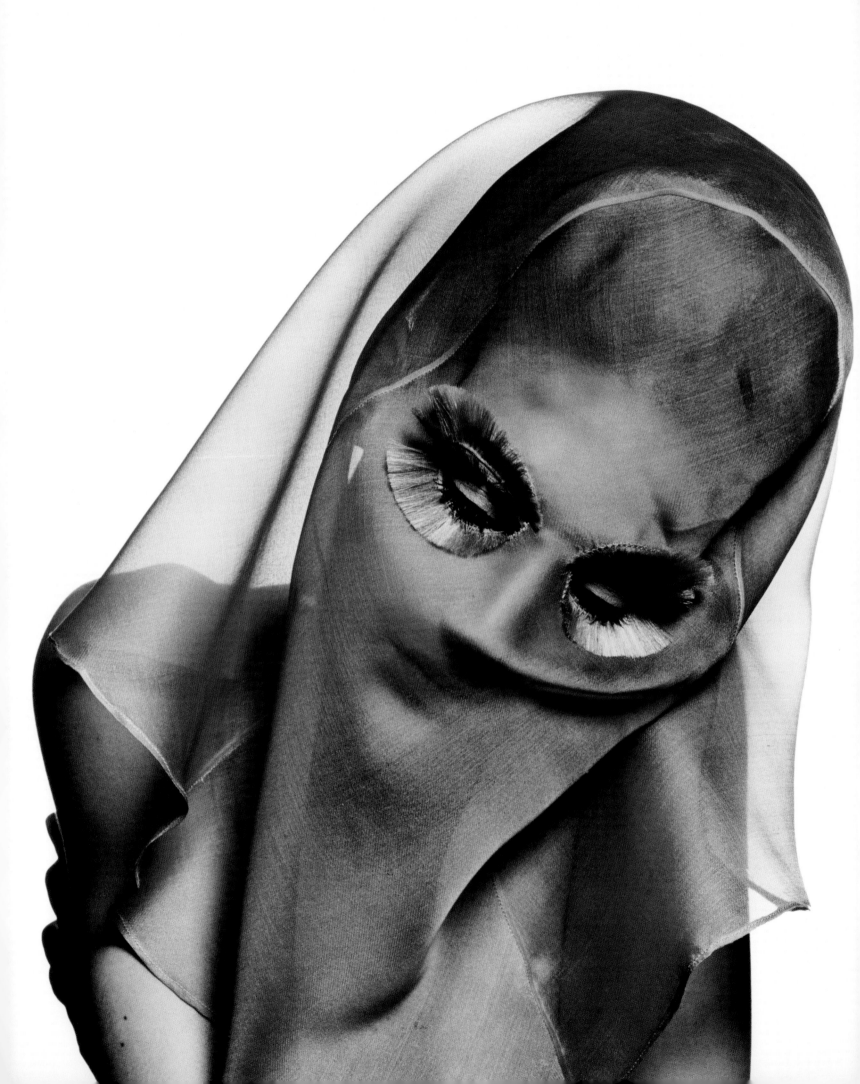

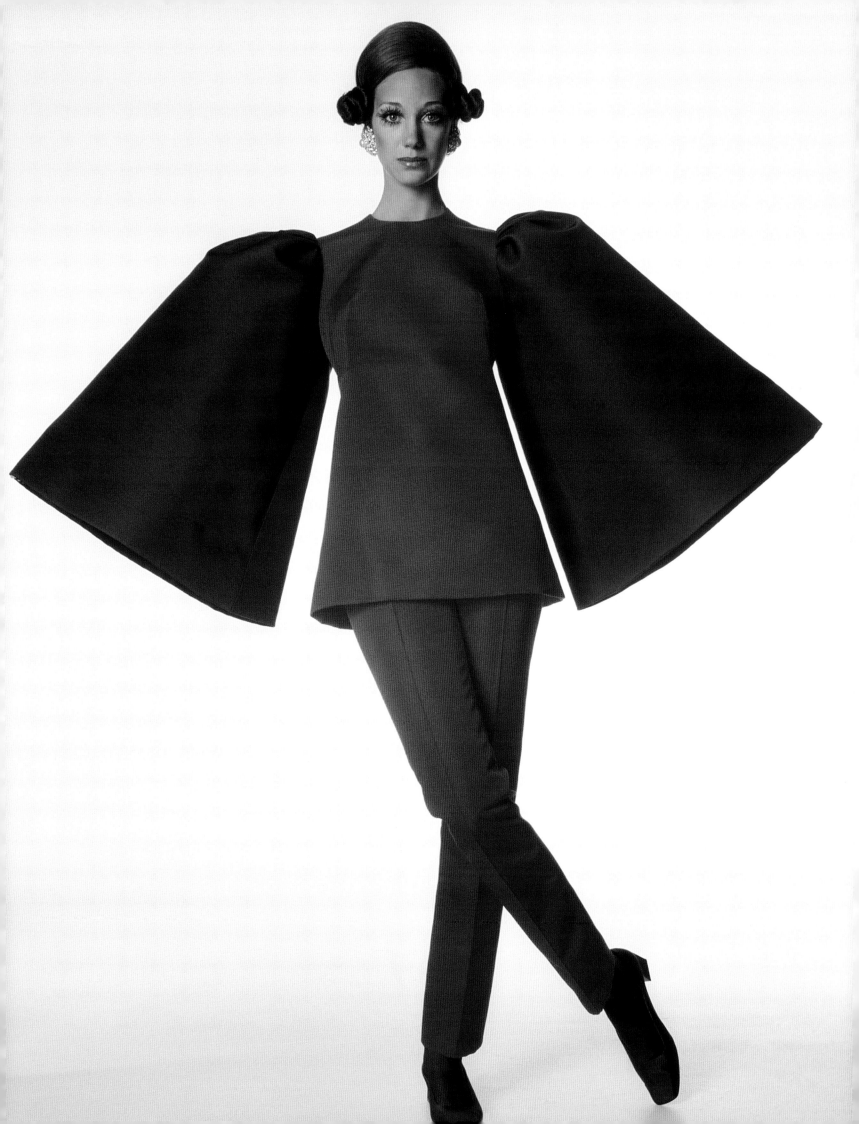

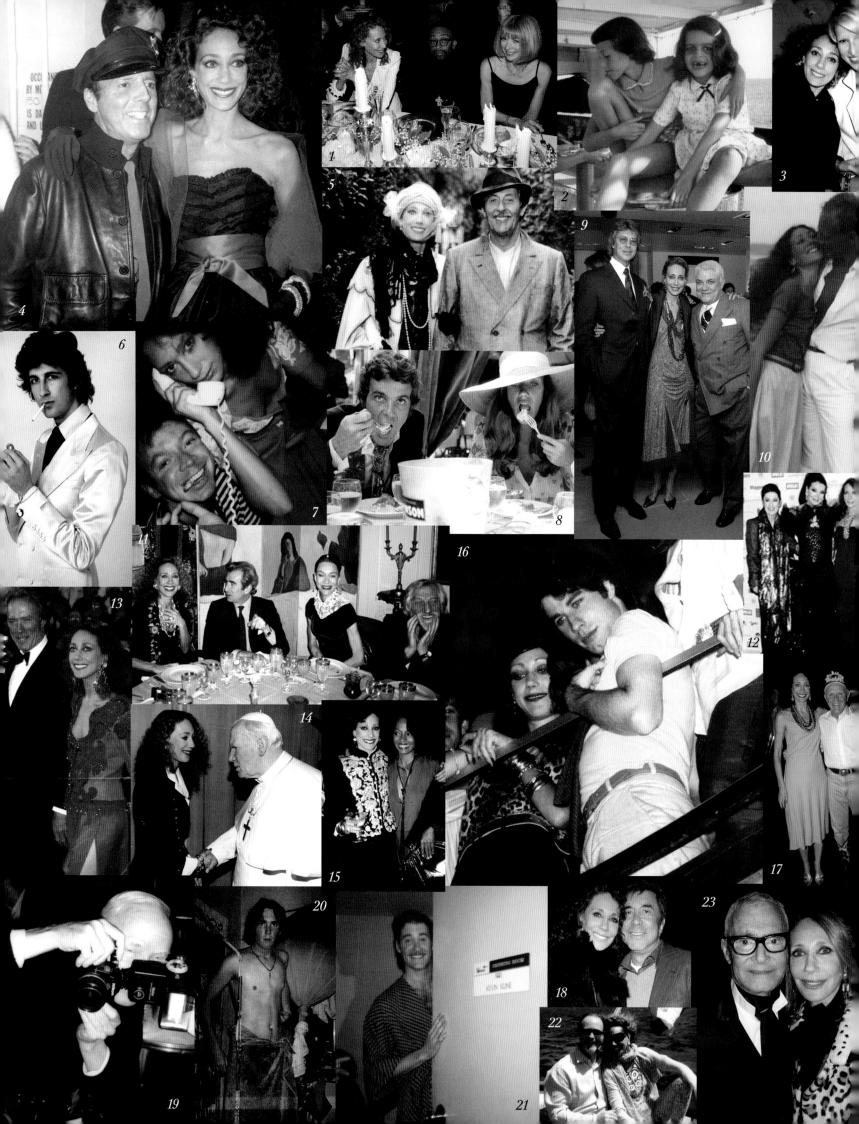

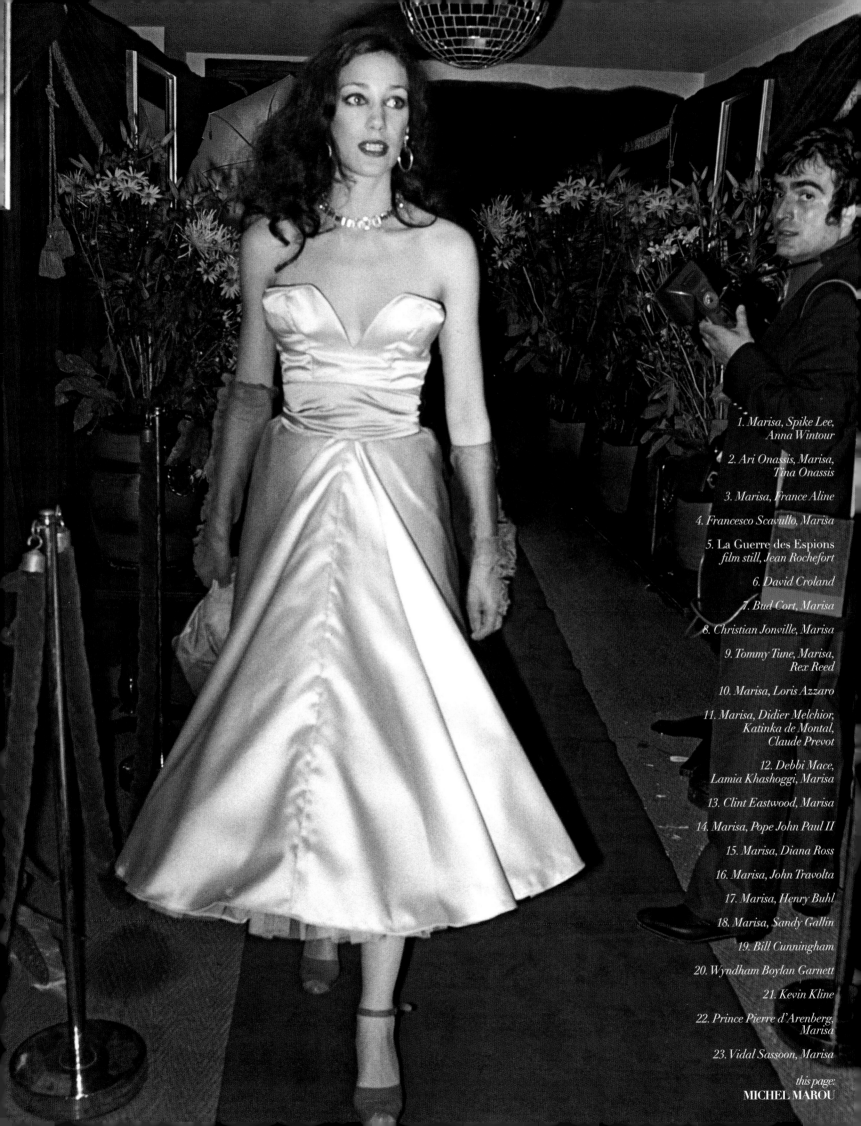

this page:
MICHEL MAROU

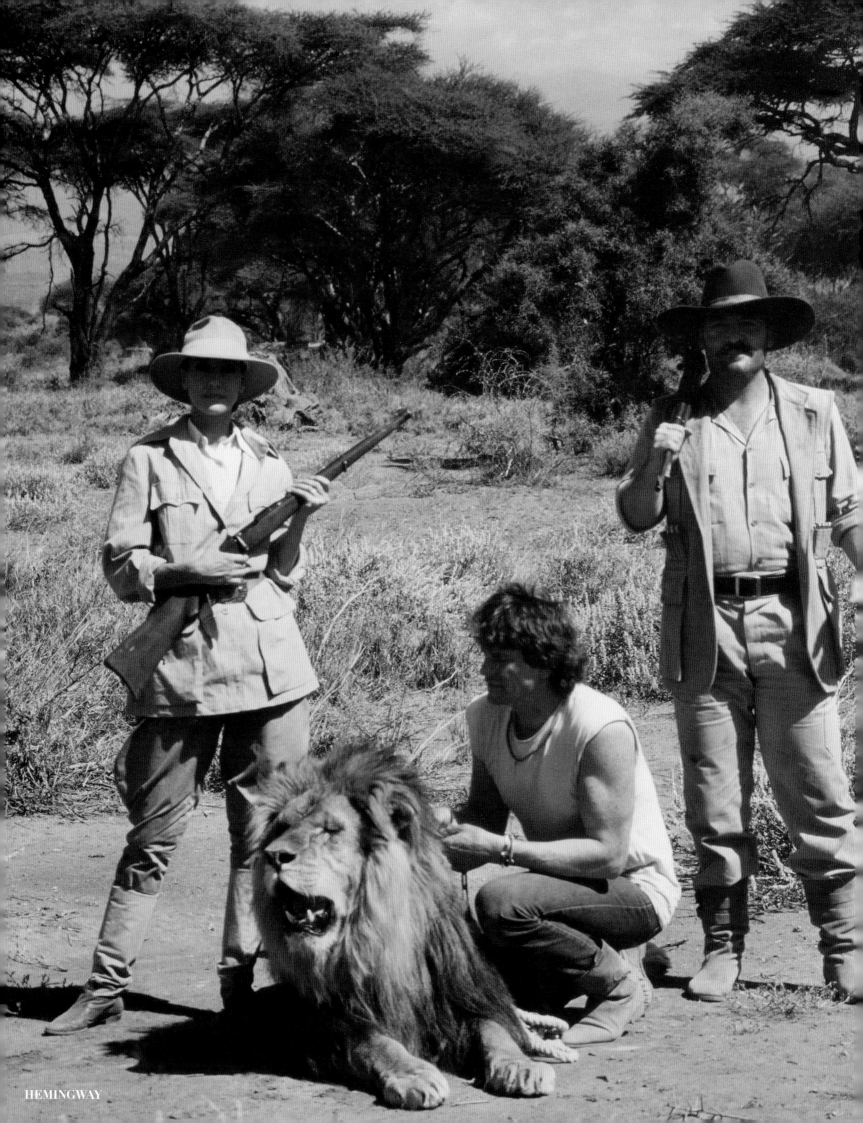

HEMINGWAY

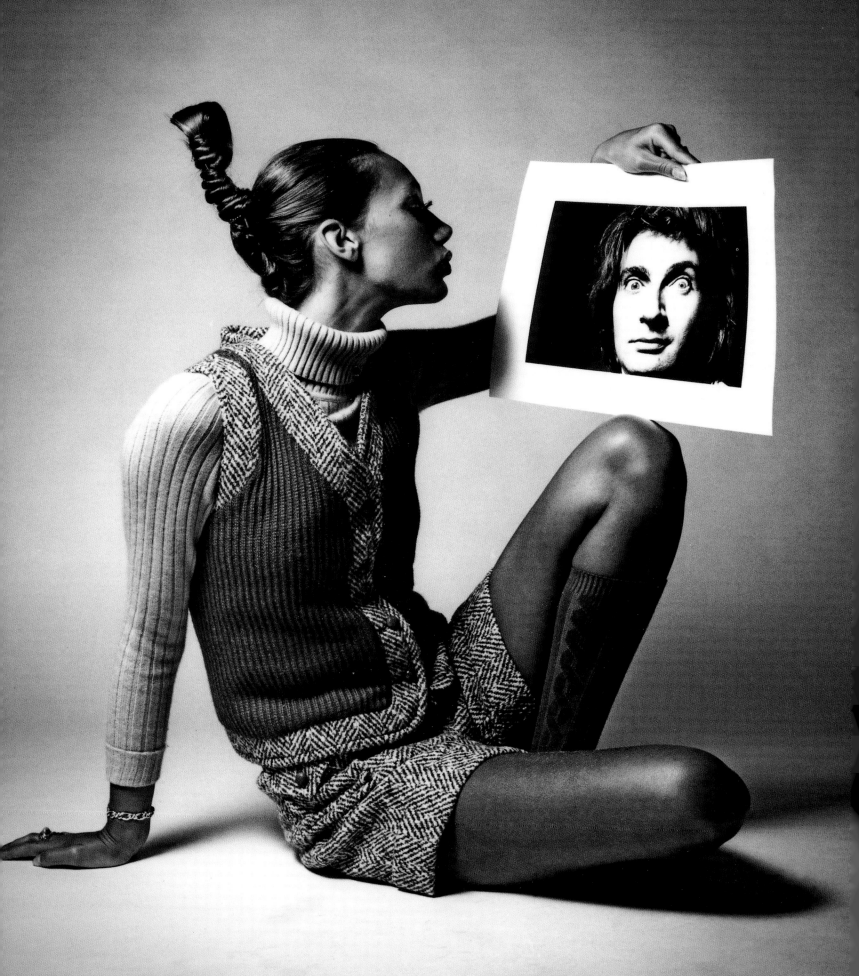

JEANLOUP SIEFF

DAVID BAILEY

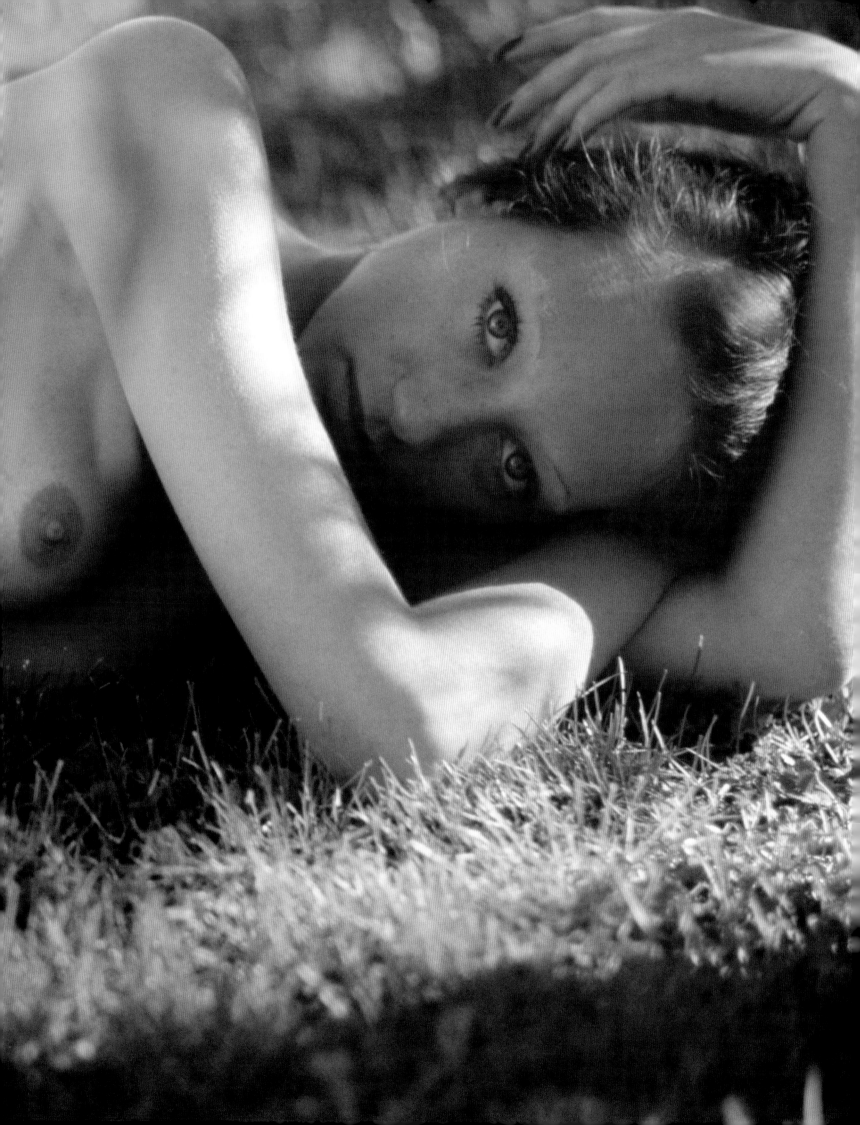

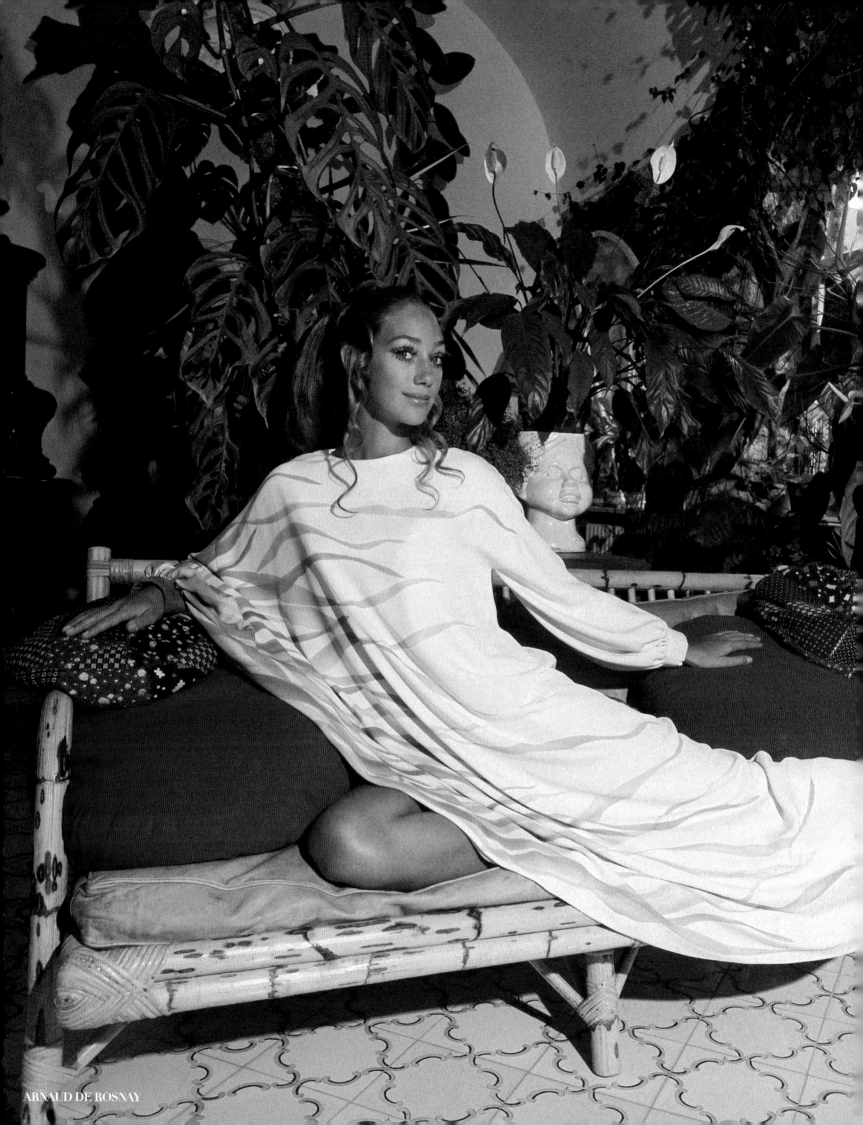

ARNAUD DE ROSNAY

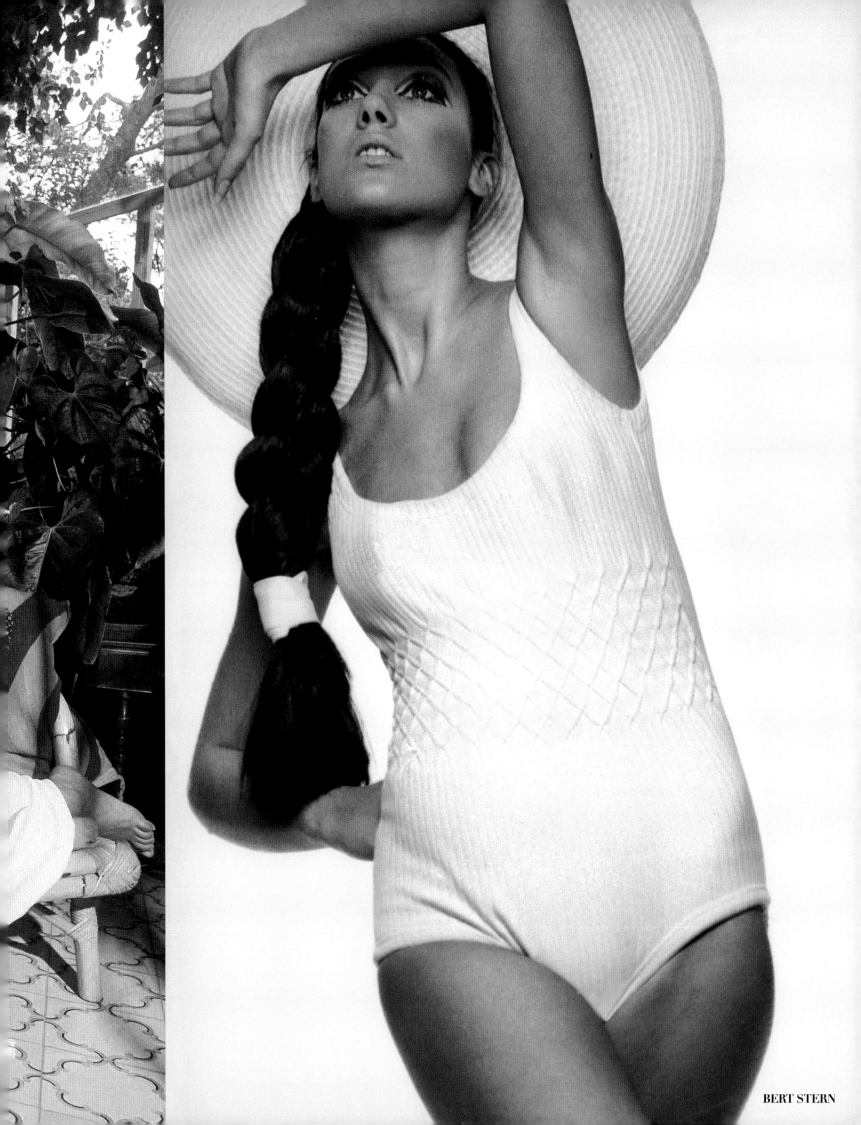

BERT STERN

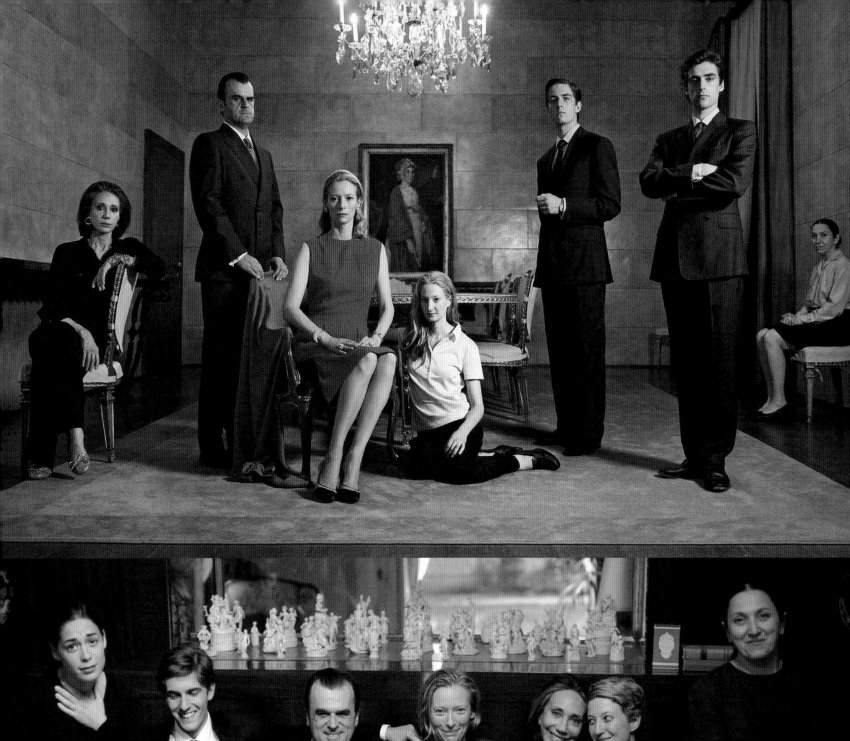
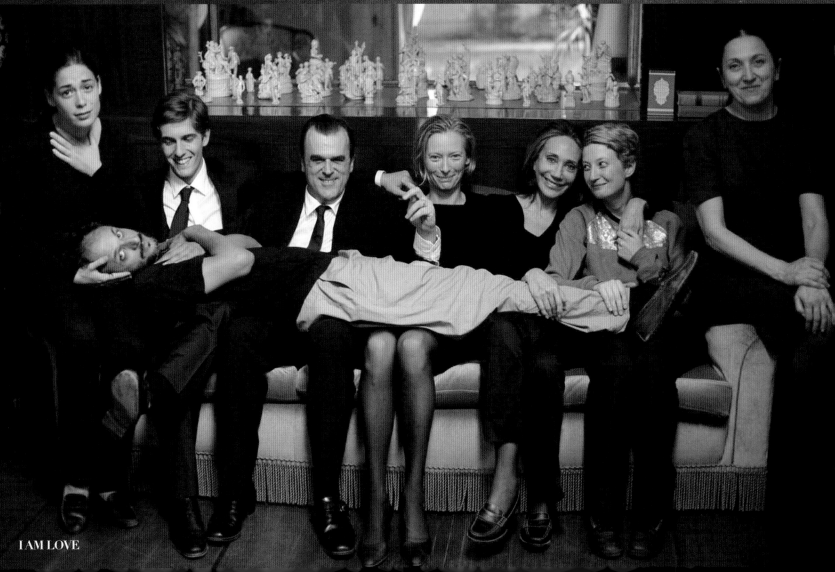

I AM LOVE

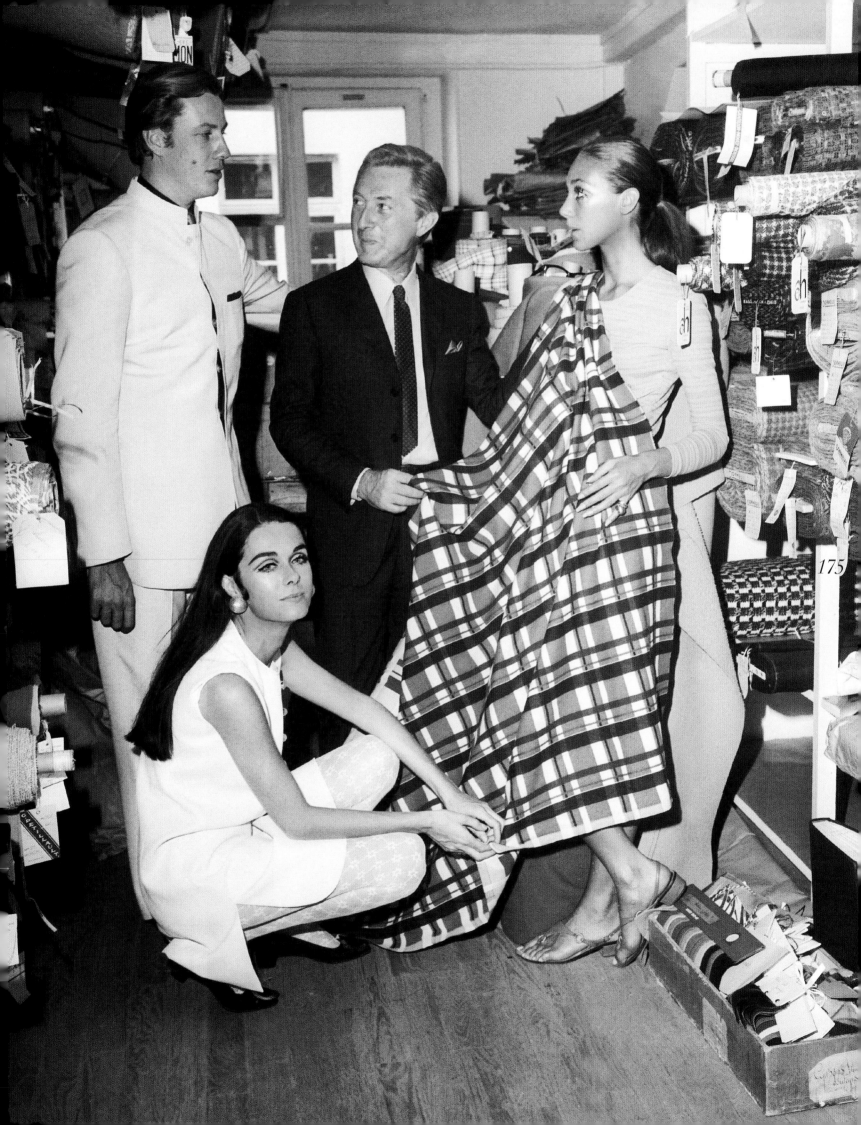

175

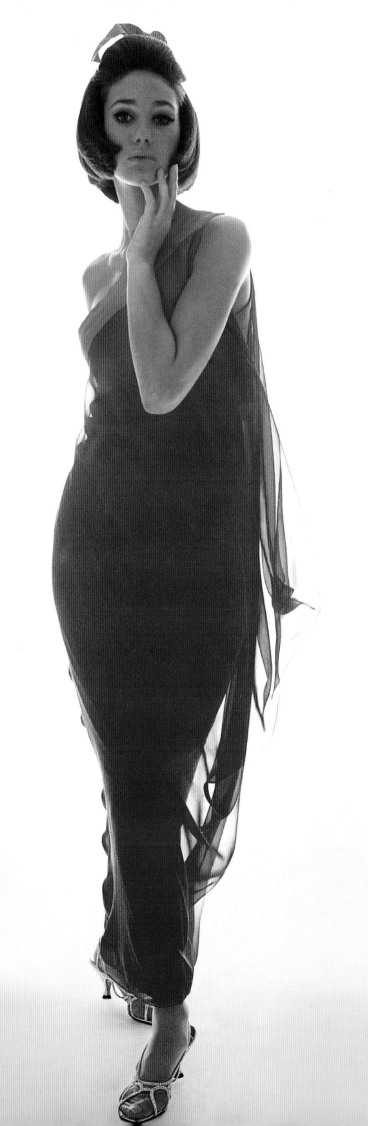

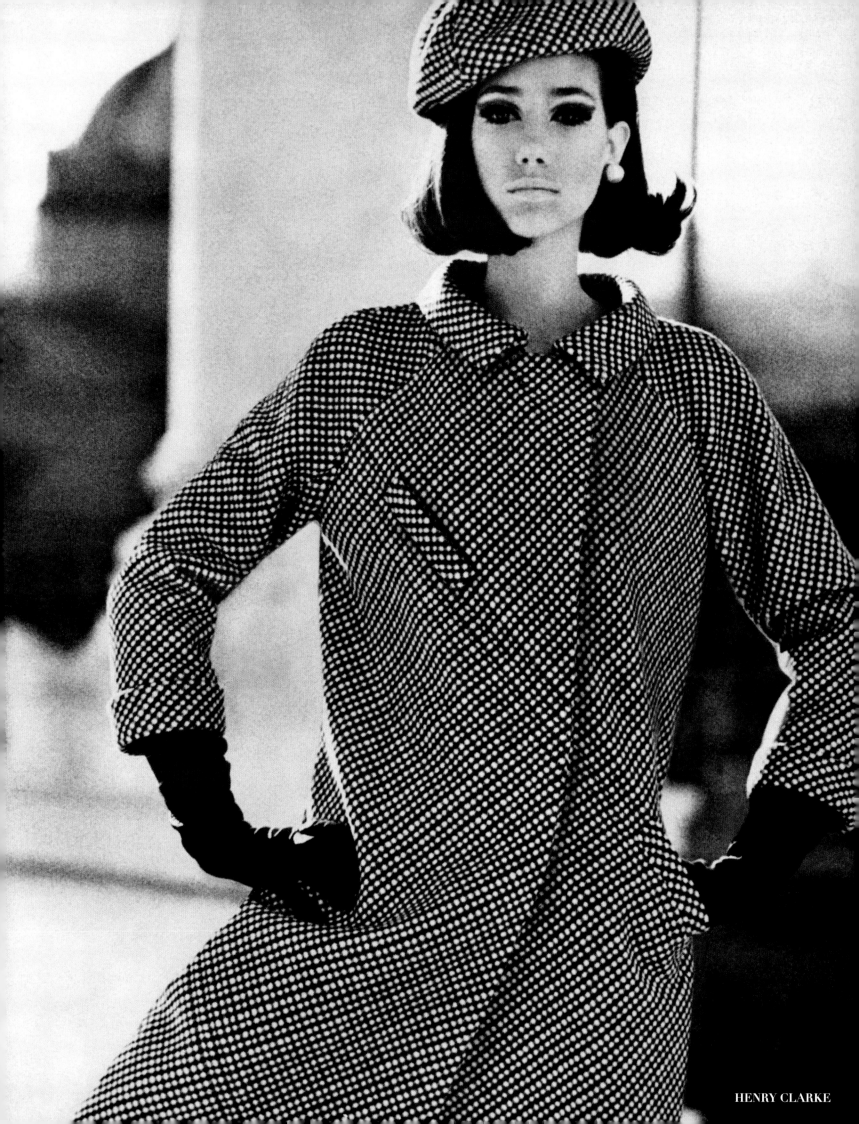

HENRY CLARKE

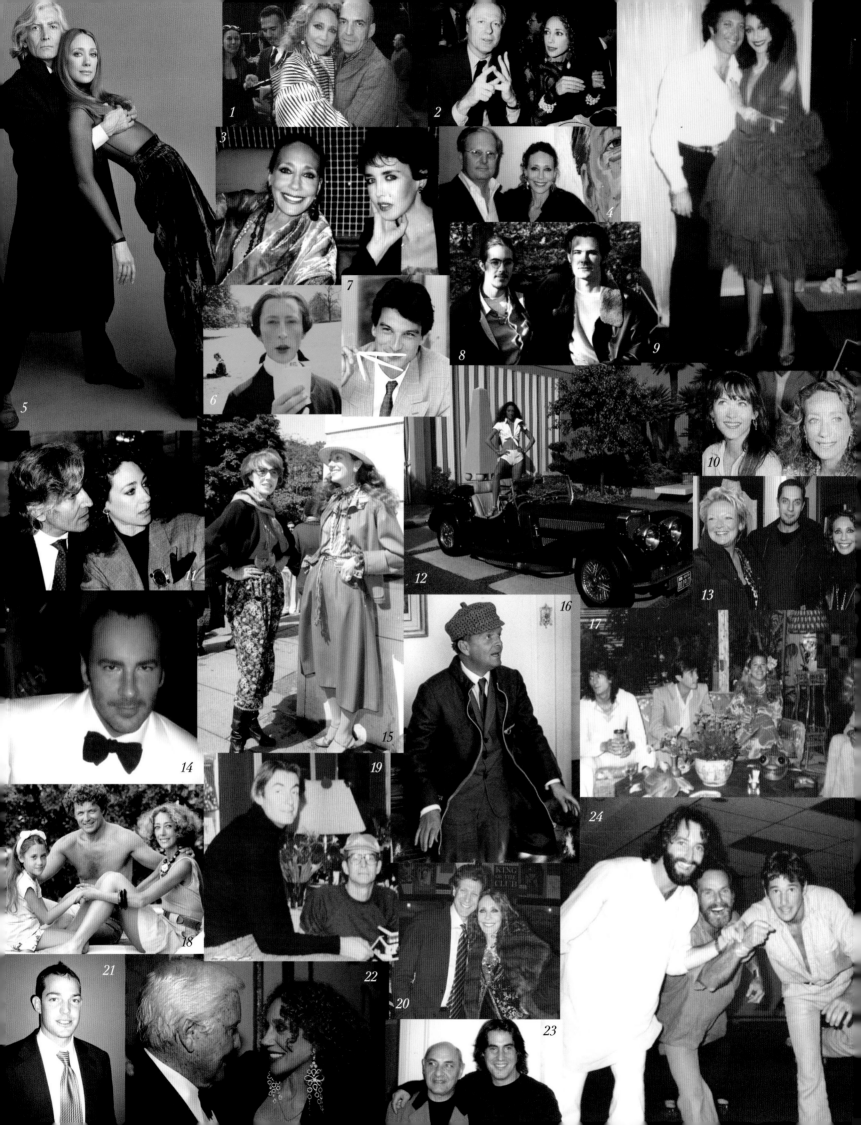

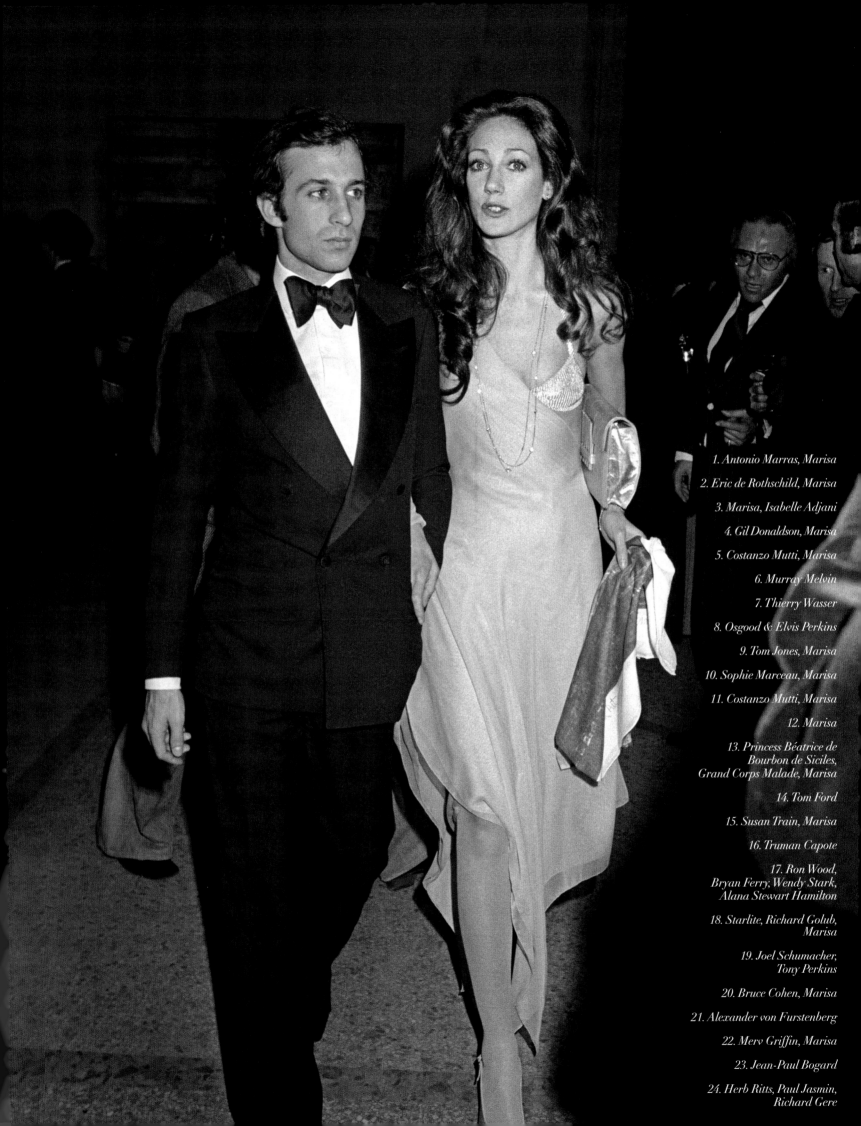

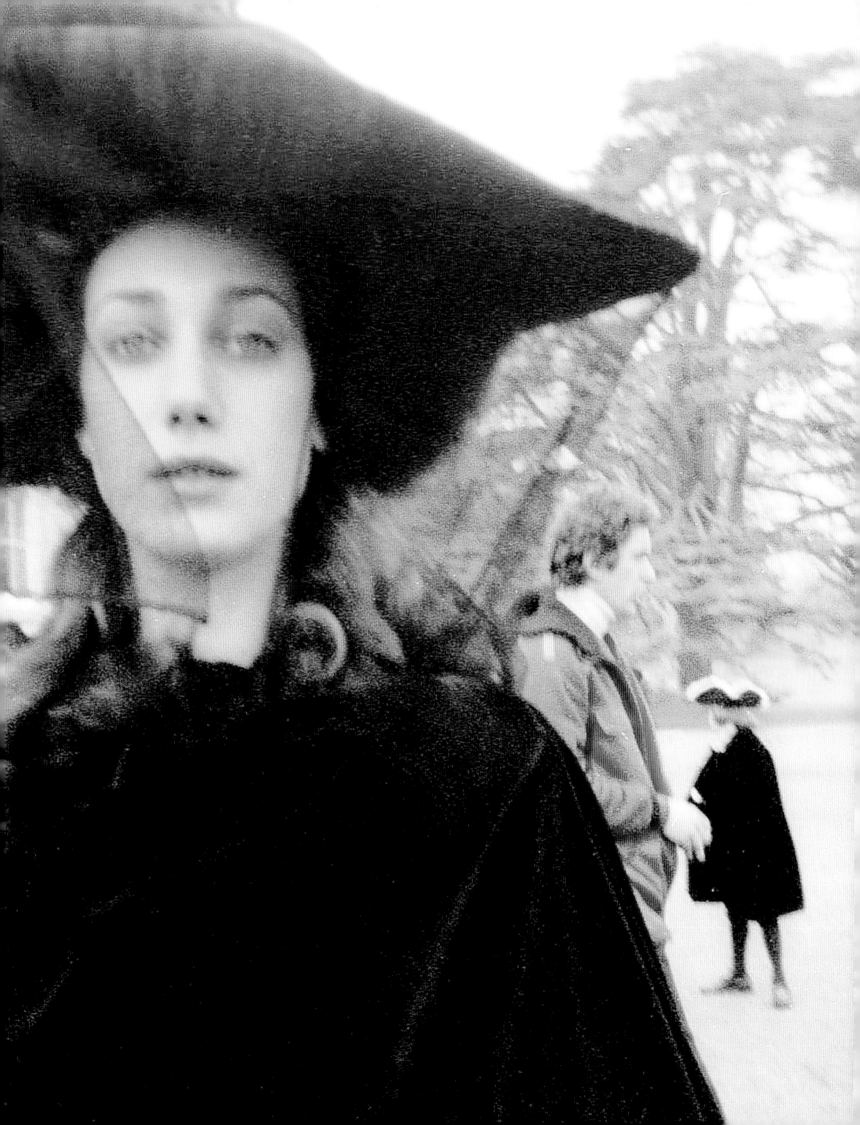

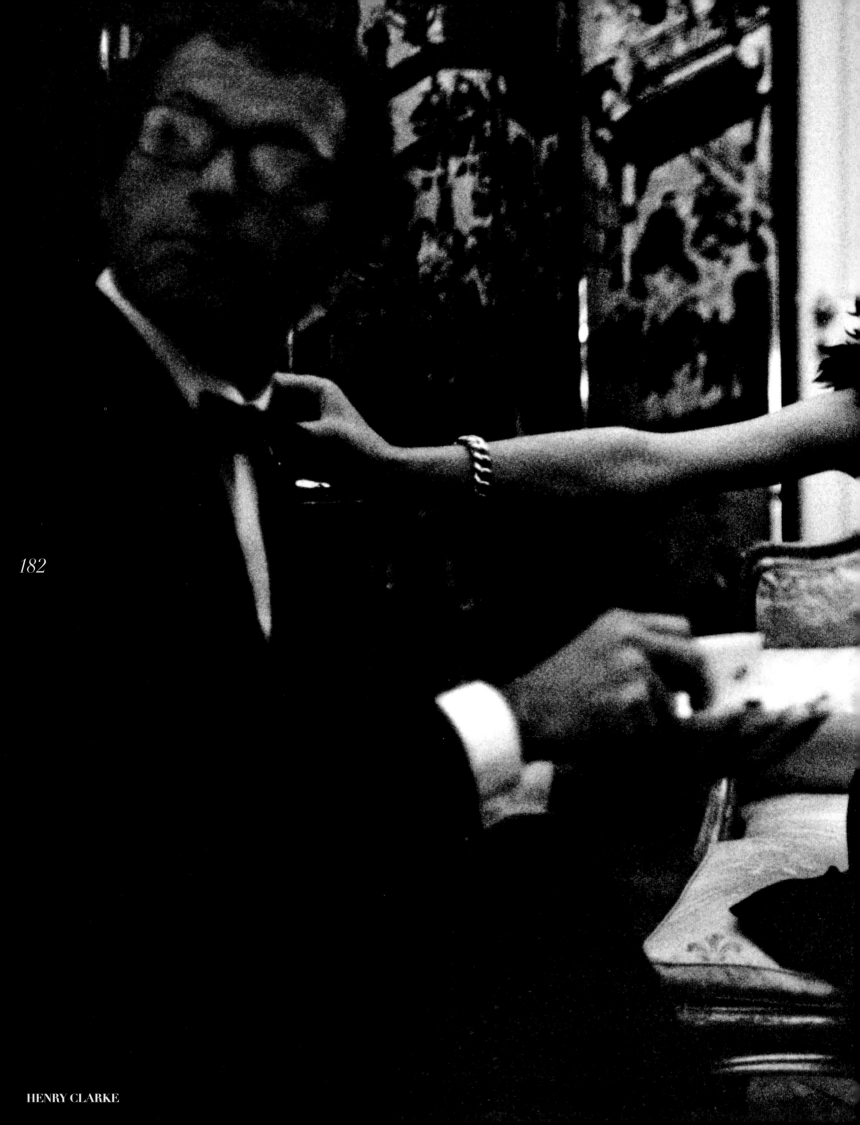

182

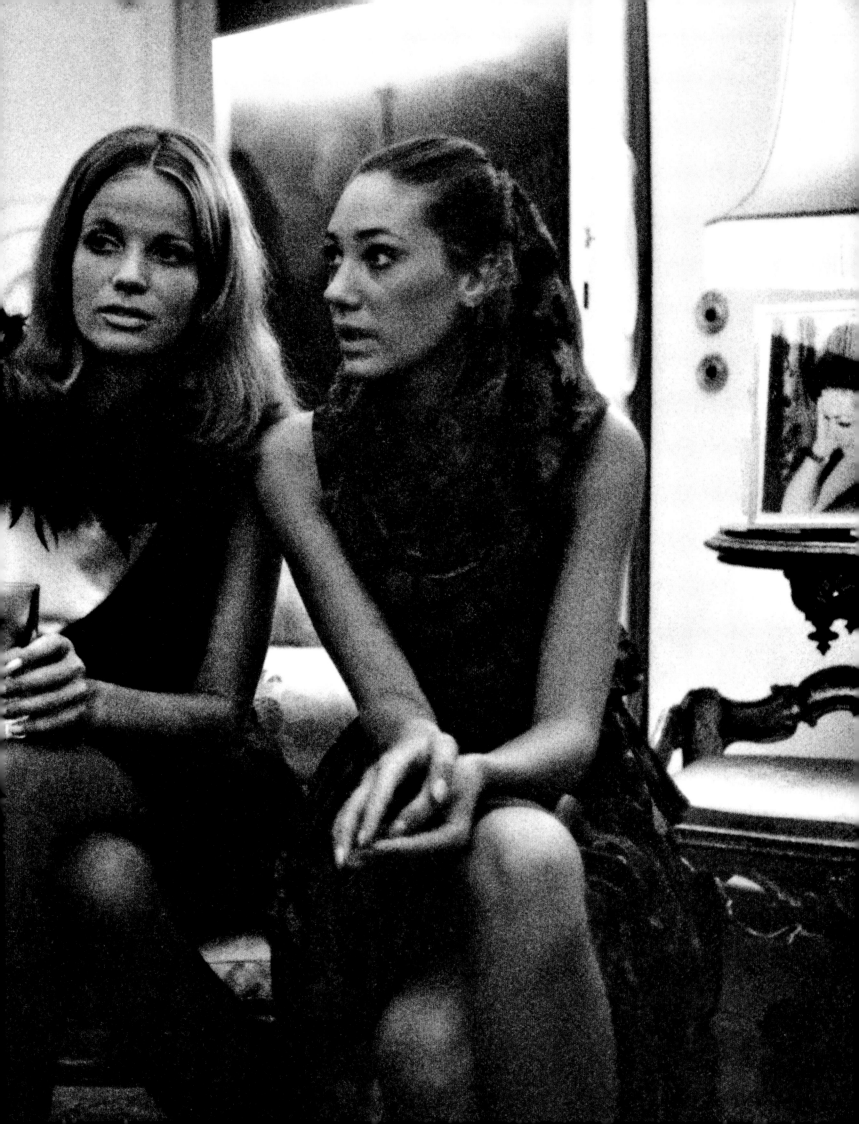

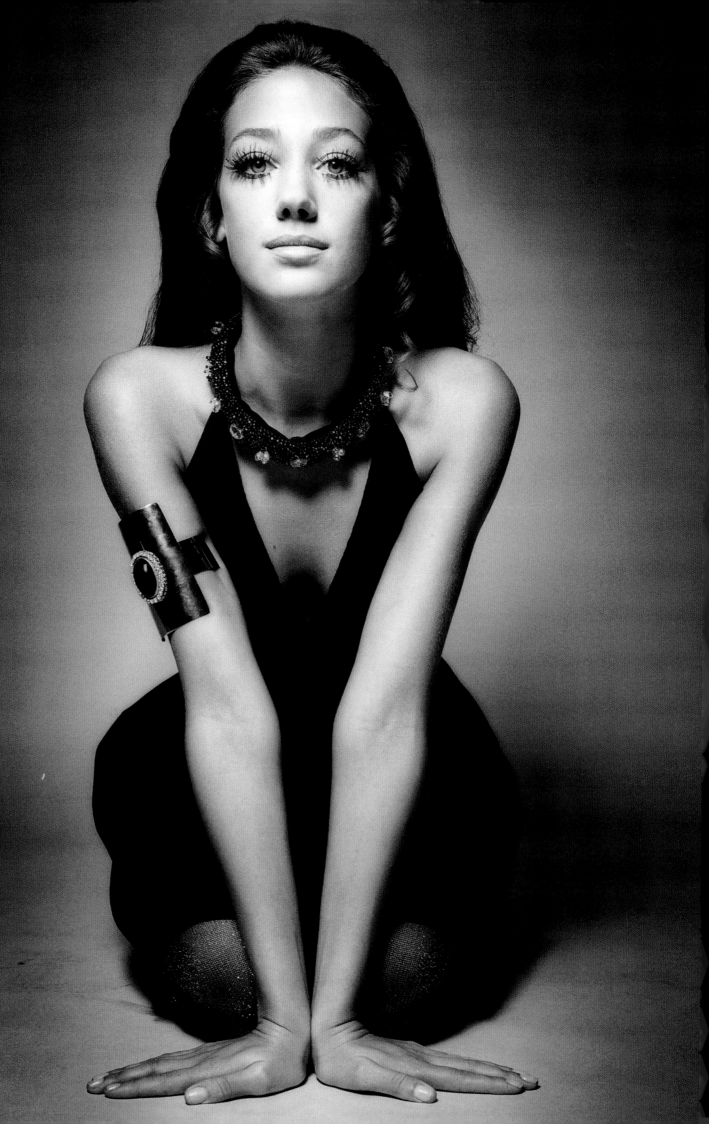

JEANLOUP SIEFF

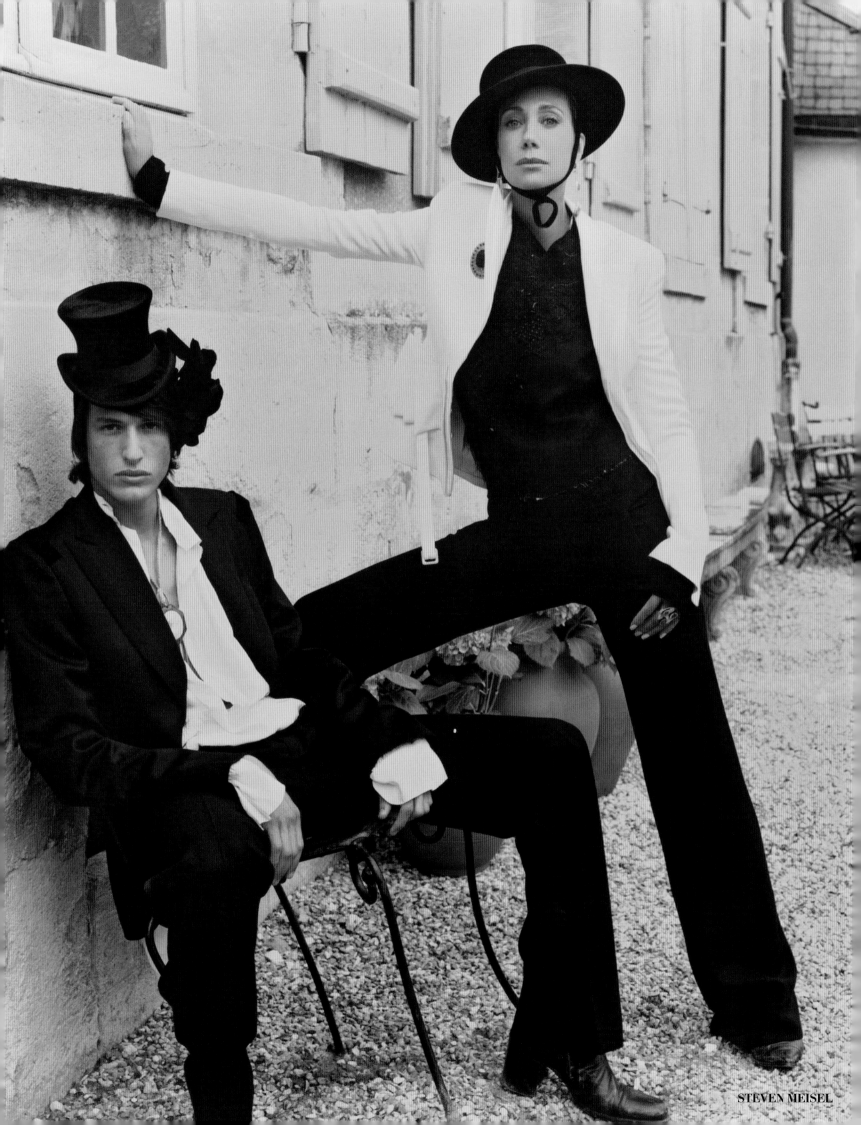

STEVEN MEISEL

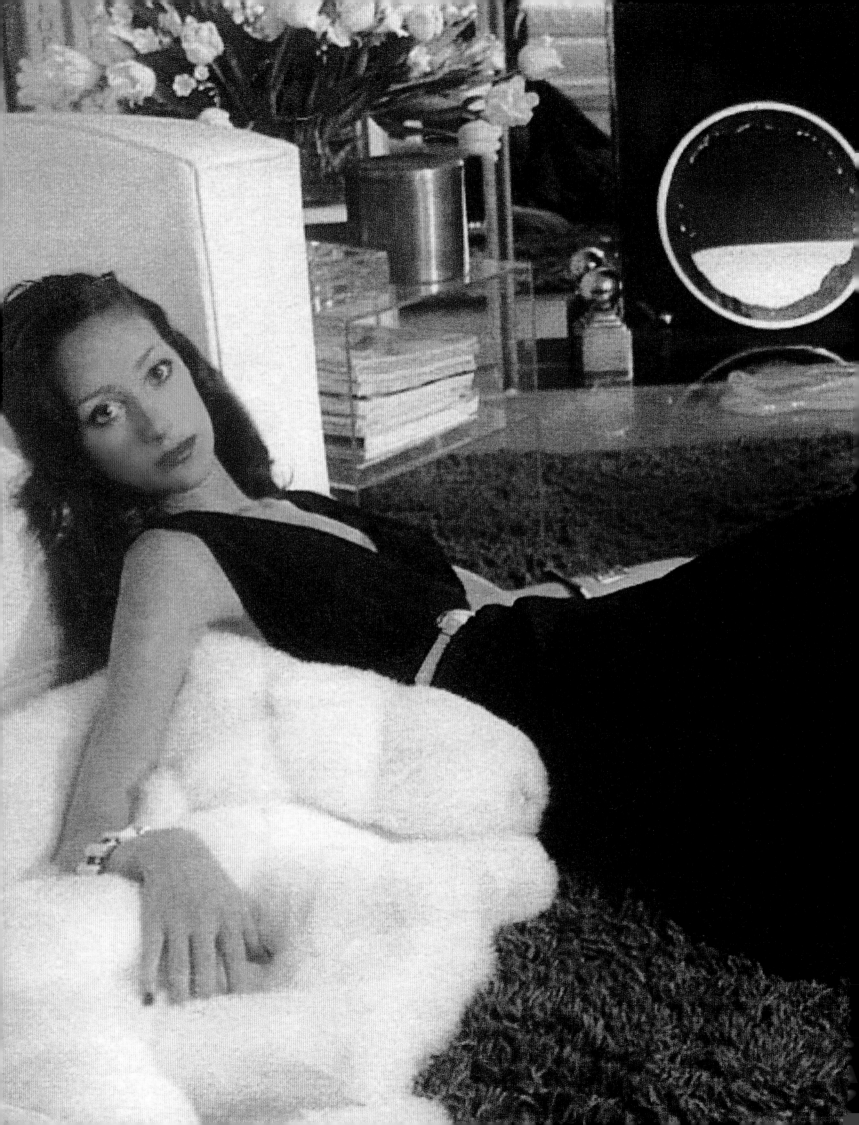

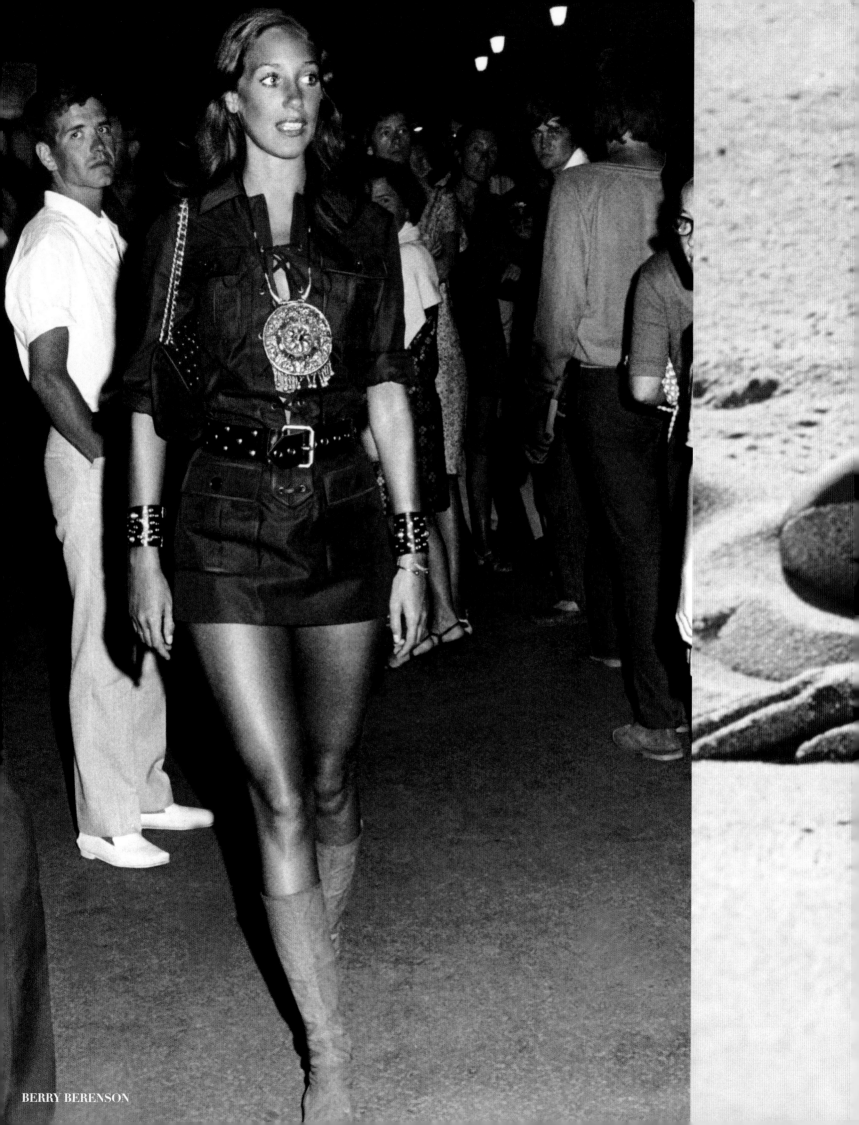

BERRY BERENSON

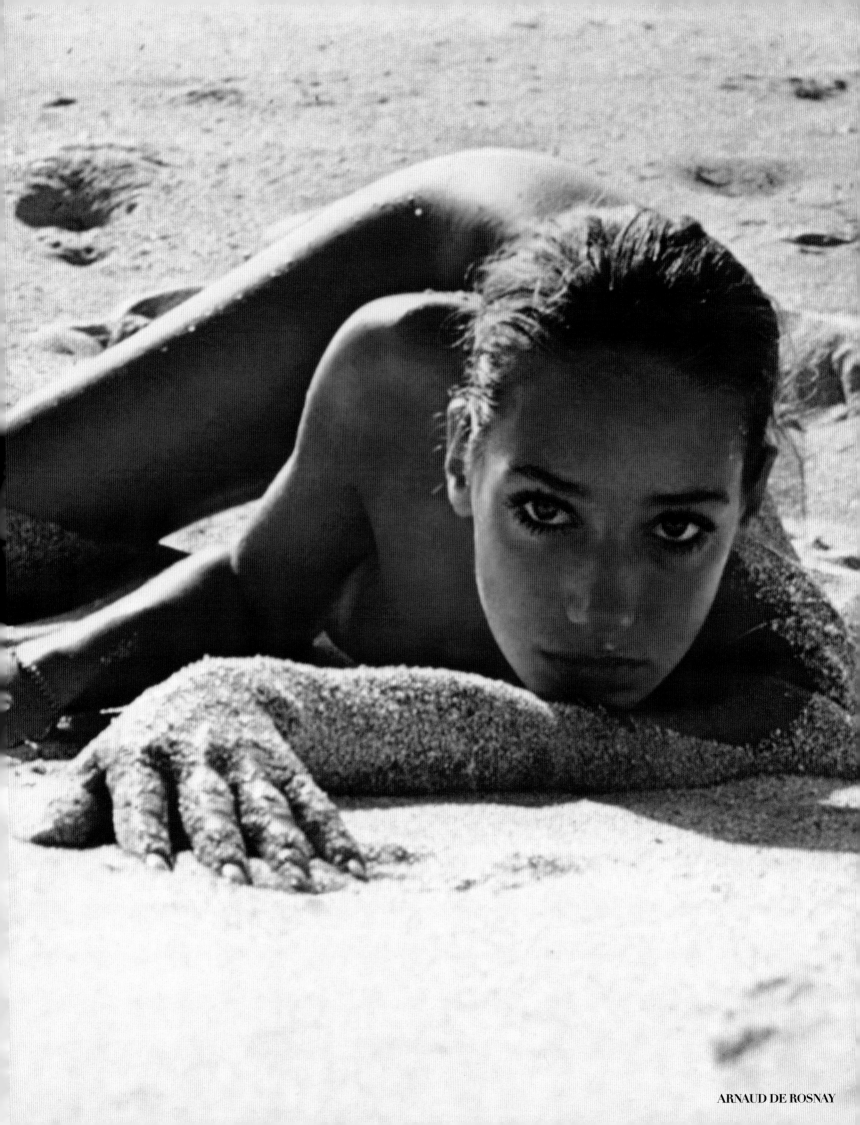

ARNAUD DE ROSNAY

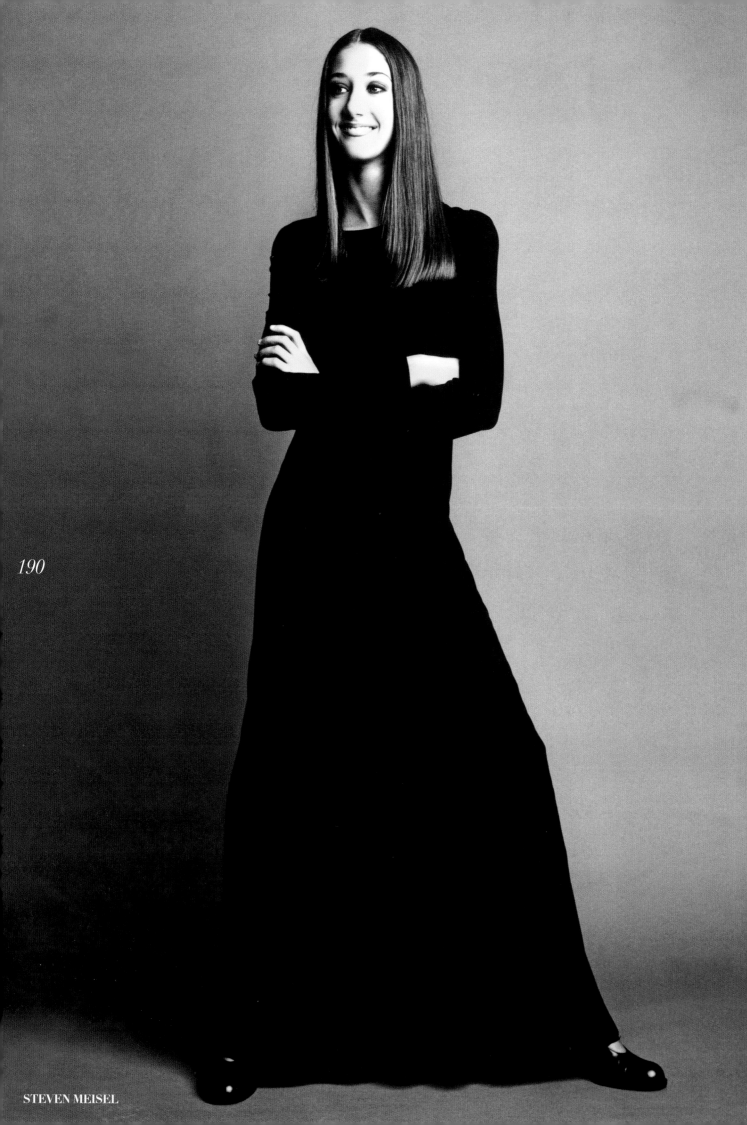

190

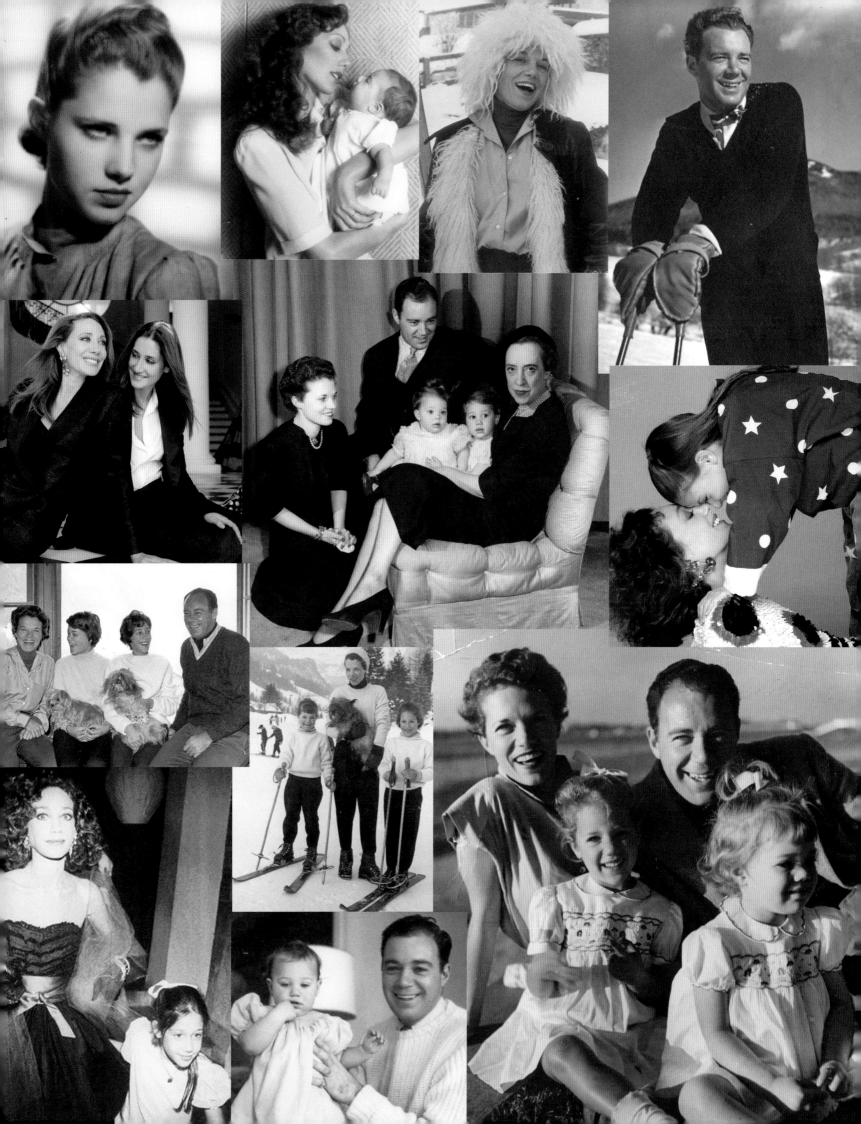

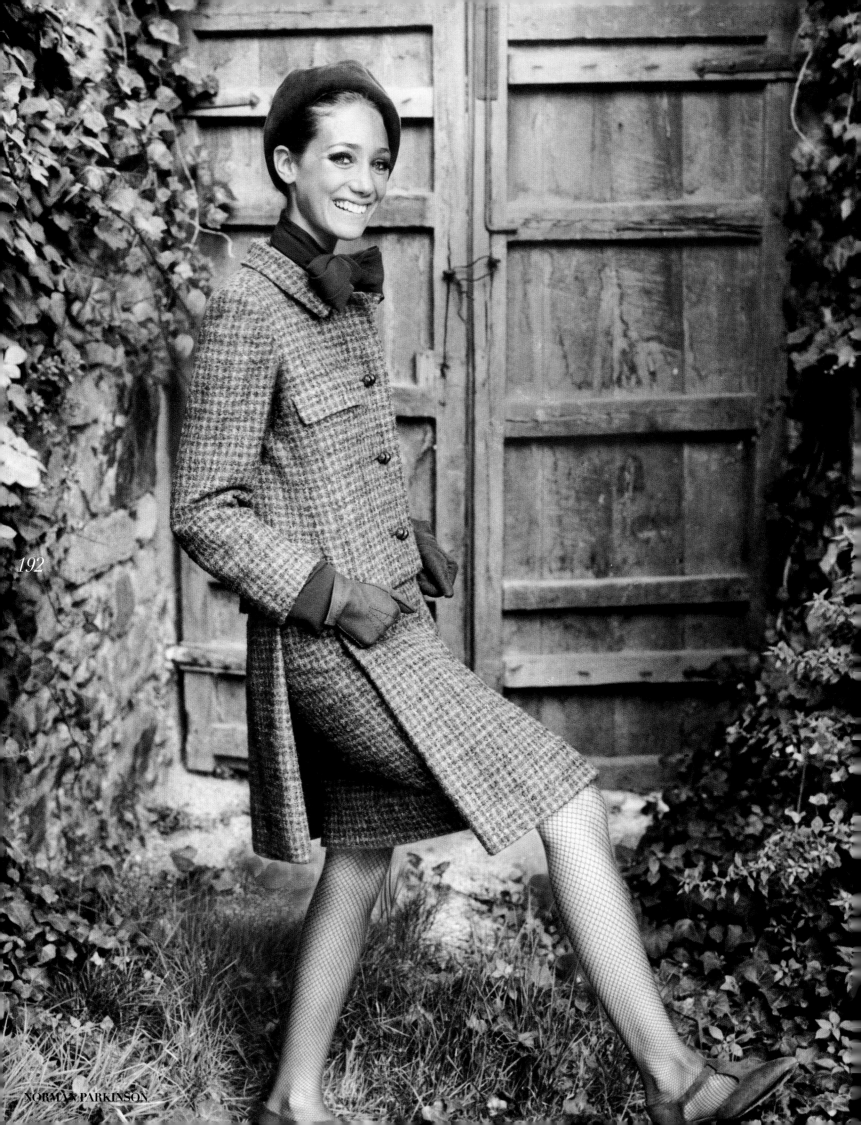

192

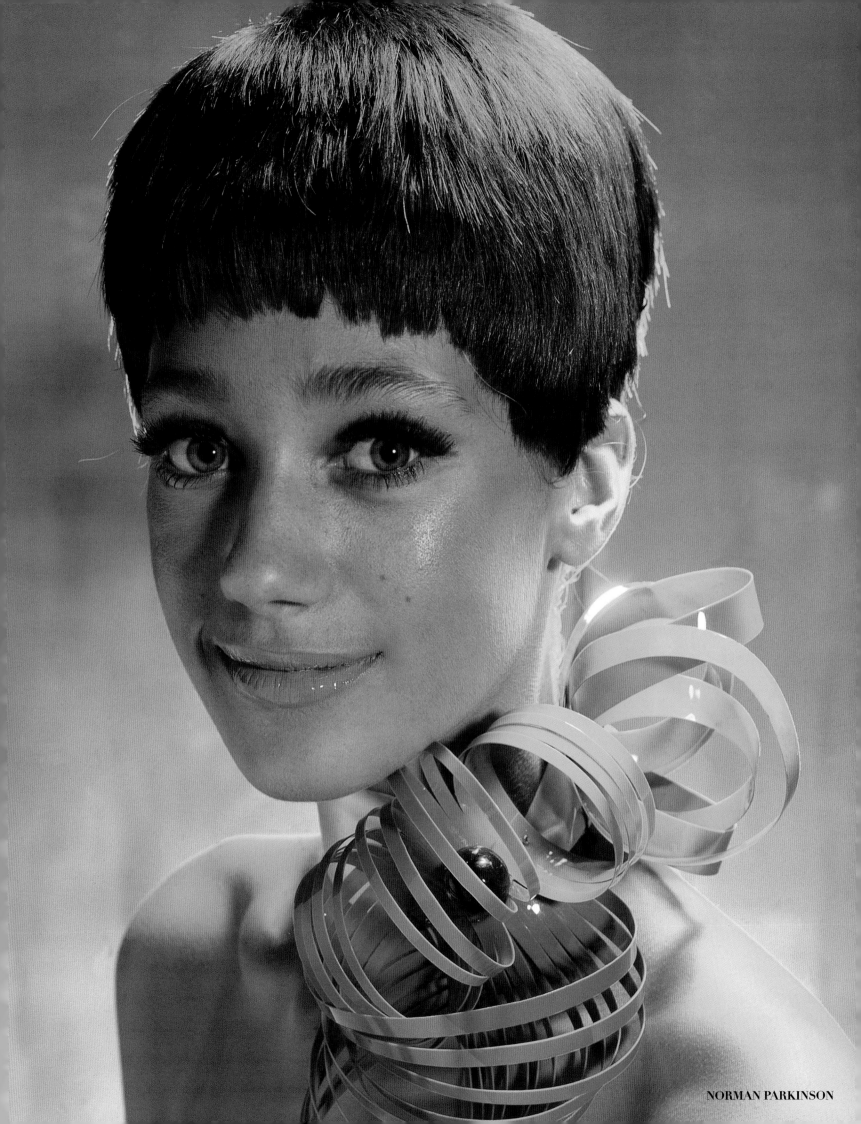

NORMAN PARKINSON

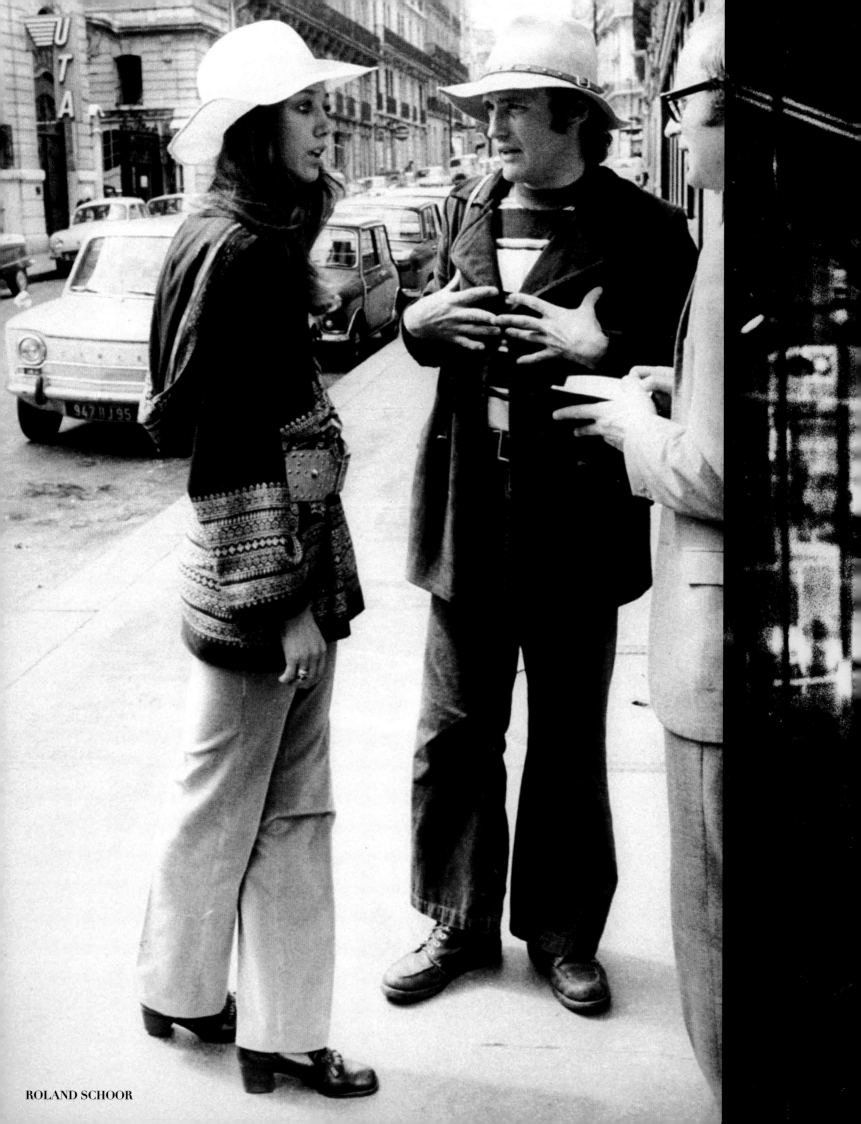

ROLAND SCHOOR

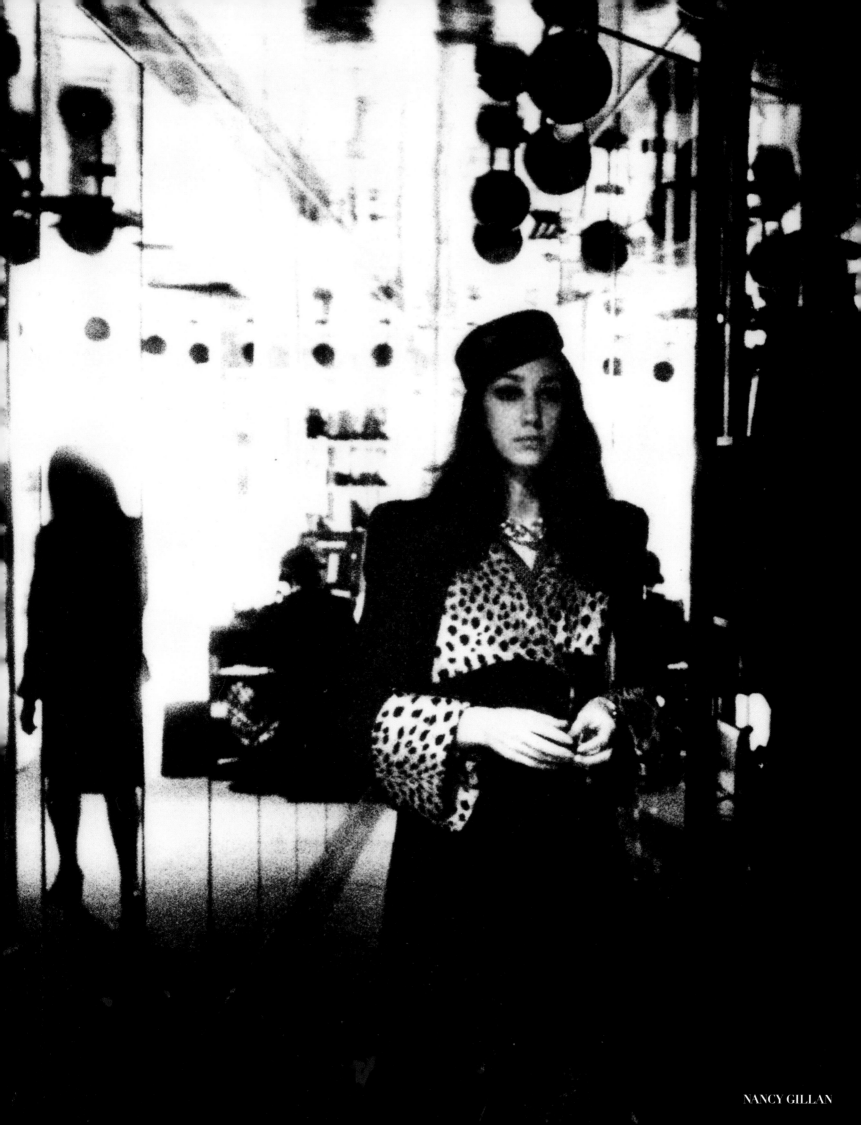

NANCY GILLAN

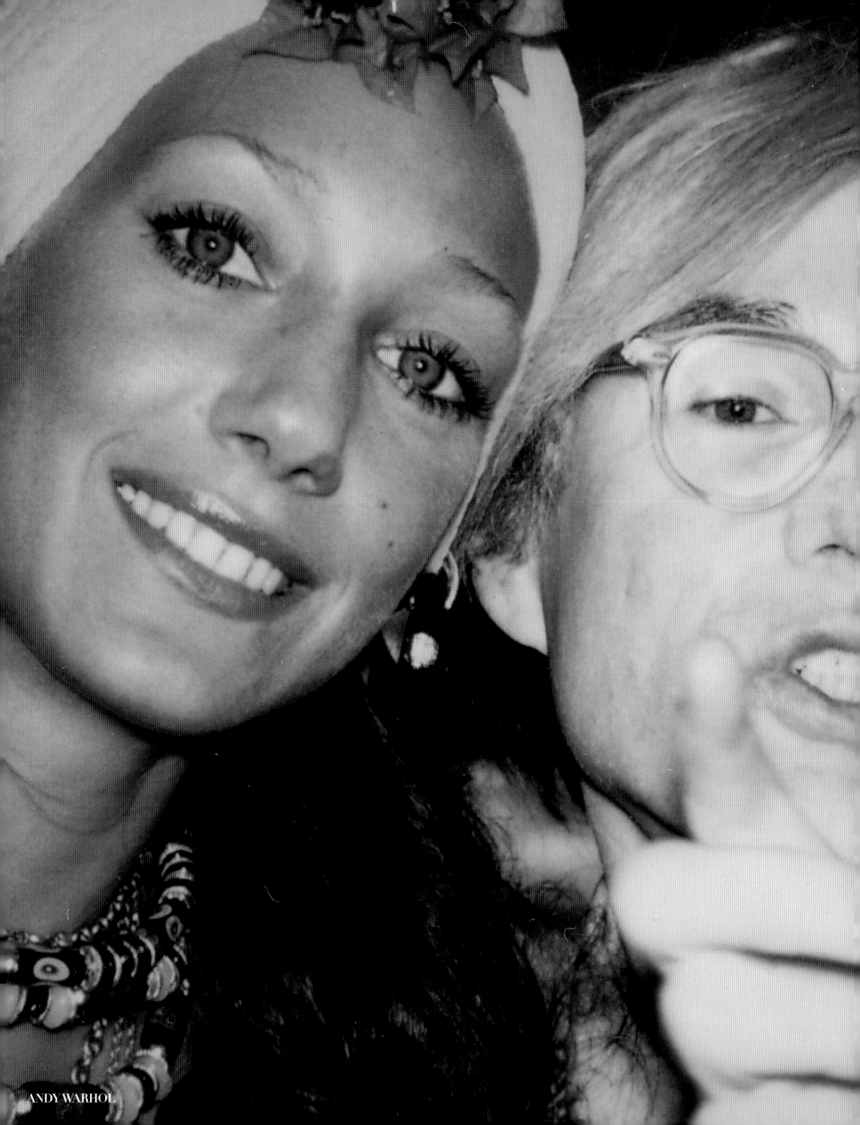

ANDY WARHOL

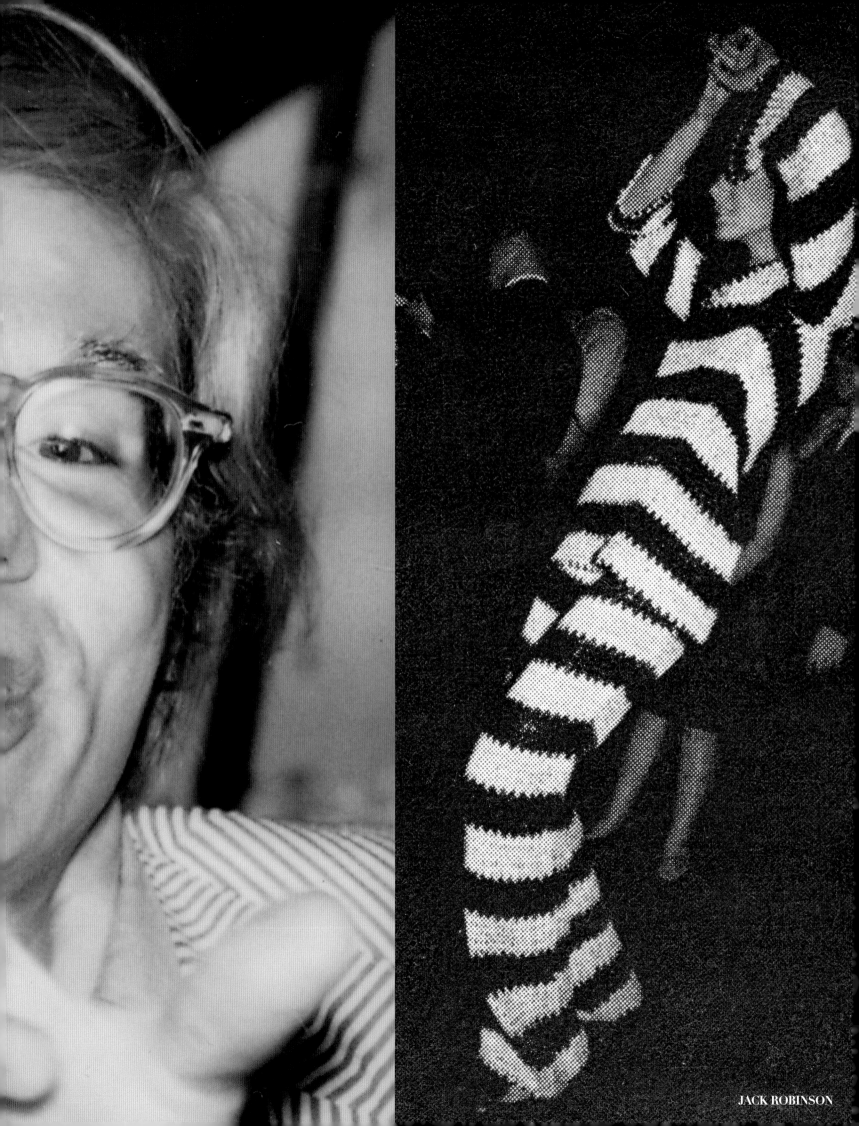

JACK ROBINSON

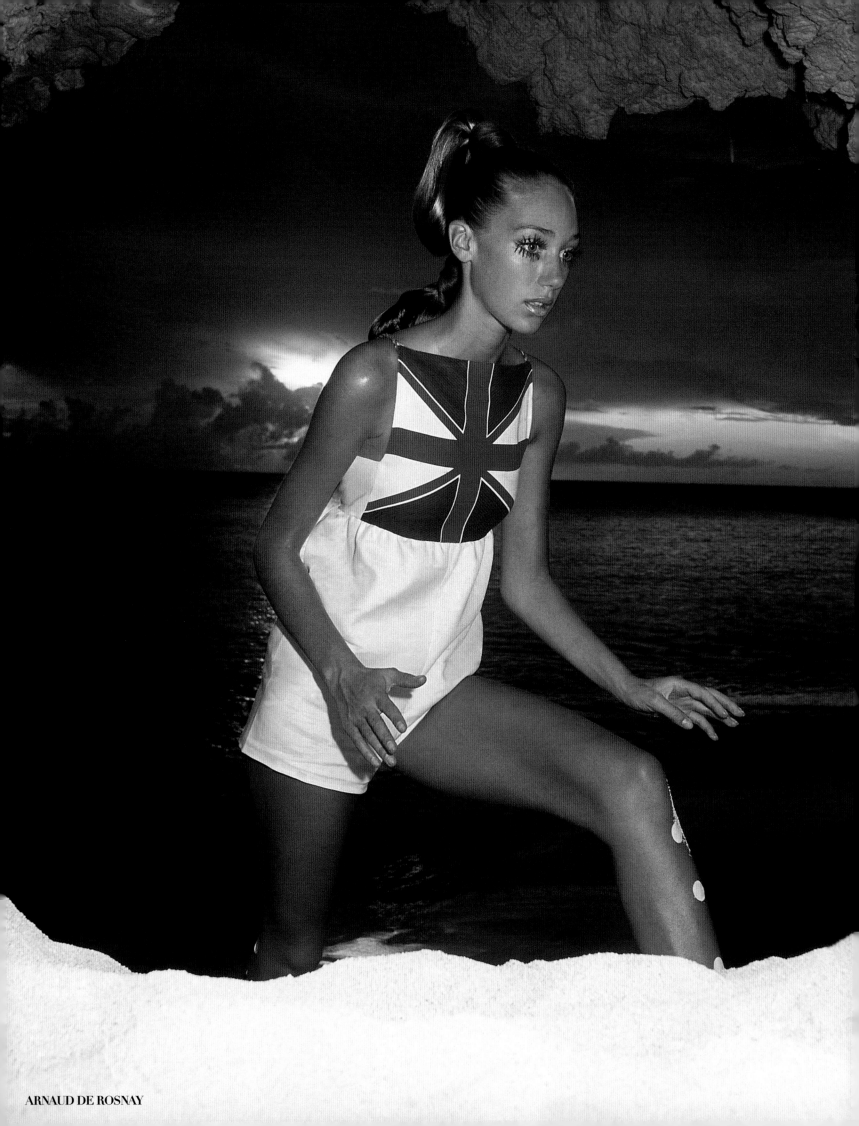

ARNAUD DE ROSNAY

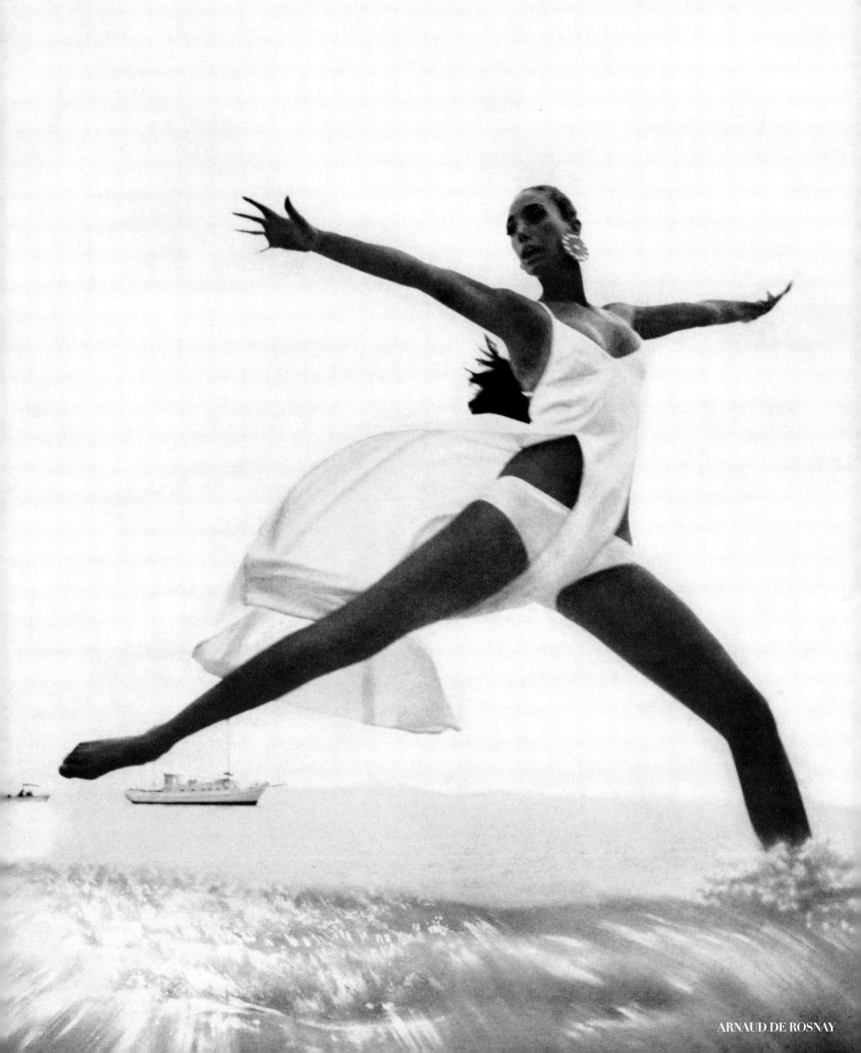

ARNAUD DE ROSNAY

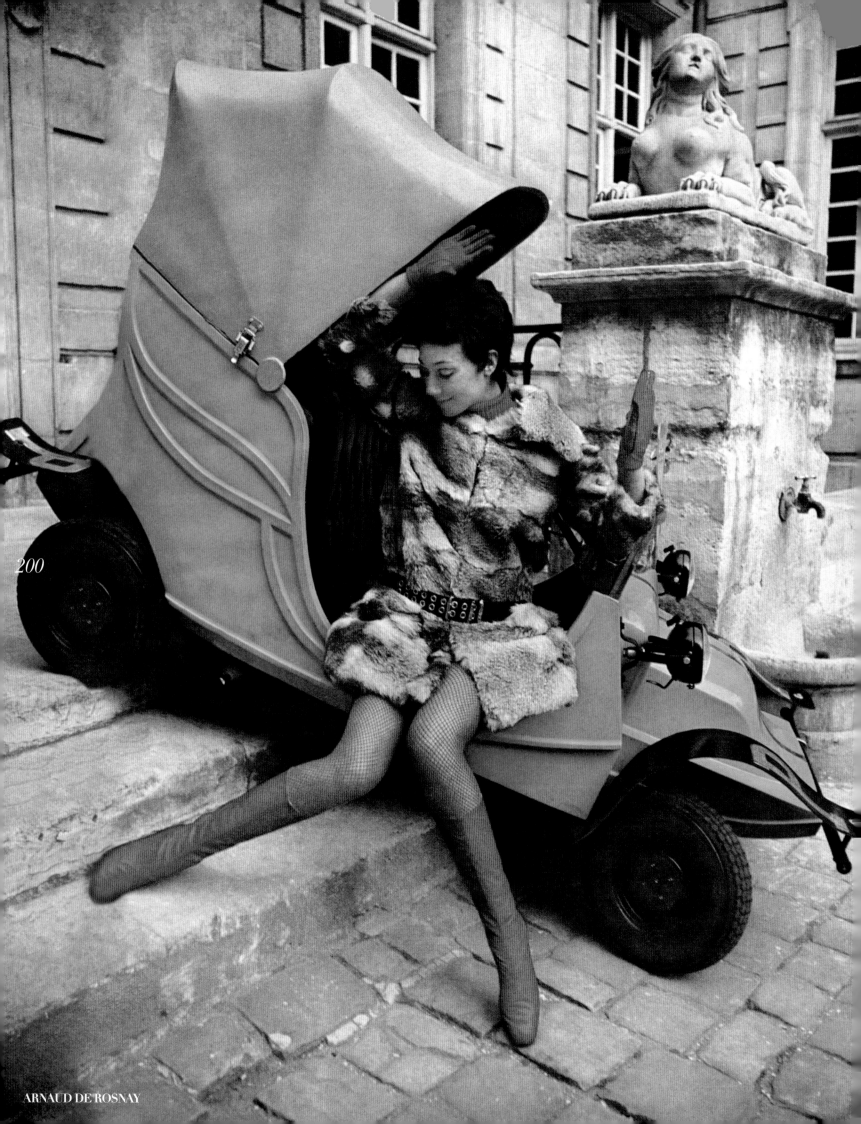

ARNAUD DE ROSNAY

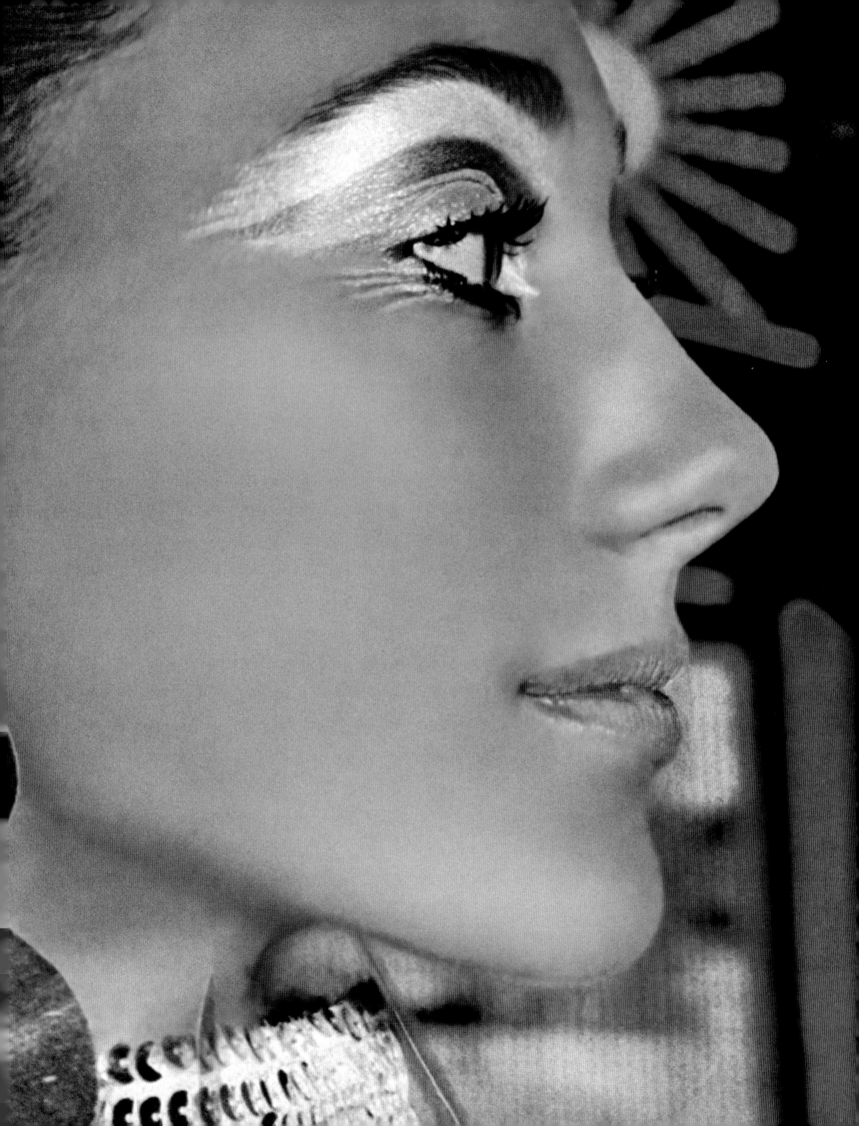

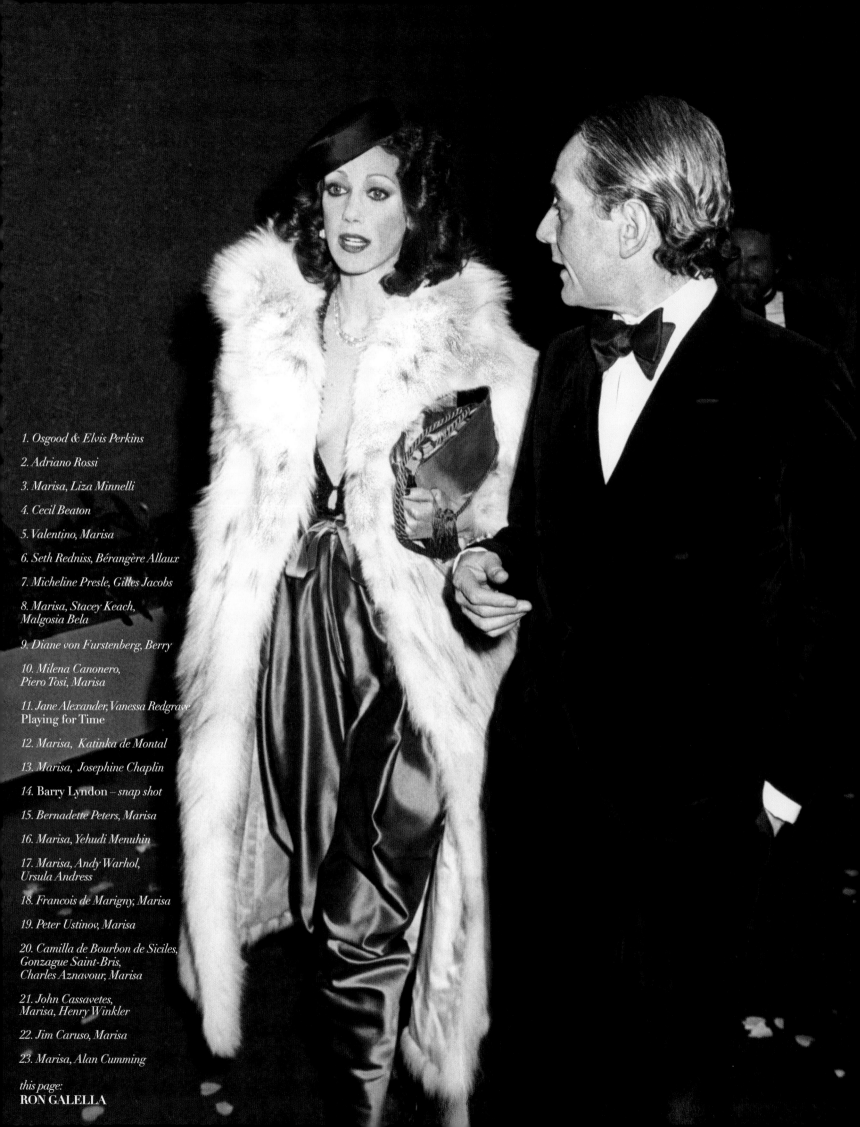

this page:
RON GALELLA

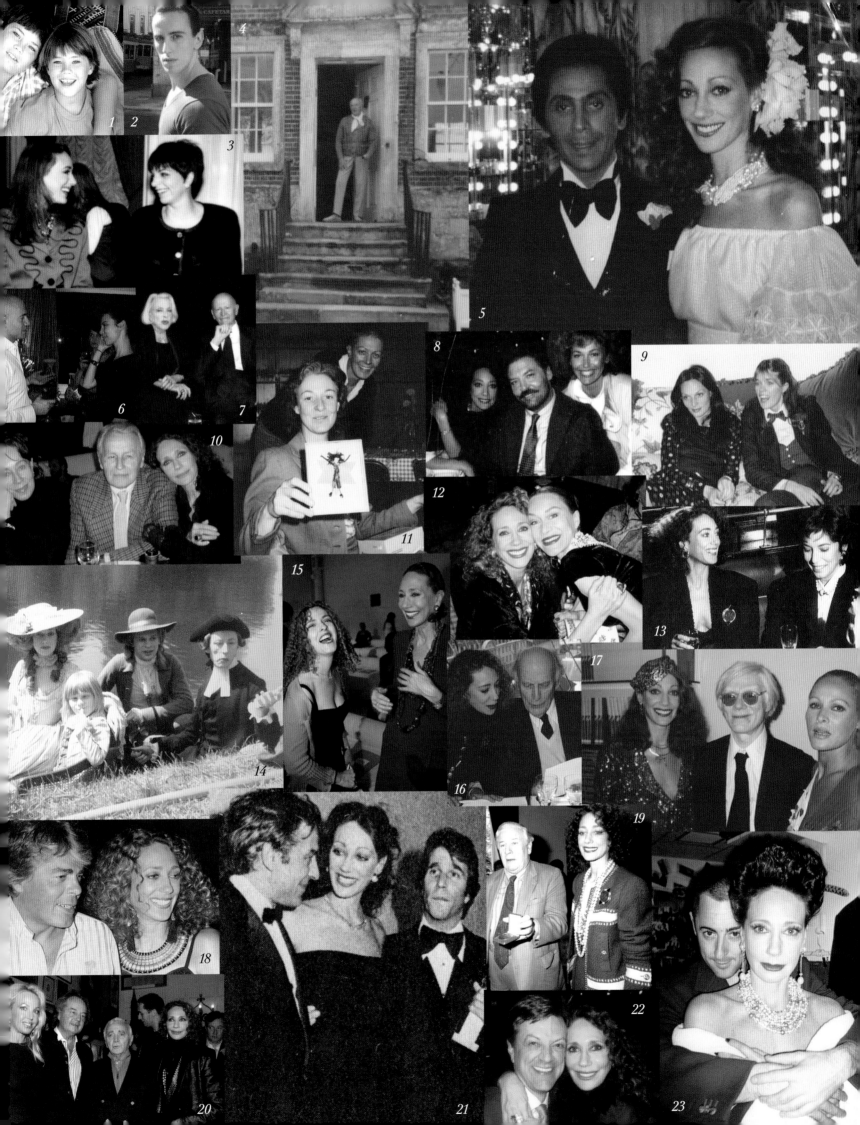

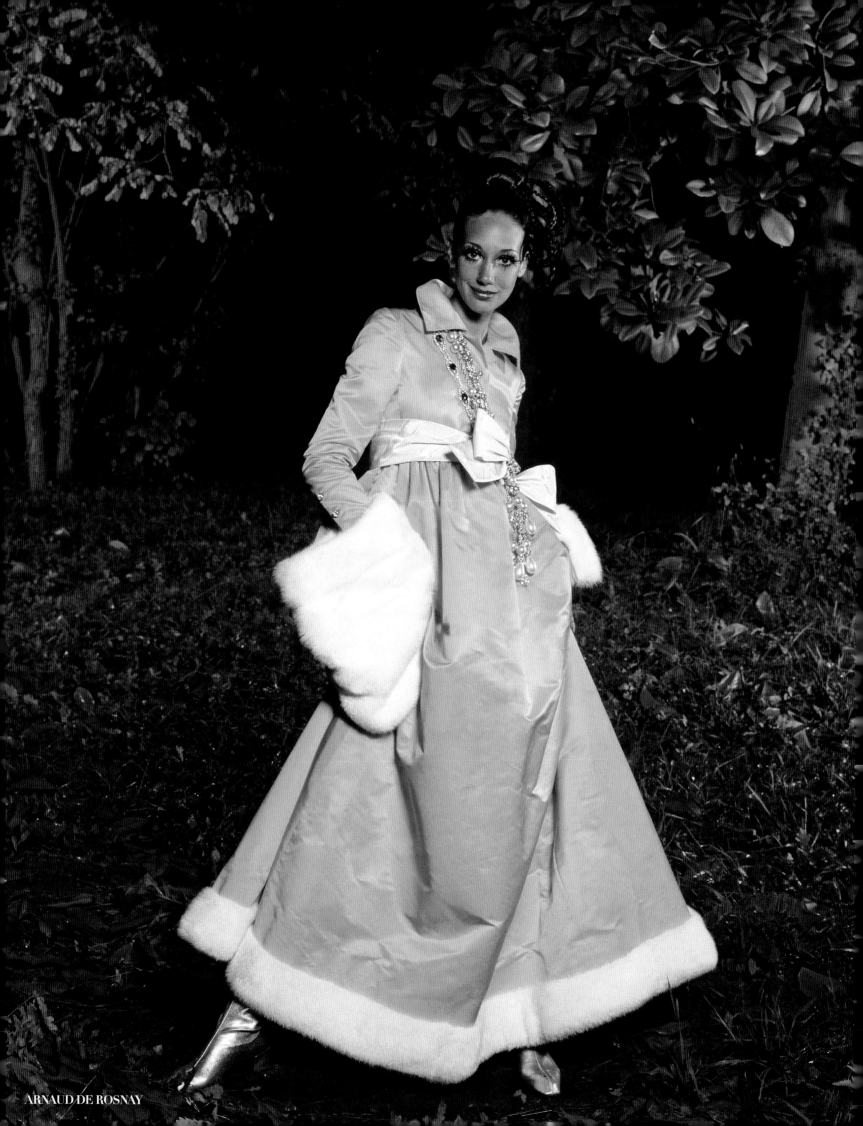

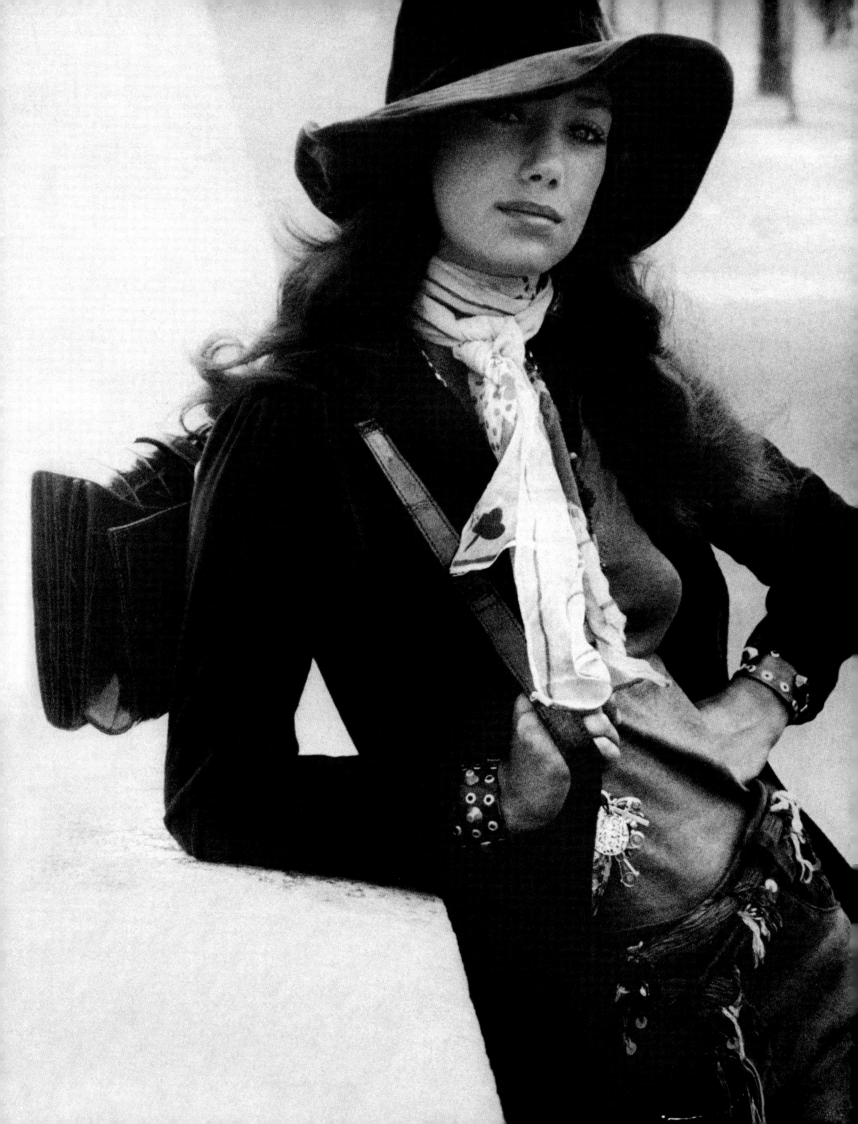

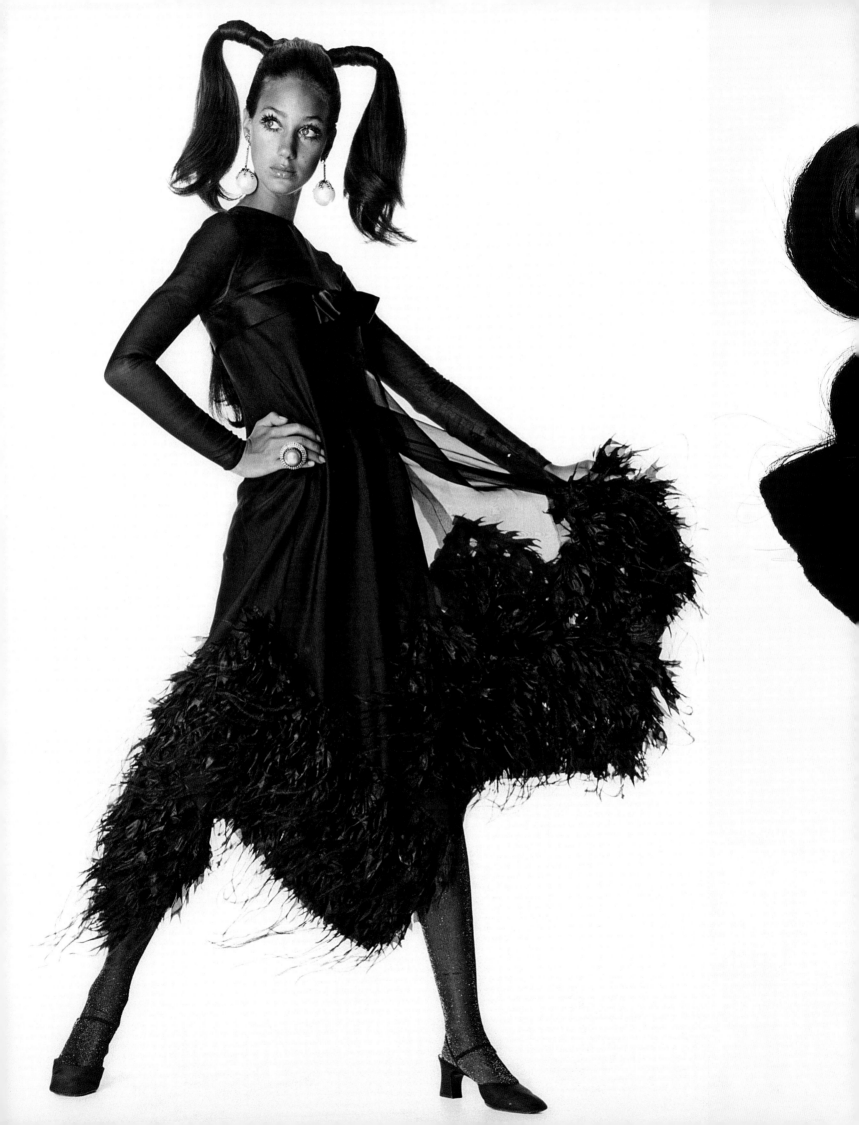

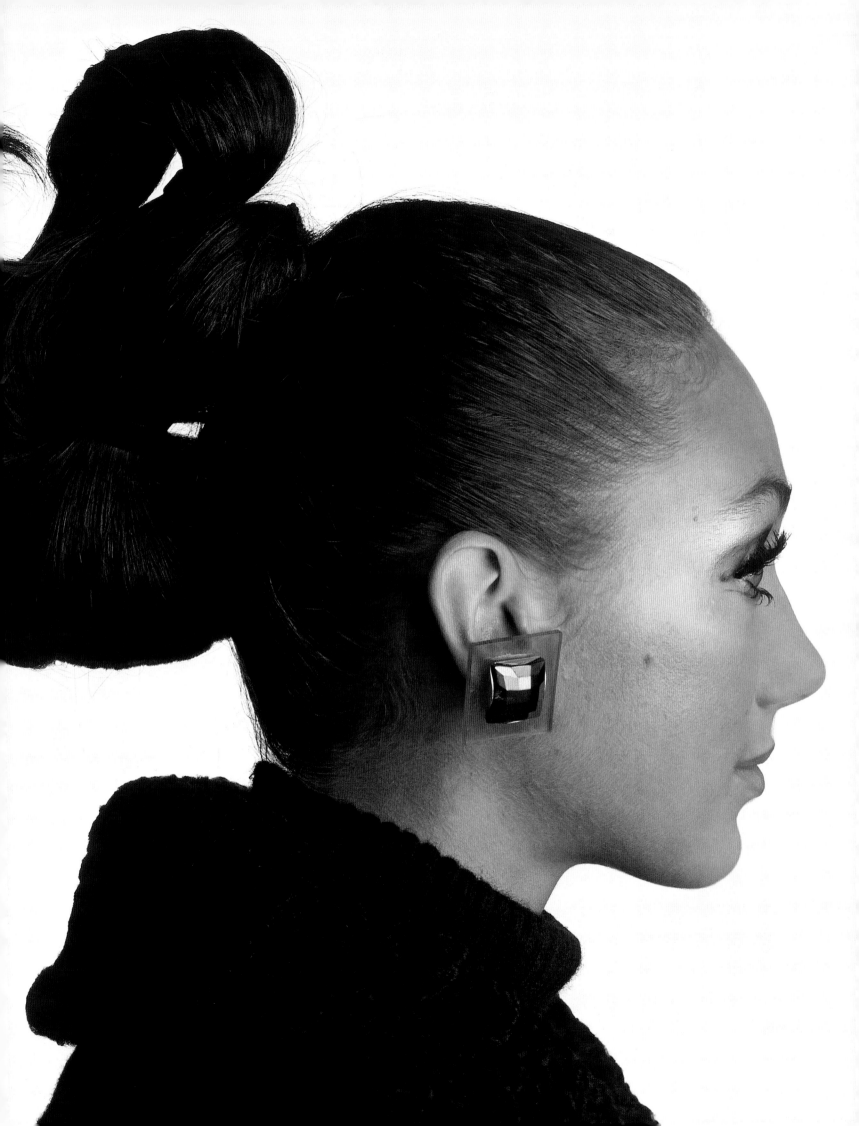

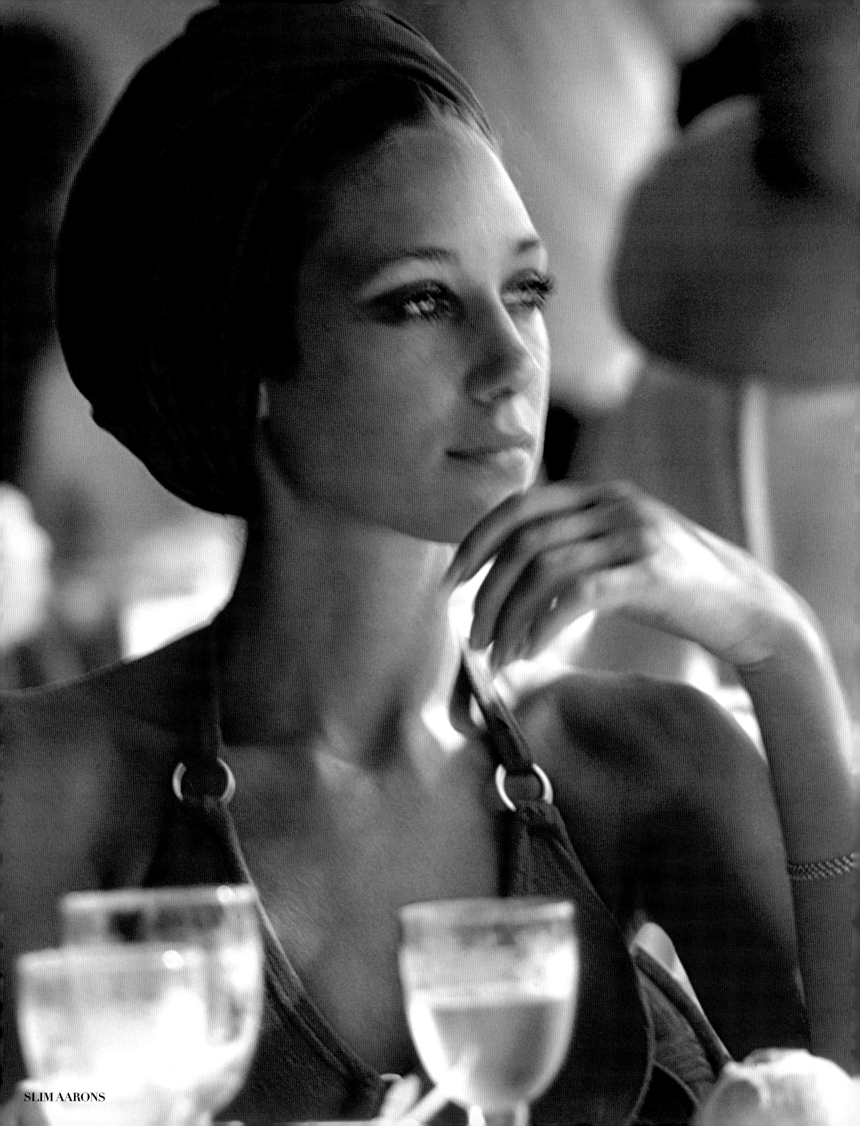

SLIM AARONS

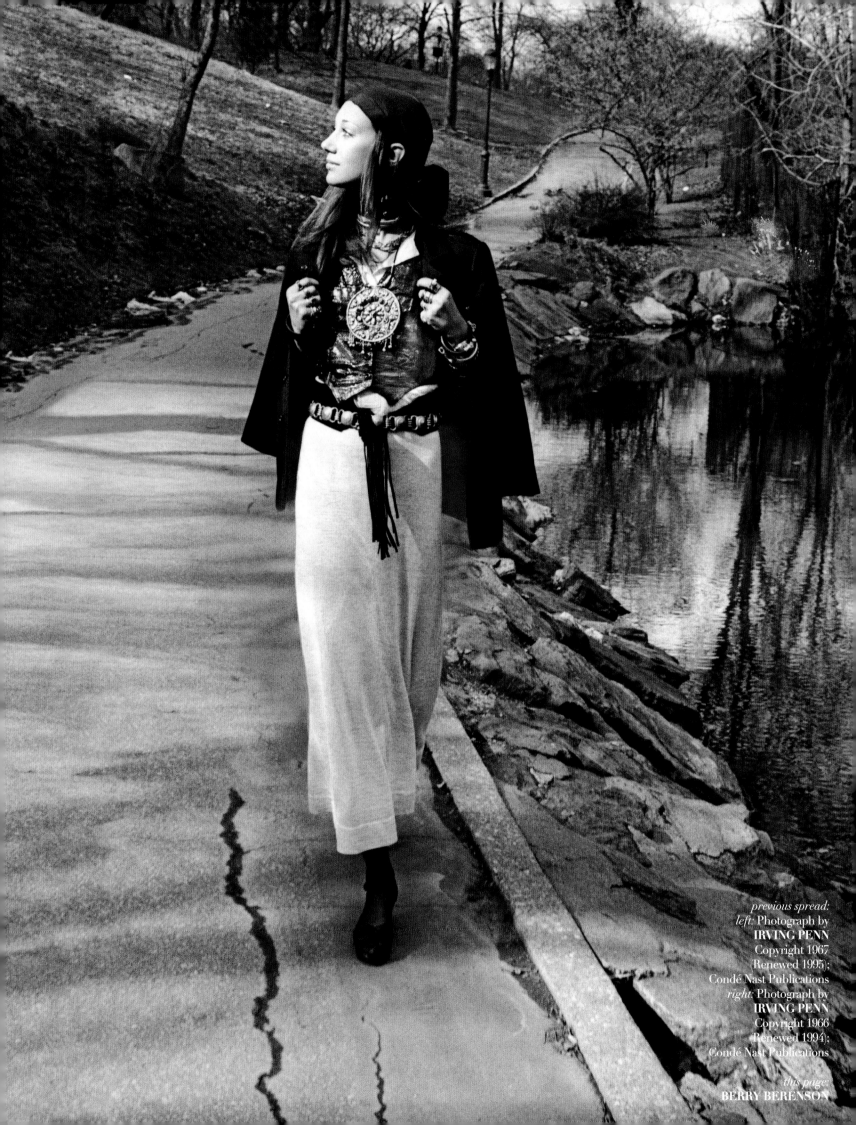

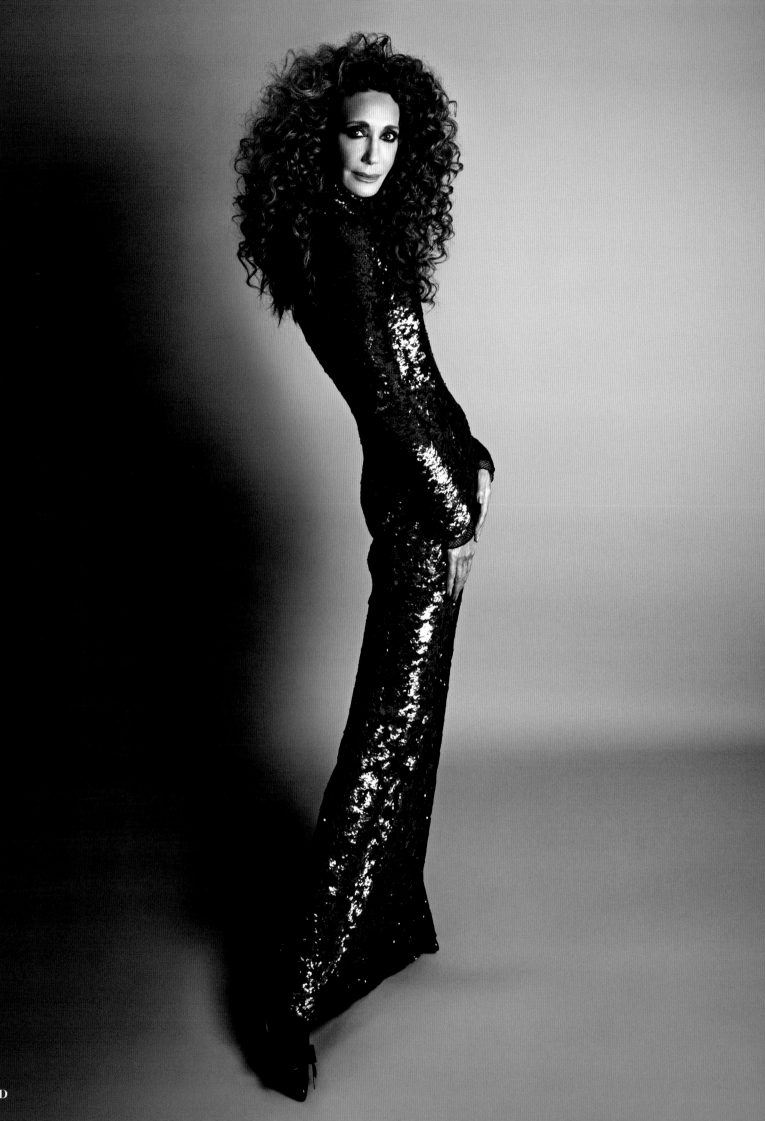

TOM FORD

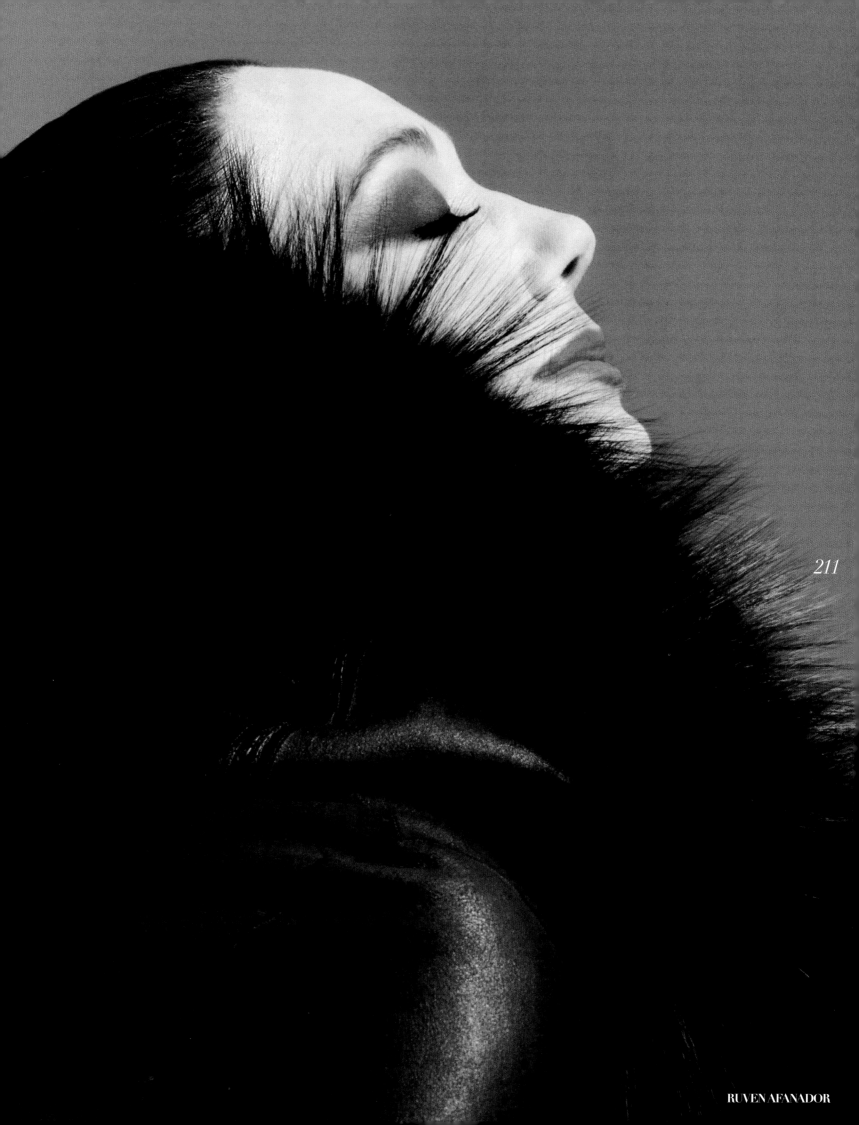

RUVEN AFANADOR

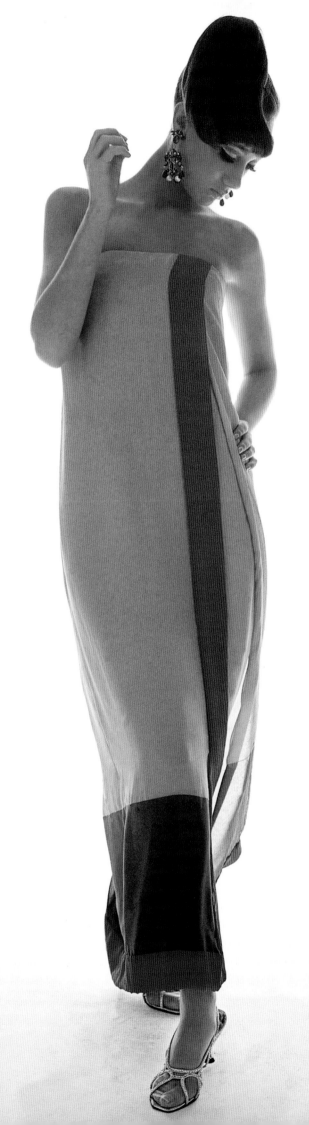

BERT STERN

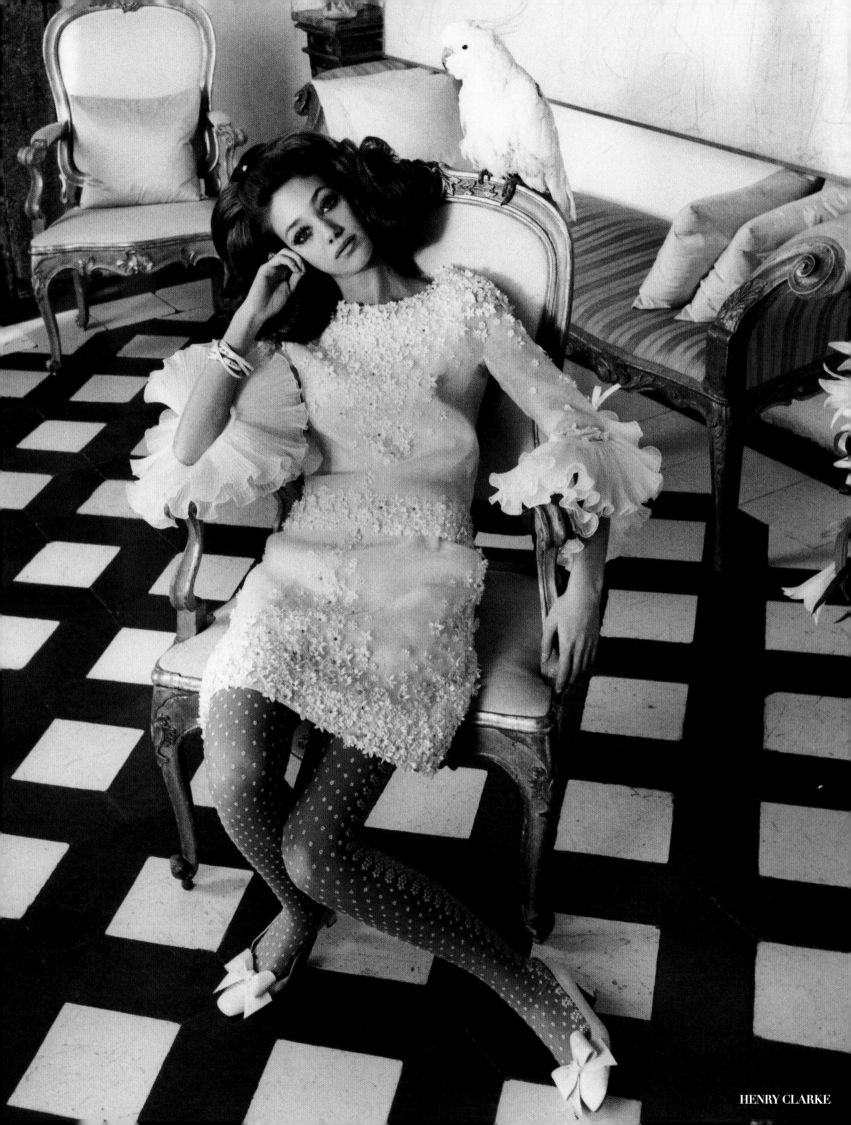

HENRY CLARKE

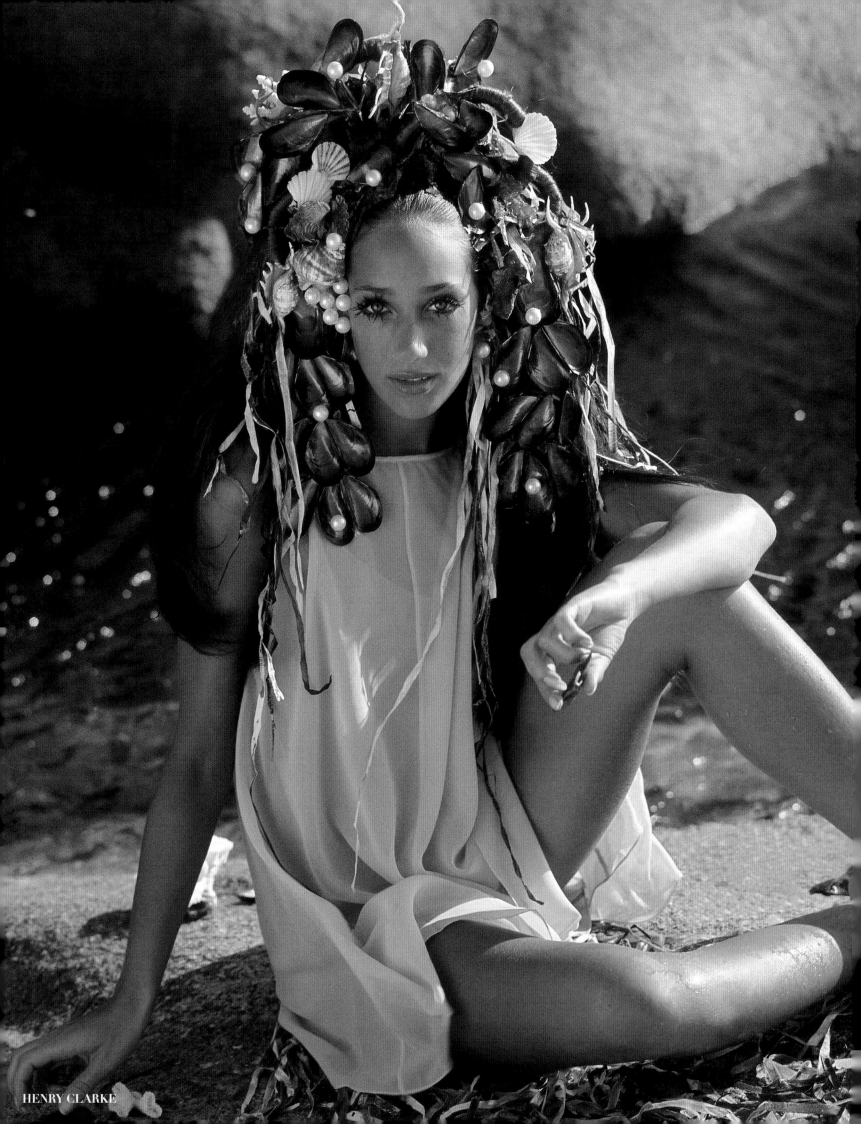

HENRY CLARKE

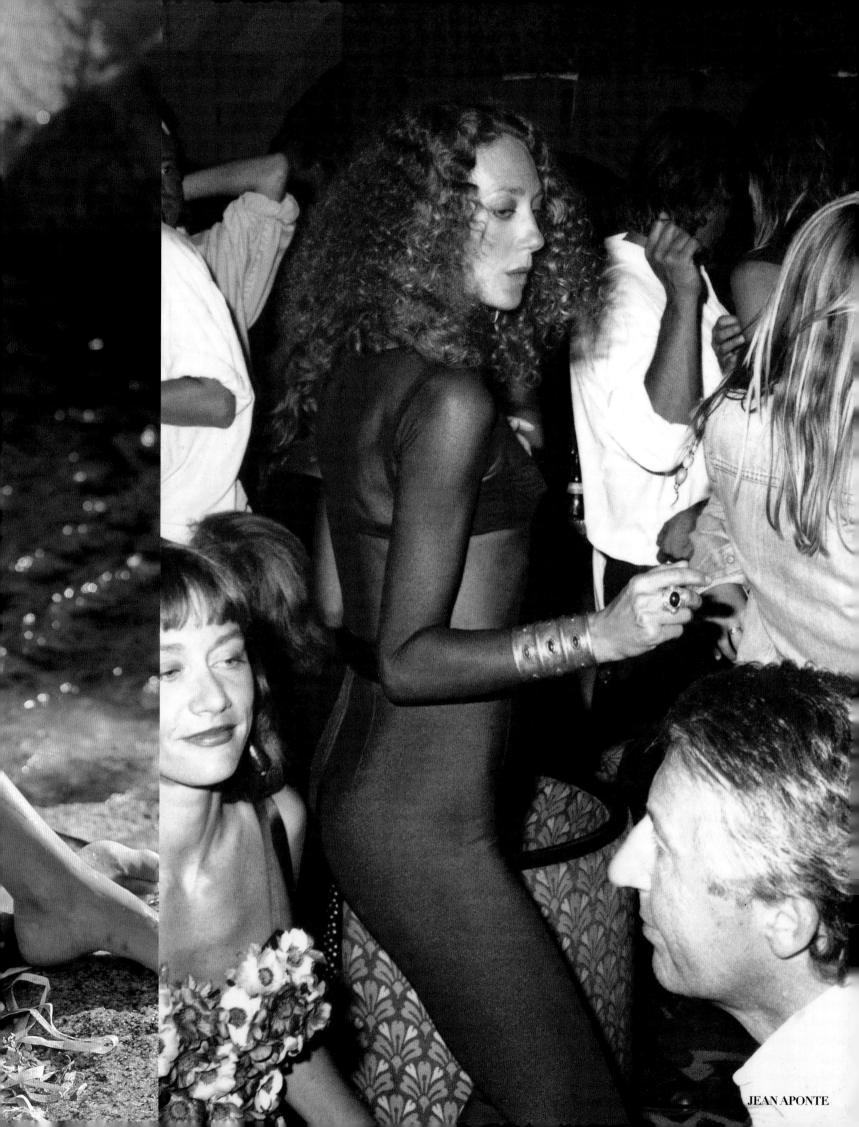

JEAN APONTE

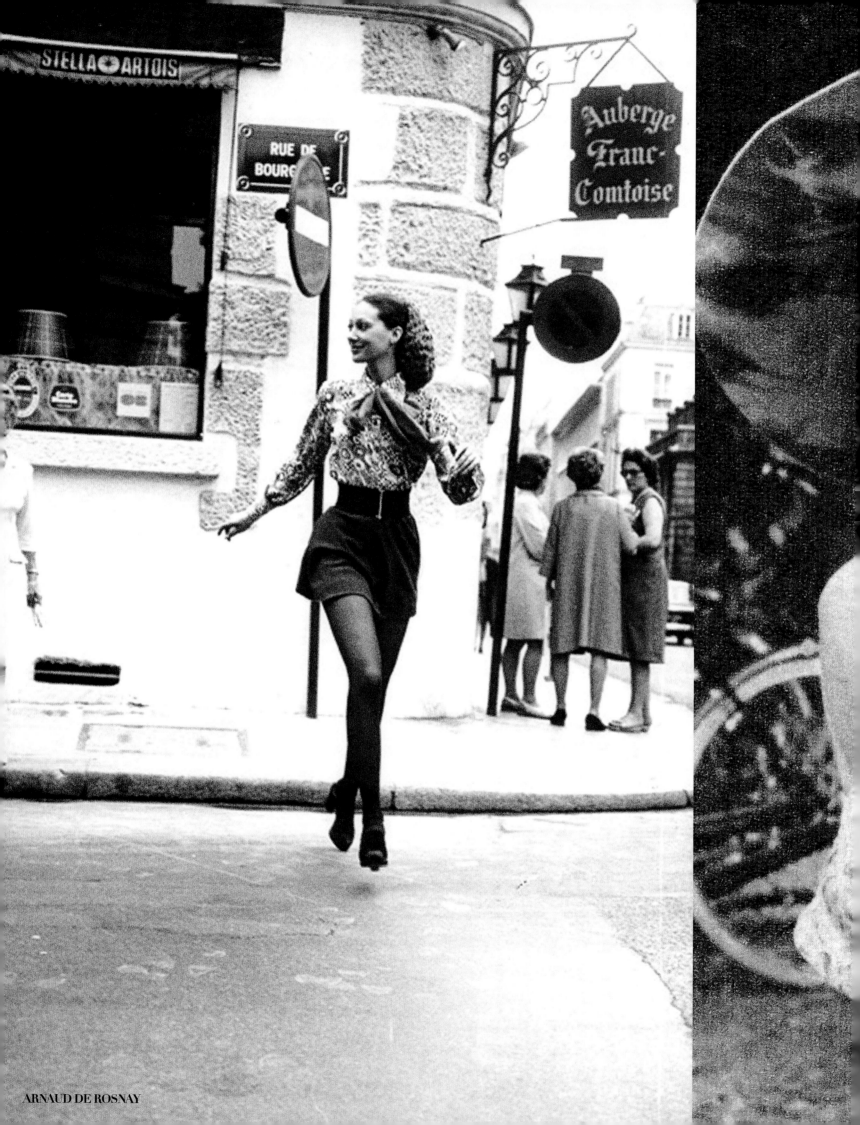

STELLA ARTOIS

RUE DE
BOURGOGNE

Auberge
Franc-
Comtoise

ARNAUD DE ROSNAY

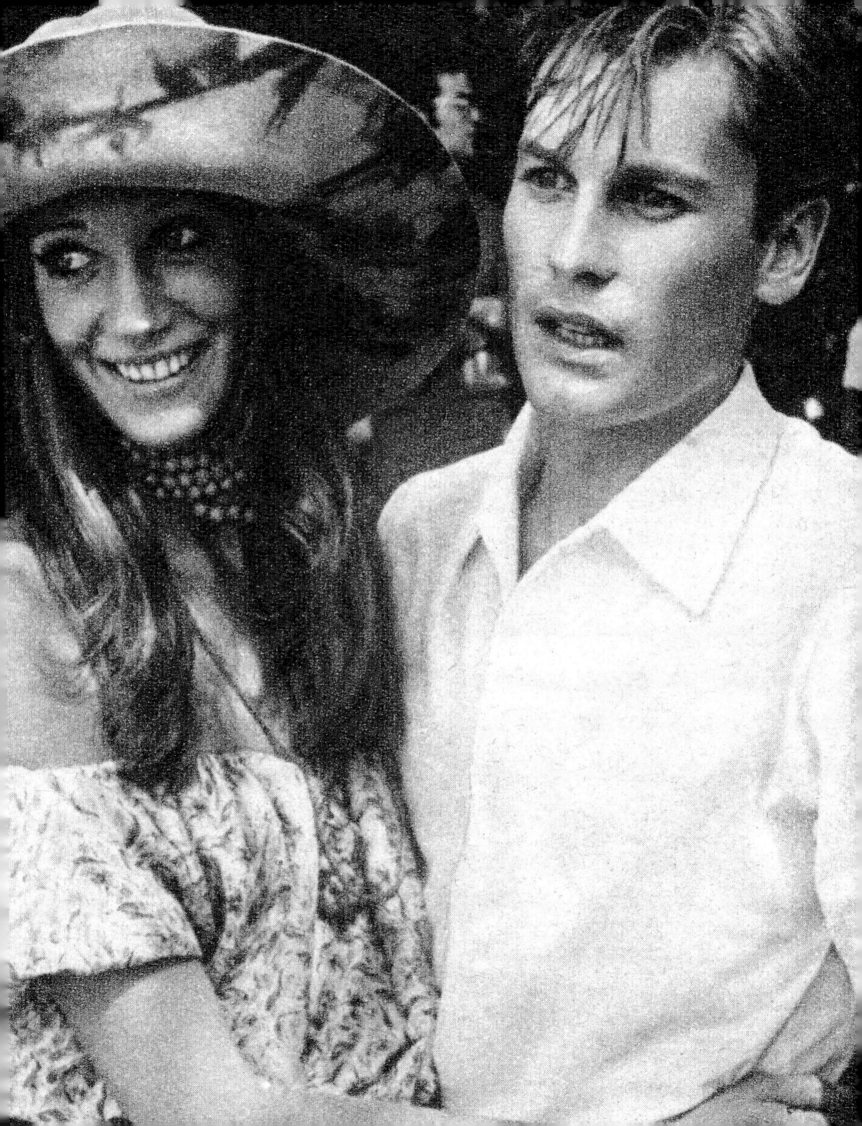

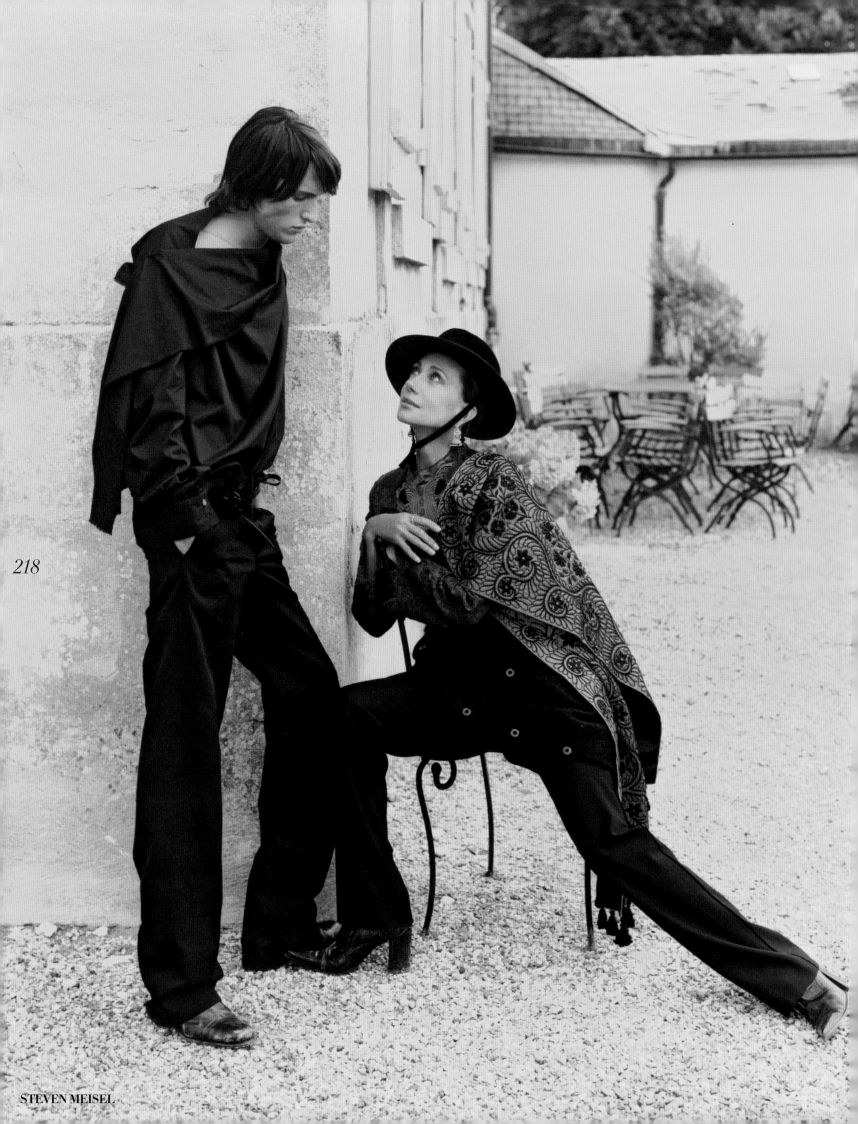

218

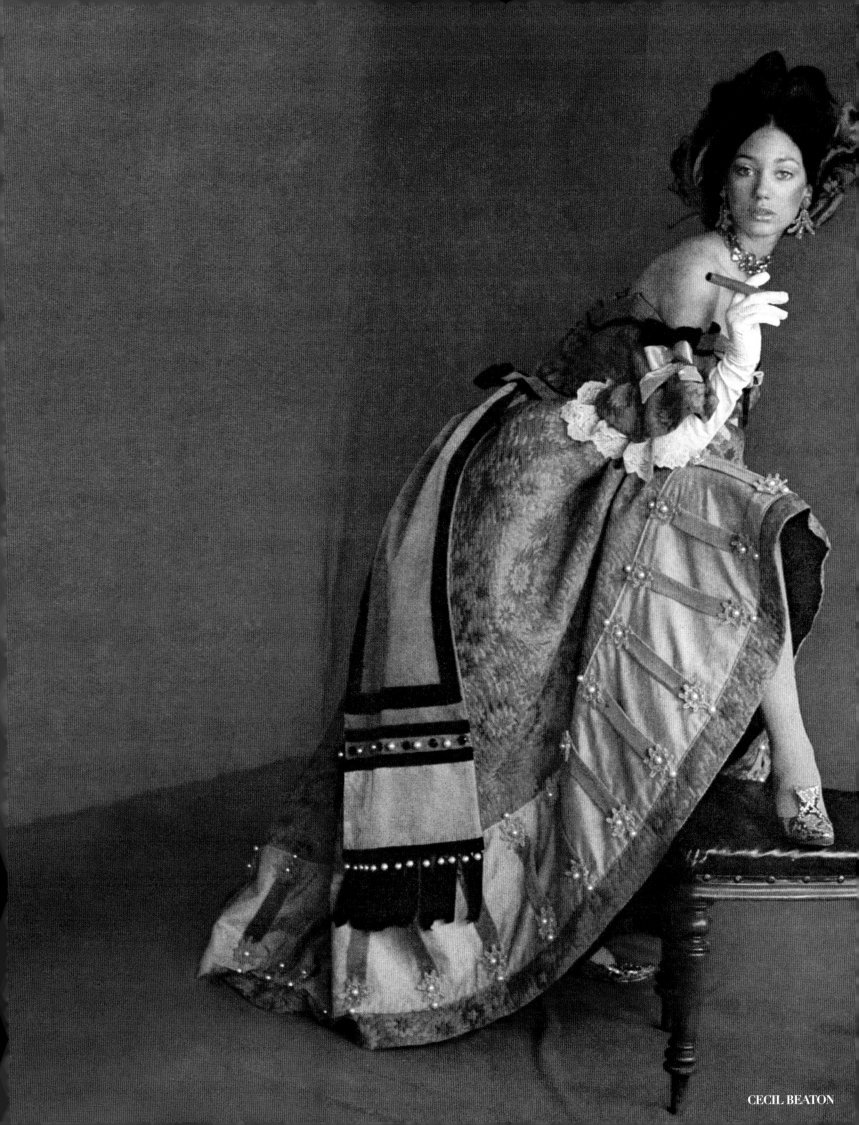

CECIL BEATON

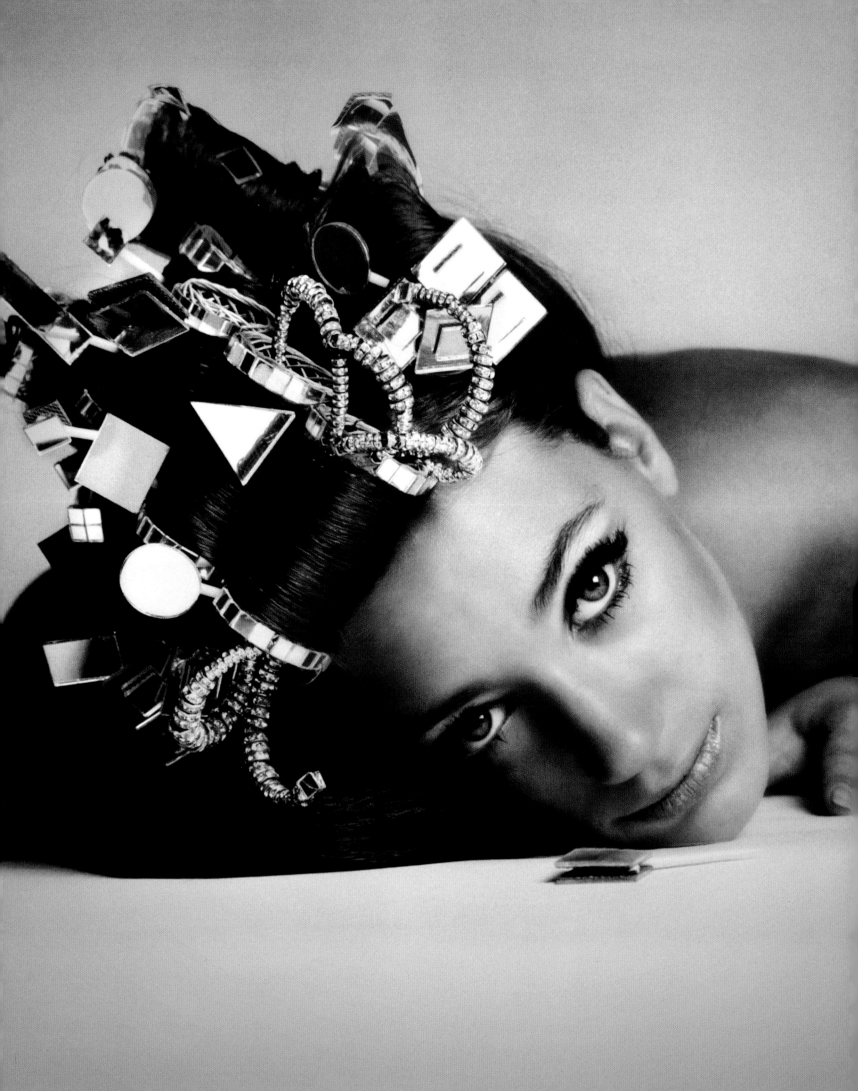

MELVIN SOKOLSKY

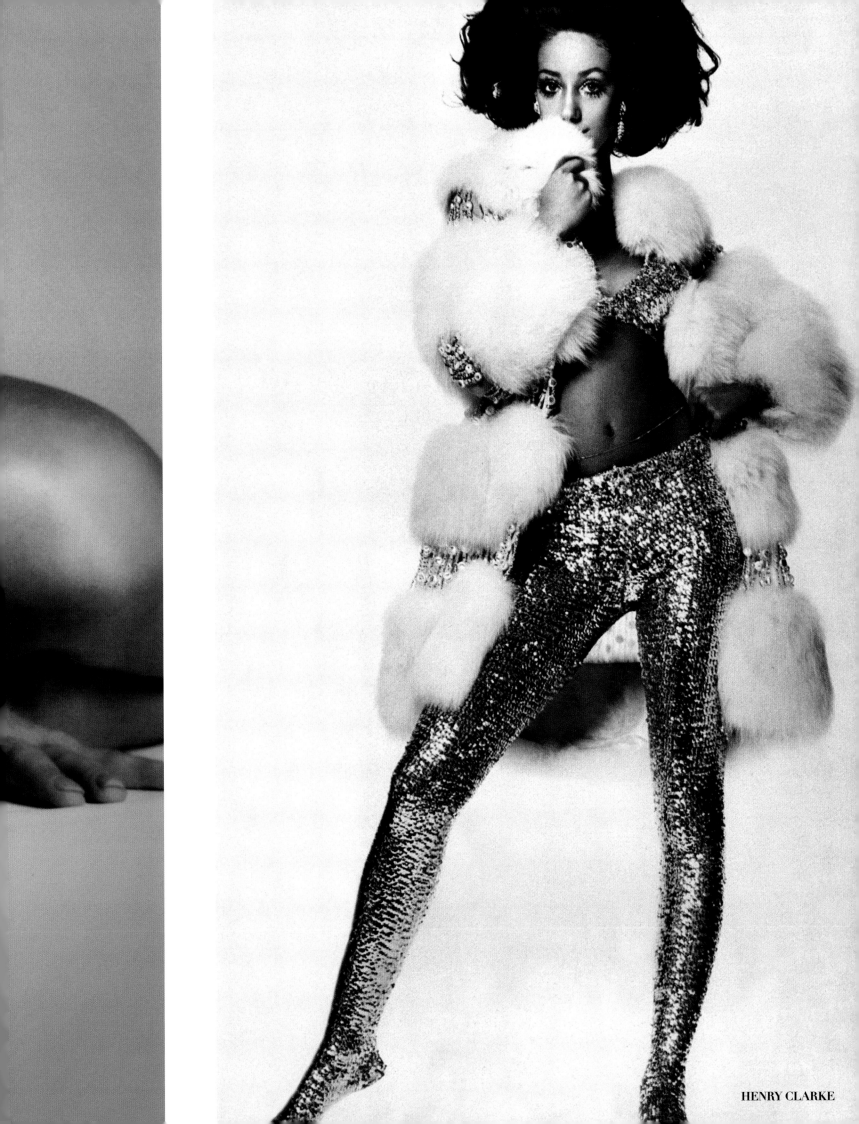

HENRY CLARKE

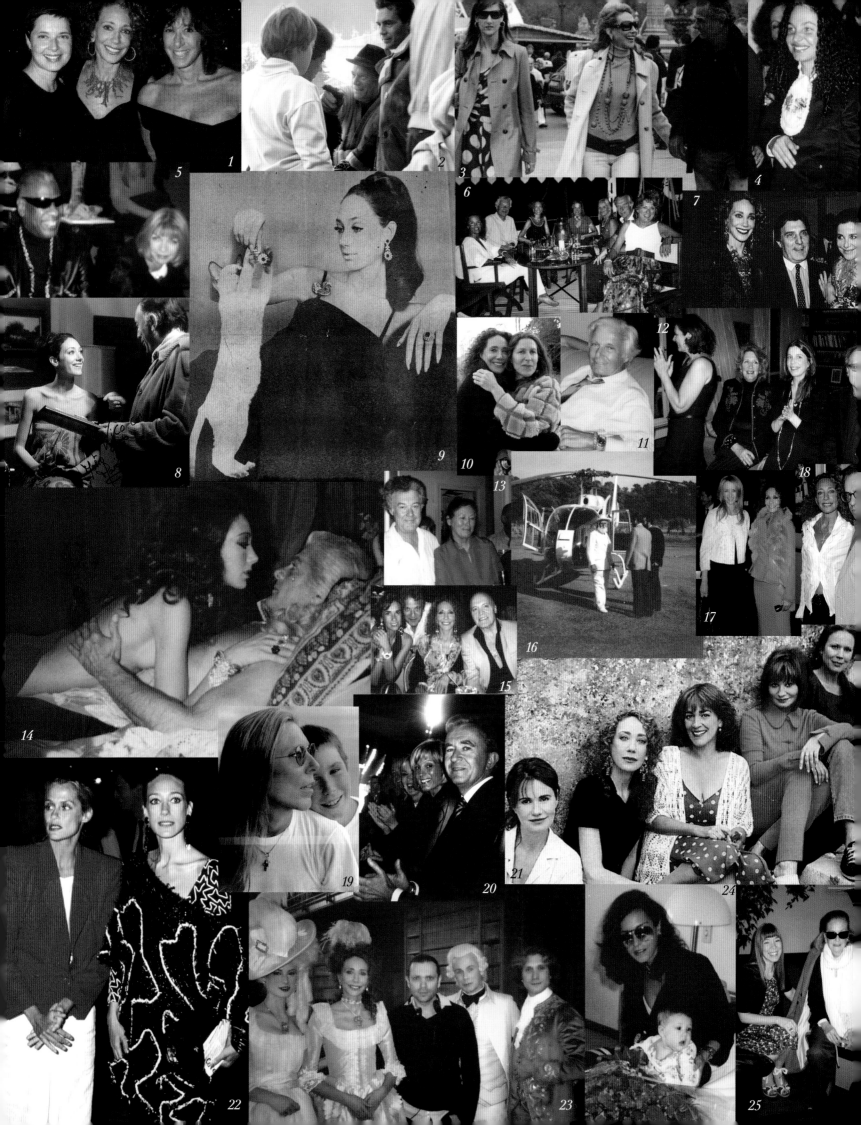

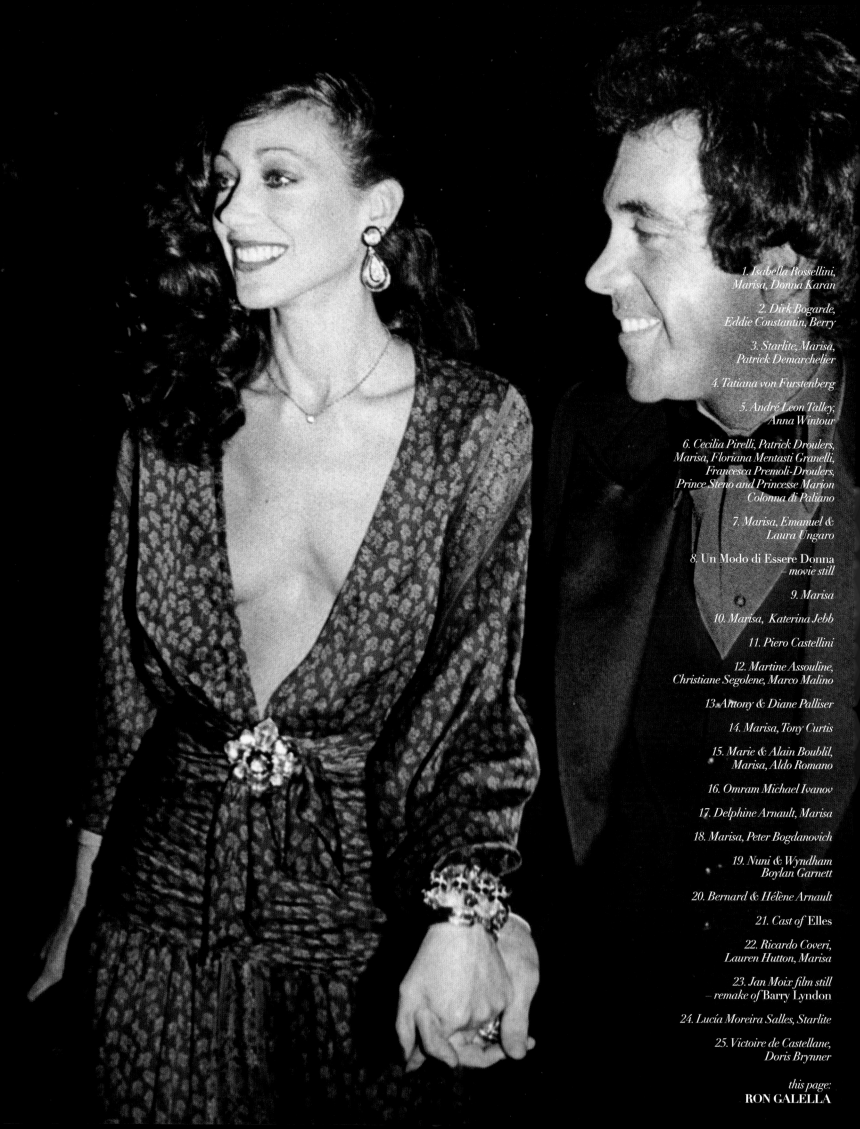

1. *Isabella Rossellini,*
Marisa, Donna Karan

2. *Dirk Bogarde,*
Eddie Constantin, Berry

3. *Starlite, Marisa,*
Patrick Demarchelier

4. *Tatiana von Furstenberg*

5. *André Leon Talley,*
Anna Wintour

6. *Cecilia Pirelli, Patrick Droulers,*
Marisa, Floriana Mentasti Granelli,
Francesca Premoli-Droulers,
Prince Steno and Princesse Marion
Colonna di Paliano

7. *Marisa, Emanuel &*
Laura Ungaro

8. *Un Modo di Essere Donna*
– movie still

9. *Marisa*

10. *Marisa, Katerina Jebb*

11. *Piero Castellini*

12. *Martine Assouline,*
Christiane Segolene, Marco Malino

13. *Antony & Diane Palliser*

14. *Marisa, Tony Curtis*

15. *Marie & Alain Boublil,*
Marisa, Aldo Romano

16. *Omram Michael Ivanov*

17. *Delphine Arnault, Marisa*

18. *Marisa, Peter Bogdanovich*

19. *Nuni & Wyndham*
Boylan Garnett

20. *Bernard & Hélène Arnault*

21. *Cast of* Elles

22. *Ricardo Coveri,*
Lauren Hutton, Marisa

23. *Jan Moix film still*
– remake of Barry Lyndon

24. *Lucía Moreira Salles, Starlite*

25. *Victoire de Castellane,*
Doris Brynner

this page:
RON GALELLA

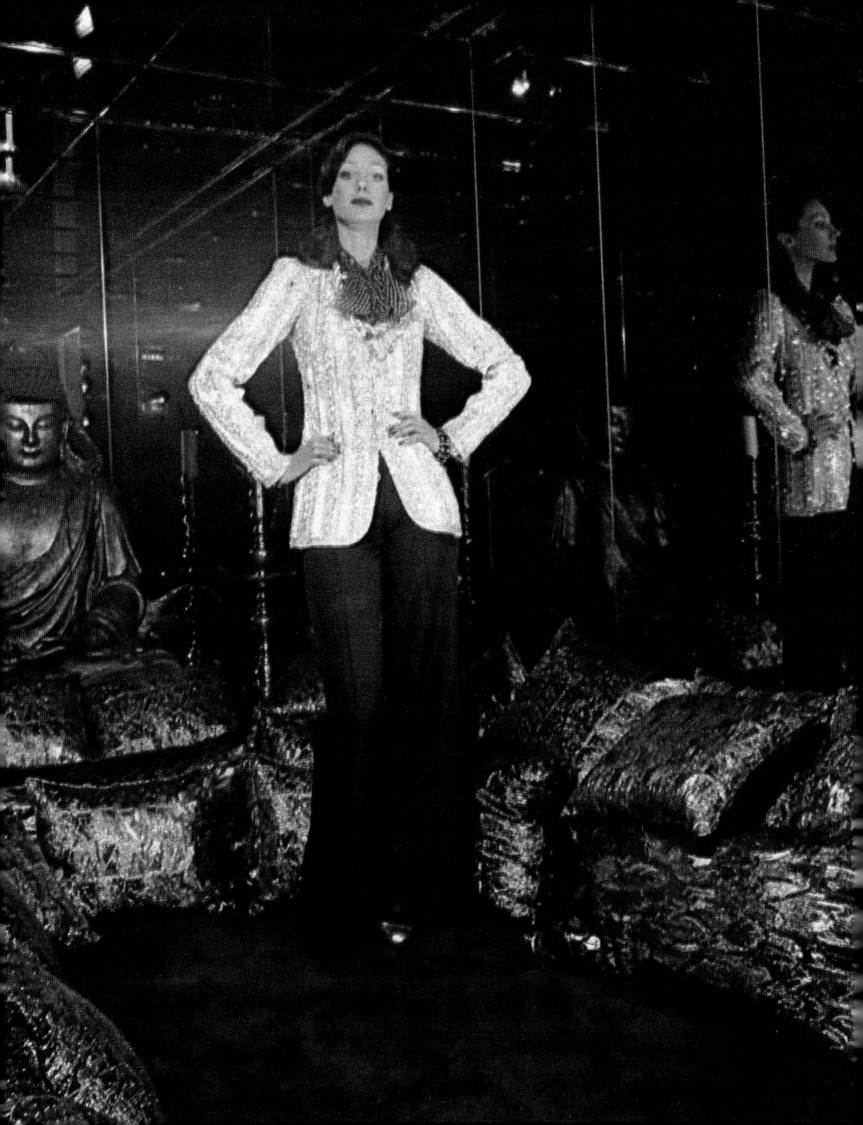

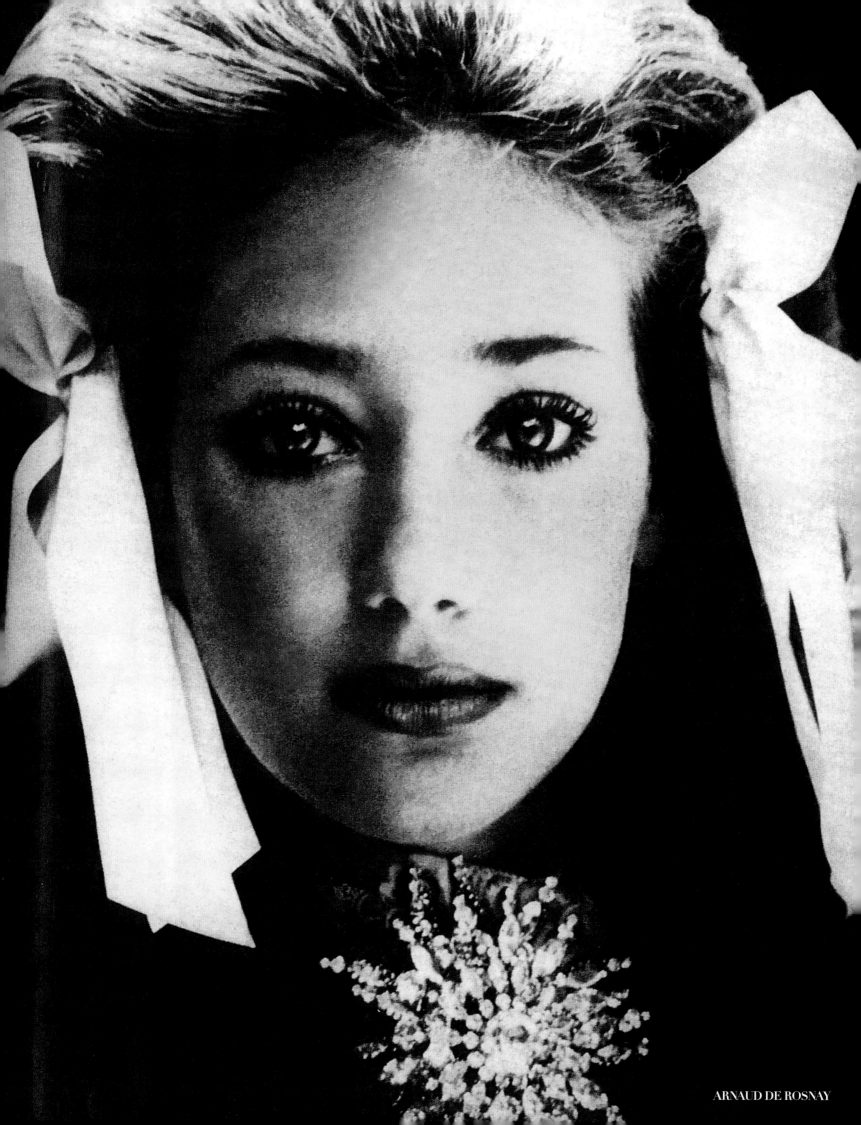

ARNAUD DE ROSNAY

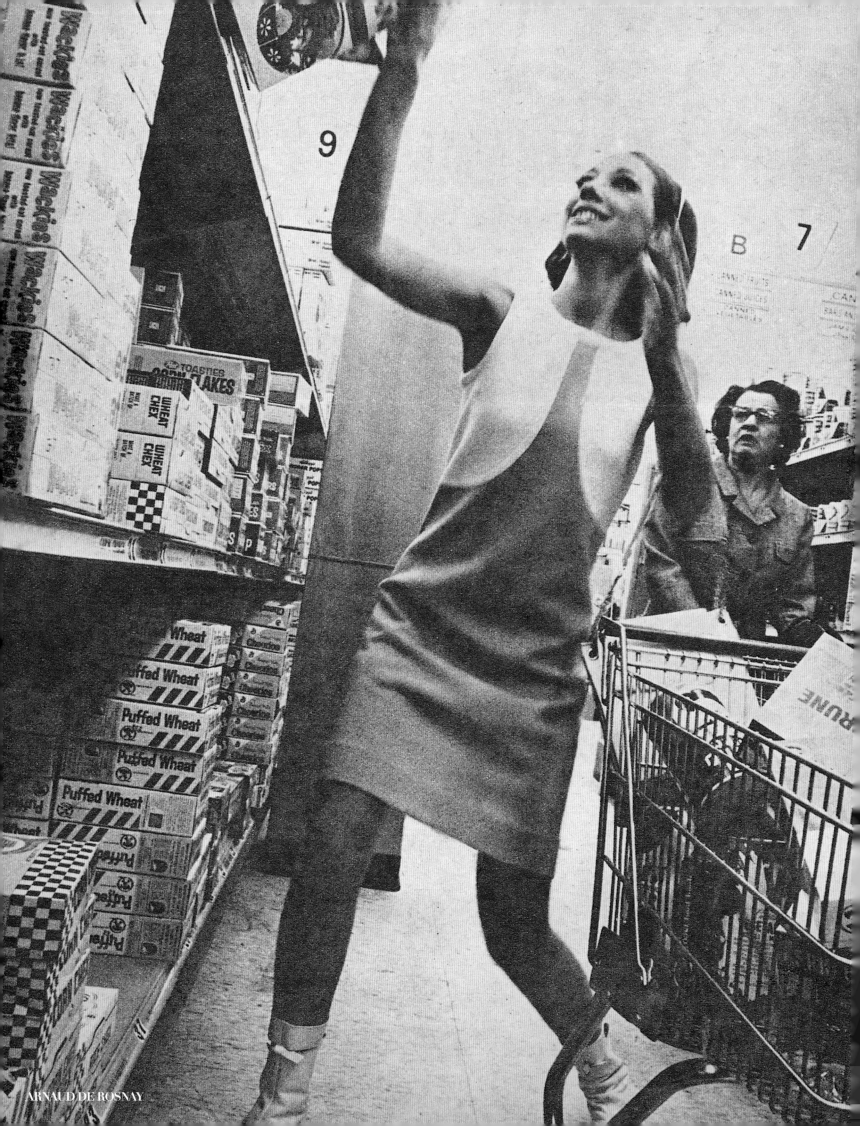

ARNAUD DE ROSNAY

The Young Go Courrèges

By PATRICIA PETERSON

...reges fever will reach epidemic proportions this summer. Seventh
...ue is madly turning out copies (both authorized and plagiarized) of
...conoclastic Paris courturier's designs. These direct, unencumbered
...es are only for young, fast-moving beauties like 18-year-old Merissa
...ason. The granddaughter of Elsa Schiaparelli, who jolted the Paris
...ure scene 30 years ago, Miss Berenson was educated here and
...ad, is currently living in New York and essaying a modeling career.
...d Courreges fantastic," she says. "It's different. It's wild."

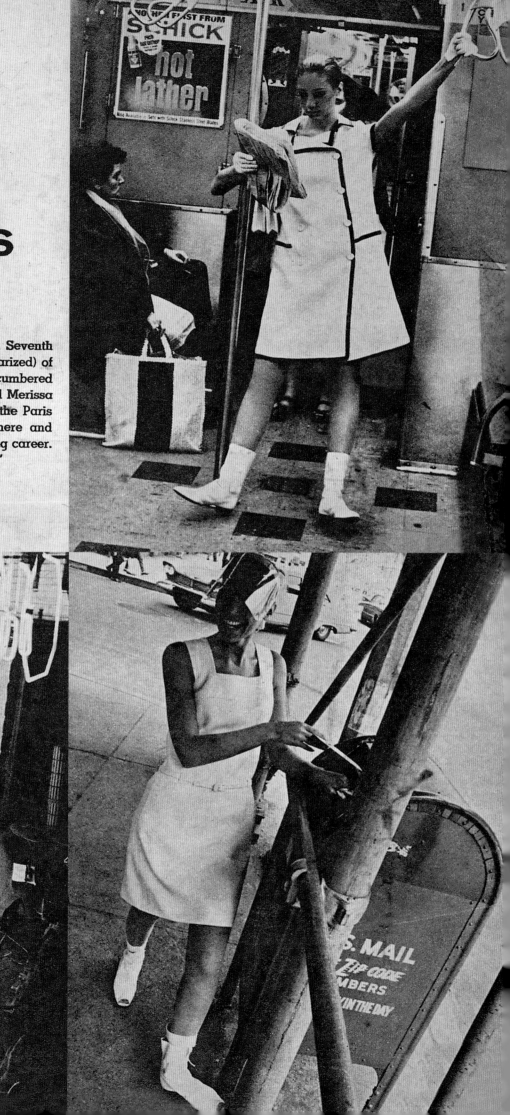

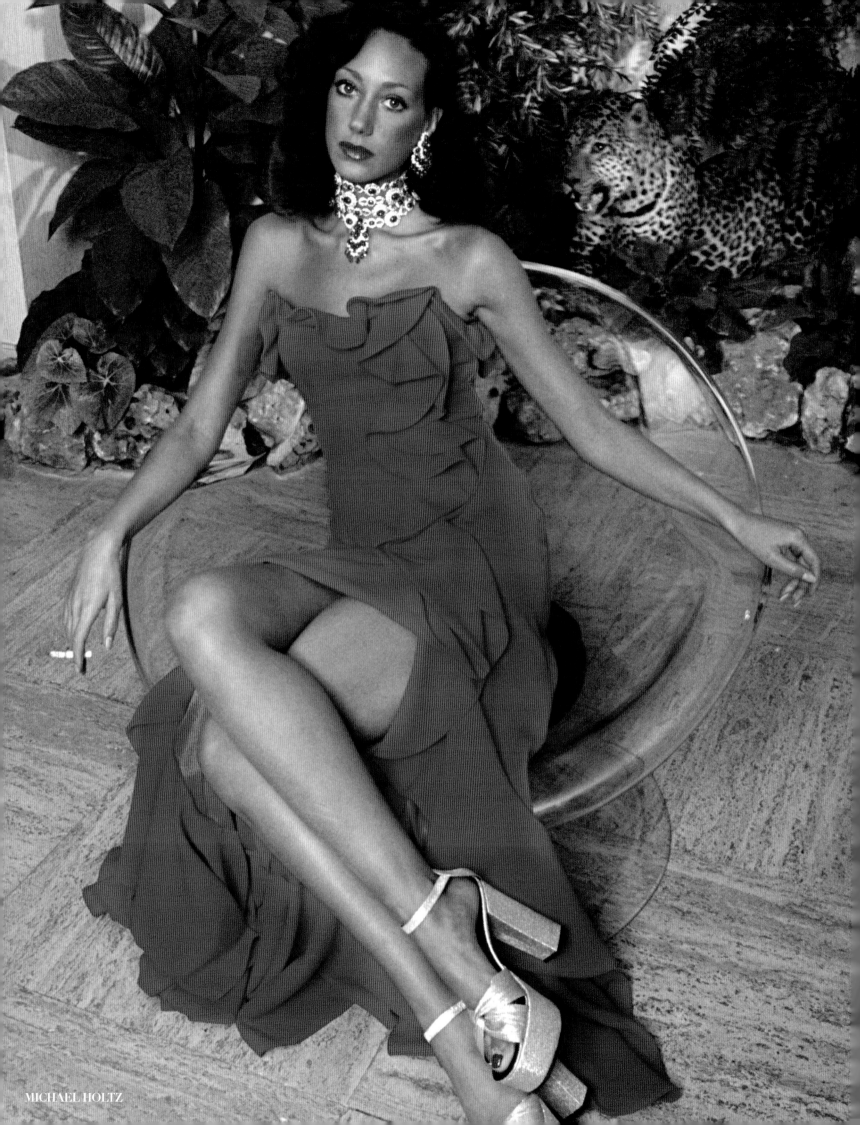

MICHAEL HOLTZ

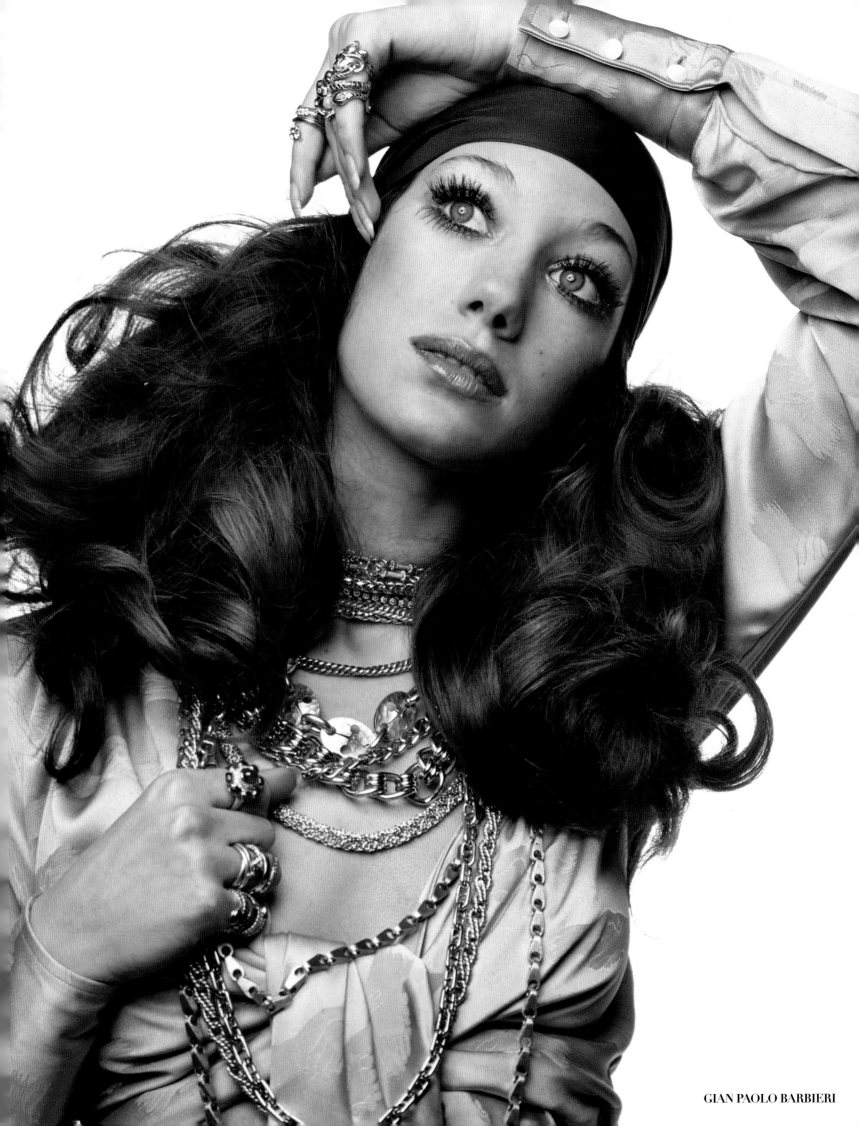

GIAN PAOLO BARBIERI

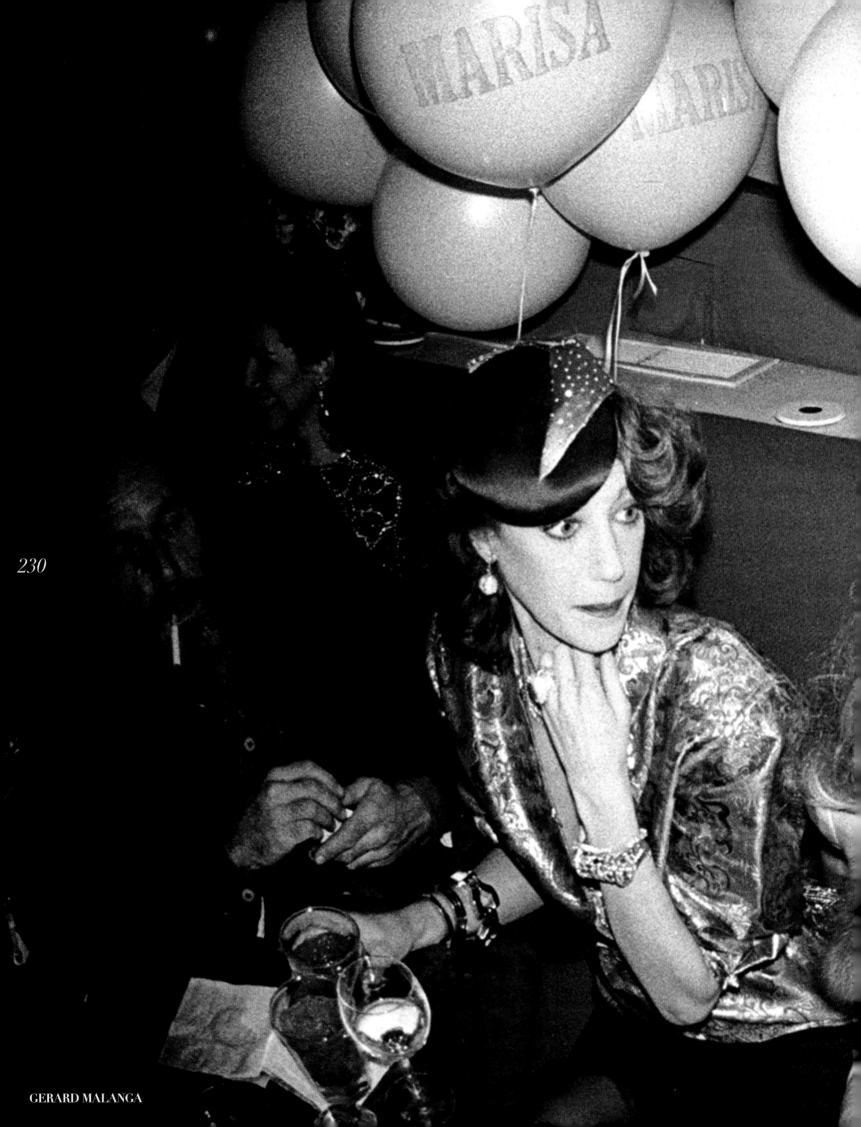

230

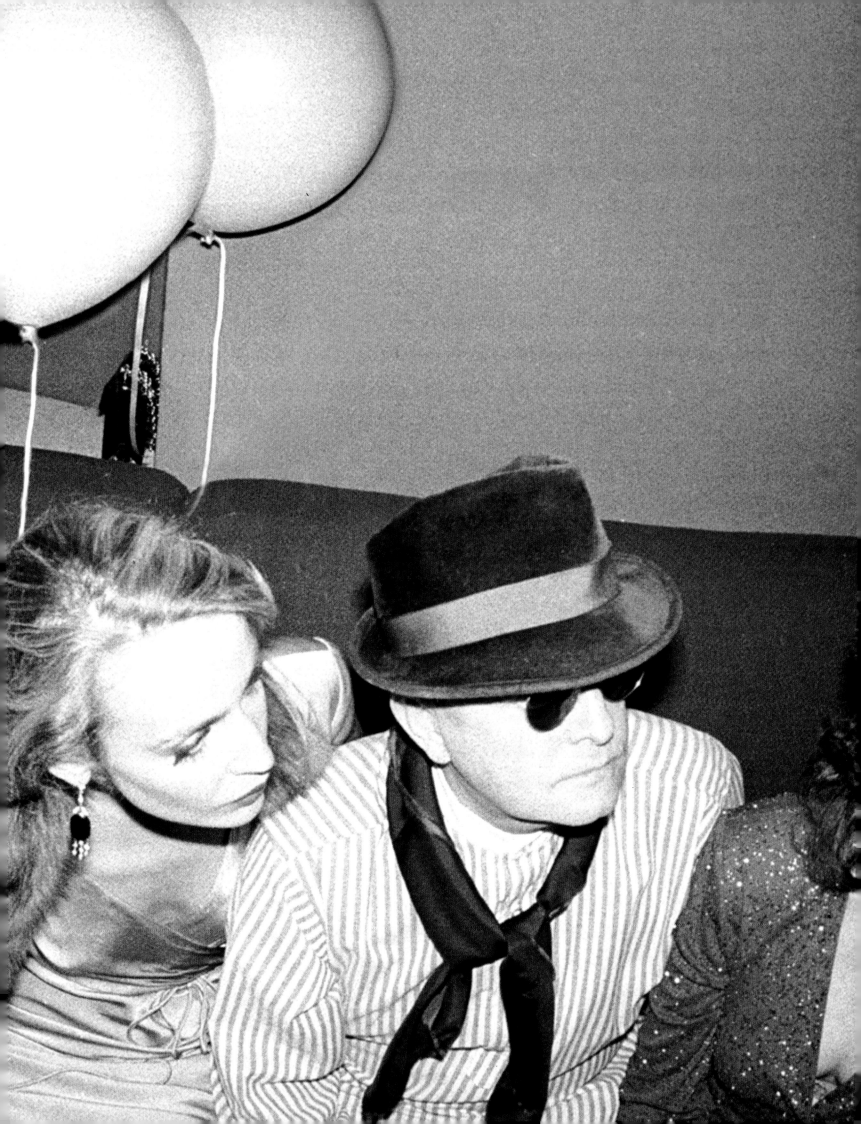

The first time I met Steven I was moved by his beauty.
A beauty that is not only skin deep but soul deep and as
mysterious as the universe. Our hearts and souls connected
in that universe, in many dimensions. His extreme sensitivity,
delicacy, gentleness, and kindness are a rare gift. Steven has
endless curiosity and humor, his dark velvet eyes never cease
to behold beauty or to discover works of poetic and boundless
fantasy, of dreams come to life, told in his own expressive and
creative language with a profound message of awareness and
wisdom. His complete understanding, strong and powerful,
refined and delicate, radiates, touching all kinds in all ways,
breaking boundaries, and always searching for the light.
That magical light that he exudes and shines upon us. That light
that shows him the way, that inspires his spirit, that shines in
his work, that guides his life. That light that is truth and purity.

I believe in angels. Those around us in the invisible and those
whom have landed here touched by grace, to enhance our lives.
Steven to me is one of those angels.

MARISA

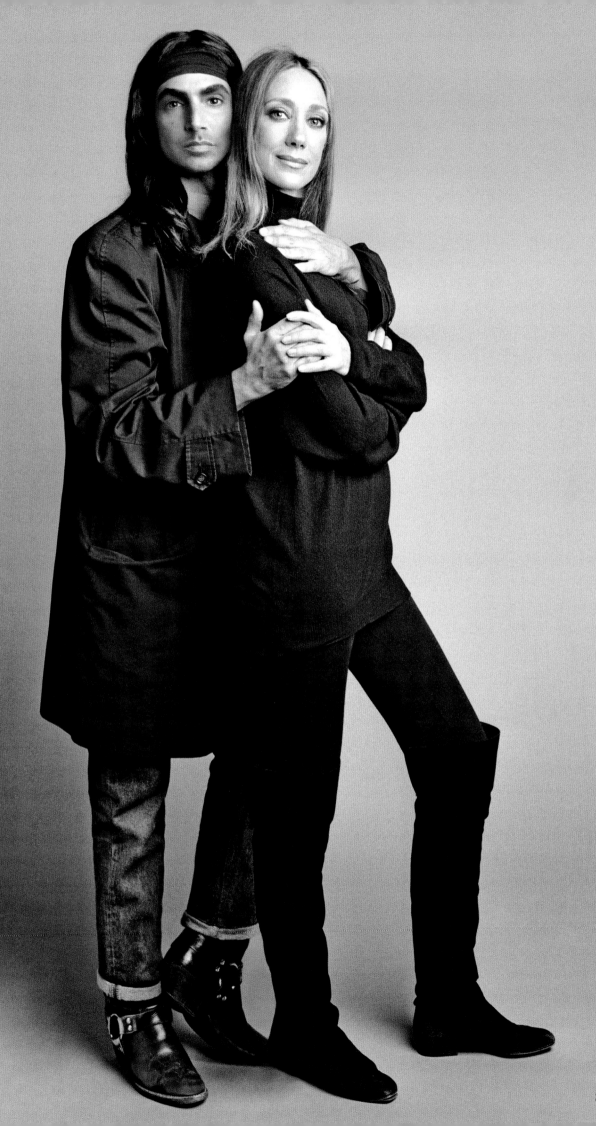

STEVEN MEISEL

ACKNOWLEDGMENTS

A heartfelt and profound thank you to:

Jonathan Newhouse,
for his great generosity, support, and friendship.

Steven Meisel,
beloved friend, for this most wonderful and generous gift, and for his love and immense talent.

Jason Duzansky,
for his gentleness, his insights, his very special talent and creativity.

Lina Bey,
For her wonderful disposition, her patience, her hard work and perfect organization.

To the wonderful, smiling, hard working team at the Steven Miesel Studio:
Liesel Soderberg, Ruk Richards, Stas Komarovski, and Delois Ursini.

Shawn Waldron at the Condé Nast Archives,
for his incredible generosity, kindness, and precious help.

Leigh Montville, Elyce Tetorka, Aaron Siegel, and the entire hard working team
at Condé Nast and WWD.

To my wonderful editors Dung Ngo and Anthony Petrillose, for their precious help
and guidance, and to Charles Miers, Shannon McBeen, and the Rizzoli team.

Hamish Bowles,
for his beautiful words and his friendship.

To my beloved friend Diane von Furstenberg.

Jean-Michel Simonian,
for his unconditional support, vision, dedication, and most precious help.

Sylvie Doubrere,
my precious archivist in Paris, for her time, hard work, and generosity.

Tom Penn,
for his generosity and kindness. His devotion to preserve his father's legacy is inspiring.

To all of the magical people I have known, worked with, and who have inspired me all my life.

And to the following individuals and companies who have helped in ways great
and small to make this book possible:

Joree Adilman	Janet Johnson	Molly Welch
Ruven Afanador	Monica Karales	David Wills
David Bailey	Karin Kato	Leigh Yule
Gian Paolo Barbieri	Francoise &	Olivier Zahm
Mary Beasley	Douglas Kirkland	
Caroline Berton	Sandro Kopp	LVMH Moët Hennessy Louis Vuitton
Samuel Bourdin	Brigitte Lacombe	Dior
Laetitia Braquenie	Olivie Lamy	Donna Karan New York
Elizabeth Bumgarner	Barry Lategan	Moët Hennessy
Michael Callahan	Dawn Lucas	Paris Match
Pierre Consorti	Anna Macri	Van Cleef & Arpel
Brett Croft	Gerard Malanga	
David Croland	Molly Monosky	M.B.
John & Regina Duzansky	Barbara Rix-Sieff	
Danielle Edwards	Emmanuele Randazzo	
Tom Ford	Andre Rau	
Michelle Franco	Paul Roth	
Samo Gale	Eugene Rutigliano	
Ron Galella	Eleanor Sharman	
Caroline Geraud	Leslie Simitch	
Richard Golub	Elizabeth Smith	
Vanessa Gomez	Melvin Sokolsky	
Michel Haddi	Carlos Souza	
Julie Heath	Marcia Terrones	
Michael Hermann	Philicia Utz	
Dominique Issermann	Michael Van Horne	
Katerina Jebb	Dee Vitale	

right:
RICHARD AVEDON
Marisa Berenson as
Irene Langhorne Gibson,
New York, December 1975

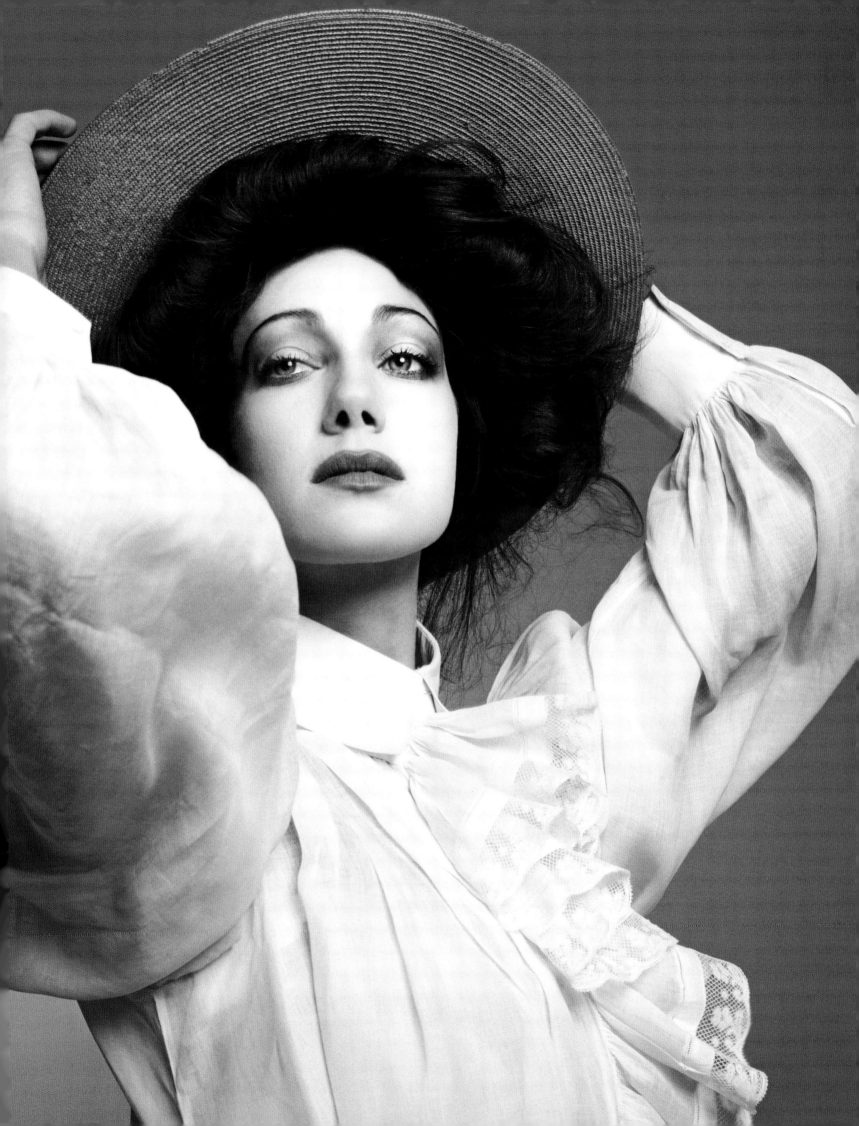

PHOTO CREDITS

Slim Aarons / Getty Images 46, 208

Agence Angeli 94, 180

Agence France Presse / Hulton Archive / Getty Images 122 (top left)

Ruven Alfanador 211

Jean Aponte 215

Richard Avedon © The Richard Avedon Foundation 2, 11, 121, 235, 237, 239

David Bailey / *Vogue* © Les Publications Condé Nast 14

David Bailey / *Vogue* © The Condé Nast Publications Ltd. 16, 20, 30, 80, 81, 142, 143

David Bailey courtesy of *Playboy* 170-71

David Bailey 31

Gian Paolo Barbieri / *Vogue* © Condé Nast 229

Baytown Studios 74 (top row, third from left)

Cecil Beaton / *Vogue* © Condé Nast 219

Cecil Beaton / Corbis 84

Bel Ami film still, © Media Press Intl 106 (photo #18)

Roloff Beny 36 (top row, third from left)

Berry Berenson / *Vogue* © Condé Nast 27, 158, 188, 209

Berry Berenson courtesy of *Interview* 18 (top row, first from left)

Alan Berliner / *WWD* © Condé Nast 127, 159

Alan Berliner / Corbis 126 (photo #21)

Guy Bourdin © Estate of Guy Bourdin. Reproduced by permission of Art + Commerce 86, 157

Richard Bruguiere 36 (bottom row, far left)

Andre Carrara courtesy of French *Elle* 129

Vic Casamento courtesy of *The Washington Post* 66 (photo #15)

Jean-Philippe Charbonnier 48 (top, bottom left, bottom right)

Michael Childers 178 (photo #12)

Henry Clarke / *Vogue* © Condé Nast 54, 163, 177, 182-83, 213, 214

Henry Clarke / *Vogue* © The Condé Nast Publications Ltd. 62, 115, 160

Henry Clarke / *Vogue* © Les Publications Condé Nast 20, 91, 221

Michel Claude 203 (photo #16)

John Cochran courtesy *Town & Country* 19

Conway Studios 145 (top row, middle photo)

John Cowan / *Vogue* © Condé Nast 146, 161

David Croland 145 (bottom row far left), 137 (photo #14)

Bill Cunningham / *Vogue* © Condé Nast 70

Arnaud de Rosnay / *Vogue* © Condé Nast 34, 71, 73, 85, 130, 150-51, 172, 199, 200, 201, 216

Arnaud de Rosnay / *Vogue* © Les Publications Condé Nast 59

Arnaud de Rosnay / *Vogue* © The Condé Nast Publications Ltd. 225

Arnaud de Rosnay / Corbis 125, 198

Arnaud de Rosnay 15, 16, 18 (bottom row, first from left), 40, 78-79, 96, 189

Carlos Eduardo de Souza 106 (photo #5)

Didier-Plowy 106 (photo #17)

Frank Diernhammer / *WWD* © Condé Nast 116

Brian Duffy courtesy of French *Elle* 135

John Engstead 191 (top row, second from left)

Richard Fegley courtesy of *Playboy* 140-41

Stephane Feugere 66 (photo #1)

Filippo Fior 89

Flagrant Desire film still, © Sofracima - Film A2 - Martel Media Productions - Third Eye Productions - Odessa Films 137 (photo #13)

Tom Ford 210

Vanessa Franklin 191 (second row, far left)

A. Frontoni 222 (photo #14)

Ara Gallant courtesy *Interview* 14 (third row, first from left)

Ron Galella 52, 107, 137 (photo #24), 202, 223

Oberto Gili courtesy *Town & Country* 14 (top row, third from left)

Nancy Gillan / *Vogue* © Les Publications Condé Nast 195

Reginald Gray / *WWD* © Condé Nast 25, 98, 99

Guerra de Spie film still, © Beta Film / Radiotelevisione Italiana (RAI) / Titanus / Telecip 126 (photo #4)

Michel Haddi 18 (middle row, second from left)

Harlip 191 (far left)

John Haynesworth / *WWD* © Condé Nast 112

Michael Holtz 66 (photo #11)

Michael Holtz courtesy of *Paris Match* © United Archives / Leemage 228

Horst P. Horst / *Vogue* © Condé Nast 123

Jean Luce Hure / *WWD* © Condé Nast 60-61, 83

Thomas Iannaccone / *WWD* © Condé Nast 203 (photo #3)

Dominique Isserman 38-39

James Karales © Estate of James Karales 5

Lionel Kazan / *Glamour* © Condé Nast 109

Keystone-France / Getty Images 175

Douglas Kirkland courtesy *People* 14 (second row, third from left)

Sandro Kopp 174

Jill Krementz courtesy of the *International Herald Tribune* 37

L'Arbalete film still, Candice Productions / Campagnie Commerciale Francaise Cinematographique 95 (photo #22)

© Brigitte Lacombe 103

Barry Lategan / *Vogue* © The Condé Nast Publications Ltd. 20

Barry Lategan 26, 76 (top, bottom), 152

Patrick Lichfield / *Vogue* © Condé Nast 105

Nick Malachaba / *WWD* © Condé Nast 29

Philippe Maille 203 (photo #20)

© Gerard Malanga 44 (photo #5), 95 (photo #21), 230-31

© Gerard Malanga (*Screen Tests A Diary* by Gerard Malanga & Andy Warhol) 156

Man Ray 36 (second row, far right and top row, second from left)

Robert Mapplethorpe 88

Michel Marou / *WWD* © Condé Nast 167

Méditerranée Photo 203 (photo #18)

Steven Meisel 51, 58, 72, 178 (photo #5), 185, 190, 218, 233

Emil Merecen © Alcor Films / Channel 4 Television Corporation / Cine Alliance 168

Helmut Newton / *Vogue* © Condé Nast 55, 104, 131, 148

Helmut Newton / *Vogue* © The Condé Nast Publications Ltd. 16

Helmut Newton / *Vogue* © Les Publications Condé Nast 21

Jack Nisberg / *Vogue* © The Condé Nast Publications Ltd. 29 (photo #1)

Jack Nisberg / Corbis 95 (photo #4)

Desmond O'Neill 145 (bottom row, far right)

Tony Palmieri 166 (photo #16)

© Norman Parkinson Ltd/courtesy Norman Parkinson Archive 192, 193

Gianni Penati / *Vogue* © Condé Nast 93

Gianni Penati / Corbis 69, 87

Irving Penn © The Irving Penn Foundation 164

Irving Penn / *Vogue* © Condé Nast 9, 12 (top left, top right, bottom left, bottom right), 13, 22-23, 64, 65, 100, 101, 165, 206, 207

Jean-Marie Perier courtesy of French *Elle* 113

Teddy Piaz 36 (bottom row far right)

Popperfoto / Getty Images 45

Andre Rau 108

Bertrand Rindoff 28 (photo #8), 57 (photo #11), 126 (photo #15 and photo #17)

Willy Rizzo 128

Willy Rizzo courtesy of *Marie Claire* 14, 18 (second row, first from left)

Jack Robinson / *Vogue* © Condé Nast 47, 197

Jack Robinson Archive 42

Francesco Scavullo / Corbis 63, 74 (Interview cover)

Roland Schoor / Pix Inc. / Time Life Pictures / Getty Images 194

© David Seymour / Magnum Photos 145

Joel Schumacher 75

Jeanloup Sieff © Estate of Jeanloup Sieff 35, 147, 169, 184

Peter Simins / *WWD* © Condé Nast 67, 77

Melvin Sokolsky 220

Bert Stern / *Vogue* © Condé Nast 24, 32, 49, 124, 139, 173

Bert Stern / Corbis 176, 212

Ellen Von Unwerth courtesy of *Vanity Fair* 203 (photo #13)

Courtesy of Roger Viollet 154 (photo #5)

© The Andy Warhol Foundation for the Visual Arts, Inc. 119, 196

Courtesy of Warner Bros., *Death in Venice* © Warner Bros., a division of Time Warner Entertainment Company, L.P. 68 (top, bottom), 102

Courtesy of Warner Bros., *Cabaret* © ABC Pictures Corp. and Allied Artists Corp. Licensed by: Warner Bros. Entertainment Inc. All Rights Reserved 122 (top, bottom), 137 (photo #8), 162

Courtesy of Warner Bros Entertainment Inc., *S.O.B.*, © Warner Bros. all Rights Reserved 83 (photo #13)

Courtesy of Warner Bros., *White Hunter Black Heart* © Warner Bros. Inc. All Rights Reserved 132 (top, bottom)

Jay Te Winburn 145 (second row from bottom second photo from right)

Daniela Zedda 106 (photo #25)

All images not noted above are courtesy the personal archives of Marisa Berenson. Every effort has been made by Rizzoli International Publications to identify and contact the copyright holder for all images in this book, including photographs and illustrations. Despite thorough research it has not been possible to establish all copyright ownership. Any inaccuracies brought to our attention will be corrected for future editions.

right
RICHARD AVEDON
Marisa Berenson
dress by Anne Fogarty
New York, November 1967

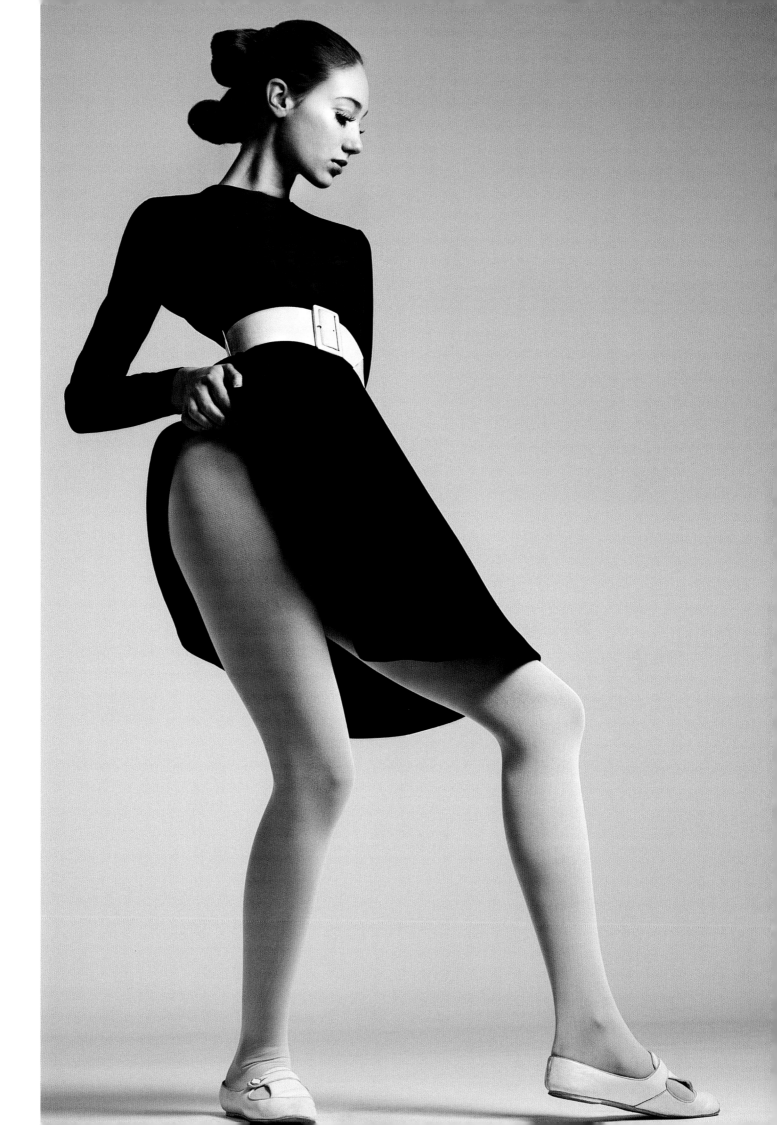

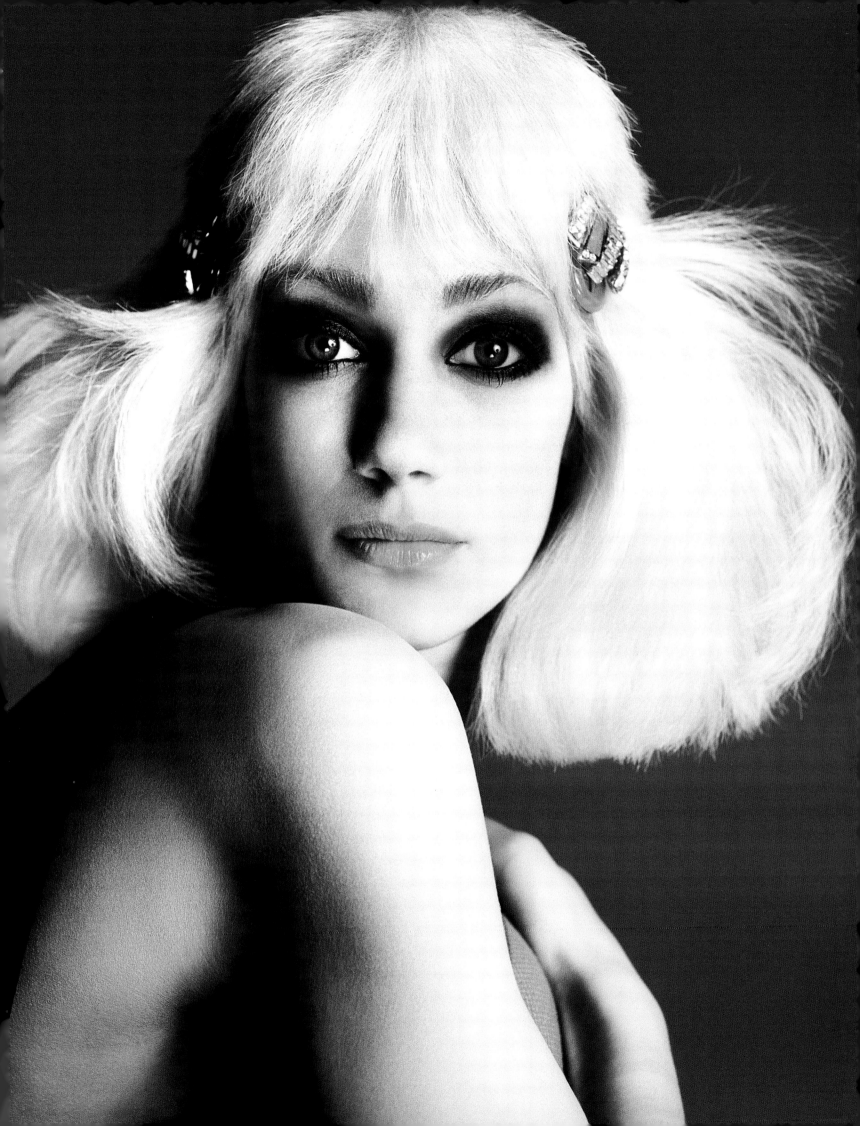

First published in the United States of America in 2011 by
RIZZOLI INTERNATIONAL PUBLICATIONS, INC.
300 Park Avenue South
New York, NY 10010
www.rizzoliusa.com

ISBN-13: 978-0-8478-3654-3
Library of Congress Control Number: 2011928838
© 2011 Rizzoli International Publications, Inc.
Text © 2011 Hamish Bowles

Editors: Dung Ngo, Anthony Petrillose
Editorial Assistants: Shannon McBeen, Liesel Soderberg
Kayleigh Janskowski, Mandy deLucia
Production: Jessica O'Neil

Distributed to the U.S. trade by Random House, New York
2011 2012 2013 2014 2015 / 10 9 8 7 6 5 4 3 2 1

Printed and bound in China